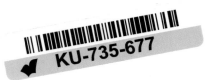

The Impressionist and the City

Dallas Museum of Art 15 November 1992–31 January 1993
Philadelphia Museum of Art 7 March–6 June 1993
Royal Academy of Arts, London 2 July–10 October 1993

Camille Pissarro, *Self-Portrait*, 1903, 41 × 33 cm,
Tate Gallery, London (see cat. 154)

The Impressionist and the City

Pissarro's Series Paintings

Richard R. Brettell *and* Joachim Pissarro

Edited by MaryAnne Stevens

Dallas Museum of Art
Philadelphia Museum of Art
Royal Academy of Arts, London

This catalogue was first published on the occasion of the exhibition
'The Impressionist and the City: Pissarro's Series Paintings'

Dallas Museum of Art, 15 November 1992–31 January 1993
Philadelphia Museum of Art, 7 March–6 June 1993
Royal Academy of Arts, London, 2 July–10 October 1993

The exhibition is supported in the United States
by a generous grant from the National
Endowment for the Arts and an indemnity from
the Federal Council on the Arts and Humanities.
Additional support in Dallas is provided by IBM,
Chubb Group of Insurance Companies, and
private donations. The exhibition is presented in
Dallas as one of the Chilton Exhibition Series.
Additional support in Philadelphia is provided by
the Pew Charitable Trusts.

In London the exhibition is 🔲

sponsored by the BANQUE INDOSUEZ GROUP

The exhibition was organised by the Dallas
Museum of Art, the Philadelphia Museum of Art
and the Royal Academy of Arts, London.

The Royal Academy is grateful to Her Majesty's
Government for its help in agreeing to indemnify
the exhibition under the National Heritage Act
1980, and to the Museums and Galleries
Commission for their help in arranging this
indemnity.

© 1992 Royal Academy of Arts

All rights reserved. This book may not be
reproduced, in whole or in part, in any form
(beyond that copying permitted by Sections 107
and 108 of the U.S. Copyright Law and except by
reviewers for the public press), without written
permission from the publishers.

Catalogue produced and distributed by
Yale University Press, New Haven and London

Typeset in Monophoto Bembo by
Servis Filmsetting Ltd, Manchester
Printed and bound in Italy by
Arnoldo Mondadori Editore, Verona

ISBN 0 300 05350 9 (clothbound)
ISBN 0 300 05446 7 (paperbound)
Library of Congress Catalog Card No.: 92–50580

COVER ILLUSTRATIONS

Front: Camille Pissarro, *Avenue de l'Opéra:
Sunshine, Winter Morning* (detail), 1898,
Musée des Beaux-Arts, Reims (cat. 69).

Back: Camille Pissarro, *Rue Saint-Honoré,
Morning-Sun Effect, Place du Théâtre
Français* (detail), 1898, The Ordrupgaard
Collection, Copenhagen (cat. 60).

EDITORIAL NOTE

All works are in oil on canvas, unless
otherwise stated. Dimensions are given in
centimetres to the nearest 0.10 cm; height
precedes width.
 The standard work of reference for
Camille Pissarro's paintings is L.R. Pissarro
and L. Venturi, *Camille Pissarro: son art—son
oeuvre*, 2 vols, Paris, 1939; rev. ed:
San Francisco, CA, 1989.
 Works listed there are referred to by their
number, preceded by 'P&V'.
 Titles of paintings in French are given as in
the *catalogue raisonné*; where new research has
justified a change of title, the 'P&V' reference
is followed by the title in the *catalogue
raisonné* in parentheses.
 Abbreviated references in the text and
catalogue entries refer to the Bibliography.
 All works included in the exhibition are
referred to by a 'cat.' number; works not in
the exhibition, but reproduced in the
catalogue are referred to by an 'ill.' number.
Comparative figures are referred to by a 'fig.'
number.

CONTENTS

SPONSOR'S PREFACE

The Banque Indosuez Group was first associated with the Royal Academy through its sponsorship of the successful exhibition, *Gauguin and the School of Pont-Aven: Prints and Paintings*, held in 1989. In keeping with the Group's continuing commitment to the Arts, expressed in its collaboration with the Royal Academy, it is now delighted to be able to make possible this important exhibition, *The Impressionist and the City: Pissarro's Series Paintings*.

Created between 1893 and his death ten years later, these serial paintings recall Pissarro's fascination with the changing effects of light, weather and seasons upon a sequence of urban views. Their presentation in this exhibition will allow the British public to view in a new light the extraordinary, experimental energy of this painter who, late in life, confirmed his preeminent position within the French Impressionist group.

The fact that the city of Paris provided the subject-matter for seven of the eleven urban series presented in this exhibition in London serves to underline the close links which the Banque Indosuez Group has with both cities. With headquarters in the French capital, this major international merchant bank, which is part of the French financial and industrial holding company, Compagnie de Suez, has had a presence in London since 1921.

We are very enthusiastic about our commitment to the Arts and our relationship with the Royal Academy, and feel assured that this will be a most successful exhibition that will leave a lasting impression on all who love the work of this most memorable artist.

Antoine Jeancourt-Galignani
Chairman and Chief Executive Officer
Banque Indosuez

FOREWORD

During the last eight years of his life, Camille Pissarro undertook a monumental task, as daring as it was novel. Whereas previously he had drawn almost all his material from rural life, he now chose to paint over three hundred canvases of urban subjects in Paris, Rouen, Le Havre and Dieppe. He seems also to have selected subjects to form eleven coherent series. Although this may have been done in emulation of Monet, Pissarro's paintings of the new quarters of Paris, the industrial quays at Rouen or the thriving seaports of Dieppe and Le Havre present a radically novel interpretation of such subjects. For Pissarro the human element was crucially important for his scenes, indeed it was the essence of city life: boulevards, bridges, riverbanks and docksides are animated by the bustle of people catching trams, labouring, dawdling, running about their business.

The last great international exhibition devoted to Pissarro, held in London, Paris and Boston in 1980–81, redefined Pissarro studies; since then the publication of Janine Bailly-Herzberg's definitive edition of his letters, the organisation of the Pissarro archive at the Ashmolean Museum, Oxford, and several monographic exhibitions and publications have done much to consolidate Pissarro's central position in the Impressionist movement, as did two fundamental Impressionist exhibitions, *A Day in the Country: Impressionism and French Landscape* (Los Angeles, Chicago and Paris, 1984–85) and *The New Painting* (Washington and San Francisco, 1986).

For all this attention, however, there has not been an exhibition that concentrated specifically on one particular aspect of Pissarro's painting. *The Impressionist and the City: Pissarro's Series Paintings* examines the problematic serial nature of his urban works. Each painting in the exhibition was created to be at once an independent work of art and a part of one of a sequence of works created in one place. Yet, never have these works been grouped as such in recent exhibitions, and, in fact, only the series devoted to the Avenue de l'Opéra was exhibited as a group during his lifetime. For that reason we can say little about Pissarro's intentions in creating these sequences until we see the works together.

We owe a great debt of thanks to the international team of sponsors who have joined forces to make this exhibition possible. The Dallas Museum of Art turned to the local offices of two major corporations: IBM and Chubb Group of Insurance Companies, and to an impressive group of private citizens. Philadelphia obtained generous support from the Pew Charitable Trusts. The Royal Academy is delighted to welcome back the Banque Indosuez Group as its sponsor; in 1989 Banque Indosuez supported the enormously successful exhibition *Gauguin and the School of Pont-Aven*. In addition, the American venues were supported by a generous grant from the National Endowment for the Arts and an indemnity from the Federal Council on the Arts and Humanities.

We are indebted to Joachim Pissarro, whose patient research over many years has made it possible to assemble such a comprehensive selection of his forebear's paintings. The exhibition stands as a tribute to the happy collaboration between the Dallas Museum of Art, the Philadelphia Museum of Art and the Royal Academy of Arts. It is an example of collaboration that can bring to fruition a project which we trust will be revelatory to our visitors and provide them with much pleasure.

Richard R. Brettell
The Dallas Museum of Art

Anne d'Harnoncourt
Philadelphia Museum of Art

Sir Roger de Grey KCVO, PRA
Royal Academy of Arts

ACKNOWLEDGEMENTS

The exhibition organisers particularly wish to thank Caroline Durand-Ruel Godfroy and her colleagues at the Durand-Ruel Archives for their invaluable contributions to the information provided in this catalogue on those paintings associated with Paul Durand-Ruel. Joachim Pissarro wishes to express his gratitude to the following people for their time and their generosity in sharing their ideas: Cornelius Castoriadis; Claire Durand-Ruel Snollaerts; Ellen and Paul Josefowitz; Ay-Whang Hsia; Christopher Lloyd; Alain Renaut; John Rewald; Richard Shiff; Anne Thorold; Tzvetan Todorov. In addition, the organisers would like to thank the following people for their advice and support:

Edythe Acquavella; William Acquavella; Marilyn Aitken; Véronique Alemany-Dessaint; Lynne Ambrosini; Walter Amstutz; Hortense Anda-Bührle; Kevin Anderson; Kristine Anderson; Sarah Annis; Alex Apsis; Louise d'Argencourt; Abigail Asher; Martha Asher; June Barrie; Pierre Bazin; Jacqueline Bell (DMA); Anne Bennett; Barbara A. Bernard; Melissa Berry (DMA); Derek Birdsall; Sarah Blaffer Hrdy; Mr and Mrs Carlos Blaquier; Mr and Mrs Henry Bloch; Küngolt Bodmer; Ada Bortoluzzi; Gail Brenner; David S. Brooke; Janet M. Brooke; the late Kevin Buchanan; John E. Buchanan; Lucero Bukantz de Regules; Thérèse Burollet; Françoise Cachin; Susan Campbell; J. Carter Brown; Raymonde Carpentier; Lucia Cassol; Philippe Cazeau; William J. Chiego; Brigitta Cifka; Roger D. Clisby; Iris Cohen; Florence Coman; Kevin Comerford (DMA); Philip Conisbee; Michael Conforti; Desmond Corcoran; Daniela Corti; Waldemar Croon; Pierre Curie; François Daulte; Gail Davitt (DMA); Christine De Metruis; Emma Devapriam; Mr and Mrs Harry Djanogly; Anne Donald; Douglas W. Druick; Paul-Louis Durand-Ruel; Jean Edmonson; George R. Ellis; David Ellis-Jones; Beatrice Epstein; Dennis Farr; Jane Farrington; Alan G. Fenton; Diane Flowers (DMA); Claude Foussé; Rosalind Freeman; Flemming Friborg; Ivan Gaskell; Susan Ginsburg; Frank Giraud; Lennart Gottlieb;

Dennis A. Gould; Harriet Griffin; Rob Grosman; Barbara Guggenheim; Mary Haas; the late Dr Armand Hammer; Mr and Mrs Carlos Hank; Meg Hanlon (DMA); Carrie Hastings Hedrick; Mrs Heim-Natanson; Liz Holland; Siegmar Holsten; Kenneth Hood; Waring Hopkins; Didier Imbert; Lisa Incardona; Shizuo Ishizaka; Philip Jago; Tom Jenkins (DMA); Jevtà Jevtovic; Kathleen Jones; Philip M. Johnston; Mr and Mrs Jack Josey; Mikako Kato; Mr and Mrs Herbert Klapper; Albert Kostenevich; Mr and Mrs Ronald Lassin; John Leighton; Octave Leroy; Richard Lockett; Mr and Mrs John L. Loeb; Lisa Luedtke; John Lumley; Christine L. Mack; Gillian Malpass; Mieko Matzuoka; Stephen Mazoh; Margaret McDermott; Susannah H. Michalson; Carleton Mitchell; Ryuichiro Mizushima; Renee Montgomery; Lee Moony; Takao Mori; Richard Morphet; Kathryn Murray; David Nash; Stephen Nash; Peter Nathan; Richard Nathanson; Giuseppe and David Nehmad; John Nicoll; David Nisinson; Brigitte Odermatt; Sadao Ogawa; Eugenia O'Hana; Sheila O'Hara; Harunobu Okada; Graziella Ombroni; Inna Orn; Jennifer Otte (PMA); Mrs J. H. Otway; Norio Oyama; Herbert Palmer; Michael Pantazzi; Lieschen Potuznik; Eva-Maria Preiswerk-Lösel; Mrs A. N. Pritzker; Stephen S. Prokopoff; Lord and Lady Rayne; Theodore Reff; Christopher Riopelle; Hedi Römer; Michael Rose; James Roundell; Erica Ruegger; Cesare Sacerdoti; Marie-Claude Saia; Salma Es-Saïd; Jennifer Saville; Mr and Mrs David T. Schiff; Manuel Schmit; Mr and Mrs F. L. Schoneman; Dieter Schwarz; Christel Schroder; Michael Shapiro; Sharon Shultz Simpson; Elizabeth Smallwood; Mark Snedegar (DMA); Lesbeth Stadshil; Anna Maria and Rufolf Staechelin; Timothy Stevens; William Stover; Michel Strauss; Martin Summers; John Tancock; Hans Christoph von Tavel; Geneviève Testanière; Gary Tinterow; Peggy Tolbert; Sydney Trattner; H. Verbeek; Horst Vey; Cynthia Vimond; Martha Ward; Lady Weir; Claus Dieter Werneyer; John Whately; Daniel Wildenstein; Guy Wildenstein; Jorg Wille; Ully Wille; Timothy Wilson; Michèle

Wittwer; Patricia Woods; Marke Zervudachi; Mr and Mrs Robert Zoellner

They are also particularly grateful to Abigail Willis, assistant to Joachim Pissarro, for her help in the preparation of the catalogue, to Sara Gordon (RA Catalogue Assistant), for her unstinting work in coordinating photographic requests and managing the constant updating of loans, and to Debra Wittrup (DMA Exhibitions Assistant), who deftly coordinated the efforts of all. Special thanks are due to the following for their assistance:

Dallas Museum of Art: Kim Bush (Registrar); Anna McFarland (Exhibitions Administrator); Emily Summers (Associate Director for Exhibition Funding)

Philadelphia Museum of Art: Gretchen Dietrich (Assistant Coordinator of Special Exhibitions); Alison Goodyear (Departmental Secretary for European Painting Before 1900); Jennifer Vanim (Administrative Assistant for European Painting Before 1900); Suzanne Wells (Coordinator of Special Exhibitions)

Royal Academy of Arts, London: Miranda Bennion (Photographic Coordinator); Annette Bradshaw (Deputy Exhibitions Secretary); Jane Martineau (Catalogue Coordinator)

LENDERS TO THE EXHIBITION

Basel
Rudolf Staechelin Family Foundation, Basel

Birmingham
Birmingham Museums and Art Gallery

Cambridge, Massachusetts
Fogg Art Museum, Harvard University Art Museums

Cardiff
National Museum of Wales

Chicago
The Art Institute of Chicago

Chicago
Lorraine Pritzker

Copenhagen
The Ordrupgaard Collection

Glasgow
Glasgow Art Gallery and Museum

Le Havre
Musée des Beaux-Arts

Hiroshima
Hiroshima Museum of Art

Honolulu
Honolulu Academy of Arts

Jerusalem
The Israel Museum

London
Harry and Carol Djanogly

London
National Gallery

London
Tate Gallery

Los Angeles
The Armand Hammer Collection, The Armand Hammer Museum of Art and Cultural Center

Los Angeles
Los Angeles County Museum of Art

Melbourne
National Gallery of Victoria

Memphis
The Dixon Gallery and Gardens, Memphis, Tennessee

Mexico City
Carlos Hank

Minneapolis
The Minneapolis Institute of Arts

Montreal
The Montreal Museum of Fine Arts

New York
Mrs Edythe C. Acquavella

New York
Simone and Alan Hartman

New York
The Metropolitan Museum of Art

Oberlin
Allen Memorial Art Museum, Oberlin College

Ottowa
National Gallery of Canada

Paris
Musée d'Orsay

Paris
Musée du Petit Palais

Paris
Galerie Schmit

Philadelphia
Philadelphia Museum of Art

Pittsburgh
The Carnegie Museum of Art

Reims
Musée des Beaux-Arts

St Louis
The Saint Louis Art Museum

St Petersburg
The State Hermitage Museum

Tokyo
Isetan

Tokyo
Matsuoko Museum of Art

Toledo, Ohio
The Toledo Museum of Art

Toronto
Art Gallery of Ontario

Urbana
Krannert Art Museum and Kinkead Pavilion, University of Illinois at Urbana-Champaign

Washington, D.C
National Gallery of Art

Williamstown
Sterling and Francine Clark Art Institute

Winterthur
Kunstmuseum Winterthur

and other owners who wish to remain anonymous

CAMILLE PISSARRO: A BRIEF CHRONOLOGY

For reasons of brevity, references to works included in the exhibition or reproduced in the catalogue are referred to by number only and are not differentiated by 'cat.' or 'ill.', as is the case elsewhere in the book.

This chronology is largely dependent upon that given in Bailly-Herzberg 1980.

1830
Birth of Jacob Abraham Camille Pissarro in Charlotte Amalie, capital of St Thomas, Virgin Islands. His father, Frédéric, was a businessman who had emigrated from Bordeaux in 1824. His mother, Rachel Pomié-Manzana, was the widow of Isaac Petit. Both were practising Jews.

1842
Camille Pissarro sent to boarding school at Passy, a suburb of Paris.

1847
Pissarro returns to his family at Charlotte Amalie; he is taken into the family business.

1852
Pissarro visits Venezuela with the Danish painter Fritz Melbye.

1855
Pissarro gives up a business career and goes to Paris. He arrives in the capital *c.*15 October; he visits the Exposition Universelle, where he is impressed by the works of Delacroix, Corot and Courbet.

1857
During the summer at Montmorency, Pissarro follows Corot's advice of painting from nature.

1858
Pissarro receives a monthly allowance from his parents.

1859
Pissarro works at a 'free' atelier and at the Atelier Suisse, where he meets Claude Monet.

1860
Pissarro starts a liaison with Julie Vellay, who had entered the service of his relations.

1861
In April Pissarro registers to copy in the Louvre and, at the Atelier Suisse, meets Armand Guillaumin and Paul Cézanne.

1863
Pissarro's son Lucien is born in Paris. Cézanne and Zola visit his studio. He becomes a member of the Société des Aquafortistes and makes his first prints.

1865
Pissarro's father dies. Julie-Rachel, his daughter, is born. He sees much of Oller, a Puerto Rican painter, and Cézanne; he sells few paintings.

1866
Pissarro meets Manet, attends Zola's 'Thursdays', the Café Guerbois in Les Batignolles, and Bazille's studio with Monet, Renoir, Sisley and others.

1868
The art dealer, Père Martin, is interested in his work, but Pissarro sells little and has to resort to painting blinds and shop signs with Guillaumin.

1869
Pissarro moves on or before 2 May to 22 Route de Versailles, Louveciennes.

1870
19 July, the outbreak of the Franco-Prussian War; Pissarro and his family are forced to flee Louveciennes, abandoning his studio; they arrive in London at the beginning of December.

1871
Pissarro lives first at Westow Hill, then at Upper Norwood, Surrey. In January, through Daubigny, he meets the dealer, Paul Durand-Ruel, a fellow exile in London, and studies the work of Turner, Constable and Crome in London collections. On 14 July, he marries Julie Vellay at Croydon and, at the end of that month, the family returns to Louveciennes to discover that his studio has been sacked; he says he has lost some 1,500 works. In November his son Georges is born.

1872

In August Pissarro moves to Pontoise, and Cézanne establishes himself shortly afterwards at Auvers-sur-Oise. He recommends Cézanne to one of his dealers, Père Tanguy.

1873

Pissarro and Cézanne are working together at Pontoise; with Guillaumin, they embark upon etching, encouraged by Dr Gachet.

1874

13 January, Hoschedé Sale at Hôtel Drouot produces favourable results for Pissarro and his fellow Impressionists. April–May, Pissarro shows with the 1st Impressionist exhibition held in Nadar's studio, Blvd des Capucines. Economic crisis in France forces Durand-Ruel to suspend support to Pissarro and his fellow Impressionists. In the autumn, at Montfoucault, he makes a group of twelve lithographs.

1876

April–May, Pissarro shows at the 2nd Impressionist exhibition, held at Durand-Ruel's galleries. He participates in Murer's 'Wednesday dinners'.

1877

April, Pissarro shows at the 3rd Impressionist exhibition, and puts work into the Impressionist Sale, 28 May, from which he gains but mediocre results.

1879

April–May, Pissarro shows at the 4th Impressionist exhibition. In the summer, Gauguin comes to paint with him at Pontoise. Evenings spent at the Café de la Nouvelle Athènes, with Zandomeneghi, Desboutin, Tivoli, de Nittis, Degas, Manet and fellow Impressionists. Pissarro makes eleven etchings, most printed at Degas's studio.

1880

April, Pissarro shows at the 5th Impressionist exhibition.

1881

February, Durand-Ruel begins buying from the Impressionists again. April, Pissarro shows at the 6th Impressionist exhibition. Summer, he is visited at Pontoise by Gauguin and Cézanne.

1882

Collapse of the Banque de l'Union Générale temporarily removes Durand-Ruel's ability to support the Impressionists. March, Pissarro shows at the 7th Impressionist exhibition. December, Pissarro moves to Osny, near Pontoise.

1883

May, Pissarro has his first one-man show at Durand-Ruel's galleries. October–November, he visits Rouen to create his first 'proto-series'. Durand-Ruel holds his first exhibition in the U.S.A. (Boston) which includes six works by Pissarro.

1884

April, Pissarro moves from Osny to Eragny-sur-Epte. Foundation of the Société des Artistes Indépendants; Pissarro does not participate since he is still committed to the Impressionist group. His commitment to radical politics becomes more pronounced; he has been reading for the past year *Le Prolétaire* (a *socialiste possibiliste* newspaper), the works of Proudhon, Zola and Flaubert, and has become an admirer of the caricatures of Daumier and Charles Keene.

1885

Pissarro adopts libertarian anarchist ideas; he takes Jean Grave's newspaper, *Le Révolté* (subsequently entitled *La Révolte* and *Les Temps nouveaux*). Autumn, he meets Signac in Guillaumin's studio, and Seurat at Durand-Ruel's.

1886

May–June, Pissarro shows at the 8th (and final) Impressionist exhibition, where he is grouped with the Neo-Impressionists, Seurat, Signac and Lucien Pissarro. He meets Vincent van Gogh and Octave Mirbeau.

1887

Pissarro visits the exhibition at the Café Tambourin, Blvd de Clichy, organised by Vincent van Gogh. He passes evenings at the Taverne Anglaise with writers from the avant-garde reviews, *La Revue Indépendante* and *La Vogue*. In September, he makes contact with Théo van Gogh, manager of modern paintings for Boussod et Valadon.

1888

September, Pissarro contracts the eye infection from which he was to suffer for the rest of his life.

1889

February, Pissarro is invited to exhibit at Les XX in Brussels. Tabarant founds the Club de l'Art social; Pissarro attends, with Luce, Rodin, Grave and Louise Michel.

1890

January, Pissarro sends to his nieces in London an album of drawings, *Les Turpitudes sociales*. He has a one-man show at Théo van Gogh's, and exhibits at the 2nd Exposition des Peintres-graveurs, held at Durand-Ruel's galleries. May–June, he stays with Lucien in London.

1891

February, Pissarro is invited to exhibit at Les XX in Brussels. May, he visits the exhibition of Monet's Grainstacks at Durand-Ruel's galleries.

1892

Pissarro disapproves of anarchist outrages but supports the families of arrested and exiled anarchists. May–August, he visits London. For short periods in November and December, he is staying at the Hôtel/Restaurant Garnier, Paris, opposite the Gare Saint-Lazare; he starts his first Paris series (Gare Saint-Lazare; see nos 35–42). By the end of the year, he is reading Claudel, Ibsen and Kropotkine.

1893

January–March, Pissarro continues to frequent the Hôtel/Restaurant Garnier, and completes the first four paintings in the first Paris series, Gare Saint-Lazare (see nos 35, 38, 40, 41); two were included in his one-man exhibition at Durand-Ruel's galleries in March.

1894

January, Pissarro buys his first printing press; he subsequently establishes contact with Ambroise Vollard. February–March, he is invited to exhibit at La Libre esthétique in Brussels. Death of Gustave Caillebotte and a retrospective exhibition of 122 of his works held in June at Durand-Ruel's galleries.

1895

February–April, Pissarro is invited to exhibit at La Libre esthétique in Brussels. End of May, he admires Monet's exhibition at Durand-Ruel's galleries of twenty *Cathédrale de Rouen*; he also visits the Corot Centennial exhibition.

1896

20 January–29 March, Pissarro is staying at the Hôtel de Paris, Rouen; he embarks upon his Rouen series (twelve paintings; see nos 1–4, 11, 12, 18, 19). 8 September–12 November, he is staying at the Hôtel de l'Angleterre, Cours Boïeldieu; he paints a further twenty-nine works in the Rouen series (see nos 5–9, 13, 14, 20–22, 24, 28).

1897

January, Pissarro is staying at the Hôtel/Restaurant Garnier, opposite Gare Saint-Lazare (completes Gare Saint-Lazare series; see nos 36, 37, 39, 42). From 10 February, he is staying at the Hôtel de Russie, 1 Rue Drouot, from where he creates his Boulevard Montmartre series (including the sub-series of the Boulevard des Italiens) (see nos 43–58). March, Durand-Ruel exhibits works by Pissarro, including some of his first Rouen series, in New York. April,

exhibition of the Caillebotte bequest at the Musée du Luxembourg. May–July, he is in London during Lucien's illness; 27 November, his son Félix dies of tuberculosis in London. November–1 January, Pissarro has works included in the 2nd International Exposition, Carnegie Institute, Pittsburgh.

1898

2 January–28 April, Pissarro is staying at the Hôtel du Louvre, from where he creates his series, the Avenue de l'Opéra (see nos 59–73). June, one-man exhibition at Durand-Ruel's galleries includes works from the Avenue de l'Opéra series. 22 July–17 October, he returns to the Hôtel d'Angleterre, Rouen, where he completes his Rouen series (see nos 15–17, 23, 25–27, 29, 30, 32–34). In November, he has two paintings included in the 3rd International Exposition, Carnegie Institute, Pittsburgh. He expresses concern over the Dreyfus Affair.

1899

January, death of Sisley. March–April, Pissarro has a one-man exhibition at Bernheim's gallery, and in April, he is included in a group exhibition at Durand-Ruel's galleries which includes works by Monet, Renoir, Sisley and Corot. November–December, he is included in the 4th International Exposition, Carnegie Institute, Pittsburgh. November, he rents an apartment at 204 Rue de Rivoli (until November 1900), and embarks upon his Tuileries Gardens series (see nos 74–89).

1900

April–October, Pissarro has works included in the Exposition Centennale (Exposition Universelle). November, he moves to 28 Place Dauphine, from where, between the end of the year and November 1903 he creates his Square du Vert-Galant (see nos 90–112) and Pont-Neuf (see nos 113–121) series.

1901

Pissarro continues to work on the Square du Vert-Galant and Pont-Neuf series. From July to the end of September he is staying in Dieppe at the Hôtel du Commerce, which overlooked the market square and the church of Saint-Jacques; he paints his Church of Saint-Jacques series (see nos 130–34).

1902

April, Pissarro exhibits Dieppe and Paris series paintings with Monet at Bernheim's gallery. July–end September, he is staying at the Hôtel du Commerce, Dieppe, but also takes a room at 7 Arcades de la Poissonnerie; he creates his Dieppe: The Harbours series (see nos 135–144). December, he decides to retain all his Dieppe paintings since both Durand-Ruel and Bernheim have offered to buy them from him for too low prices.

1903

January, Pissarro's Dieppe series paintings are purchased by F. Gerard et fils and other dealers. 13 March–end May, he stays at the Hôtel du Quai Voltaire, Paris, from which he paints his Quai Voltaire series (see nos 122–29). 3 July, he returns to Dieppe with the intention of starting a third Dieppe series; he moves to Le Havre on 10 July, where he stays until 26 September, creating his final series, Le Havre (see nos 145–53). At the end of October, he returns to Paris and stays at the Hôtel du Quai Voltaire where he finishes the Quai Voltaire series. He is taken ill and moved, by ambulance, to 1, Boulevard Morland. He dies there on 13 November and is buried in the Cemetry of Père-Lachaise, Paris.

1904

April, a major retrospective exhibition of Pissarro's work is held at Durand-Ruel's galleries (130 works, with a catalogue introduction by Octave Mirbeau).

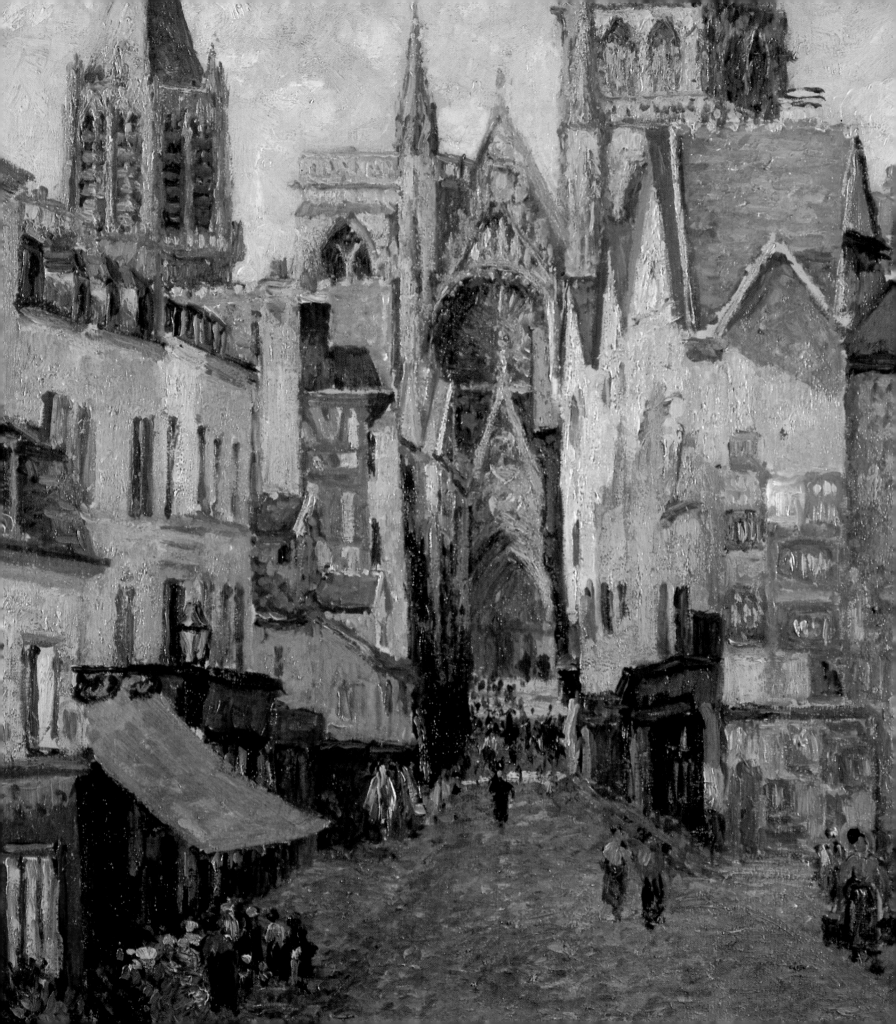

CAMILLE PISSARRO
AND URBAN VIEW PAINTING
AN INTRODUCTION

Richard R. Brettell

Among the major Impressionists, Camille Pissarro was the pre-eminent painter of rural life. Whereas Degas and Renoir painted bourgeois families, prostitutes, popular entertainers and other urban or suburban dwellers, Pissarro's figures are peasants or rural workers. And while Monet and Sisley transcribed landscapes that are fundamentally suburban, Pissarro tended, more often than not, to concentrate on the traditional villages, fields and market gardens, which were largely untouched by the world of machines and urban transactions.[1] The two places most often associated with Pissarro are Pontoise and Eragny-sur-Epte, not Paris, Rouen, Dieppe or Le Havre.[2] Yet, in the last decade of his life, between 1893 and 1903, Pissarro made more than 300 paintings, at least as many drawings and several prints representing these four French cities.

These paintings were made in several clearly defined urban campaigns that commenced in Paris in the winter of 1892/93 and then oscillated back and forth between the capital and the ports of Normandy – Rouen, Le Havre and Dieppe – until Pissarro's death in 1903. No 'series' is quite like another, and, unlike Monet's series paintings of the same decade, none of Pissarro's seems to have been undertaken expressly for a particular exhibition. By contrast, it seems as though Pissarro 'tested the waters' of urban view painting, found them temptingly warm and stayed in them less as a result of a grand design than because he was enjoying the experience. One senses little of the intense struggle to redefine painting that occupied Monet in his series. Rather, Pissarro appears almost to have been liberated by urban view painting.

Pissarro painted more cityscapes than any other major Impressionist and, as such, made the most sustained contribution to urban view painting by any great artist since the death of Canaletto in 1768.[3] True, Monet's boulevard paintings (fig. 1) preceded Pissarro's representations of the Boulevard Montmartre and the Avenue de l'Opéra, and both Monet and Renoir had painted the Pont-Neuf before Pissarro got there at the turn of the century (fig. 4). Pissarro's friend and patron Gustave Caillebotte made earlier investigations of the right-bank boulevards and streets frequented by Pissarro only after his friend's death in 1894 (fig. 5). Even Edvard Munch, whom Pissarro most probably never met, created an important group of urban landscapes in both Oslo and Paris in the years around 1890 (fig. 6).[4] Yet, none of these artists painted the city with as great a determination and with such spectacular results as did Pissarro.

Pissarro himself never claimed that his urban paintings were radically innovative. In fact, he was always honest about his precursors. What he could have claimed was a consistency of both observation and representation of the city that

1 The best modern study of Impressionist urban imagery is Robert L. Herbert's *Impressionism: Art, Leisure, and Parisian Society*, New Haven and London, 1988. However, Herbert's analysis is confined almost exclusively to the period between 1863 and 1886, before Pissarro painted his urban series. See also Sylvie Gache-Patin's essay, 'The Urban Landscape', in *A Day in the Country: Impressionism and the French Landscape*, Los Angeles 1984.

2 See Brettell 1989.

3 The most accessible recent study of Canaletto makes no reference to Pissarro or, indeed, to nineteenth- and early twentieth-century view painting. See Katherine Baetjer and J.G. Links, *Canaletto*, New York, 1989.

4 See particularly, in addition to fig. 6, *Military Band on Karl Johan Street*, 1889, oil on canvas, 102 × 142 cm, Kunsthaus, Zurich, and *Rue de Rivoli*, 1891, oil on canvas, 80 × 63 cm, Fogg Art Museum, Cambridge, Mass.

facing page: detail of cat. 34

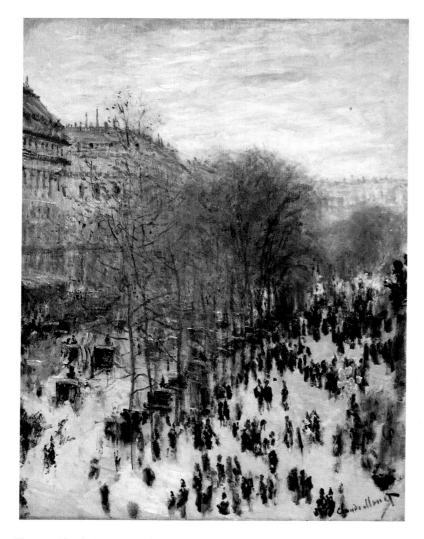

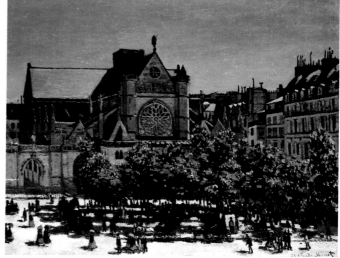

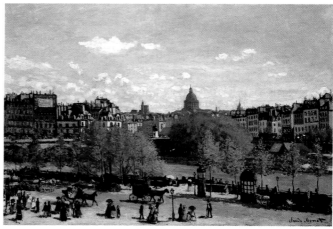

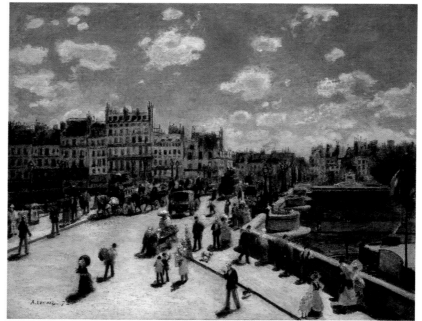

Fig. 1 Claude Monet, *Boulevard des Capucines*, 1873–74, 79.4 × 59.1 cm, The Nelson–Atkins Museum of Art, Kansas City, Mo., Kenneth A. and Helen F. Spencer Foundation Acquisition Fund

Fig. 2 Claude Monet, *Saint-Germain l'Auxerrois*, 1867, 79 × 98 cm, Nationalgalerie, Berlin

Fig. 3 Claude Monet, *The Quai du Louvre*, 1867, 65.5 × 93 cm, Haags Gemeentemuseum, The Hague

Fig. 4 Auguste Renoir, *The Pont-Neuf*, 1872, 75 × 94 cm, National Gallery of Art, Washington, D.C.

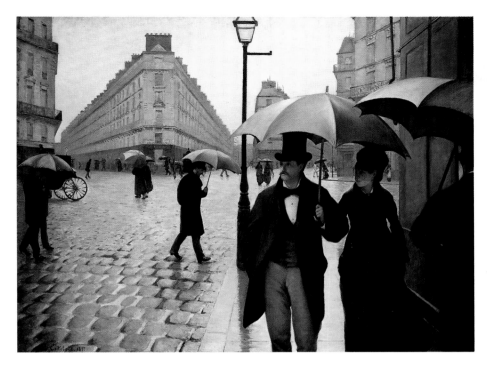

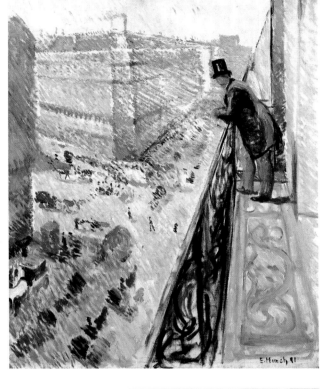

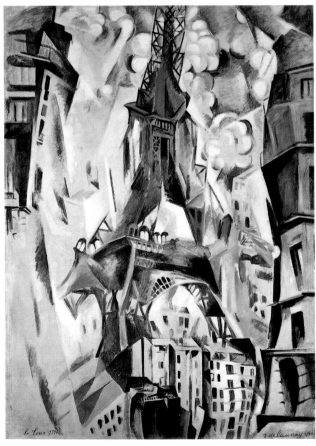

Fig. 5 Gustave Caillebotte, *Paris Street: Rainy Day*, 1877, 212.2 × 276.2 cm, The Art Institute of Chicago, Charles H. and Mary F.S. Worcester Collection, 1964.336

Fig. 6 Edvard Munch, *Rue Lafayette*, 1891, 92 × 73 cm, Nasjonalgalleriet, Oslo

Fig. 7 (*above*) Stanislas Lépine, *View of Paris*, c.1865, 25.4 × 44.6 cm, Virginia Museum of Fine Arts, Richmond, Virginia, Collection of Mr. and Mrs Paul Mellon

Fig. 8 Robert Delaunay, *The Eiffel Tower*, 1911, 202 × 138.4 cm, Solomon R. Guggenheim Museum, New York, Gift, Solomon R. Guggenheim, 1937

no other painter of his own or the next generation could match. Indeed, only minor artists like Raffaëlli and Lépine (fig. 7) created a sort of 'bread-and-butter' urban view painting in the last two decades of the nineteenth century. Not until Robert Delaunay became obsessed with Paris as a visual emblem of modernity in 1910 (fig. 8) was Pissarro's role as the primary painter of the modern dimensions French cities challenged.[5] Yet, oddly enough, Pissarro's cityscapes were seldom grouped for exhibition during his lifetime and have never been seen together since his death in 1903.[6] Only two of the series were exhibited as such: the Avenue de l'Opéra, which consumed his attention in the winter of 1897/98, was exhibited as an urban series in 1898,[7] and his first Rouen series, executed in the spring of 1896, was exhibited in New York at the Durand-Ruel Galleries in the same year. Many of the other urban paintings have simply been included in the various samplings of his *oeuvre* mounted in our century. Now, fully a century after he made his first important paintings of Paris, this challenging body of work is at last being confronted. Why this neglect? First of all, we must remind ourselves that it has not been absolute. The art market has admitted the late urban paintings into the 'inner circle' of the painter's work since Paul Durand-Ruel began commissioning series paintings in 1896, and most of the paintings have changed hands at a brisk rate during the last generation. Virtually every great Impressionist collection has one – or more – of the urban paintings, and the list of lenders to the present exhibition shows the geographical range of modern interest in them. Every major exhibition devoted to Pissarro's work or to Impressionist landscape has included a small group of the urban paintings. The neglect, if it exists, is not of individual paintings, but of the series.

In this, Pissarro follows Monet, as he so often did. The series paintings by the younger artist were exhibited in groups during his lifetime before those of Pissarro. In acknowledgement of this fact, recent exhibitions devoted to Monet's works have tended with increasing frequency to recognise that his paintings made in series should be so reunited. This has emphatically not been the case for Pissarro, and even the last exhibition devoted to the end of his career, *Homage to Camille Pissarro: The Last Years, 1890–1903*, contained no important serial group.[8] The same neglect can be identified in public collections of Pissarro's paintings. Unfortunately, no institution has a sub-group of a Pissarro series comparable to the group of Monet's Grainstacks at the Art Institute of Chicago or the Monet Rouen Cathedral series at the Musée d'Orsay, and very few possess more than one Pissarro painting from a single series.

The reasons that might have led Pissarro, the painter of agrarian life, to turn his attention to urban life are complex and demand explanation. Before the 1890s he had shown but slight interest in urban subjects. A small Parisian snow scene from the window of his flat on the Rue des Trois Frères from 1878 (P&V 435) and another winter scene, *The Outer Boulevards: Snow Effect* (fig. 9), in 1879 are his only views of Paris from the Impressionist decade, and his trip to Rouen in 1883 produced several wonderful industrial riverscapes, but only two truly urban views of the Place de la République (P&V 608 and 609). All of these paintings deal with a populated urban world viewed from above, and all contain elements of caricature in the treatment and disposition of the figures. The first two might even be read as pictorial proof of Pissarro's aversion to Paris, so bleak and messy are their urban subjects. In each case, Pissarro was less concerned with architecture *per se* than with the city as an arena of human movement and activity. And, in three

5 See particularly, in addition to fig. 8, Delaunay's *Champs de Mars, the Red Tower*, 1911, oil on canvas, 163 × 130 cm, The Art Institute of Chicago. For a full discussion of the Paris series see Sherry A. Buckberrough, *Robert Delaunay: The Discovery of Simultaneity*, UMI Research Press, Ann Arbor, Michigan, 1982, pp. 47–78.

6 There is one small, but important exception to this rule, an exhibition entitled *Paris by Pissarro*, held in New York at the Carstairs Gallery, 12–26 April 1941. The small catalogue includes a wonderful short preface by G. Westcott.

7 The Avenue de l'Opéra series was included in an exhibition at Durand-Ruel's gallery in Paris; see Paris 1898.

8 Memphis 1980.

of the four cases, that activity occurs in inclement weather. As a 'début' for a painter of city life, they are odd indeed.

The year 1892, in which he launched his urban series, was not an easy one for Pissarro. His ever-present worries about money continued, and, with the marriage of his eldest son, Lucien, to a young English woman, it was necessary to raise cash to help the young couple with housing. Pissarro travelled to London during the summer months of 1892 and, while there, worked on a group of paintings in Kew Gardens. He also painted a delightful urban scene, *Bank Holiday, Kew* (P&V 793), which he left unfinished, and which seems to have set the stage for his first small series of urban paintings done in Paris in late 1892 and early 1893 (cats 35, 38, and ills 40, 41).

It is tempting to speculate that, while on that trip to London, Pissarro spent half a day – or at the very least a couple of hours – in the National Gallery. While there, he could easily have reacquainted himself with its small, but superb group of paintings by Canaletto. How one would love to know that Pissarro had studied Canaletto's famous *Stonemason's Yard* (fig. 10), presented to the National Gallery in 1828, or that he had analysed the relationships among architecture, figures and weather in the two great views of the Grand Canal that had entered the collection in 1838 and 1876 respectively. Even *Venice: The Feast Day of Saint Roch*, given to the Gallery in 1876, has wonderful affinities with the later urban market paintings made by Pissarro in Rouen and Dieppe.[9] Yet, although there is no specific evidence of a single visit to the National Gallery when Pissarro was in London in 1892, nor a single mention of the great Venetian painter in all of his vast correspondence, scrupulously collected in five volumes by Janine Bailly-Herzberg, a reference to

9 See *National Gallery: Illustrated General Catalogue*, London, 2nd ed. rev., 1986, pp. 84–88.

Fig. 10 Canaletto, *Venice: Campo S. Vidal and S. Maria della Carità ('The Stonemason's Yard')*, c.1730, 123.8 × 162.9 cm, National Gallery, London

'musées sur musées à visiter' in a letter written to his wife, Julie, from London in May 1890, suggests that he would have been familiar with the National Gallery and probably, therefore, with the *Stonemason's Yard*.[10]

Pissarro's neglect of Canaletto in his correspondence comes as no surprise. Although the Venetian painter occupies virtually a canonical position in the British and American histories of European painting, he plays no such rôle in France. Indeed, the Louvre's holdings of Canaletto's view paintings were notoriously poor in the nineteenth century and remain so today.[11] And even a superficial glance through the large bibliography devoted to Canaletto will note the conspicuous absence of French contributions to it.

It would be wrong, however, to ignore the comparison completely, given the likelihood of Pissarro's familiarity with the Canaletto. Indeed, the larger history of urban painting in modern times could not be written without a serious analysis of both Canaletto and Pissarro, and the fact that a connection between their urban work may not have been referred to or even recognised by Pissarro himself should not dissuade us from making it. Canaletto's *Stonemason's Yard* is one of the principal masterpieces of urban painting, taking its place squarely between Vermeer's famous *View of Delft* (fig. 24) and Monet's *Boulevard des Capucines*. Its originality has puzzled even the most intrepid students of Canaletto's rather placid career, mostly because its subject — and the attitude towards cities that it embodies — has no real precedents and few successors in Canaletto's career. Its combination of the historical and the contemporary, the sacred and the secular, the transcendent and the mundane gives it an originality that one does not expect of Canaletto.

A direct comparison between the *Stonemason's Yard* and any of a number of compositionally similar paintings by Pissarro makes clear the modern artist's

10 Bailly-Herzberg 1986, p. 352 (London, 27 May 1890; to Julie Pissarro).

11 In fact, the most important painting attributed in the nineteenth century to Canaletto in the Louvre is now known to be by Marieschi. However, the greatest group of Venetian view paintings in France are eight large canvases from a major series of twelve. All of these canvases, perhaps painted from drawings by Canaletto, depict major festivities associated with the Doge. Although Pissarro undoubtedly saw these paintings, their affinities with his mature series are less direct than those of the Canaletto paintings in the National Gallery in London.

contribution to urban view paintings. The Canaletto is considerably larger than any of the 300 paintings of cities by Pissarro, indicating by its very size not just its status as a premeditated, studio-based work, but also its singularity as a work of art rather than as a constituent member of a group or series of related works. When compared with, say, *The Pont Boïeldieu, Rouen* of 1896 now in the Carnegie Institute in Pittsburgh (cat. 6) – and Pissarro himself compared Rouen with Venice[12] – the theatricality of Canaletto's painting becomes evident. Although the Canaletto is nearly twice as large as the Pissarro, it describes a much smaller pictorial world, and the carefully placed architectural elements to the left and right create a spatial arena for the figures that is so highly controlled that it almost suggests a stage set viewed from a comfortable balcony seat.

For Pissarro, the ships, machines and factories define a sort of meta-space in which buildings and figures often appear minuscule. His vantage point is unrelated to the scene itself (with the possible exceptions of cats 86, 87, 88, 89, there is seldom any use of the architectural *repoussoir* on which Canaletto depends), and, for that reason, the viewer has no sense of participation in the urban spectacle before him. Even Pissarro's wonderfully observed sky and his clever pictorial interaction of clouds with the various puffs of steam and smoke contrast with the placid warm light that bathes Canaletto's setting and clarifies its spaces. For Canaletto, appearances are so carefully regulated that one can 'wander' lazily throughout his urbanscape without ever confronting ambiguity or losing one's place. Pissarro's Rouen has an overarching unity in its composition, yet each part of the painting quivers equally, refusing to allow the viewer's eye to rest or wander slowly.

What, then, are the characteristics of Pissarro's urban aesthetic in contrast to those of his great predecessor as a view painter? Both artists viewed cities from above and compressed thousands of forms and figures into their panoramic views. Each loved urban spectacles – for Canaletto, they were the entrances of royal entourages into Venice, religious processions and sacred festivals. For Pissarro, it was Mardi Gras in Paris, secular parades, market days in Rouen or Dieppe or holiday traffic on the Pont-Neuf. Of the two, Pissarro was infinitely more attracted both to movement and to images of work and economic exchange. One feels in his cities as if money is being made while machines work, middle managers dash for trams, housewives shop, urban workers rush to and fro across bridges. Even when his subject is the Tuileries Gardens or the charming Square du Vert-Galant at the tip of the Ile de la Cité, his figures seem simply to be passing through these elegant spaces on their way home, to work, to shop or to eat. For Canaletto, the tumult and confusion, the bustle and class interactions of every city were so underplayed – or so well ordered – as to be subsumed by the architecture and urban spaces. Indeed, Canaletto's figures are 'placed' so as to create the illusion of space. They act out their parts in Canaletto's systems of urban order.

By contrast, Pissarro thrived on a high level of pictorial and social energy in his urban paintings. The population of most is quite large, and the exercise of describing his figures is fascinating. The throngs on the bridges of Rouen or around the basin of Le Havre are almost uncountable, and the relatively unpopulated winter views of the Square du Vert-Galant or even the Avenue de l'Opéra in Paris can be interpreted only in the context of the populated norm. Traffic, motion, work, transport, exchange, unloading, loading, moving, buying, selling, walking, riding – these activities dominate Pissarro's urban views, and the architecture and urban space simply frame this human spectacle.

12 Bailly-Herzberg 1989, p. 266 (Rouen, 2 October 1896; to Lucien Pissarro).

When Pissarro returned from England in mid-August 1892, he made several brief trips to Paris, spending short periods in November and December in the Hôtel/Restaurant Garnier just opposite the Gare Saint-Lazare. While there, he began work on a group of four urban paintings that, in many ways, signals his efforts for the next decade. Of the four, all are dated 1893, and the two largest (60 × 73 cm) were included in an important exhibition of Pissarro's work mounted by Durand-Ruel in March of that year. From the evidence of the artist's letters and of the exhibition, all four paintings were made in the five months between November of 1892 and March of 1893. The two largest (cats 35 and 38) hark back to the great boulevard paintings of the 1870s by Monet, Renoir and Caillebotte. Each is viewed from above, treating the architecture as a sort of light-struck canyon wall that serves as the backdrop for human activity. In analysing the Art Institute of Chicago's *Place du Havre, Paris* (cat. 38), one thinks immediately of the most famous of all Monet cityscapes, the Pushkin Museum's *Boulevard des Capucines* of 1873 (fig. 11). Pissarro had seen this painting twice – first at its début in the Impressionist exhibition of 1874 and, more recently, at the Monet-Rodin exhibition held at the Galerie Georges Petit in 1889.

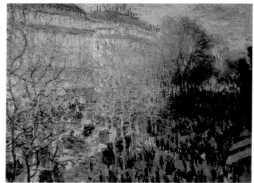

Fig. 11 Claude Monet, *Boulevard des Capucines*, 1873, 61 × 80 cm, Pushkin Museum, Moscow

In 1889, Pissarro himself was struggling to perfect a kind of modern ruralism using a personal modification of the Neo-Impressionist technique of Seurat and Signac. His masterpiece of that year is the often reproduced *Apple Picking at Eragny-sur-Epte* in the Dallas Museum of Art (fig. 12). Yet, just three and a half years later, his technique had loosened considerably, his productivity increased dramatically, and he could again confront a subject that is quintessentially Impressionist – urban motion. The two larger of his four attempts quiver with life. Each uses a widely varied palette – with hundreds of hues mixed on the palette and separately applied in short, comma-like or linear strokes, reminiscent of his short-lived phase of experimentation with Neo-Impressionist technique. Indeed, all of his experience with what might be called the mechanics of 'optical mixing' proves to have been invaluable in making these palpitating paintings. In each, the wintery city is alive with a warm light that dances across the façades, is picked up by the shiny paint on the spokes of wheels and glints on the tops of the silk top hats worn by male members of the bourgeoisie.

Fig. 12 Pissarro, *Apple Picking at Eragny-sur-Epte*, 1889, 58.4 × 72.4 cm, Dallas Museum of Art, Munger Fund

The contrast with Monet could not be greater. Where the younger – and bolder – artist dissolves the figures with overlapping curvilinear strokes mixed on the brush, Pissarro defines figures with all the artfulness of a caricatural artist. Indeed, Pissarro's *Place du Havre, Paris* (cat. 38) is 'about' the figures and their movement, setting the stage for an urban humanism at odds with the grand visual unity that Monet applied to the city. For the Monet of the *Boulevard des Capucines*, as early critics and contemporary writers alike have stressed, the character of each form was less important than was the participation of all forms in a unified visual realm.[13] Hence, while Pissarro was less interested in compositional order and the clarity of pictorial space than was Canaletto, he was more interested than was Monet in the particular nature of human, architectural and vegetal forms. Indeed, Pissarro's figures are each separately observed and separately described. Each act of transcription takes a specific figure from the city and places it within the cityscape.

Interestingly, Pissarro looked through his earlier work when choosing paintings for the March 1893 exhibition, and, of the thirteen paintings from his first urban group, painted in Rouen in 1883, he chose two that evidently interested him almost ten years after they were made. The links between the two Rouen paintings, *Place de*

13 An easily accessible bibliography can be found in D. Wildenstein, *Claude Monet: Biographie et Catalogue Raisonné*, vol. I, Lausanne and Paris, 1974, no. 292, pp. 240–41. For a modern discussion of the criticism, see C.S. Moffett, *The New Painting: Impressionism 1874–1886*, Washington, D.C., and San Francisco, 1986.

facing page: detail of cat. 38

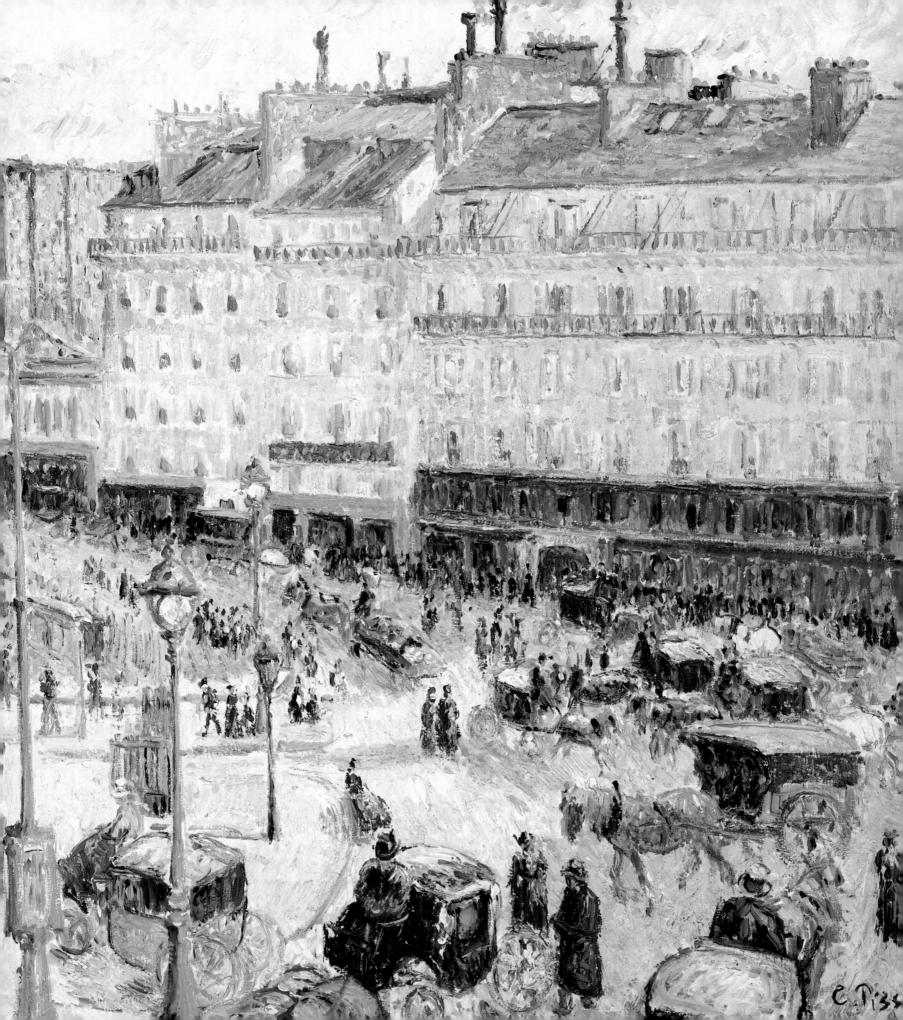

la *République* (P&V 608) and *The Côte Sainte-Catherine, Rouen* (P&V 612), and the two Paris paintings must have stimulated Pissarro, because he began work on a stunningly original small painting, *Place Saint-Lazare* (ill. 41), just before the opening of the exhibition. This painting is nothing more nor less than the first serious study of traffic in the history of art. Here, a mêlée of carriages, hansom cabs, pedestrians, wheelbarrows and an omnibus are anchored by little more than a lamp post. The architecture of the city ceases even to frame the life of the street, and the carefully constructed urban spaces of earlier masters of urban views gives way to a controlled chaos. Indeed, the visual energy of the painting is remarkable, especially when we remember that Pissarro was in his sixties and in relatively ill-health when he made it.

This small painting – and its numerous progeny which culminate, perhaps, in the great *Place du Théâtre Français* of 1898 in the Los Angeles County Museum (cat. 73) – forces us to confront the issue of Pissarro's politics and to make an overt link between his painting and his anarchist politics. It is surely no accident that Pissarro's renewed interest in the movement coincided with the rise in the public profile in France of anarchism in the early 1890s. He made an illustration for the politically charged publication *La Plume* in May 1893, just two months after exhibiting the two great Paris street scenes that concentrate so forcefully on the movement of urban crowds. For Pissarro, the delicate balance between individual, social class and 'crowd' that he steadfastly maintained in his painting had its roots in the political theories of his friends and colleagues in the anarchist movement.[14]

The social variety in Pissarro's urban figures is perhaps their most original quality, and a direct comparison with the earlier cityscapes of Monet and Caillebotte makes that particularly clear. Pissarro had renewed his associations with Monet in 1892. Indeed, he even borrowed 15,000 ff from the younger artist so that he could buy his house in Eragny. And the year 1894 brought Caillebotte's work closer to his mind because of the artist's long illness and eventual death on 21 February 1894.[15] Pissarro's letters of 1893/94 contain many references to Caillebotte, and Pissarro even delayed his departure on a summer trip to Holland in 1894 just to see the Caillebotte memorial exhibition at Durand-Ruel's gallery. The death of Caillebotte appears to have brought the original Impressionist group back together, if only temporarily, forcing them to confront each other's recent work, to reflect upon their earlier collaborations and, at a more basic level, to confront their own mortality. Further, the death of Caillebotte and the ensuing memorial exhibition renewed Pissarro's connections with the advanced urban paintings of the 1870s. Caillebotte, moreover, had owned major urban paintings, including three superb examples of the first urban 'series', Monet's views of the Gare Saint-Lazare of 1877, and three scenes by Renoir. Seeing these works again, some after a period of more than fifteen years, brought Pissarro face to face with urban Impressionism once more, allowing him to be liberated by the past to confront the present.[16]

Pissarro had recently exhibited his *Place Saint-Lazare* (ill. 41) at Durand-Ruel's gallery in March of 1894 when he saw the landmark Caillebotte retrospective on 4 June of that same year. With 122 paintings, the exhibition was immense, and the criticism was largely favourable. Of the large paintings, the Musée d'Orsay's *Floorsanders* was most frequently referred to. Yet, virtually all of the critics wrote about the series of boulevard paintings completed in the new north-west quarter of Paris by Caillebotte between 1878 and 1880.[17] To Thiébault-Sisson, these paintings

14 The clearest discussion of Pissarro's politics can be found in Shikes 1980.
15 See Marie Berhaut, *Caillebotte: Sa Vie et Son Oeuvre*, Lausanne, 1978, pp. 7–21.
16 Berhaut, *Caillebotte*, p. 251.
17 Berhaut, *Caillebotte*, pp. 261–62.

facing page: detail of cat. 73

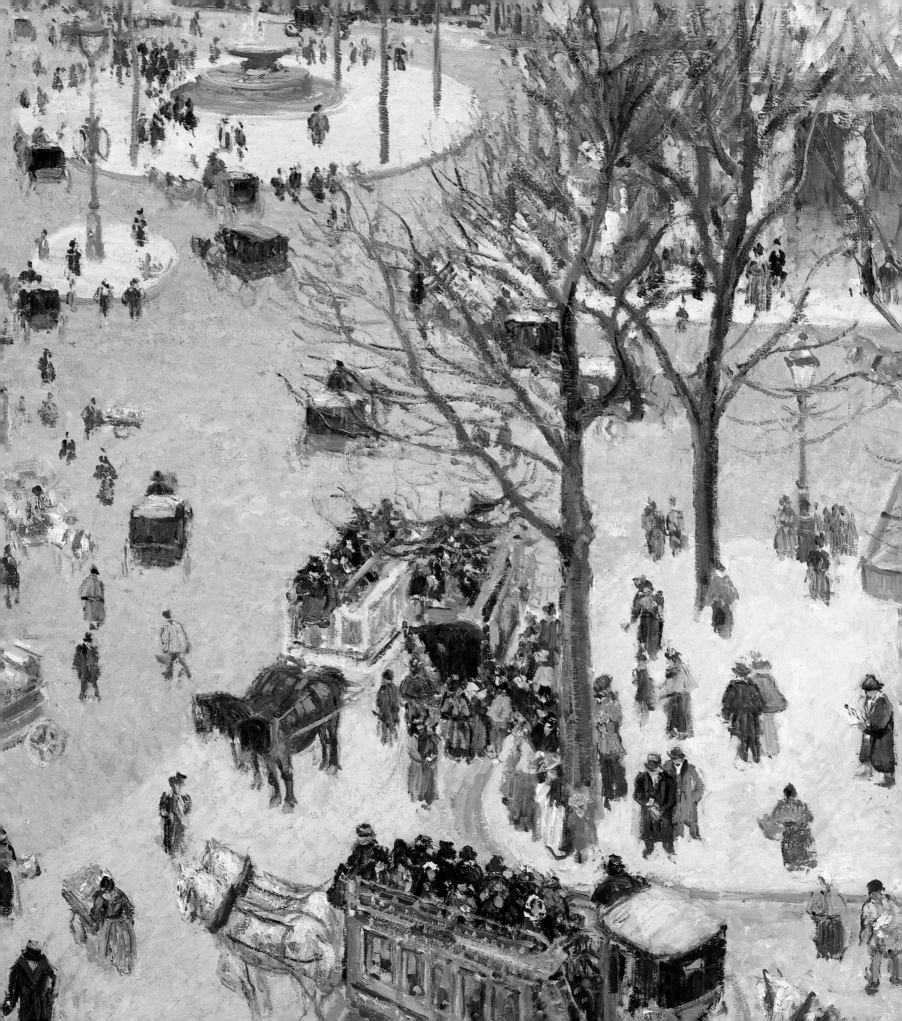

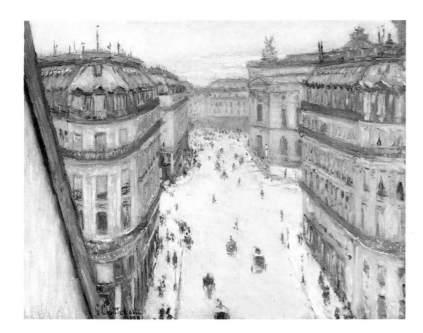 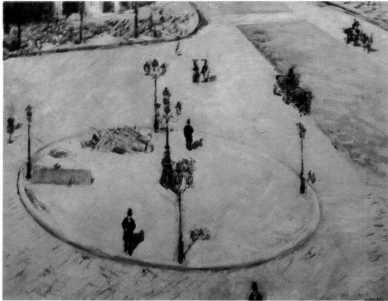

were totally 'bourgeois', carrying with them the burdens – and the pleasures – of that most nineteenth-century of social classes.[18] To others, they were simply modern.[19] All in all, the exhibition contained nine paintings of Paris streets and boulevards, including several that in recent years have become almost icons of Impressionist Paris. The stark simplicity of each of the paintings is remarkable,[20] as is their evidence of Caillebotte's fascination with the immensity of modern urban space. How different they are – both socially and aesthetically – from Pissarro's crowded views. Both *Rue Halévy seen from the Sixth Floor* (fig. 13) and *Traffic Island, Boulevard Haussmann* (fig. 14) create a sense of modern Paris as vast, impersonal and utterly bourgeois. There are very few figures: each is relatively isolated, and the majority are bourgeois men. Caillebotte's palette was confined to various greys, beiges, browns and blacks, with a little acid green on the occasional tree.

Pissarro's cityscapes are everywhere the opposite. Filled with colour, light and movement, they even convey a sense of the sounds and smells of the city. The figures, when they are not massed in large crowds, are socially specific – workers with their blue shirts, soldiers in uniform, bourgeois men in caped overcoats and hats, middle-class women in drab, close-fitting dresses, female workers in white aprons and caps, and wealthier women in tailored jackets. Indeed, describing each figure in a Pissarro urban painting could easily fill several pages, so concentrated and specific are his distillations of urban experience.

The renewal of Pissarro's 'Impressionism' was only one strand of his urban aesthetic of the 1890s, for there were at least two others: Japanese prints and urban caricature. Pissarro's letters of February 1892 are full of enthusiasm for the prints of Hiroshige, whom Pissarro dubbed 'a marvellous Impressionist'.[21] He had seen and

Fig. 13 Gustave Caillebotte, *Rue Halévy seen from the Sixth Floor*, 1878, 59.7 × 73.3 cm, Private Collection, Dallas

Fig. 14 Gustave Caillebotte, *Traffic Island, Boulevard Haussmann*, c1880, 81 × 101 cm, Private Collection, Paris

18 Thiébault-Sisson, in *Le Temps*, 7 June 1894, n.p.
19 Gustave Geffroy was perhaps the most eloquent on the subject: 'Pour moi, le sens dans lequel le peintre marque le mieux son effort c'est la série des paysages des rues de Paris, parfois vues d'un balcon: des avenues larges, des voies droites, de hautes maisons alignées, des maisons qui forment des caps aux carrefours et qui ont vraiment dans l'atmosphère de la ville, la beauté massive de hautes falaises. Là il y eut non seulement recherche, mais trouvaille et originalité et le commencement de quelque chose qui pourra bien être continué' (*Le Journal*, 25 February 1894). If Pissarro read these sentences – and he probably did, because he was very close both to Caillebotte and to Geffroy – he must surely have heeded their advice.
20 These paintings include nos 26, 112, 113, 114, 116, 130, 136, 139 and 141 in Berhaut, *Caillebotte*.
21 Bailly-Herzberg 1988, p. 309 (Paris, 3 February 1893; to Lucien Pissarro): 'Hiroshige est un impressionniste merveilleux'.

below: detail of ill. 107

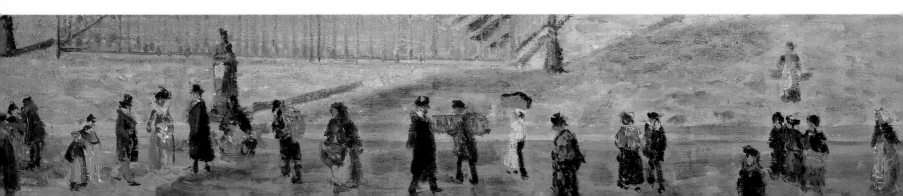

Fig. 16 (*right*) Katsushika Hokusai, *Artisans*, from the *Manga*, vol. I, 1854

Fig. 17 (*far right*) Pissarro, *Le Temple du veau d'or*, from *Les Turpitudes sociales*, pl. 3

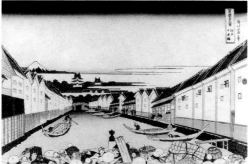

Fig. 15 Katsushika Hokusai, *Mount Fuji and Edo Castle seen from Nihonbashi*, from the series *Thirty-six Views of Mount Fuji*, c.1834, woodblock, Gerhard Pulverer Collection

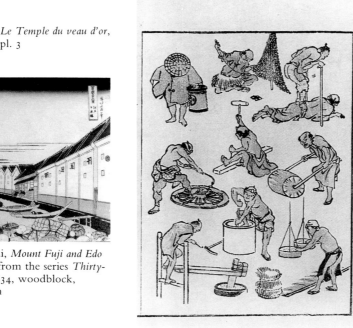

Fig. 18 Honoré Daumier, *Exposition en plein vent des provinciaux venus à Paris pour voir le Palais de l'Industrie*, from *Le Charivari*, 1855

22 Pissarro was keenly interested in Japanese prints in the first years of the 1890s and referred to his collaborative project with his son Lucien, *Les Travaux des Champs*, as 'notre Mangoua'. All these references are discussed and itemised in Brettell 1980, p. 68.
23 Brettell 1980, pp. 36–38.
24 London 1980–81, pp. 184–86.

admired the prints of the great Japanese artist in an exhibition mounted by Samuel Bing at Durand-Ruel's gallery early in 1892. He was joined in his admiration of the prints by Monet and Rodin, both of whom collected Japanese prints. All three artists extended their admiration to the famous prints of Hokusai, whose collection of printed 'studies', the so-called *Manga* (fig. 16), Pissarro owned.[22] All of these show evidence of a Japanese fascination with the contemporary world, urban pleasures and travel (fig. 15). Each print places specifically observed figures in complex settings and shows a combination of interest in detailed social observation and in general principles of design and composition.

The third strand of Pissarro's urban aesthetic is caricature. Pissarro had purchased at least one volume of Champfleury's great *Histoire de la caricature* in 1883 in Rouen, and, from his letters of those years as well as from later letters, we know of his abiding interest in the popular urban art of Daumier in France (fig. 18) and Charles Keene in England.[23] His surviving drawings of the early 1890s contain numerous examples of urban caricature, including studies of urban markets, *promeneurs* and even riots. In keeping with his anarchist politics, Pissarro was interested in representing both the crowd and the individual in the city, and many of his studies were made in preparation for a privately distributed collection of drawings called *Les Turpitudes sociales*, completed in 1890 (figs 17, 19, 23).[24] This manuscript contains the clearest visual evidence of Pissarro's anarchism and of his highly critical attitudes towards the exploitation of the urban worker by the world of capital, as epitomised by the bourgeoisie. Without this book, it would be difficult to make compelling connections between the figures in Pissarro's various urban series and his political ideals. With it in mind, the mêlée of social classes, sexes and ages in his urban paintings forms a sort of visual/political manifesto in which the city can be interpreted as a vast setting for social and economic interaction.

An unpublished pair of drawings in a French private collection, entitled

Comment l'on cause à la ville and *Comment l'on cause à la campagne*, are further proof of Pissarro's fascination with caricature. Yet, they are also evidence of the startling dichotomy that Pissarro, and most Frenchmen of the nineteenth century, perceived to exist between the city and the country. Pissarro's friend and his most sympathetic critic in the 1890s, Gustave Geffroy, referred to his late paintings as either 'apparitions of country life' or 'spectacles of urban existence'.[25] This complete contrast is evident in this curious pair of drawings. These sheets make it clear that, in order to be a complete artist, the modern painter had to represent both urban and rural life, and that each way of life was viewed as the opposite of the other.

Perhaps the most obvious – and mundane – reasons that Pissarro took to painting cityscapes in 1892/93 had to do with his finances and his health. The economic success the urban paintings enjoyed was presumably a motivating factor in Pissarro's decision to paint so many of them. Quite simply, they sold better and more quickly than any paintings he had ever produced, enabling the elderly Pissarros to pay off their debts, support their children and enjoy a life of unprecedented comfort. And we know from Pissarro's voluminous correspondence in the last decade of his life, that there were many more series he could have painted – and wanted to paint – before his death in 1903.

Yet, his health was also a factor. Like many of the Impressionists, Pissarro had problems with his eyes, and, in the spring of 1893, his persistent infection of the tear duct became so bad that he was forced to undergo surgery. In fact, his eyes bothered him for the remainder of his life, forcing him to paint a good deal from indoors, whether in the city or the country. These physical limitations significantly affected his art. Because he was discouraged by his physician from painting directly out-of-doors in order to avoid wind, inclement weather and excessive light (though he continued to do so whenever possible), his work in the country was often restricted to views from his large studio window.

During his urban campaigns, Pissarro's choices, first of hotels and, later, of apartments rented for short periods, were made with both price and potential motifs in mind. To achieve visual variety, he seldom stayed more than twice in the same establishment. During the course of his last decade in Paris, for example, he chose three hotels and three apartments, each of which he used as the source for as many different paintings as possible. Certain of the locations had greater pictorial possibilities than others. He managed only fifteen paintings from the Hôtel du Louvre at the bottom of the Avenue de l'Opéra and the Rue Saint-Honoré, while he painted an astonishing forty-two (at least) from his apartment just off the Place Dauphine at the tip of the Ile de la Cité.

The impact of his physical environment on the structure of the series is significant. He lived and worked in small rooms and painted canvases that reveal no hint of the physical constrictions of their making. The viewer is never given the opportunity to think about Pissarro himself. Never do we see a window frame, a balustrade or a curtain that could provide an interior reference. Indeed, the artful interplay between inside and outside that had been such an important part of the

Fig. 19 Pissarro, *Enterrement d'un Cardinal qui avait fait voeu de pauvrété*, from *Les Turpitudes sociales*, pl. 6

25 London 1980–81, pp. 35–37.

below: detail of ill. 77

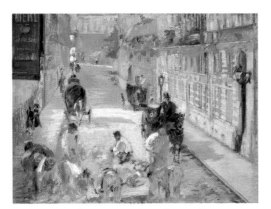

Fig. 20 Eugène Manet, *Street Pavers, Rue Mosnier*, 1878, 65 × 81 cm, Private Collection

urban aesthetics of Caillebotte, Monet and Manet is nowhere evident in Pissarro. The bourgeois figures that cling to the right edge of Monet's *Boulevard des Capucines* (fig. 11) let the viewer know that he or she, too, is on a balcony like those painted by Manet and Caillebotte in the 1870s (fig. 20). And the windows or roof lines that are so important in Caillebotte's urban scenes force the viewer to think about the room from which the view was made.

In Pissarro's work, this self-consciousness is absent. In only two of his four self-portraits, made in 1897/98 and 1900 respectively, do we see him painting himself in front of the windows from which he observed the ceaseless patterns of traffic and the seasonal changes of Paris (cat. 154 and P&V 1115). Only in these small visual documents are we asked by Pissarro to reflect upon the relationship between urban interiors and the vast cities in which they are placed. More often than not, Pissarro's eye is as omniscient as had been Canaletto's or Hiroshige's, allowing the viewer a kind of liberation to reflect on the subject of the painting itself rather than on the life, mood, psychology or identity of the painter. For this reason, Pissarro's urban paintings are curiously anti-modern in their refusal to deal overtly with the consciousness of the artist himself.

In 1896 Pissarro immersed himself in the river-port city of Rouen, which had then – and maintains today – the largest inland port in France. His cityscapes from this intensely productive trip, and from the rest of his career, must be contrasted with the exactly contemporary urban paintings of his young contemporary, Pierre Bonnard. Bonnard and his fellow Nabi, Edouard Vuillard, drew, painted, printed and decorated the city throughout the 1890s. Pissarro was familiar with their work, but it was in January of 1896 that he was forced to contend with Bonnard's recent work in an important exhibition held by Pissarro's own faithful dealer, Durand-Ruel.[26]

Interestingly – and a little surprisingly – Pissarro was vociferous in his rejection of Bonnard's painting, calling the exhibition 'hideous' and 'a complete fiasco', in a long letter to Lucien.[27] The exhibition itself contained several of Bonnard's urban paintings, as well as two screens, prints and illustrated books. Its catalogue is an exercise in the new urban aestheticism of Bonnard and Vuillard – elegant, sparse and subtle, even its titles read like evocative short poems: *Effet de soir dans la banlieue*, *Accessoires de carnaval*, *Lapins*, *Avenue du bois*. And the paintings and prints show a world of tiny apartments, corridors, small streets, city parks, cafés and staircases, a world in which windows and doors intersect urban space and organise it into private realms.[28]

Again, the contrast between Pissarro and this younger painter of urban life could not be greater. A slightly later painting by Bonnard of the Rue Tholozé, near his apartment in Montmartre (fig. 21) can easily be contrasted with any of the Rouen views – or, more effectively, with one of the most poetic of Pissarro's 1897/98 views of the Avenue de l'Opéra (ill. 62). In each, the city becomes a grey/beige continuum of inclement weather. Bonnard's sky resembles visceral clouds cast in lead, while Pissarro fills the city with a sort of London fog. Yet, for all its 'atmosphere', Pissarro's Paris is grand and impersonal, while Bonnard's is a neighbourhood painted by an *habitué*. The Rue Tholozé is a short, narrow street that ends in the busy Rue Lepic. Black-and-brown clad figures hurry to the *fromagerie* or the *boulangerie*. Children peer out of lower-middle-class apartment windows. The blank wall of an apartment building, parallel to the picture plane, seems to yearn for a poster or a painted sign.

26 Paris, Galerie Durand-Ruel, *Bonnard*, 1896.

27 Bailly-Herzberg 1989, p. 159 (Rouen, 31 January 1896; to Lucien Pissarro): 'hideuse'; 'un fiasco complet'.

28 For a wonderful essay on Bonnard's urban imagery see the chapter called 'Les gris de la ville', in A. Terrasse, *Pierre Bonnard*, Paris, 1967, pp. 34–58.

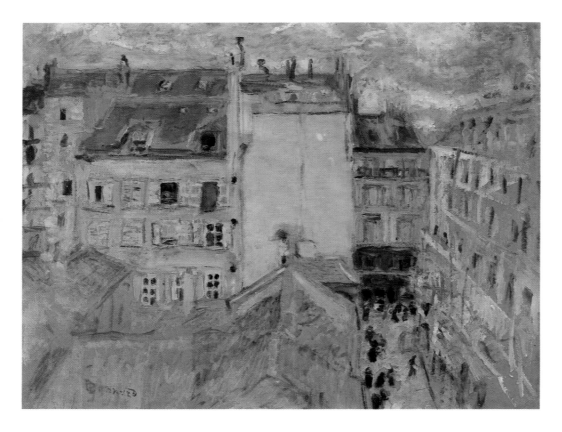

Fig. 21 Pierre Bonnard, *Rue Tholozé*, c.1897, oil on cardboard, 53 × 68.4 cm, Private Collection, Texas

Pissarro's Paris – like his Rouen or his Le Havre – is perceived by a visitor, not a native, and, perhaps for that very reason, it can be contrasted not only with this particular Bonnard, but with every urban painting, drawing or print by Bonnard and Vuillard as well as with every photograph of Paris by the quintessential Parisian photographer of the turn of the century, Eugène Atget. To each of these men the term 'intimist' could easily be applied. Bonnard and Vuillard portrayed a family-oriented, neighbourhood-centred Paris, far from the tourist centres and the big hotels. Atget's Paris most often appears deserted because he observed it either at or near dawn, when everyone was in bed. Yet, even without its inhabitants, Atget's city is a humanscape, alive with memories and grimed with an urban patina. The textures of peeling plaster contrast with the shiny enamel of the doorways and shopfronts so characteristic of Paris. Atget's Paris is never for the tourist, but for the urban connoisseur.

Again, one confronts a contrast. Pissarro was disgusted by the 1896 exhibition of Bonnard, but, as usual, he leaves to us the task of extrapolating the specific reasons for his disapproval. Was it because, by 'aestheticising' a particularly private Paris, Bonnard was creating an art too close to a dissolution of that critical relationship between the reality of the city and the artist's depiction of it? Or, was it the messy, blurred, ultimately decorative mode of painting that the young Nabi had adopted, a mode that Pissarro might have taken to be a form of highly subjective interpretation rather than objective description? We shall never really know. But, we can tell from this utter contrast of realms that, for all of Pissarro's desires to be a contemporary painter, his late urban paintings have more to do with Canaletto or Caillebotte than they do with the most advanced urban art of the 1890s.

This contrast can be made most clearly by creating a confrontation between

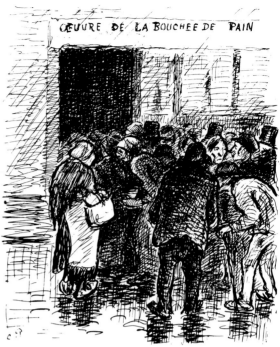

Fig. 22 Pierre Bonnard, *The Avenue du Bois de Boulogne*, *c*.1898, from the suite *Quelques aspects de la vie de Paris*, 1899, colour lithograph, The Metropolitan Museum of Art, New York, Harris Brisbane Dick Fund, 1928

Fig. 23 Pissarro, *La Bouchée de pain*, from *Les Turpitudes sociales*, pl. 15

Pissarro's only great sequence of urban drawings, *Les Turpitudes sociales*, and the collection of lithographs created by Bonnard in the late 1890s and published in 1899 as *Quelques aspects de la vie de Paris* (figs 22, 23) .[29] The scratched, caricatural style of *Les Turpitudes* and the fact that Pissarro allowed no colour into this urban realm are indicators of the stark power of his subject. For Pissarro, the city was no paradise. Its façades concealed a drama of the exploitation of the many by the few that no great artist has represented more simply. Bonnard's Paris, by contrast, is a series of subtle urban delights arranged for the epicurean of cities. Little girls with schoolbooks or big hats, groups of unmarried young women gathered for our delectation like bunches of flowers – and on and on the descriptions could go. Never in Bonnard does one sense evil or greed, never lechery. Those negative feelings are more obviously present in Vuillard's interiors or in the closeted urban realm of Toulouse-Lautrec. Yet, in all these cases, the realisation of the political dimension of the city is negatively stated. Never do these younger artists approach the urban experience as political experience, as did Pissarro in *Les Turpitudes sociales* and, by extension, in his urban paintings.

In 1900 Pissarro painted obsessively in Paris. His apartment, at the time, was on the second floor of the northernmost building on the Place Dauphine, the first planned urban square in Paris. His corner windows allowed him to study a wide panorama from the Pont-Neuf looking north to the Seine as it divided around the tip of the Ile de la Cité, dominated by the statue of Henri IV on the Square du Vert-Galant. To the north, across the Pont-Neuf, was a great monument to capitalist, commercial Paris, the Samaritaine, a department store of the type that had come to dominate the image of modern Paris, even for Zola.[30] To the west rose the architectural embodiments of monetary power, of former royal authority and of official art – the façades of the Monnaie and of the Louvre.

Pissarro's letters make it clear that he was in sympathy with none of these monuments. He detested the large-scale commercialism of the department store,

29 The best discussion of this marvellous series in English is in *Pierre Bonnard: The Graphic Art*, New York, 1989. The relevant chapter is Colta Ive's 'City Life', pp. 93–144, cats 59–77, pp. 224–28.

30 E. Zola, *Le Ventre de Paris*, Paris, 1873.

favouring street markets in which individual purchasers confronted individual sellers. He was also an enemy of monarchy – indeed of any form of centralised and paternalistic government. Unfortunately, we know nothing of his view of France's great monarch, Henri IV, whose equestrian sculpture is such an assertive presence in Pissarro's Paris (however, on this point, see below, p. 124). We know only a little more about his attitudes towards the national collections housed in the Louvre: like those of most artists of his generation, these were ambivalent at best and violently critical at worst.

Yet, all these monuments – together with the Opéra, Garnier's symbol of the Empire, with the Tuileries Gardens, and with Haussmann's boulevards – join the harbours at Rouen, Le Havre and Dieppe as the centrepieces of Pissarro's urban realm. How do we make connections between the vastly official – and commercial – Paris, Rouen, Le Havre and Dieppe of Pissarro's paintings and the politically engaged drawings for *Les Turpitudes sociales*? There are several answers, but surely the most important has to do with the way in which Pissarro subsumed their identity into the larger visual realm of a city in flux. In Pissarro's series of compositions that culminate with the Opéra, for example, the grandiose structure is simply a terminal point in a painted image that reveals more about light, atmosphere, traffic and people than it does about architecture. And the same can be said for Pissarro's images of the Samaritaine and the Louvre. The monuments are part of the fabric of his city rather than potent forms in their own right. In this way, Pissarro's architecture differs markedly from that of Canaletto, Corot or Caillebotte.

But what about the Louvre? Early in his career, Pissarro is reported to have told Cézanne that it would be better if the Louvre were burned.[31] This oft-quoted remark must be interpreted as having been made by a young artist who was rebelling against the dominance of the official academy and, by extension, against all officially revered art. It must also be put into the context of the fact that Pissarro painted the Louvre at least fifty times in the last five years of his life. His paintings of the Tuileries from the Rue de Rivoli penetrate the Louvre's great arms as they open to the Gardens. And his views from the Place Dauphine investigate its celebrated river façade, as the building mimicked the Uffizi by connecting the medieval castle (replaced in the seventeenth century by Perrault and others) with the Tuileries Palace, recently destroyed in 1871. Even the greatest sculptural allegory of the nineteenth-century Louvre, the Pavillon de Flore, was painted from three angles by Pissarro. His aesthetic caress of the Louvre was clearly not an act of criticism.

In 1898 Pissarro wrote to his son Lucien, telling him what to see on a future trip to Holland. The letter is fascinating, not only because it mentions Rembrandt and Hals, painters who had already been admired by advanced French artists for two generations, but also because it makes a specific reference to Vermeer's *View of Delft* (which Pissarro, using the nomenclature of Thoré-Bürger, referred to as by Van der Meer) (fig. 24).[32] Without this reference, one would think that Pissarro had never seen this most famous of seventeenth-century urban paintings. He had just made a trip to Amsterdam in October of 1898 to see the great Rembrandt exhibition of that year at the Rijksmuseum. His letters indicate that he made two excursions from Amsterdam, one to Harleem, undoubtedly to see the works by Frans Hals, and the second to The Hague, where he visited a dealer, and where he would last have seen the Vermeer. He must have been dumbstruck by Vermeer's masterpiece, because he went so far as to liken it forthrightly to Impressionism.

31 R.P. Rivière and J.P. Schnerb, 'L'Atelier de Cézanne', *La Grande Revue*, 25 December 1907. Reprinted in M. Doran, ed., *Conversations avec Cézanne*, Paris, 1978, p. 90.
32 Bailly-Herzberg 1989, p. 520 (Paris, 22 November 1898; to Lucien Pissarro): 'ce *Canal* de Van der Meer'.

facing page: detail of ill. 98

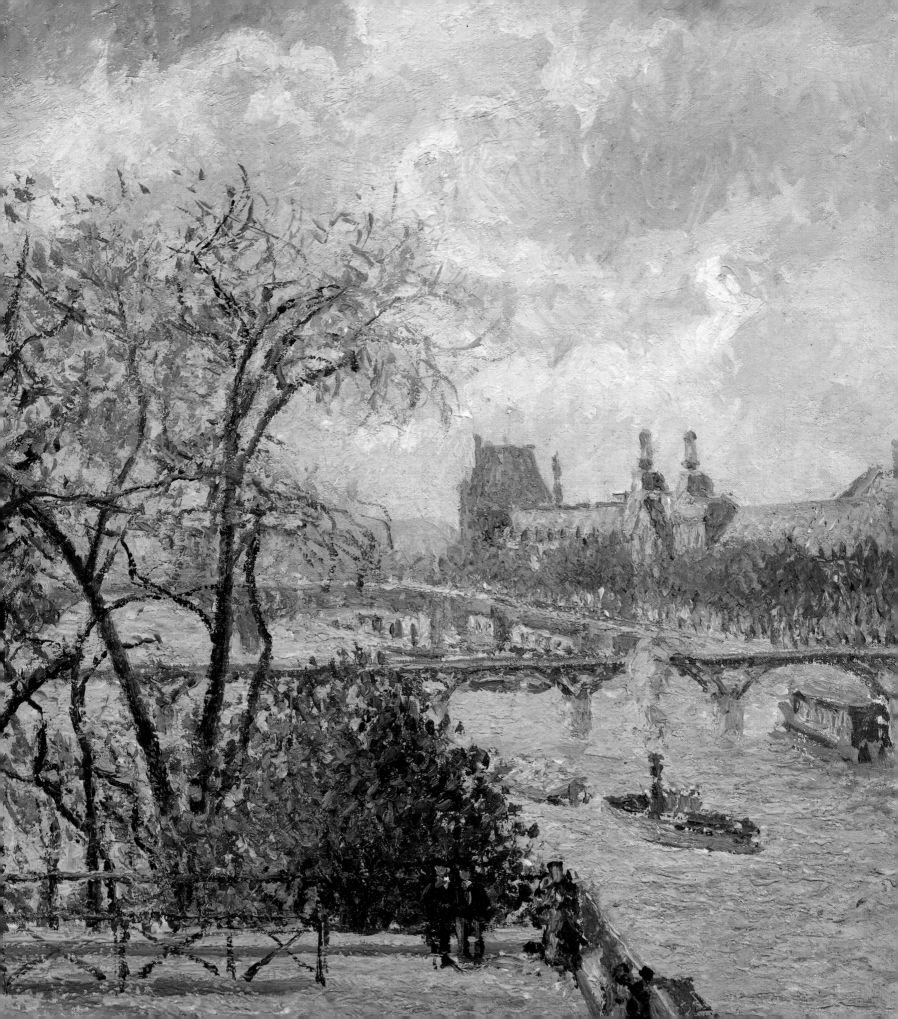

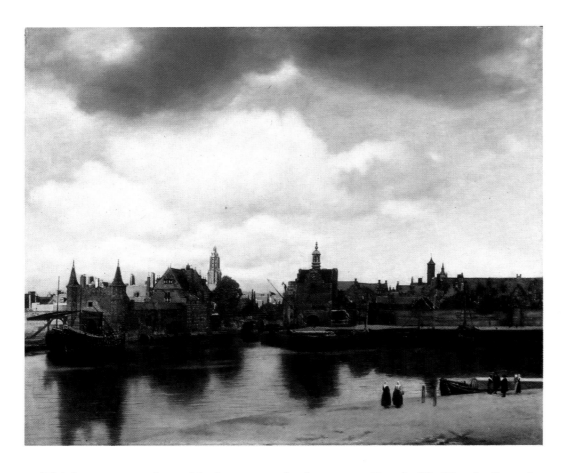

Fig. 24 Jan Vermeer, *View of Delft*, *c.*1662, 98.5 × 117.5 cm, Mauritshuis, The Hague

This letter – together with the scores of references to Botticelli, Claude, Poussin, Chardin and other Old Masters in Pissarro's late letters and interviews – makes it clear that the contents of the Louvre were very familiar to Pissarro. In fact, he was involved in a crusade in the late 1890s against paid admission to the greatest French museum and must have visited it countless times when he lived on the Rue de Rivoli, the Quai Voltaire and the Place Dauphine.[33] The fact that it had been a royal palace, liberated by and for the people and transformed into a public library of art, must have held greater power for the elderly Pissarro than it had for the youthful literary arsonist. And, in this way, Pissarro's virtual circumambulation of the Louvre can be contrasted in every sense with Monet's group of three urban views painted from the Louvre in 1867 (figs 2, 3, 25).[34] For Monet, who applied for a licence to copy great art in order to enter the Louvre with his easel and palette, the view from the building was more important than were the paintings in it. Ironically, Monet 'copied' the view! Yet, for Pissarro, contemplating death as he did so often in the last decade of his life, the Louvre was literally the centre of his pictorial world.

It is, for that reason, reasonable to make a direct link between a particular Old Master painting – alas, not in the Louvre – and a key group of paintings featuring the museum. Vermeer's *View of Delft* was perhaps the most admired Dutch painting of the period. Both Marcel Proust and Henry James wrote prolix, but gorgeous paragraphs about it, and, for many artists, connoisseurs and collectors, it was a point of pilgrimage on the art tour of Holland.[35] Pissarro's memories of the painting must have recurred powerfully in 1901–2, when he painted the Louvre

33 Bailly-Herzberg 1988, p. 148 (Eragny par Gisors, 22 November 1891; to Octave Mirbeau).

34 Herbert, *Impressionism*, pp. 10–12. Also Wildenstein, *Claude Monet*, nos 83–85, pp. 158–59.

35 Marcel Proust made an almost precisely simultaneous trip to Holland as Pissarro in 1898 to see the great nineteenth-century Rembrandt exhibition at the Rijksmuseum. Both men also visited Harleem to study Hals, and The Hague. For Proust, see, for example, *Le Temps retrouvé*, in *À la recherche du temps perdu*, Paris, 1989, vol. IV, p. 474, where Proust touches upon a theme surprisingly close to that of Pissarro: 'Grâce à l'art, au lieu de voir un seul monde, le nôtre, nous le voyons se multiplier, et autant qu'il y a d'artistes originaux, autant nous avons de mondes à notre disposition, plus différents les uns des autres que ceux qui roulent dans l'infini, et . . . qu'il s'appelât Rembrandt ou Ver Meer, nous envoient encore leur rayon spécial.' See also the celebrated scene of Bergotte's death in front of the *View of Delft* in *La Prisonnière*, in *À la recherche*, vol. III, p. 692.

Fig. 25 Claude Monet, *Garden of the Princess,
Louvre*, 1867, 91.8 × 61.9 cm, Allen Art Museum,
Oberlin College, Oberlin, Ohio; R. T. Miller, Jr.
Fund, 1948

from the Ile de la Cité, placing the Square du Vert-Galant in the lower left corner
and 'populating' it with a very few figures. Looking at these paintings – and
particularly at *The Louvre: Winter Sunshine, Morning* (cat. 90) – it is clear that
Pissarro was performing an act of homage not only to the Louvre, but also to
Vermeer, whose spit of sand with its boat and six figures acts as a kind of *repoussoir*
to Delft just as Pissarro's bit of the Square does to the distant Louvre.

In these late paintings the Louvre becomes Paris, its towers, façades and
courtyards literally filling the picture. Across from it – and fundamentally
separated from it – is the realm of the people, the Parisians who cross the Pont-Neuf
and stop at the Square du Vert-Galant to admire the view. They are as apart from
the great museum as the group of figures in Vermeer's painting are apart from their
city. In both paintings, there is an enforced and deliberate isolation of the figures
from the urban motif, an isolation that, when repeated time after time by Pissarro,
raises questions in our minds about the relationship between art and daily life in
Pissarro's France.

Pissarro could never have imagined that, at the end of our century, his paintings
would find their way in great numbers into what might be called the Louvre of
nineteenth-century art, the Musée d'Orsay (Orsay has forty-two paintings by
Pissarro in its permanent collection). Ironically enough, he had painted the great
station under construction three times in 1900 (ill. 79, and P&V 1125 and 1126), at a
time in which art from the second half of the nineteenth century was shown in what
Pissarro would have thought nauseating abundance in the Musée du Luxembourg.
In the first years of the twentieth century, he had reason to feel ambivalence, not so
much about the Louvre itself, as about the relationships between the art of the past
properly enshrined at the Louvre and the best art of his own generation enshrined
by no institution. The elderly painter's pictorial fascination with the Louvre might
be interpreted as a realisation of the lasting importance of great art. Indeed, we must
remember that Pissarro studiously omitted the most conspicuous monument of
modern Paris – the Eiffel Tower – from his city, and that he also avoided her second
greatest symbol, Notre-Dame de Paris. For Pissarro, the Louvre, in rain and snow,
at dawn, in autumn and winter, became the centre of what might be called his
'series' of series. Never before has his visual hymn to great art been so clearly
presented as now, nearly ninety years after his death.

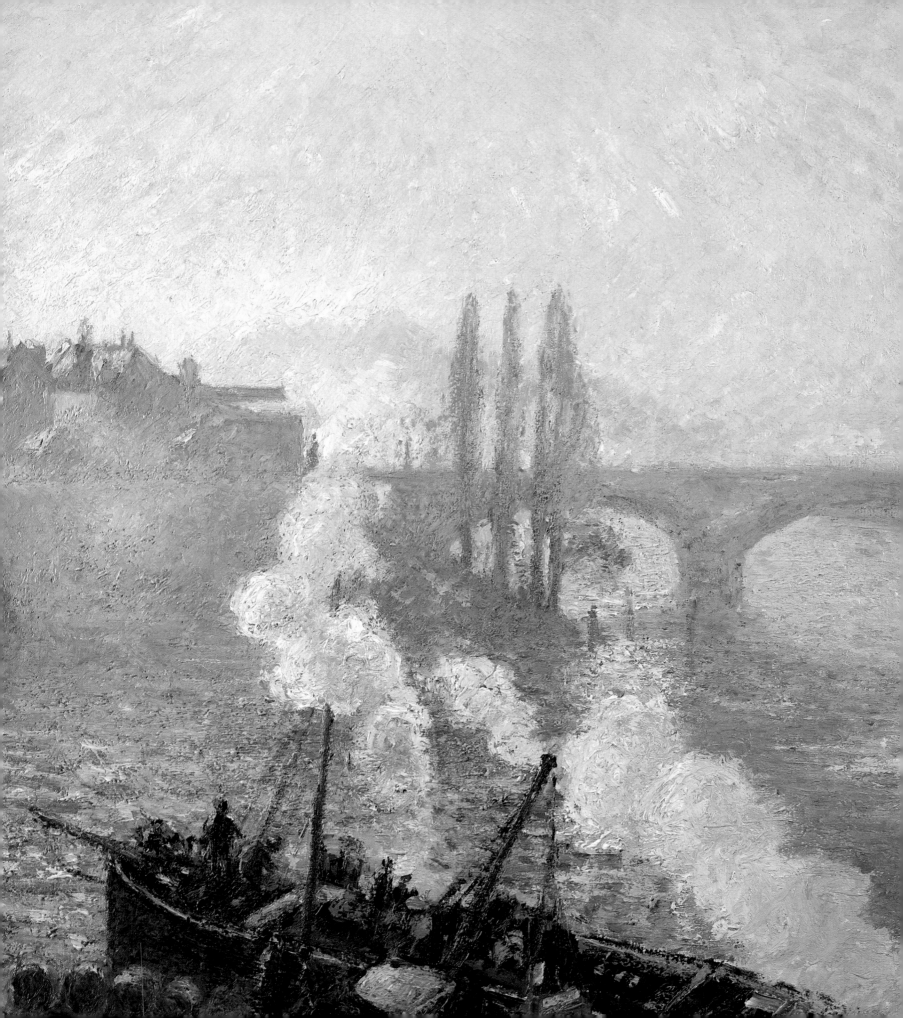

PISSARRO'S SERIES CONCEPTION, REALISATION AND INTERPRETATION

Joachim Pissarro

'It is now raining, I must run to my window'

'I notice by myself here the difficulty, or rather the difficulties, always unexpected, that come to assail you outdoors. The weather here is most uncertain, it is discouraging; I have nine canvases in progress, all at a more or less advanced stage.'

'until now, I have not been able to find any effect; I have even had to modify slightly this effect, which is always dangerous'.

'I have . . . a few oil sketches done of the harbour with ships [*Port of Rouen (Sketch)* (P&V 610), *Steamboat, Rouen* (P&V 611)]; the following day, it was impossible to continue working on them; everything was in a shambles, the motifs no longer there; it is impossible; one has to execute them all at once.'[1]

These extracts, taken from Camille Pissarro's first letter written in Rouen, indicate some of the difficulties involved in painting a series created from a single motif. Pissarro first went to Rouen in 1883; he painted thirteen works, which can be divided into three groups, each treating a set of motifs, and which can thus be regarded as an initial, if as yet unsystematic, attempt at painting a group of cityscapes. Pissarro returned to Rouen thirteen years later, in 1896, and again in 1898. In the course of these two visits, he completed his first series of cityscapes, consisting of over forty-five paintings focusing on a small range of motifs – bridges, docks, harbours, the brand-new train station (the Gare d'Orléans), the Gothic cathedral – painted under different conditions of light, weather and atmosphere, and depicting variations in the patterns of street and river traffic: crowds crossing the bridges and rushing from the station; carriages, barges, trawlers; steamboats churning out puffs of steam which intermesh with smoke spewing from smokestacks in the background and then dissolve into the clouds or into the air, creating a screen in front of the light. All these motifs were linked together, visually and pictorially, by the River Seine, present everywhere in Pissarro's Rouen series, except in the few scenes of the cathedral and the city's roof-tops.

During the last ten years of his life, Pissarro painted over three hundred urban views, distributed through eleven series. These series were executed in only four cities: Paris (1893–1903), Rouen (1896 and 1898), Dieppe (1901 and 1902) and Le Havre (1903). The Seine flows through Paris, Rouen and Le Havre, while Dieppe, Rouen and Le Havre are major shipping ports in Normandy. The movements of the sea and of the river, in conjunction with the movements of people and the bustle of city traffic, are a principal theme throughout Pissarro's series.

1 Bailly-Herzberg 1980, p. 241 (Rouen, 19 October 1883; to Lucien Pissarro): 'Voilà qu'il pleut, je cours à ma fenêtre'; p. 240: 'Cependant je constate par moi-même, ici la difficulté, toujours inattendues qui viennent vous assaillir en plein air. Le temps ici est on ne peut plus variable, c'est décourageant; j'ai neuf toiles en train, plus ou moins avancées'; p. 240: 'jusqu'à présent je n'ai pu trouver mon effet, j'ai même été obligé de changer un peu l'effet, ce qui est toujours dangereux'; p. 240: 'J'ai . . . plusieurs esquisses peintes à l'huile faites sur le port avec des navires; le lendemain, impossible de continuer, tout était bousculé, les motifs n'exstaient plus, c'est pas possible, on est obligé de les faire en une fois.'

facing page: detail of cat. 12

Unlike Monet in his works in series, Pissarro does not seem to have been searching for variety in subject-matter: 'You know that the motifs are of secondary interest to me: what I consider first is the atmosphere and the effects.'[2] He continued: 'If I listened to myself, I'd stay in the same town or village for years, contrary to many other painters; I'd end up finding in the same place effects that I didn't know, and that I hadn't attempted or achieved.'[3] In this crucial letter, Pissarro highlights some fundamental components of painting in series. The first of these is the fact that the variations of effects to be found in a given location are inexhaustible, owing to the ceaselessly changing sets of variables that inform and transform the scene; no matter how long the artist stayed in any one town or village, he would still discover effects unknown to him, or subjects that, even if known, had not yet been tried by him or not been represented successfully.

The task of painting series, as far as Pissarro was concerned, was inherently endless – or, more exactly, could be brought to an end only with his death. Shortly before he died, he was planning a further series of the Rue Saint-Lazare (of which he had already executed two small series in 1893 and 1897) and another to be painted from his new apartment on Boulevard Morland, overlooking the tip of the Ile Saint-Louis and the Panthéon. He died before either plan could be executed.

Another important aspect of the production of Pissarro's series, as revealed in his letters, is the artist's psychological and visual response to the ceaseless transformation of motif and effects. The key notion here is that of anticipation. The duration and alterations of certain effects, their succession and replacement by others, were inevitably unpredictable: the artist did not and could not know what to expect next. Yet, paradoxically, Pissarro never stopped hoping for things to happen a certain way, in order to fit in with what he had already done: 'I still need a session of very beautiful weather, without too much fog, in order to give those canvases something firmer'.[4] Regularly he would expect the passage of time to offer up the desired solutions: 'let's hope', 'let's wait with patience'.[5] Sometimes his expectations were satisfied: 'Since I've been in Paris, unable to go out, I've been able to work from my window incessantly; I've had winter effects that charmed me in their finesse; the view of the Louvre on the Seine is an absolutely exquisite and captivating subject.'[6] At other times, however, he was frequently frustrated: 'As a result of the bad weather which has been inflicted on us for the last few days, I have had to give up my series of canvases already started upon and tackle another series of grey and rainy weather, waiting until the sun brings us joy again.'[7] At times it was his dealer's expectations that were disappointed, as he recounted to his son with a notable touch of humour: 'Durand [-Ruel] recommends that I do paintings with sun so that they are light and luminous and of a selling effect!!! sadly the sun refuses to have anything to do with us and when it appears it is to disappear for a long time, also I've got nothing but grey-weather paintings, the sun effects are waiting their turn in their crates.'[8]

This continuous struggle with the unpredictable demanded agility from the painter: he had to be ready to capture with great speed whatever effect presented itself, or else prepare all his canvases for a given series in advance, in expectation of any number of possible effects. Hence, an extremely flexible and rapidly adjustable technique became characteristic of Pissarro's series practice in these last ten years of his life, and he himself referred to the vitality necessary in order to go in search of motifs and effects: 'I have been harassed owing to the energetic physical movements that one has to do in order to see those motifs'.[9] It is quite extraordinary that in

2 Bailly-Herzberg 1991, p. 352 (Le Havre, 6 July 1903; to Rodolphe Pissarro): 'Tu sais que les motifs sont tout à fait secondaires pour moi: ce que je considère, c'est l'atmosphère et les effets.'

3 Bailly-Herzberg 1991, p. 352 (Le Havre, 6 July 1903; to Rodolphe Pissarro): 'Si je m'écoutais, je resterais dans une même ville, ou village, pendant des années, au contraire de bien d'autres peintres; je finis par trouver au même endroit des effets que je ne connaissais pas, et que je n'avais pas tentés ou réussis.'

4 Bailly-Herzberg 1980, p. 240 (Rouen, 19 October, 1883; to Lucien Pissarro): 'il manque encore une séance de très beau temps sans trop brouillard pour leur donner un peu de fermeté'.

5 Bailly-Herzberg 1989, p. 259 (Rouen, 25 September 1896; to Durand-Ruel): 'espérons', 'attendons avec patience'.

6 Bailly-Herzberg 1991, p. 294 (Paris, 17 December 1902; to Julius Elias): 'Depuis que je suis à Paris, ne pouvant sortir, j'ai pu travailler de ma fenêtre avec rage; j'ai eu des effets d'hiver qui m'ont charmé par leur finesse; la vue du Louvre sur la Seine est un thème tout à fait exquis et captivant.'

7 Bailly-Herzberg 1991, p. 365 (Le Havre, 29 July 1903; to Pieter Van der Velde): 'Par suite du mauvais temps qui sévit depuis quelques jours, j'ai dû abandonner ma série de toiles commencée et m'atteler à une autre série de temps gris et pluvieux, en attendant que le soleil vienne de nouveau nous réjouir.'

8 Bailly-Herzberg 1989, p. 260 (Rouen, 28 September 1896; to Lucien Pissarro): 'Durand me recommande de faire des tableaux avec du soleil afin que ce soit clair et lumineux et de vente!!! malheureusement le soleil nous boude et quand il apparaît c'est pour disparaître pour longtemps, aussi je n'ai que temps gris, les effets de soleil attendent dans leur caisse leur tour.'

9 Bailly-Herzberg 1989, p. 165 (Rouen, 18 February 1896; to Lucien Pissarro): 'j'étais harassé à cause de la gymnastique qu'il faire pour voir les motifs'.

1902, a year before his death, the total output of his work was the same as in 1872, his most productive year to date. He had developed techniques that enabled him to paint with a renewed vitality and an extreme fluidity of action: 'when one does one or two sessions, it is neccesary to make sure that everything is there: I do up to six or seven sessions for a size 8 canvas, the same for a size 15. If I want to do it in one session, I must change my manner of proceeding completely, in attempting to have the air and the light, etc. etc.'[10] The constant mobility and speed of the effects to be depicted required that the artist be autonomous and be able, therefore, to adjust freely to the changes affecting the motif and to transform either it or its pictorial representation, as necessary.

The methods and techniques that Pissarro used in order to catch the complex fluctuations of external reality had, however, a rather simpler-sounding basis: 'I can see only patches. When I start off a painting, the first thing I strive to catch is its harmonic form [*l'accord*]. Between that sky and that ground and that water there is necessarily a link. It can only be a set of harmonies [*relation d'accords*], and this is the ultimate hardship with painting.'[11]

* * *

The extraordinarily arduous task that Pissarro set himself between the ages of sixty-three and seventy-three (when he died) had some logical, historical and technical precedents which informed the pictorial practice of his series. Initially, Impressionism had been concerned with the task of representing the fleeting effects and phenomena of the external world:[12] trembling leaves on a river bank, freckling the sunlight that will soon disappear; patches of light and shade playing with each other and merging with constantly mobile reflections from water; peasants walking on a rural path or digging in kitchen gardens; smokestacks spewing smoke; barges moving along a river; the cycles of seasons as they transform the countryside. These are familiar images represented in Pissarro's Impressionist pictures of the 1870s. Having selected one of these passing effects, actions or movements as his subject, the artist was not only constrained by the brevity of the effect in question, but almost inevitably confronted by the problem: why this effect or that movement and not the next ones? The notion of sequentiality was thus introduced within Impressionist painting. Pissarro, Monet and Sisley, each in different ways, experimented with this problem very early on: all three artists painted groups of views of the same spots in Louveciennes in different light or under different atmospheric conditions. Monet did the same in Argenteuil and, later on, in Paris, at the Gare Saint-Lazare. The concept of series – the multiplication of representations of a given site as its aspects change – became one of the inherent manifestations of Impressionism. Given the search for greater compositional stability in their work after the 1870s, it is probably not coincidental that practically all the Impressionists explored the potential of painting in series in the closing decades of the century.

A second stimulus prompting Pissarro to embark upon serial painting was presented by his friend Monet's initial series. From 1891 Pissarro had the chance to see Monet's series, which had by then become central to his pictorial activity.[13] Oddly enough, Pissarro did not express enthusiasm for Monet's Grainstack or Poplar series, but he was wildly excited when he saw the Rouen Cathedrals in 1895 (fig. 26). One of his first observations (relevant to the concept behind the present

10 Bailly-Herzberg 1991, p. 347 (Eragny-Bazincourt par Gisors, 28 June 1903; to Rodolphe Pissarro): 'quand on fait une ou deux séances, il faut s'arranger à ce que tout y soit: je mets jusqu'à six ou sept séances pour une toile de huit, comme pour une de quinze. Si je veux la faire en une fois, il faut que je change ma manière de procéder hardiment, en cherchant à avoir l'air et de la lumière, etc. etc.'

11 *Le Havre Eclair*, 25 September 1904, cited in Bailly-Herzberg 1991, p. 369: 'Je ne vois que des taches. Lorsque je commence un tableau, la première chose que je cherche à fixer, c'est l'accord. Entre ce ciel et ce terrain et cette eau, il y a nécessairement une relation. Ce ne peut être qu'une relation d'accords, et c'est là la grand difficulté de la peinture.'

12 I discuss briefly below the equally crucial factor of the subjectivity of the painters; on this point, see R. Shiff, *Cézanne and the End of Impressionism; A Study of the Theory, Technique, and Critical Evaluation of Modern Art*, Chicago, 1984, pp. 14–49.

13 Bailly-Herzberg 1988, p. 60 (Paris, 9 April 1891; to Lucien Pissarro).

exhibition) was that these works were conceived together and were made to be seen together.[14] Monet would appear to have fully endorsed this notion. Yet, the irony of history is such that as these works gained in popularity they would necessarily be dispersed – unless, as Clemenceau jokingly speculated, a millionaire could be found who would 'understand, even dimly, the significance of keeping these twenty cathedrals together and say: "I buy the lot", as he would have done with a bundle of shares.'[15] Pissarro was much more pragmatic than Clemenceau about the inevitable fate of the Cathedrals: 'His Cathedrals are going to be scattered here and there, and yet it is as a whole that it must be seen.'[16] A week later he was urging his son Lucien, who lived in London, to come to Paris as soon as he could, so as not to miss this unique event: 'I so much wish that you could have seen this as a whole, for I find in this a superb unity that I have been seeking for so long. I find the whole thing so important that I came only to see it.'[17] A familiarity with Pissarro's letters is necessary in order to appreciate that such unqualified enthusiasm is very rare and therefore all the more significant. Indeed, about a year later, Pissarro was settling in Rouen, with the firm intention of beginning his first major series of cityscapes.

The third precedent for his series is more personal to Pissarro. Unlike Monet, but in common with Degas, Pissarro was a zealous and passionate printmaker. Michel Melot has drawn attention to the innovatory nature of Pissarro's printmaking: 'Pissarro and Degas had introduced a major break in the traditional concept of print, insofar as they had ceased totally to consider each state of a print as a technical step toward the fabrication of a finished and successful end result – the final state . . . [They] had introduced the habit of numbering and signing each state, and also each proof of each state'.[18] This was unprecedented in the history of printmaking. Melot rightly emphasised the notion that these various states formed an inseparable ensemble, and this has a direct bearing on Pissarro's series practice in the 1890s: 'When they are put together, the various states of a print give it an altogether different meaning. The work of art is composed out of all its states. They cannot be considered separately. They form a series, which does not even imply any direction nor any end, of different impressions of the same motif . . . They do not tend toward a final result, but they are as many equivalent versions of the same vision – an unacceptable conception to the mind of the Academy student in search of an absolute ideal.' During the last Impressionist exhibition of 1886, Pissarro included seven prints in addition to his paintings; four of these represented Rouen motifs (fig. 28). It is also interesting to note that, while Pissarro resorted very little to drawing (in the context of his series work), he made several sets of lithographs and etchings of urban motifs during the 1890s.

The fourth factor that helps to achieve a clearer understanding of Pissarro's reasons for launching into painting in series is of a different kind. Though it has a far less direct and immediately measurable effect, I believe that the circulation of current ideas made possible and indirectly motivated Pissarro's search for new methods of painting and his new pictorial stance, as expressed in his series. 'It is a grave mistake', he wrote, 'to think that all the arts are not intimately linked to an epoch'.[19]

Pissarro was passionately engaged in thinking about issues other than just artistic ones: he was, as is often noted, a committed sympathiser of anarchism; he read avidly and, as his friend and biographer, Georges Lecomte, wrote in 1922, 'he had a taste for ideas as much as for nature'. As Lecomte put it, Pissarro was

as sensitive to the charm of literature as to that of the visual arts, [and] he loved dreams that were transcribed into expressive images, soaring imagination,

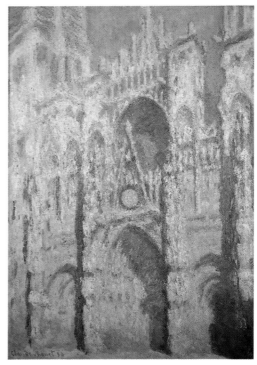

Fig. 26 Claude Monet, *Rouen Cathedral*, 1894, 106 × 73 cm, Private Collection, Japan

14 Bailly-Herzberg 1989, p. 78 (Paris, 1 June 1895; to Lucien Pissarro).

15 G. Clemenceau, 'Révolution des Cathédrales', in *Grand Pan*, Paris, 1896, p. 436.

16 Bailly-Herzberg 1989, p. 75 (Paris, 26 May 1895; to Lucien Pissarro): 'ses *Cathédrales* vont être dispersées d'un côté et d'autre, et c'est surtout dans son ensemble qu'il faut que ce soit vu.'

17 Bailly-Herzberg 1989, p. 78 (Paris, 1 June 1895; to Lucien Pissarro): 'J'aurais tant voulu que tu voies cela dans son ensemble, car je trouve une unité superbe que j'ai tant cherchée . . . Je juge la chose tellement importante que je suis venu exprès.'

18 Michel Melot, 'La pratique de l'artiste: Pissarro graveur en 1880', *Histoire et Critique des Arts*, June 1977, p. 17.

19 Bailly-Herzberg 1989, p. 504 (Rouen, 19 August 1898; to Lucien Pissarro): 'Fais attention que c'est une erreur grave de croire que tous les arts ne se tiennent pas étroitement liés à une époque.'

Fig. 27 Pissarro, *The Place du Havre, Paris,*
*c.*1897, 14 × 21 cm, lithograph (1st state)

Fig. 28 Pissarro, *View of Rouen (Cours-la-Reine),*
1884, 14.8 × 19.9 cm, etching (2nd state)

gripping and truthful human stories recounted in an artistic form. Besides, in his
noble concern for a society with more justice, wherein the labour of those who
create would no longer be exploited in such a derisory way, he was always eager
to read sociological treatises, in which he could find a severe critique of the

present social organisation and alternatively an attempt to draw up the plan for future society worked out by some daring constructors.[20]

Through his series of urban motifs, Pissarro gave pictorial form to problems that were an inherent part of the age in which he lived, painted and thought. He responded vividly to the different forces operating in the contemporary world. 'Paris', he wrote, 'that large hubbub, throws us into the midst of so different a world.'[21] His perception of the world was in keeping especially with the modern notion of time. As Habermas summarised it, the notion of modernity and of a new era came into being when one 'called into question the meaning of imitating the ancient models; in opposition to the norms of an apparently timeless and absolute beauty, modern artists elaborated the criteria of a relative or time-conditioned beauty and thus articulated the self-understanding of the French Enlightenment as the beginning of a new epoch.'[22] This best summarises Pissarro's attitude toward tradition throughout his career, and in particular in the last decade of his life, when, while painting his series, he was increasingly conscious of his own position in history. An advocate of the need for artists to return to nature rather than imitating models inherited from the ancients, he contributed to the evolution of a modern tradition, believing that the return to nature (understood here as reality, whether urban or rural) can be successful only by 'observing nature with our own modern temperament'.[23] Rejecting tradition as a source of models is quite compatible with admiring tradition. This paradox was close to Pissarro's heart, especially during the 1890s and early 1900s; his enthusiasm for Vermeer's *View of Delft* (see above, p. xxxii) offers but one significant instance of his intense visual response to the older masters. His views are clearly articulated in his correspondence: 'To invent and to imitate are two different things. We today have a general concept bequeathed by our great modern artists, we therefore have *a tradition of modern art*; my conviction is that we should follow it while modifying it from our own individual viewpoint' (my emphasis).[24] His letters written during the period that he was painting the Louvre from the window of his apartment in the Place Dauphine are rich with references to what he saw in the Louvre. The singularly vehement tone adopted by him at the government's decision to introduce an entrance fee to the museum is indicative of his strong feelings about the accessibility of the old masters: 'the government is planning to play us one of its tricks . . . They are going to introduce an entrance fee to pay for the right to contemplate the Botticellis at the Louvre! the swines! the triple idiots! one might as well bang one's head against a wall!'[25]

Pissarro argued that the Impressionists, by cultivating their 'sensation vitale', were more advanced in artistic terms than any other so-called 'modern' group, such as the Gothic Revivalists or the Pre-Raphaelites, for instance, whose sentimental, meek work was, in Pissarro's eyes, simply duplicating another strand of traditional art. The genuinely modern alternative, suggested by the Impressionists, was to be true to nature, like the Gothic artists, whose works Pissarro observed in detail and at length while painting his Rouen series: 'If I had to be subject to an influence, I would rather it were that of the true French Gothics whom I see with my own eyes all the time'.[26] Pissarro found a reassuring visual link between Gothic sculpture he admired in Rouen and the work of Degas. Similarly, Rembrandt, for whose *Femme au bain* in the Louvre he professed unreserved admiration and of which he kept a reproduction pinned on his wall, was referred to in the same letter as a proponent of the same aesthetic values.

Yet, while emphasising more than ever before 'influences' from the past (but

20 Lecomte 1922, p. 16.

21 Bailly-Herzberg 1986, p. 343 (Eragny par Gisors, 4 April 1890; to Theo Van Gogh): 'Ce grand brouhaha de Paris, nous jette dans un monde si différent.'

22 J. Habermas, 'Modernity's Consciousness of Time', in *The Philosophical Discourse of Modernity*, p. 9.

23 Bailly-Herzberg 1989, p. 504 (Rouen, 19 August 1898; to Lucien Pissarro): 'l'on ne fait dans ce sens qu'en observant la nature avec notre propre temperament moderne'. Pissarro concludes by saying that to invent and to imitate are two totally different activities. What is left for the modern artist to do is invent.

24 Bailly-Herzberg 1989, p. 504 (Rouen, 19 August 1898; to Lucien Pissarro): 'Nous avons aujourd'hui un type général que nos grands artistes modernes nous ont légué, nous avons donc une tradition d'art moderne; je suis d'avis de le suivre en le modifiant à notre point de vue individuel.'

25 Bailly-Herzberg 1988, p. 148 (Eragny par Gisors, 22 November 1891; to Octave Mirbeau): 'le gouvernement compte nous jouer un air à sa façon . . . Il va nous faire payer le droit de contempler les Botticelli au Louvre, ah! les rossards! les triples brutes; vraiment c'est à se briser le crâne contre un mur'.

26 Bailly-Herzberg 1989, p. 282 (Rouen, 20 October 1896; to Lucien Pissarro): 'Si je devais subir une influence, j'aimerais mieux subir celle des vrais gothiques français que j'ai à chaque instant sous les yeux.'

facing page: detail of cat. 152

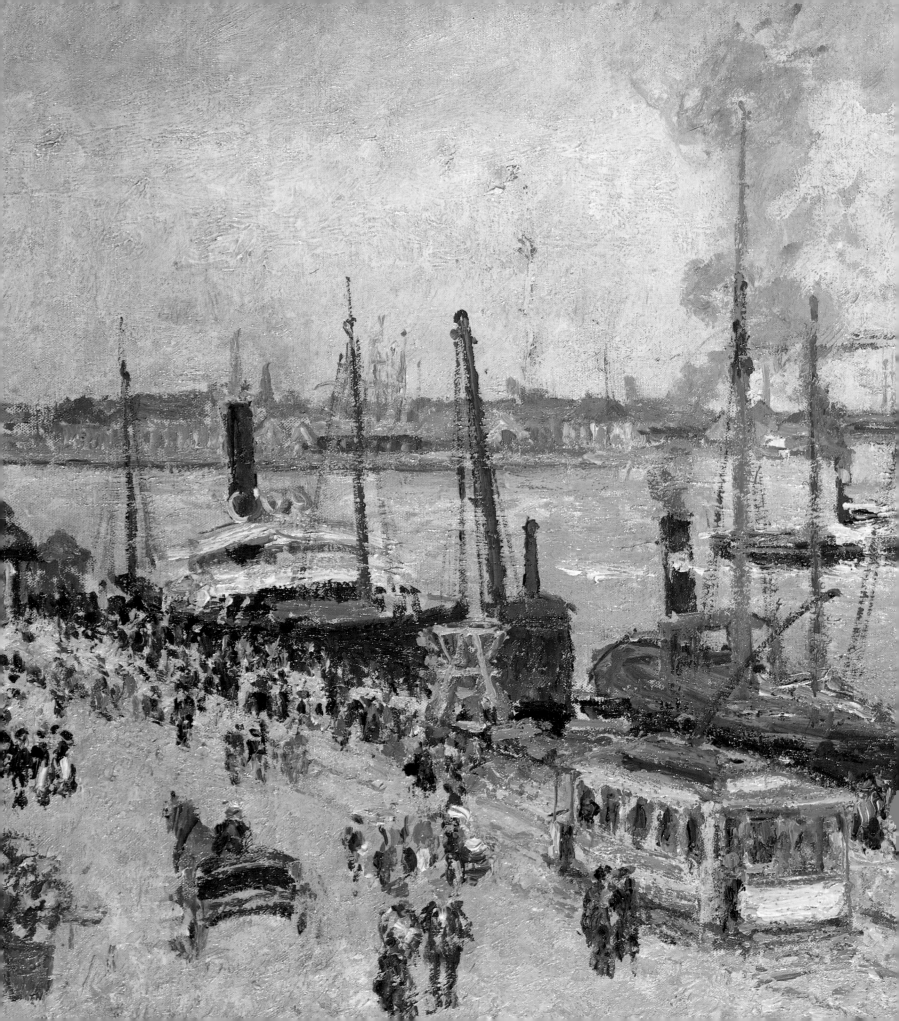

influences that could not possibly be described in imitative terms or formal analogies), Pissarro looked to the future, not only for solutions to the socio-political problems of his day, but also for the aesthetic recognition he considered to be deserved by his and his closer colleagues' efforts and achievements: 'It will take twenty years to open people's eyes, even of those who specialise in art'.[27] Expectation and patience are here correlated in an almost messianic way: a retrospective historical interest is complemented by a hope for recognition, both of which informed Pissarro's present as he painted his series. His attitude and his detached interest in the models offered by the art of the past constitute his active modern stance, comparable to that of Cézanne or Degas: 'in opposition to the norms of an apparently timeless and absolute beauty', he and his closest colleagues 'elaborated the criteria of a relative or time-conditioned beauty',[28] which, by consensus or intercommunication, would establish a basis for proper recognition. The pivotal, yet always elusive and fragmentary presence of the Louvre in most of Pissarro's Paris series is therefore perhaps not the result of mere chance.

Baudelaire was perhaps the first to endeavour to formulate some answer to the same dilemma: if all art is time-relative, what makes past art still interesting and the art of the present of potential interest to those who will look at it in 'twenty years time', as Pissarro put it? And consequently, where does an artist stand, in his immediate present, and in relation to the Louvre – the Louvre of the past as well as of the future? Baudelaire conceived the work of art as an embodiment of both the transient present and the eternal: 'Modernity is the transient, the fleeting, the contingent; it is one-half of art, the other being the eternal and immovable'; 'Beauty is made up, on the one hand, of an element that is eternal and invariable . . . and, on the other, of a relative, circumstantial element, which we may call . . . contemporaneity'.[29] Pissarro was an avid reader of Baudelaire, and these two texts by the poet and critic seem to go straight to the heart of Pissarro's historical, pictorial and technical concerns during the time when he was painting his series featuring the Louvre. Pissarro's argument, echoed throughout his letters, is clear: since the transient present cannot define itself in regard to a past whose value as a model has been rejected, the truth of the present (modernity; Pissarro's series) will therefore be affirmed as the authentic past of a future present. This solution illuminates Pissarro's position throughout his series in several ways: from the Tuileries series until the very last paintings of Paris bridges, Pissarro concentrated on representing the bastion of artistic tradition, the Louvre, observed under every transitory effect, from different vantage points.

In 1900, referring to the Impressionists' physical and historical situation at the Centennial Exhibition, Pissarro remarked: 'we are coming on the tail of the 1830 School.'[30] He was clearly linking Impressionist practice to an immediately historical precedent (the School of Barbizon). Nine years earlier he had given his son Lucien a definition of that short-lived, period-specific '1830 School': 'as for the art of 1830, it is Corot, it is Courbet, it is Delacroix, it is Ingres! . . . and it is eternally beautiful.'[31] Pissarro is here, perhaps unintentionally, paraphrasing Baudelaire's definition of modern art in describing the transient movement that received its name from its passing phase in history ('1830') and that was shortly to be replaced by Impressionism as 'eternally beautiful'. But, as we saw above, the two are not incompatible.

The importance of this particular reference to the School of Barbizon is not irrelevant to Pissarro's series. As he was searching for the motif and site of what

27 Bailly-Herzberg 1988, p. 62 (Paris, 13 April 1891; to Lucien Pissarro): 'il faut vingt ans pour dessiller les yeux même des gens qui s'occupent d'art!'

28 Habermas, *Philosophical Discourse of Modernity*, p. 9.

29 C. Baudelaire, 'The Painter of Modern Life', in *Selected Writings on Art and Artists*, New York and Harmondsworth, 1972, pp. 403 and 392.

30 Bailly-Herzberg 1991, p. 83 (Paris, 22 April 1900; to Lucien Pissarro): 'nous venons à la suite de l'Ecole de 1830'.

31 Bailly-Herzberg 1988, p. 100 (Eragny par Gisors, 28 June 1891; to Lucien Pissarro): 'car l'art 1830, c'est Corot, c'est Courbet, c'est Delacroix, c'est Ingres! . . . et c'est beau éternellement'.

turned out to be his last series (Le Havre), he went to the Hôtel Saint-Siméon, near Honfleur, to see whether he could revive memories of the origins of Impressionism. He explained that the hotel was 'famous for all the painters who have stayed here from 1830 up to the present day. In former times there was a farm under the apple trees planted in the green meadows, overlooking the sea. Boudin, Corot, Cals, Daubigny, Monet, Jongkind all passed through here. But there is nothing left of this glorious past. The stupid new proprietors have tidied it all up! . . .'[32]

This juxtaposition of the new and the old, of tradition and modernity, of the transient and the eternal constitutes, I believe, one of the principal connecting themes of Pissarro's series. This can be argued in three ways: historically, iconographically and technically.

Historically, the series were executed at a time when Pissarro was, together with the other Impressionists, finally gaining recognition and success. This became particularly obvious at the turn of the century with the Centennial Exhibition, at which they were given an official place in the pavilion of French painting. Pissarro's growing awareness of his position in history was subsequently reinforced by the experience of painting the Le Havre series. The port of Le Havre was to be destroyed shortly after, hence, in part, the decision of the Musée des Beaux-Arts to buy two paintings from this particular series. These were the first and only official purchases of his work by any French museum during his lifetime. He explained, with some irony, the reasons for his acquisition: 'I am waiting for a collector who wants to see my motifs of the port. It seems that they are very important from an *historical and documentary* point of view! They are about to demolish the port to build a bigger one, when they have demolished this one, it will seem unique! One ought not to rush to sell, but I so badly need to sell. I will still try to keep a few.'[33] The documentary value of the Le Havre paintings is incidental and not deliberate, as the surprised tone of the letter indicates. The same is true of the Rouen and Dieppe series, since, although Pissarro could not have predicted it, both towns suffered considerably during World War II. But the confirmation of the importance of Pissarro's series from an 'historical and documentary' point of view remains an external factor and, certainly in the cases of Rouen and Dieppe, totally accidental to his pictorial strategy.

In fact, Pissarro's choice of subject-matter appears to have been determined by totally contrary considerations, since he seems generally to have favoured settings that were quite blatantly 'modern' and new. Again, the juxtaposition of the new world with the old is what consistently honed Pissarro's imagination, not so much because the old was about to disappear, but because the new offset the old. In Rouen, for his first major series, he chose to represent 'the new quarter of the Saint-Sever district, just opposite, and the ghastly Orléans station, brand new and shiny, and a pile of smokestacks, some huge, some tiny, with their arrogant air!'[34] The letter in which this comment occurs is fundamental to Pissarro's aesthetics as exemplified in his series: not only is the new set up as a counter to the old (the medieval buildings of Rouen in this case), but the opposition between the two is resolved by the articulation of this opposition, i.e. by Pissarro himself — his eye, his 'window': his 'point of view'. 'Figure-toi de ma fenêtre . . .' ('imagine from my window . . .') are the words that open this fascinating description of the 'brand new', 'ghastly', 'banal', 'trivial', and yet, 'beautiful, truly beautiful' and 'extraordinary' motifs of his Rouen series. This 'point of view', which transcends the dichotomy between old and new, ghastly and beautiful, is also that of 'art', an

32 Bailly-Herzberg 1991, p. 356 (Le Havre, 10 July 1903; to Lucien Pissarro): 'renommé par le séjour de tous les peintres depuis 1830 jusqu'à nos jours. C'était autrefois une ferme sous des pommiers plantés dans des prés verts, avec vue sur la mer. Boudin, Corot, Cals, Daubigny, Monet, Jongkind y sont passés, mais il n'y a plus rien de ce passé glorieux, ces imbéciles de nouveaux propriétaires y ont mis bon ordre!! . . .'

33 Bailly-Herzberg 1991, p. 367 (Le Havre, 20 August 1903; to Georges Pissarro): 'J'attends un amateur qui désire voir mes motifs du port. Il paraît que c'est très important au point de vue *historique et documentaire*! On est en train de démolir le port pour en construire un plus vaste, quand ce sera démoli ce sera paraît-il unique!! Il faudrait peut-être ne pas se presser de vendre, mais j'ai tant besoin de vendre. Je vais tâcher d'en garder plusieurs.'

34 Bailly-Herzberg 1989, p. 266 (Rouen, 2 October 1896; to Lucien Pissarro): 'le quartier neuf de Saint-Sever, juste en face avec l'affreuse gare d'Orléans toute neuve et brillante et un tas de cheminées, d'énormes et de toutes petites, avec l'air panache.'

art that is, like Gothic art, 'damn true to nature and not religious',[35] and an art that is 'seen through our own sensations'.

Several similar examples of Pissarro's choice of subject-matter confirm his interest in the simultaneous presence of the new and the old. The Avenue de l'Opéra can be offset against the Louvre, and within the former series, painted with his back turned to the Louvre, he could incorporate another juxtaposition of the new and the old: the Avenue de l'Opéra contrasted to the seventeenth-century Palais Royal. Pissarro described the Avenue de l'Opéra motif in words reminiscent of his description of his Rouen motifs: 'It's going to be beautiful to paint! It is not very aesthetic perhaps, but I am delighted to be able to try to do these Paris streets which are often called ugly, but which are so silvery, so luminous and so lively and which are so different from the boulevards – it's completely modern.'[36] As in the representations of Rouen, the ghastly turned out to be extraordinary; the architecture of Rouen's brand-new station turned out to be just as beautiful as a piece of Gothic sculpture; here, what seemed at first 'not very aesthetic' was revealed as enchanting to paint. Benjamin, in his magisterial work *Paris, Capitale du XIXe Siècle*, provided his own interpretation of the possible paradox inherent in the Avenue de l'Opéra: 'The Avenue de l'Opéra which, according to the malicious comments of the time, at least, if nothing else, improves the view from the concierge window at the Hôtel du Louvre, demonstrates how little it took to satisfy the megalomaniac ambitions of the Préfet Haussmann.'[37]

Pissarro in fact painted that view of the Avenue de l'Opéra from the Hôtel du Louvre, and his comment obviously refers to the rather poor reputation of this avenue built under the auspices of Haussmann. Benjamin, emphasising the theatrical and artificial components of Haussmannian architectural aesthetics, continued his analysis of Paris in terms relevant to Pissarro's series: 'The Haussmannisation of Paris meant that phantasmagoria would be transformed into stone. As it is destined to a sort of eternity, it partially reveals at the same time its flimsy character'.[38] Despite its critical tone, he here posits an opposition between the eternal and the transient. Transposed into Pissarro's pictorial aesthetics, the opposition – quintessential to his own series – becomes that between 'not very aesthetic' and 'beautiful to paint'.

Another example of this type of opposition is offered by Pissarro's seemingly least 'modern' subject-matter: the Louvre. In fact, he, typically, chose to depict those aspects of the Louvre that had just been subjected to major restoration, such as the two Pavillons (Flore and Marsan), together with the street passing in front of its western wing which had been constructed in the 1880s. Likewise, the Tuileries Gardens, visible in his paintings of the Louvre, had been created and opened to the public after the firing and destruction of the Palais des Tuileries during the Commune.

Through his choice of urban imagery, there are, therefore, several ways in which an articulation of the old and the new, the passing of time and the eternal, the conflation of tradition and modernity can be distinguished. The destruction of the old (Le Havre); the renovation of the old (the Louvre); the transformation of the old (the Tuileries Gardens); the construction of the brand new (the Gare d'Orléans in Rouen and the Gare d'Orsay, in Paris); juxtaposition of the old and the modern (steel bridges in Rouen, next to the medieval district; the Pont-Neuf, Paris's oldest bridge, next to the Samaritaine store) – these oppositions offer examples of this emphasised 'modern' dichotomy.

35 Bailly-Herzberg 1989, pp. 266–67 (Rouen, 2 October 1896; to Lucien Pissarro): 'C'est de l'art et vu par nos propres sensations . . . C'est rudement nature et pas religieux'.

36 Bailly-Herzberg 1989, p. 418 (Paris, 15 December 1897; to Lucien Pissarro): 'C'est très beau à faire! C'est peut-être pas très esthétique, mais je suis enchanté de pouvoir essayer de faire ces rues que l'on a l'habitude de dire laides, mais qui sont si lumineuses et si vivantes, c'est tout différent des boulevards – c'est le moderne en plein!!!'

37 W. Benjamin, *Paris, Capitale du XIXe Siècle*, Paris, 1989, p. 57: 'L'avenue de l'Opéra qui, selon l'expression malicieuse de l'époque, ouvre la perspective de la loge de la concierge de l'hôtel du Louvre, fait voir de combien peu se contentait la mégolomanie du préfet.'

38 Benjamin, *Paris, Capitale du XIXe Siècle*, p. 57: 'Dans l'haussmannisation de Paris la fantasmagorie s'est faite pierre. Comme elle est destinée à une sorte de perennité, elle laisse entrevoir en même temps son caractère ténu.'

facing page: detail of cat. 58

The underlying duality that informs Pissarro's paintings in series reflects another facet of Baudelaire's aesthetic system, as laid out in the poet's *Spleen*: the need to extract from the modern urban experience an appropriate poetic form. The themes and images in the work of these two artists differ conspicuously, but I am more interested here in the relationship between the dichotomies that are apparent in their work.

In his study of Baudelaire, Todorov calls the first type of dichotomy seen at work in *Spleen* 'ambivalence', that is, two opposite qualities characterising a single object. Throughout Pissarro's series, numerous examples of such ambivalences, sometimes compounded, can be found: the sun, all-pervasive in a picture (e.g. *Boats, Sunset, Rouen* (ill. 26)), with its glowing, overpowering, harmonising gold-vermilion effect, remains hidden behind the clouds and is unseen; furthermore, its effects can be seen only through its opposite element, water (the clouds, the steam, the river); the movements of a crowd, apparently chaotic (e.g. *Place du Théâtre Français: Spring* (cat. 72)), follow certain patterns, like the clouds; a bridge, in spite of its modern, steel, architectural solidity and its static mass, is vibrating under the rhythm and pace of the bustling traffic crossing it, and appears almost weightless as it reflects and absorbs the shimmering lights of an after-rain effect; furthermore, it can be represented as though cut through by a powerful and voluminous puff of smoke (e.g. *The Pont Boïeldieu, Rouen: Damp Weather* (cat. 1)).

Further similar comparisons can be made between Pissarro's and Baudelaire's work: certain themes receive the same ambivalent treatment in Pissarro's series as in Baudelaire's prose poems. The theme of dusk – the ambiguous dividing line between day and night – receives an equally vibrant treatment in 'Le Crépuscule du Soir'[39] and in Pissarro's *Quay in Rouen: Sunset* (ill. 24), *The Pont Boïeldieu, Rouen: Sunset* (cat. 2), *Sunset, the Port of Rouen (Steamboats)* (cat. 25), *Boats, Sunset, Rouen* (ill. 26), *Sunset, Rouen* (ill. 27)). Another theme focused upon in the work of both artists is the harbour, where action (on the docks) and meditative contemplation (from the artist's window) interpenetrate (see Baudelaire's *Le Port* and almost any harbour scene from Pissarro's series). In Pissarro's work, this ambivalence is compounded, often, by the effect of a sunset over a harbour scene.

The second aspect of Baudelaire's approach found in Pissarro's series is that of antithesis, that is, the juxtaposition of two objects, facts, beings, actions with opposing characteristics. Pissarro's series abound with these – broad and intricate oppositions of the elements (air/water (steam), water/fire (sunsets, puffs of steam, clouds)), supplemented by oppositions of earth/water etc., are complemented by formal, textural, dynamic, social, architectonic antitheses: frenetic movement/ stillness; dry/wet; nature/architecture; humanity/nature; solitude/crowds; horizontals/verticals. Oppositions of techniques inherent in almost all of Pissarro's series support and strengthen these sets of constitutive dichotomies, and create a complex web of dynamics that hold the works together in series.

It could be argued that the dynamic structure of any of Pissarro's series emanates from the internal structure of any one of its constituent paintings. It is thus useful to consider a contemporary account of the artist's creative procedures, recorded by Robert de la Villehervé, and published in *Le Havre Éclair* on 25 September 1904, which emphasises the same problematics:

He had glorified our harbour, its movement and energy, through the alchemy of colours. Through a peculiar coincidence, he was coming to the end of his life at a

39 C. Baudelaire, *Le Spleen de Paris, petits poèmes en prose*, Paris, 1972, pp. 90–92.

time when that which moved him and caught his interest in our maritime architecture was also about to disappear: the bastions, the wave-breakers, the jetties, which were already at the mercy of the explosives and pickaxes of the demolishers . . . From the beginning of July, Camille Pissarro was established at the Hôtel Continental. He had chosen a room there in the wing that runs along the Rue Renouf. The window opens onto a balcony, and from this balcony he could look towards the jetty and the semaphore, or concentrate his attention on the pilots' jetty, or study that corner of the outer harbour that never looks the same and which delighted him. Pissarro was a relentless worker.

Up at 5 a.m., he would start off his day immediately . . . You would have seen in his bedroom – which turned out to be his last studio – two crates in which he would tightly pack his canvases. There he would keep half a dozen of his future pictures; they soon were diligently sketched, and then he would resume each one, as long as the conditions, the time, the state of the sky, the light would allow it. Indeed, he resumed his works following these rules, never putting a brushstroke down at random, but striving to interpret nature, constantly observed, as accurately as he could, with his marvellous sensibility. And gradually his works were gaining completion . . . as they were constantly resumed with the most uncommon patience: this is the reason why he had to have prepared several canvases, sun or rain effects, morning or evening, windy or still weather. This way, his work could be carried out daily as he wished. The weather truly had to be quite gruesome, and all things had to look quite dull, colourless and discouraging before he would resign himself not to do anything. Then he would go out. He would take a stroll along the jetty . . . As soon as a ray of sunshine pierced through the clouds, he would return happily to his work . . . Nothing would then distract him. He would, however, smoke small cigars, but never in front of his easel. Meticulous as he was, he would frequently clear off his palette, scratching off the lumps of colours with his palette knife, before squeezing out the rainbow colours, neat and pure, from his pewter tubes, together, of course, with the silver white, which is light.

His method was unwavering. He always started a painting by searching for a harmony between the sky on one hand, and earth and water on the other. Then only would he care for details. He himself used to say so: 'I can see only patches. When I start off a painting, the first thing I strive to catch, is its harmonic form [*l'accord*]. Between that sky and that ground and that water there is necessarily a link. It can only be a set of harmonies [*relation d'accords*], and this is the ultimate hardship with painting. What I find of less and less interest through my art, he also used to say, is the material side of painting, i.e. the lines. The great problem to resolve is to bring everything, including the tiniest details of the picture, within the harmony of the whole.'[40]

This account provides essential evidence of Pissarro's technical concerns and his pictorial methods during his last series. It also clearly spells out his priority in any one painting and within a series: an 'accord' of tones. In other words, his interest lies in creating an internally coherent whole, based on a set of harmonies. However, the way in which these two are achieved does not necessarily accord with traditional approaches to picture-making or the reading of pictures as a finite group present in a predetermined sequence. For, Pissarro was confronted with a twofold technical problem, as described in this interview: first, to create a general, cyclical 'accord'

40 Cited in Bailly-Herzberg 1991, p. 369.

(between patches of sky, earth and water); second, within this general 'accord', to bring the smaller details into harmony with the ensemble.

Creating a set of systematic and cohesive reflections is here at the core of Pissarro's working methods: the water mirrors the sky; that in turn mirrors the earth; at the same time the water mirrors the sky's reflections of the earth and water. Each painting within a series can thus be referred to as a relation of tunes or harmonies (*relation d'accords*). It refers internally to itself and generates a pictorial autonomy that sustains the inner structure of the work. However, paradoxically, this method is limited, both by the external conditions on which it depends, and by the other pictorial constituents of the same series, and can never reach completion as a whole.

It is perhaps instructive to place Pissarro's two major concerns, emanating from both his need to translate fleeting effects into paint on canvas and his concern to provide internal coherence within a series as a whole, within a broader aesthetic structure derived as much from literary theory as from art-historical fact.

Pissarro's paintings within each series were necessarily constructed from painterly gestures. In literary terms, gestures are seen by Blackmur as the precursors of symbols.[41] Symbols, in their turn, and not in the historically specific definition accorded to them by writers and painters who were Pissarro's contemporaries, are the equivalent constituted out of gestures of something that cannot be expressed in verbally specific form. In other words, writers, and painters, are confronted with the inherent impossibility of representing anything without recourse to a word or group of words, or to a brushstroke or group of brushstrokes, which are equivalent to, but can never physically be the same as, that which is being described. Thus, as Cézanne declared to Maurice Denis, 'I felt content with myself once I had discovered that the sun could not be reproduced but that one had to represent it through something else . . . through colour'.[42]

While Pissarro fully comprehended this inevitable gap between the real and the represented, he also, in any given painting within the urban series, appears to have been acutely aware of a parallel, and equally potent, use of the brushstroke applied to canvas, namely to perform a range of non-representational, that is, formal and aesthetic, functions. In this not exclusively representational domain, paint, or 'patches' of colour, acting as gestures equivalent to Blackmur's poetic gestures, function in themselves on two levels, working both autonomously and as part of a greater whole. Thus, in the first instance, 'patches' of colour are used to create a cohesive composition, as in the *Pavillon de Flore and the Pont Royal* (ill. 124), where the green of the River Seine both represents the river in its passage through the composition in a strictly descriptive sense, and exists in relation to other areas of green within the picture which, as the eye records them, come to create a secondary cohesive element within the composition as a whole. In this second function, patches of a given colour are used also to fulfill a more active role. Distributed across the surface of a picture such as *The Fish Market, Dieppe* (cat. 144), they serve to propel the spectator's eye from one patch to the next, thus creating an equivalence to the representation of urban movement, or flux, so much the leitmotif of Pissarro's urban series. Lastly, patches of appropriate colour are distributed through a single painting in such a way that the overall harmony is achieved despite latent oppositions established by the constituent descriptive elements within a given subject. Hence, in *Quay in Rouen: Sunset* (ill. 24), opposing motifs – fire, sunset and industrial energy, and the water, the River Seine and rain – are both resolved as

41 R.P. Blackmur, *Language as Gesture*, 1952, quoted in T. Todorov, 'Autour de la poésie', in *Les Genres du discours*, Paris, 1978, p. 100.

42 *Conversations avec Cézanne*, ed. M. Doran, Paris, 1978, p. 173: 'J'ai été content de moi . . . lorsque j'ai découvert que le soleil, par exemple, ne se pouvait pas reproduire, mais qu'il fallait le représenter par autre chose . . . par de la couleur'.

industrial smoke merges with clouds, and are held in counterpoint as the setting sun is reflected in water but diffused by the smoke and the steam.

While structural cohesion is achieved through the premeditated application of paint as visibly defined 'patches' of colour, so too it can be realised through the mediation of certain structural elements within a given composition. In the *Avenue de l'Opera* (cat. 69) and *Rouen* (cat. 3), the potential to tear apart the composition of the insistent horizontal and vertical statements established by the buildings, the quays or the lines of factories beyond, is held in check by the dramatic diagonal plunges into the depth of the composition of the vast recession of the avenue itself or of the solid, arched bridge.

In the final analysis, Pissarro in each of his individual paintings that ultimately constitute a given series, lays as much store upon the physical construction of the surface of the canvas through patches of colour, structural lines and blocks of colour held in harmonious accord as he does on the scene represented. It is thus that he not only pursues his belief that true painting, 'la peinture peintre', is one that does not dissimulate its physical means of realisation (i.e. paint built up on the surface of the canvas), as did the so-called academic painters, but also realises to the full his persistent belief that out of the potentially fragmentary procedure of placing patches of colour on the surface of a canvas, a harmonious whole, or 'relations d'accords' can be achieved. That this was a difficult and frequently elusive goal for painting in general was recognised in his comment: 'I was thinking: how rare it is to find true painters who can put two tones in harmony with each other'.[43]

Such a search for 'relations d'accords' can also be extended beyond the four edges of a canvas to encompass a series as a whole. Pissarro balances, in the Boulevard Montmartre series, for example, morning, evening, midday and night effects, while in the Tuileries Gardens series, he seeks out morning and evening, brilliant sunshine and overcast skies. When seen within the context of his stress upon urban flux, the capturing of the unpredictable changes of weather and light means that no order of succession was or could be assigned to any one series. Pissarro, like Monet, would work on a number of canvases simultaneously, over several successive phases. Yet, unlike Monet, he appears to have been far less concerned with recording on a sequence of canvases the 'progression' of light over a single motif during the course of a day. To be sure, Monet himself noted time and again the impossibility of working in any coherent, logical way, moving from one time or weather condition to another. Can any 'order', any combination, be acceptable therefore? Although, in theory, it is possible to recreate as many sequences for each series as there are possible mathematical combinations, in practical terms, some combinations make no sense at all.[44]

Essentially, what both Pissarro and Monet had come to recognise in the construction of their series was the impossibility of any longer regarding a single image, or sequence of related images, as a definite, absolute statement, the objectively 'truthful' representation of a given scene. To be sure, this position had been inherent in Impressionism from its inception. As Richard Shiff in particular has demonstrated,[45] Zola's definition of Impressionism as 'nature seen through a temperament' contained an inherent paradox for the movement's programme: while deriving its principles from the realist doctrine of Courbet and, to a lesser extent, the landscape painters of the School of Barbizon, which demanded that only by depicting objectively the external world could the artist truthfully represent a scene (i.e. nature), the programme also recognised that each individual can only

43 Bailly-Herzberg 1989, p. 119 (Paris, 21 November 1895; to Lucien Pissarro): 'je me faisais cette réflexion: combien il est rare de trouver de vrais peintres, qui sachent mettre en accord deux tons'.

44 See the Editorial Note on p. 1 for an explanation of the rationale behind the ordering of the pictures in this present exhibition.

45 R. Shiff, *Cézanne and the End of Impressionism: A Study of the Theory, Technique and Critical Evaluation of Modern Art*, Chicago, 1984.

'see' that nature in a personal, and hence unique way. It was precisely this combination of the objective and the subjective that allowed the Impressionists both to paint using a similar technical vocabulary and to create identifiably individual pictorial manifestations. In attempting, therefore, to address this paradox within a series of paintings whose primary intention was to capture, in a non-predetermined sequence of images, the fleeting effects of light and weather conditions across a single motif, Pissarro was merely exacerbating the latent problem of relative as opposed to absolute truth in front of Nature. He elaborated on this during the practical process of picture-making: 'The changes of weather are giving me a tough time and I am worried stiff';[46] 'I absolutely have to finish what I am doing here: when shall I finish? This will depend on the weather of each day and on the difficulty of the motifs. I have two small sun effects which are giving me a tough time, for it is raining, and when there is a little sun, that's not it. Even the rain is not constant in its effects, and, moreover, the ships are dropping out now'.[47]

In this respect, Pissarro's personal recognition of the impossibility of capturing absolute truth upon a canvas or group of canvases, can find an analogy with contemporary developments in the fields of science and philosophy. These had been in large measure shaped by the epistemological theories of Auguste Comte which, reflecting in part Leibniz's monad theory of the individual's irrevocably singular and unique perceptions, posited that all knowledge derived from observation was by definition relative.[48] On the one hand, it can be suggested that Comte's intrinsically relativist system provided the basis for the evolution of Heisenberg's uncertainty principle, as Cornelius Castoriadis has demonstrated.[49] Published at the beginning of this century, the principle established that, from the observer's point of view, the properties of the electron – position and velocity – could not both be known or calculated at the same time. In other words, if one wanted to know one of these properties with precision, one had to forego knowledge of the other. *Mutatis mutandis*, it can be argued that Pissarro was confronted by a similar choice throughout his series: to give emphasis either to the constancy of a chosen motif or to the transient aspect of an effect. On the other hand, Comte established a framework for contemporary debates within physiology and psychology surrounding the elimination of the distinction between object and subject: 'Reality came to be equated with consciousness, and, as so many maintained, the primordial act of consciousness was to perceive an impression: the impression was neither subject nor object, but both the source of their identities and the product of their interaction.'[50] Here again, this interaction can in several ways be described as lying at the nexus of Pissarro's series.

It was against this intellectual and cultural background that Pissarro and his fellow Impressionists were working. For Pissarro, such relativism accorded well with his own anarchist beliefs which implied both a politically autonomous individualism and a vehement disregard for all externally imposed aesthetic rules. In this latter domain, what he regarded as of greatest importance were the self-generated constraints established by the reading of the artist himself in his major endeavour: the creation of eleven monumental series during the last ten years of his life. These constraints can be appropriated today by the observer of his series. While, as was discussed above, his individualism and his sense of relativity implied that no logically predetermined order of succession can be assigned to any one series, they help to clarify a critical paradox that underlies the relationship between individual constituent paintings and a series as a whole. Each series is by definition

46 Bailly-Herzberg 1989, p. 282 (Rouen, 20 October 1896; to Lucien Pissarro): 'Le changement de temps me donne bien du mal et l'inquiétude me paralyse'.

47 Bailly-Herzberg 1989, p. 283 (Rouen, 21 October 1896; to Georges Pissarro): 'Il faut absolument que je finisse ce que je fais ici, quand finirai-je? Cela dépend du temps qu'il fait et de la difficulté des motifs, j'ai deux petits effets de soleil qui me donnent du mal car il pleut ou quand il y a un peu de soleil, cela n'y est pas, même les pluies ne sont pas stables d'effet, et qui plus est, les bateaux fichent le camp'.

48 For a study of the development of the theories of subjectivity within the evolution of the concept of modernity, see A. Renaut, *L'Ere de l'individu– contribution à une histoire de la subjectivité*, Paris, 1989, pp. 38ff. I am also grateful to Richard Shiff who kindly drew my attention to a precise reference to Leibniz in Gustave Planche's *Salon de 1831*; see R. Shiff, 'Cézanne's physicality' in *The Language of Art History*, ed. S. Kemal and I. Gaskell, Cambridge, 1991, p. 174, n. 28.

49 See C. Castoriadis, *Les Carrefours du Labyrinthe*, Paris, 1978. For an analogy between physics and modern art, see also, J.M. Pontevia, 'Ogni Dipintore Dipinge Se', in *Ecrits sur l'Art et Pensées détachées*, vol. III, Paris, 1986, p. 151.

50 Shiff, *Cézanne and the End of Impressionism*, p. 26.

the sum of its parts. Yet, since each part was created without an apparently predetermined view as to where precisely within the single sequence it would appear, then, if one of the parts is taken away, theoretically the whole, while being numerically depleted, can still function adequately as a series. However, given that simultaneously Pissarro apparently conceived of a particular treatment of a given motif as part of the whole, any reduction in the number of parts must mean that the whole, that is the series, functions less adequately, although the degree to which this is so is not quantifiable in absolute terms until the number of parts has been so reduced as to threaten the very existence of the group as a series.

It is this open-ended approach to the constituent parts of any of his series, coupled with a profound understanding of the parts' inherent interdependence, that also reflects Pissarro's own creative procedures during the making of a given series, and thus constitutes the spectator's processes of understanding and appreciation. In keeping with the world within which they were created, Pissarro's sets of cityscapes are an individual's readings and pictorial interpretation of a world in flux; they cannot remain the same at the beginning and the end of either the production of a given constituent painting out of pictorial gestures, or the assembling of these given paintings into a series as a whole. Furthermore, as does the act of vision that reconstructs both the pictorial gestures in a single painting and establishes connections between individual paintings, each series becomes a continuous act of creation and recreation. If the visitor to the present exhibition were to walk through the galleries more than once, he or she would not see the same thing each time. Pissarro's series of views call for our own series of observations. In the 1890s, Pissarro's creative gaze was attracted by the autonomous, collective, routine movements of people as they walked in the streets. The objects of constantly renewed scrutiny, from above, from the artist's window, they participated, as does the viewer of today following a route through this exhibition, in the anonymous creative process that was the celebration of one man's confrontation with a world which he appreciated to be ultimately modern, forever in flux.

CATALOGUE

EDITORIAL NOTE

Camille Pissarro painted eleven series in four cities, Rouen (1896, 1898), Paris (1892–93, 1897, 1898, 1899, 1900–3), Dieppe (1901, 1902) and Le Havre (1903). He gave no indication as to his preferred sequence of pictures within each series. Thus this catalogue has, where relevant, used shifts of vantage point across a particular subject to identify sub-series within a series, and has imposed no rigid temporal sequences upon the succession of images within each series.

Pissarro chose to create his series on canvases of different sizes. The canvases were of standard dimensions; purchased ready stretched, their formats are given in the table on the right in centimetres. The sizes of the reproductions in the catalogue reflect in principle this variety of format.

In order to represent as comprehensively as possible the extent and variety of motifs and formats within each series, the catalogue also illustrates works that are not included in the exhibition. A distinction is made between exhibited and non-exhibited works by (1) indicating their status after the reference number of the work, and (2) giving exhibited works full catalogue details.

FORMAT NO.	F (figure)	P (paysage)	M (marine)
3	27 × 22	27 × 19	27 × 16
4	33 × 24	33 × 22	33 × 19
5	35 × 27	35 × 24	35 × 22
6	41 × 33	41 × 27	41 × 24
8	46 × 38	46 × 33	46 × 27
10	55 × 46	55 × 38	55 × 33
12	60 × 50	60 × 46	60 × 38
15	65 × 54	65 × 50	65 × 46
20	73 × 60	73 × 54	73 × 50
25	81 × 65	81 × 60	81 × 54
30	92 × 73	92 × 65	92 × 60

facing page: detail of cat. 56

1 ROUEN: THREE CAMPAIGNS

'I wanted to paint the animation of that beehive: Rouen and its quays.'[1]

Pissarro's first substantial, systematic series of cityscapes was begun in Rouen in 1896, over two separate campaigns, and was resumed in a third in 1898. He had already visited the city twice before: in 1883, when he had painted several views of its quays; and in 1895, when he had done some watercolours.[2] A number of reasons lay behind his decision to launch a major campaign in serial painting in Rouen. The first, which can hardly be overestimated, is the pictorial presence of Monet in the city. This gave rise to what I have elsewhere described as a 'multifaceted pictorial dialogue'[3] between the two artists, with Rouen as their subject-matter. Monet's series of paintings of the cathedral at Rouen had gone on exhibition at Galerie Durand-Ruel in Paris shortly after Pissarro's visit to Rouen in 1895. He was immediately struck by a 'unity' in the works, of a kind for which he himself had been searching for some time.[4] He had already made tentative attempts at serial painting, first in Rouen in 1883, and then, more substantially, in Paris in 1892/93 with a group of four paintings, which was supplemented by a companion group in 1897 (see below, pp. 51–57). But the two Paris groups quite obviously lack the unity Pissarro was looking for: they are fragmentary, with the links between the works loose, the use of formats unsystematic, and the dividing line between sketch and finished picture sometimes difficult to detect.

Another important element in the evolution of Pissarro's Rouen series was the precedent he believed that he had set himself in 1883. By 1896 he was referring to the paintings made at that time as 'the Rouen series of 1883'.[5] Furthermore, in 1886 he had included in his contribution to the last Impressionist exhibition seven prints, of which four were views of Rouen.[6] Iconographically and technically,

therefore, he can be seen to be developing in Rouen an interest in serial procedures by exploring the technical opportunities offered by printing as a medium. He experimented with the etched image in different ways: each state of the print offered a different treatment of a single motif and hence could be seen as an independent work.

In April 1895, twelve years after his preliminary work in Rouen, Pissarro was in the city again, looking for a place from which he could paint: 'I am in Rouen with Dario; I am going to look for a hotel on the quays from where I will be able to do some thoroughly worked pictures without too much risk, nor tiredness from carrying [size] 30 canvases. It's very difficult now that I am old and penniless.'[7] A month later, he was referring to the exhibition of Monet's Cathedrals at Durand-Ruel's as 'la great attraction' (sic).[8] While full of praise for Monet's series, Pissarro noted (to his dismay) that what was still being questioned by visitors to the exhibition was the act of painting 'light, the open air'.[9] What impressed him about these works was their synoptic character: 'above all, it [the series] must be seen as a whole'.[10] A week after his first reference to the exhibition, he announced: 'I feel truly inclined to do a good campaign of work; if I hear of a place that isn't too expensive, with urban motifs, I will go and see it'.[11] By early 1896 he had decided definitely upon Rouen, where the motifs were familiar to him – though he declared himself open to the possibility of choosing different subjects from those pursued thirteen years earlier.[12]

Pissarro stayed in Rouen from January until early April 1896 at the Hôtel de Paris, where he rented two rooms: one on the second floor, and one on the third.[13] His first group of views of Rouen enjoyed a vast succès d'artiste when it was exhibited at Durand-Ruel's soon after his return. Encouraged by the reception of these works, Pissarro went back to the city from 8

1 Bailly-Herzberg 1989, p. 170 (Rouen, 7 March 1896; to Lucien Pissarro): 'J'ai voulu rendre l'animation de cette ruche qu'est Rouen sur les quais.'

2 Bailly-Herzberg 1989, p. 153 (Rouen, 20 January 1896; to Lucien Pissarro).

3 J. Pissarro, Monet's Cathedral, London and New York, 1990, p. 14.

4 Bailly-Herzberg 1989, p. 78 (Paris, 1 June 1895; to Lucien Pissarro).

5 Bailly-Herzberg 1989, p. 178 (Rouen, 24 March 1896; to Lucien Pissarro).

6 Pissarro, Monet's Cathedral, p. 9.

7 Bailly-Herzberg 1989, p. 64 (Rouen, 19 April 1895; to Lucien Pissarro): 'Je suis avec Dario à Rouen; je viens chercher un hôtel sur les quais d'où je pourrai faire des tableaux très travaillés sans trop de risque, ni de fatigue, pour porter les toiles de trente. C'est d'une grande difficulté, à présent que je suis vieux et sans argent.'

8 Bailly-Herzberg 1989, p. 69 (Eragny par Gisors, 11 May 1895; to Lucien Pissarro).

9 Bailly-Herzberg 1989, p. 74 (Paris, 25 May 1895; to Georges Pissarro): 'de la lumière, du plein air'.

10 Bailly-Herzberg 1989, p. 75 (Paris, 26 May 1895; to Lucien Pissarro): 'c'est surtout dans son ensemble qu'il faut que ce soit vu'.

11 Bailly-Herzberg 1989, p. 70 (Eragny par Gisors, 19 May 1895; to Lucien Pissarro): 'je me sens bien disposé à faire une bonne campagne, si je connaissais un endroit pas trop cher, avec des motifs de ville, j'irais voir'.

12 Bailly-Herzberg 1989, p. 149 (Eragny-Bazincourt par Gisors, 15 January 1896; to Lucien Pissarro).

13 Bailly-Herzberg 1989, pp. 152–87.

facing page: detail of ill. 8

September to 11 November, this time staying at the more expensive Hôtel d'Angleterre, on the same side of the river but on the other side of the Pont Boïeldieu. During these two campaigns in 1896, he produced twenty-eight paintings of the city. Two years later, having by this time completed his first two substantial Paris series (Boulevard Montmartre and Avenue de l'Opéra; see pp. 59–77 and 79–101), he returned to Rouen, staying again at the Hôtel d'Angleterre, from 23 July to 17 October, and painting a further nineteen canvases.

The forty-seven views of Rouen far exceed the numbers in any other series. They are characterised by an intensity and rapidity of execution and a broad handling that single them out from the rest of the artist's serial works. Given the more exploratory nature of the 1893 Paris series (see below, p. 51), the 1896 group can, moreover, be regarded as Pissarro's first major urban series.

The Rouen series is also the first to anchor its compositions in the theme of the River Seine – and its multiple pictorial, poetic and functional rôles. After the 1898 Rouen campaign, all of Pissarro's series were articulated around the presence (visible or hinted at, as in the Tuileries series) of either the Seine or maritime harbours. From then on, the movements of the river and sea, and the passage of traffic upon them, became a central aspect of his work (the exception is the Church of Saint-Jacques series in Dieppe, pp. 172–79).

The 1896 Rouen series can be divided, thematically, into two main groups: paintings of bridges, and paintings of the docks. The former consists of sixteen works: *The Pont Boïeldieu, Rouen: Damp Weather* (cat. 1); *The Pont Boïeldieu, Rouen: Sunset* (cat. 2); *The Pont Boïeldieu, Rouen: Sunset, Misty Weather* (cat. 3); *The Seine in Flood, Rouen* (ill. 4); *Morning, Overcast Day, Rouen* (cat. 5); *The Pont Boïeldieu, Rouen* (cat. 6); *Fog, Morning, Rouen* (ill. 7); *The Pont Boïeldieu, Rouen: Rain Effect* (ill. 8); *Afternoon, Sun, Rouen* (ill. 9); *The Pont Corneille, Rouen: Grey Weather* (cat. 11); *The Pont Corneille, Rouen: Morning Mist* (cat. 12); *The Pont Boïeldieu, Rouen: Fog* (ill. 14); *The Seine at Rouen, The Pont Boïeldieu* (P&V 954); *The Pont Corneille, Rouen: Morning* (P&V 962); *Saint-Sever Quay and Faubourg, Rouen* (P&V 966); *Fog, Rouen* (P&V 972). Pissarro returned to the theme in 1898: *Sunrise, Rouen* (cat. 10).

The docks were represented in nine paintings in 1896: *Steamboats in the Port of Rouen* (ill. 18); *The Port of Rouen, Saint-Sever* (cat. 19); *Morning, Rouen, the Quays* (cat. 20); *Foggy Morning, Rouen* (ill. 21); *Morning, after the Rain, Rouen* (ill. 22); *Quay in Rouen: Sunset* (ill. 24); *Unloading Wood, Rouen* (ill. 28); *Sunset, Rouen: Unloading Wood* (P&V 965); *Sunset, Rouen* (P&V 967); and in another eight in 1898: *View of the Cotton Mill at Oissel, near Rouen* (cat. 23); *Sunset, the Port of Rouen (Steamboats)* (cat. 25); *Boats, Sunset, Rouen* (ill. 26); *Sunset, Rouen* (ill. 27); *The Port of Rouen: Unloading Wood* (cat. 29); *The Docks of Rouen: Afternoon* (cat. 30); *The Port of Rouen: Afternoon, Rain* (P&V 1051); *The Port of Rouen* (P&V 1052).

In common with all Pissarro's series, the Rouen group has an intermediary sub-series which overlaps the main sub-series, but which does not fit into either. This sub-series could be called the Gare d'Orléans sub-series, for it focuses on the then newly built railway station on the left bank, set between the Pont Boïeldieu (truncated, if not completely omitted) and the docks to the right. The works in this group are *The Saint-Sever Quay, Rouen* (ill. 13) and *The Pont Boïeldieu, Rouen: Fog* (ill. 14) of 1896; *The Seine, Rouen* (P&V 1041) and *Saint-Sever, Rouen: Morning, Five o'clock,* (cat. 15); *Rouen, Saint-Sever: Morning* (cat. 16); *Rouen, Saint-Sever: Afternoon* (ill. 17) of 1898.

In addition to this sub-series, there is a smaller group of works (two in 1896 and three in 1898) concentrating on the reverse aspect of the main sub-series. Turning his back on the industrial smokestacks, bustling bridges and shiny new iron structures accumulating along the Seine, Pissarro could see the old medieval town. Looking at it from above the roofs, he focused on the church spires of Saint-Maclou and Saint-Ouen (*The Roofs of Old Rouen: Sunshine* (P&V 947)) or on the cathedral (*The Roofs of Old Rouen: Grey Weather (the Cathedral)* (cat. 31)); or, in 1898, on the cathedral again, this time from street level (*Rue de l'Epicerie, Rouen: Morning, Grey Weather* (ill. 32), *Sunny Afternoon, Rue de l'Epicerie, Rouen* (cat. 34), *Rue de l'Epicerie, Rouen* (ill. 33)). The Rouen series, the cornerstone of all of Pissarro's urban series, thus appears to be extremely complex. This complexity is increased by the fact that the Rouen bridges were known by different names over the centuries, and different

names are occasionally used to refer to the same bridge in the titles given in the *catalogue raisonné*. (When such a case arises in the catalogue entries that follow, the title has been modified, so that one bridge is referred to by one name only).

Three bridges are represented in this series:

Pont Boïeldieu This is the most frequently depicted bridge in Pissarro's Rouen series. It had been built in 1885, two years after Pissarro's preliminary group of Rouen views was painted. It had replaced a suspension bridge (1836–84), which itself had been built in place of the Pont Mathilde (constructed in the twelfth century), otherwise known as the Grand Pont, also a name occasionally used in the *catalogue raisonné*. The street that led to the Pont Boïeldieu on the right bank was called the Rue Grand Pont. On the left bank the bridge led to the Quartier Saint-Sever, hence another name, Pont Saint-Sever, used for the same bridge (see, for example, ill. 14). Throughout this catalogue the bridge is referred to as the Pont Boïeldieu.

Pont Corneille This was the official name of a two-armed bridge that joined the two banks of the Seine, via the tip of the Ile Lacroix. In this, the bridge was comparable to the Pont-Neuf in Paris (the subject of another series). The Pont Corneille was more commonly known among the Rouennais as the 'Pont de Pierre'. It receives both names in the *catalogue raisonné* and is here referred to only as the Pont Corneille.

Pont du Chemin de fer This is the third bridge represented in the Rouen series. It is never referred to by name in the *catalogue raisonné* as it appears only in the background of such compositions as *Afternoon, Sun, Rouen* (ill. 9) and *Grand Pont, Rouen: Rain Effect* (P&V 950) (or in *The Côte Saint-Catherine, Rouen*, painted in 1883 (P&V 612)). The Pont du Chemin de fer crossed the Ile Brouilly, which can be seen upstream from the main city.

All three bridges were destroyed during World War II and were subsequently replaced.[14]

As he shifted his vantage point to the right, away from the bridges, the next motif that came in to his line of vision was the brand-new Gare d'Orléans at the end of the Pont Boïeldieu on the left bank, in the Quartier Saint-Sever. The railways in nineteenth-century France still belonged to competing private companies. Three companies had bought the various concessions of the Rouen network, and each company had to have its own station. The Compagnie d'Orléans started construction on a station in 1896, and the building was officially inaugurated in 1898. Indeed, when Pissarro described what he could paint from his hotel window (during his second campaign of 1896), he was not exaggerating when he referred to 'the new quarter of Saint-Sever, just opposite, and the ghastly Orléans station, *brand new and shiny*, and a pile of smokestacks, some huge, some tiny, with their arrogant air' (my emphasis).[15]

Extending yet again to the right, the third motif constituted the so-called 'docks' – huge brick warehouses set on the left bank – and the adjacent quays or docksides on the left bank, a few hundred years downstream from the Gare d'Orléans.

The principal characteristics of the Rouen paintings are mapped out in Tables 1, 2 and 3 in the Appendix. With these details in mind, the three sub-series of Pissarro's Rouen series gain in significance, and the clarity of his procedures emerges more precisely. The three sub-series or groups are intrinsically linked: the group of bridges (Pont Boïeldieu and Pont Corneille) is painted as the artist's gaze is oriented towards the south-east, looking to his left from his hotel window; the Gare d'Orléans group follows an axis orientated southwards; the paintings of the docks and the Quartier Saint-Sever have a south-west point of orientation. Within each of these general categories Pissarro's gaze shifts slightly to the left or to the right, as is particularly apparent in the bridges and even more so in the docks sub-series. It must be remembered, however, that the subjects of the paintings in these three sub-series are diametrically opposite to the subjects he painted when he turned his back to the south and looked northwards at the cathedral and the churches of Saint-Maclou and Saint-Ouen. A similar opposition – physical, ideological and historical – points to one constant in Pissarro's pictorial poetics: the new is new only in reference to the old, and vice versa. He was fascinated by the destruction of the old and its replacement by the new: 'I have begun a few sketches of the old streets which are going to be demolished.'[16] Analogously, in Paris at the same time – early

14 It is worth noting that the appearance today of the whole area of Rouen depicted by Pissarro bears no resemblance to its late nineteenth-century appearance. All the main architectural features identifiable in Pissarro's paintings were destroyed in World War II, and this part of Rouen was subsequently transformed.

15 Bailly-Herzberg 1989, p. 266 (Rouen, 2 October 1896; to Lucien Pissarro): 'le quartier neuf de Saint-Sever, juste en face, avec l'affreuse gare d'Orléans toute neuvre et brillante, et un tas de cheminées, d'énormes et de toutes petites, avec l'air panache'.

16 Bailly-Herzberg 1989, p. 160 (Rouen, 31 January 1896; to Lucien Pissarro): 'j'ai commencé quelques croquis de vieilles rues que l'on fait disparaître'.

1898 – he was focusing on the new Hausmannian perspectives created in the Avenue de l'Opéra, his back turned to the Louvre. Later on in the year, he was to focus on the Louvre itself, and the Jardins des Tuileries. This complementarity is constantly present as a basic element of Pissarro's series.

The juxtaposition of the old and the new, represented, whether implicitly or explicitly, in Pissarro's paintings of Rouen, is reinforced by several sets of visual, pictorial, thematic or elementary oppositions: steel, new (Pont Boïeldieu) v. stone, old (Pont Corneille); modern (Gare d'Orléans) v. medieval (Quai Saint-Sever); medieval (Quai Saint-Sever) v. industrial (the docks); clouds v. sun (the Rouen series has more sunsets seen through the clouds than any other series); clouds v. puffs of steam from tugboats, and industrial smoke (inherent in this opposition are further oppositions between the natural and the artificial, the eternal and the transient). Water is seen through its opposing element, air; water in turn is transformed into clouds, fog, steam, rain and river. It is condensed, vaporous, diaphanous, flowing, evaporating. The only state of water that Pissarro does not depict in this series is that of ice or snow: in their lack of any snow effects, the Normandy series (Rouen, Dieppe and Le Havre) differ conspicuously from the Paris series.

The Rouen series also stages interactions of different forms and directions of traffics: the flow of pedestrians and carriages on bridges is superimposed on and opposed to the passage of barges with their cargoes of wood on rivers. Sometimes they cross each other on their different levels; sometimes the barges are stationary, while moored and being loaded or unloaded.

These ambivalences and oppositions seem in many ways to constitute the point of departure for Pissarro's Rouen series. The web of ambivalent and antithetical themes forms a whole set of relations and creates a highly organised universe. Such polarities, inherent in Pissarro's aesthetics, were explored in his own writing:

I am working like a black, I have ten paintings in front of me . . . all different effects. I have a motif that will be the despair of poor Mourey: imagine from my window the new quarter of Saint-Sever, just opposite, and the ghastly Orléans station, brand new and shiny, and a pile of smokestacks, some huge, some tiny, with their arrogant air. In the foreground boats and the water, to the left of the station the working-class district that runs all along the quays up to the iron bridge, the Pont Boïeldieu; it's morning with a fine misty sunlight. Oh well that idiot Mourey is an ignoramus to think that this is banal and down to earth, it is as beautiful as Venice, my dear, it has an extraordinary character and it is truly beautiful[17]

In another letter, written shortly after he had embarked on his second campaign, Pissarro summarised the multifarious thematic interests that stimulated him pictorially:

Rouen is admirable; here at the hotel, from my window at the second mezzanine floor, I see the boats glide by with their plumes of black, yellow, white, pink smoke. I see the ships loaded with planks of wood being moored, being unloaded and going off. It does not take long, just the length of three sessions. To my left, I also have the bridge that I painted last year – but on the opposite side, with the docks and the houses on the opposite bank: there is a whole block of houses with grey roofs. To do those gives me a real headache because of the horizon which forces me to drop my perspective lines on the docks.[18]

Finally, what the Rouen series demonstrates fully is that the process of anticipation and expectation that sustains the dynamics and the progress of all Pissarro's series is endless: there is always more to do. Having finished his second campaign, he immediately thought of coming back: 'there is so much to do in that admirable atmosphere'.[19] Eventually, the intrinsically endless 'variability' of his Rouen effects was such that Pissarro had to return to Paris before he could conceive of the series as complete: 'I would be sorry to have to leave Rouen without being able to push them [his effects] further, but they are so variable. This is quite annoying.'[20]

17 Bailly-Herzberg 1989, p. 266 (Rouen, 2 October 1896; to Lucien Pissarro): 'Je travaille comme un nègre, je mène dix tableaux de front . . . de tous les effets. J'ai un motif qui fera le désespoir de ce pauvre Mourey: figure-toi de ma fenêtre le quartier neuf de Saint-Sever, juste en face avec l'affreuse gare d'Orléans toute neuve et brillante et un tas de cheminées, d'énormes et de toutes petites, avec l'air panache. Au premier plan des bateaux et l'eau, à gauche de la gare le quartier ouvrier qui court tout le long des quais jusqu'au pont de fer, le pont Boïeldieu, c'est le matin par un fin soleil brumeux. Eh bien! cet imbécile de Mourey est une brute de croire que c'est banal et terre-à-terre, c'est beau comme Venise, mon cher, c'est d'un caractère extraordinaire et vraiment, c'est beau!'

18 Bailly-Herzberg 1989, pp. 253–54 (Rouen, 13 September 1896; to Georges Pissarro): 'Rouen est admirable, ici à l'hôtel, de ma fenêtre au deuxième au-dessus de l'entresol, je vois filer les bateaux empanachés de fumées noires, jaunes, blanches, roses, je vois les navires chargés de planches s'embosser sur les quais, décharger et filer, ce n'est pas long, l'espace de trois séances. J'ai aussi à ma gauche le pont que j'ai fait l'année dernière, mais du côté contraire avec les quais et maisons de l'autre rive, tout un pâté de maisons à toits gris que j'ai un mal de chien à faire, à cause de l'horizon qui me fait tomber mes lignes de perspective des quais.'

19 Bailly-Herzberg 1989, p. 291 (Rouen, 2 November 1896; to Paul Durand-Ruel): 'il y a tant à faire dans cette atmosphère admirable'.

20 Bailly-Herzberg 1989, p. 292 (Rouen, 6 November 1896; to Paul Durand-Ruel): 'Quitter Rouen sans les pousser me donnerait des regrets, mais quelle variabilité. C'est fort ennuyeux.'

facing page: detail of cat. 31

The Pont Boïeldieu, Rouen: Damp Weather 1896

Le Pont Boïeldieu à Rouen, temps mouillé
P&V 948
73.7 × 91.4 cm
Signed and dated lower right: *C. Pissarro 1896*

Art Gallery of Ontario, Toronto, Gift of
Reuben Wells Leonard Estate, 1937

PROVENANCE Bought from the artist by
Galerie Durand-Ruel, Paris, 1896; New
York, 1896–99; probably Georges Durand-
Ruel's private collection, Paris, 1899;
Durand-Ruel Galleries, New York, arrived
late 1920s; bought with funds from the
Reuben Wells Leonard Estate by the Art
Gallery of Ontario, 1937

EXHIBITIONS Paris 1896, no. 4; probably
New York 1897, no. 4; Paris 1910(ii), no. 11;
Paris 1914, no. 94; Paris 1925, no. 38; New
York 1929, no. 11; Buffalo 1930, no. 55;
New York 1933, no. 12; Cleveland 1936,
no. 299; Baltimore 1936, no. 11; Toronto
1937, no. 35 (repr.); Montreal 1939, no. 89;
Toronto 1940, no. 94; Montreal 1942, no. 60;
Toledo 1946–47, no. 50; New York 1965,
no. 60; London 1980–81, no. 75 (repr.
pp. 41(col.) and p. 138); Tokyo 1984, no. 53
(repr. pl. 53); Birmingham 1990, no. 79

LITERATURE Mauclair 1904, p. 139 (repr.);
Meier-Graefe 1907, p. 171; Pica 1908, p. 137
(repr.); Hamel 1914, pp. 25–32 (repr. p. 26);
Faure 1921, p. 384 (repr.); *Le Bulletin de la vie
artistique*, February 1921 (repr.); Fontainas
1922, p. 1412 (repr.); *Art News*, 23 January
1937, pp. 9–10; Jedlicka 1950, pl. 31;
Natanson 1950, pl. 31; *The Art Gallery of
Toronto: Painting and Sculpture*, 1959, p. 38
(repr.); Hubbard 1962, pp. 40–41 (repr.
no. xx); *Art Gallery of Ontario: Handbook*,
1974, p. 72 (repr.); Shikes 1980, p. 292
(repr.); Vaizey 1981 (repr. col. pp. 60–61);
'World Fine Arts', *Yomiuri Shimbun
Newspaper*, 27 June 1984 (repr. col.); *Art
Gallery of Ontario: Masterpieces from the Art
Gallery of Ontario*, 1987, p. 58 (repr.); Goff
1987 (repr. jacket); Seiberling 1988, p. 37
(repr. fig. 30); *Art Gallery of Ontario: Selected
Works*, 1990, p. 143 (repr.); Denvir 1991,
p. 341 (repr. fig. 333)

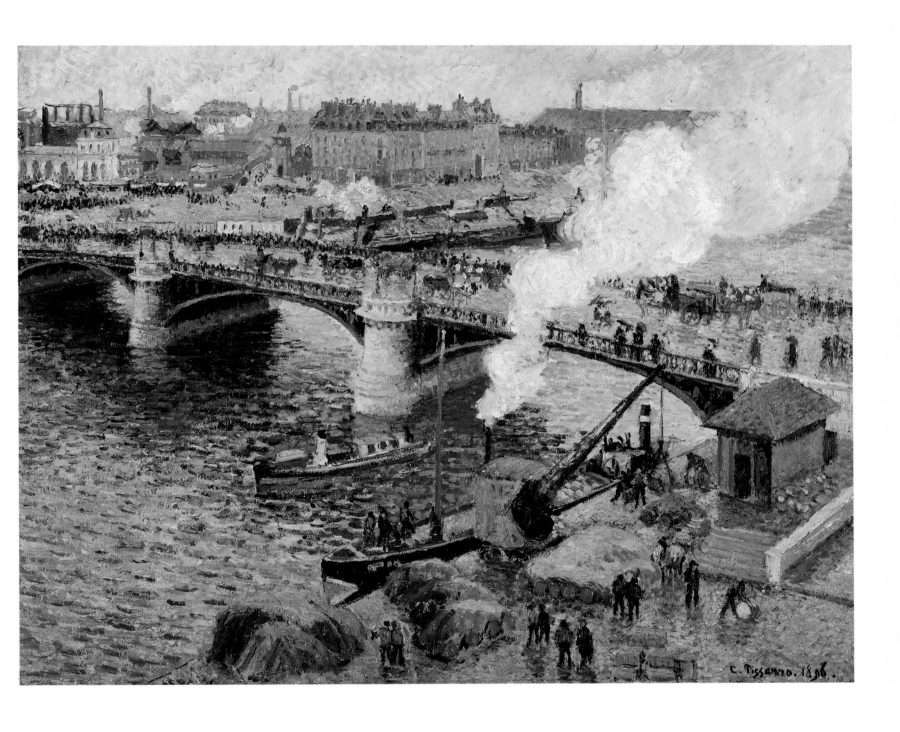

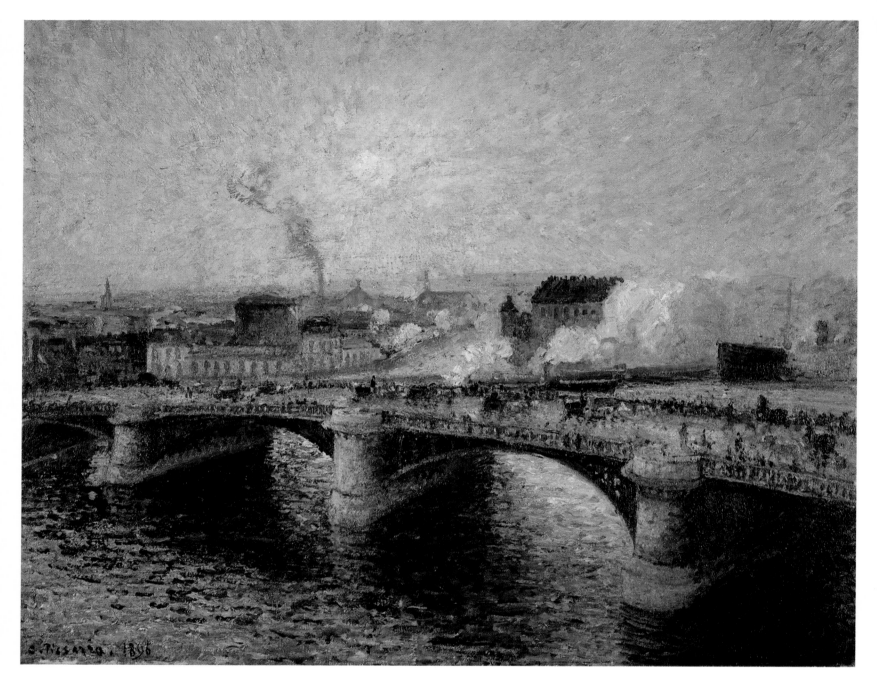

2 EXHIBITED

The Pont Boïeldieu, Rouen: Sunset 1896

Le Pont Boïeldieu à Rouen, soleil couchant
P&V 952
74.2 × 92.5 cm
Signed and dated lower left: *C. Pissarro 1896*

Birmingham Museums and Art Gallery

PROVENANCE E. Décap; Maurice Barret-Décap; M. Fabiani, Paris; bought by Alex Reid & Lefevre, London, 25 September 1950 (102/50); bought by Birmingham Museums and Art Gallery, 8 December 1950

EXHIBITIONS Paris 1896, no. 1; London 1957, no. 13; London 1962, no. 245 (repr.); London 1968, no. 18 (repr.); Birmingham 1990, no. 80 (repr. col. fig. 137); Birmingham 1991 (no cat. no., repr. col. p. 41)

LITERATURE *Letters* 1943, pp. 266–81; advertisement supplement to the *Burlington Magazine*, vol. XCII, no. 573, December 1950, pl. IV; Young 1967, pp. 748–49 (repr.)

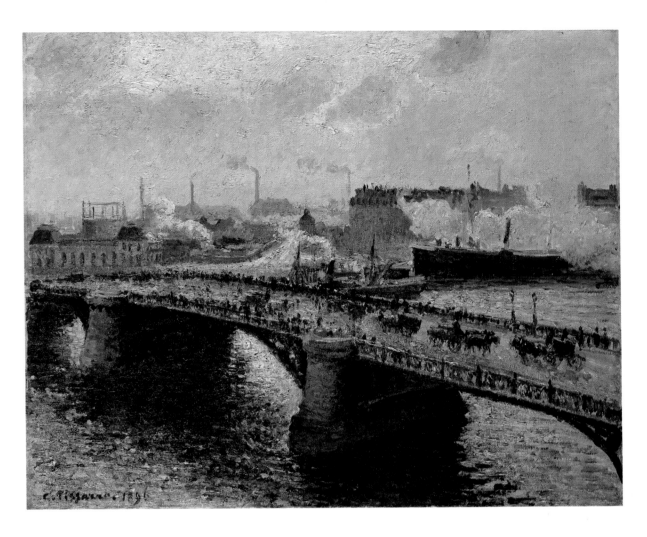

3 EXHIBITED IN DALLAS AND
PHILADELPHIA

The Pont Boïeldieu, Rouen: Sunset, Misty Weather 1896

Le Pont Boïeldieu à Rouen, soleil couchant, temps brumeux
P&V 953
54 × 65 cm
Signed and dated lower left: *C. Pissarro 1896*

Musée d'Orsay, Paris

PROVENANCE Durand-Ruel Family
Collection; given to the Musée d'Orsay,
Paris, 1983

EXHIBITIONS Paris 1896, no. 9; Paris
1899(ii), no. 61; London 1905, no. 201; Paris
1910(ii), no. 18; Paris 1928, no. 72; Paris
1932, no. 35; Paris 1984–85

LITERATURE *The Studio*, 15 July 1903;
Basler 1929 (repr.); 'Museos Grandes del
Mundo: El Impresionismo', *El Mundo*
(Madrid), 23 March 1941, p. 267; *Le Matin*,
18 June 1983; Compin 1989, vol. IV, p. 139
(repr.); Rosenblum 1989, p. 318 (repr.)

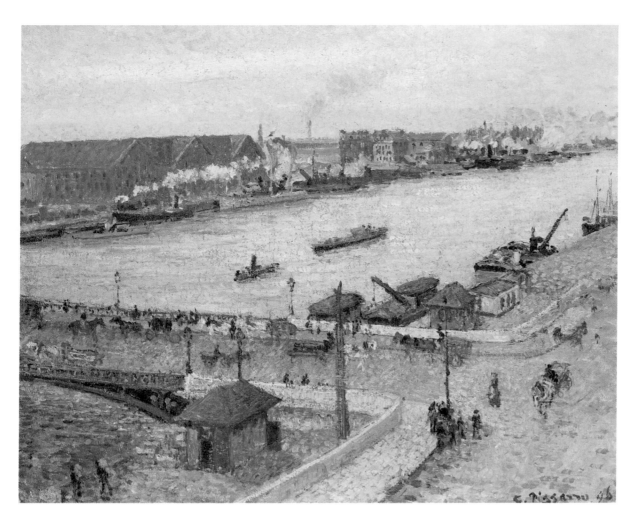

4 NOT EXHIBITED

The Seine in Flood, Rouen 1896

Crue de la Seine à Rouen
P&V 955
55 × 65.5 cm

Private Collection

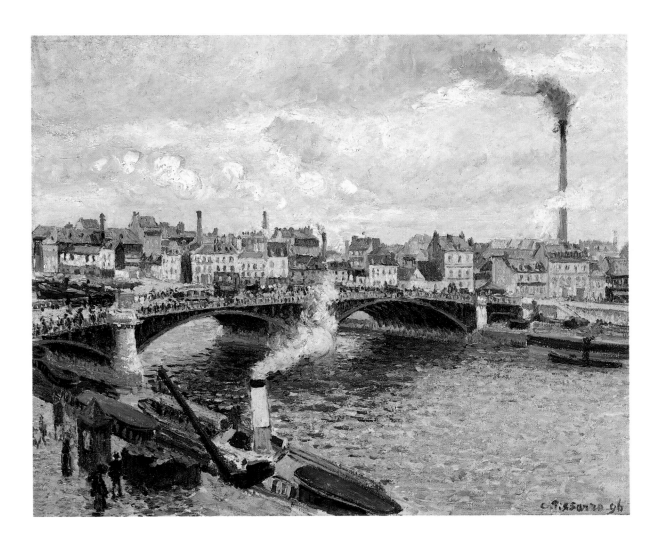

5 EXHIBITED IN DALLAS AND
PHILADELPHIA

Morning, Overcast Day, Rouen
1896

Matin, temps gris, Rouen
P&V 964
54.3 × 65.1 cm
Signed and dated lower right: *C. Pissarro. 96*

The Metropolitan Museum of Art, New
York, Bequest of Grégoire Tarnopol, 1979,
and Gift of Alexander Tarnopol, 1980

PROVENANCE Grégoire Tarnopol, New
York, 1965; given by Alexander Tarnopol to
The Metropolitan Museum of Art, New
York, 1980

EXHIBITIONS New York 1941, no. 1; New
York 1965, no. 62

The Pont Boïeldieu, Rouen 1896

Le Pont Boïeldieu, Rouen
P&V 956 (known as *Le Grand Pont, Rouen*)
74.1 × 92.1 cm
Signed and dated lower left: *C. Pissarro 96*

The Carnegie Museum of Art, Pittsburgh,
Museum Purchase (00.9)

PROVENANCE Durand-Ruel Galleries, New
York; bought by The Carnegie Museum of
Art, Pittsburgh, 31 December 1900

EXHIBITIONS Pittsburgh 1900–1, no. 189;
New York 1945, no. 34 (repr. p. 35);
Chicago 1946; Colorado Springs 1946;
Toledo 1949; New York 1950(i); Dayton
1951; Pittsburgh 1951; Columbus 1952;
Detroit 1954; Toronto 1957; Palm Beach
1960, no. 20 (repr.); New York 1965, no. 61
(repr.); Portland 1967, no. 25 (repr.); London
1980–81, no. 76 (repr.); Los Angeles 1984–85,
no. 37 (repr.); Pittsburgh 1990

LITERATURE *New York Herald Tribune*, 28
October 1945 (repr.); *Art News*, March 1950,
p. 31; O'Connor 1951, pp. 236–37 (repr.
p. 236); Sterling 1951 (repr, no. 112); Rewald
1963, p. 142 (repr. col. p. 143); Myers 1966,
p. 177 (repr.); Canaday 1969, vol. IV, pl. 293;
Bellony-Rewald, 1976, p. 247 (repr.); Lloyd
1979, pp. 7, 10, 15 (repr. pl. 36); *Museum of
Art, Carnegie Institute Collection Handbook*,
Pittsburgh, 1985, p. 88 (repr. p. 89); *Journal
des Instituteurs*, May-June 1987 (repr. p. 3;
repr. col. p. 59)

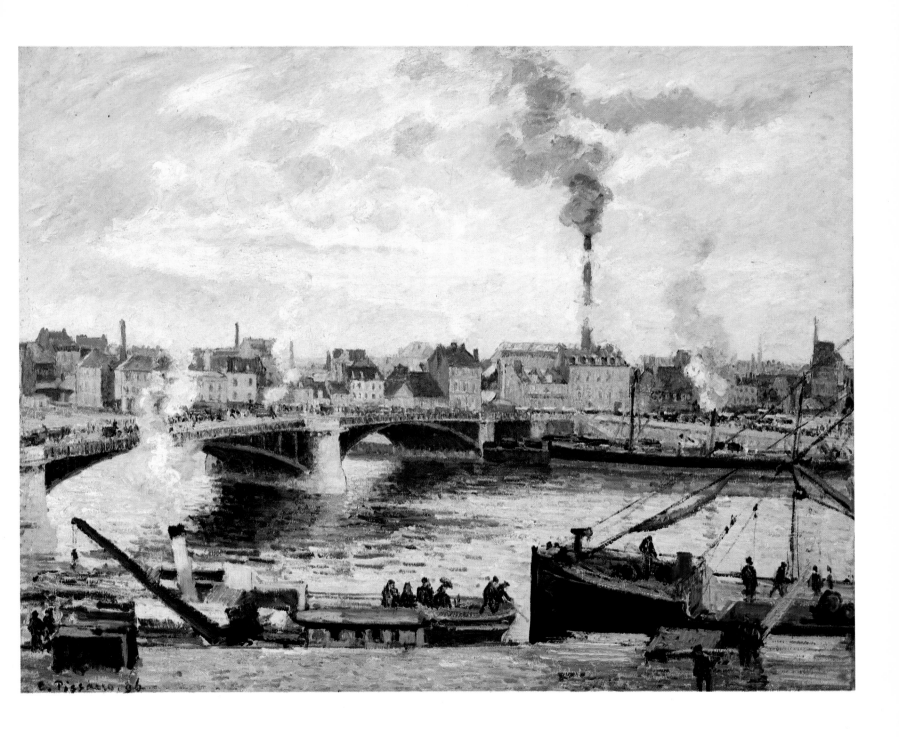

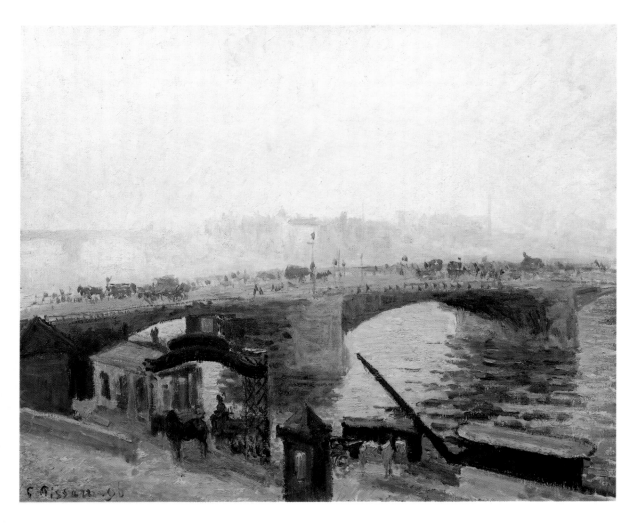

7 NOT EXHIBITED

Fog, Morning, Rouen 1896

Brouillard, matin, Rouen
P&V 951
50 × 61 cm

Private Collection

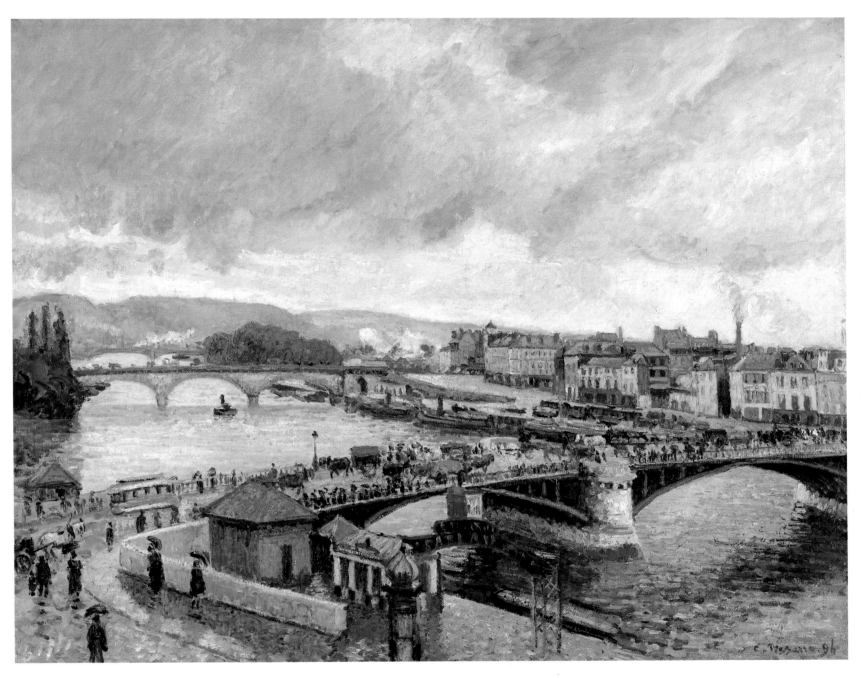

8 NOT EXHIBITED

The Pont Boïeldieu, Rouen: Rain Effect 1896

Le Pont Boïeldieu, Rouen, effet de pluie
P&V 950 (known as *Le Grand-Pont, Rouen, effet de pluie*)
73 × 92 cm

Staatliche Kunsthalle Karlsruhe

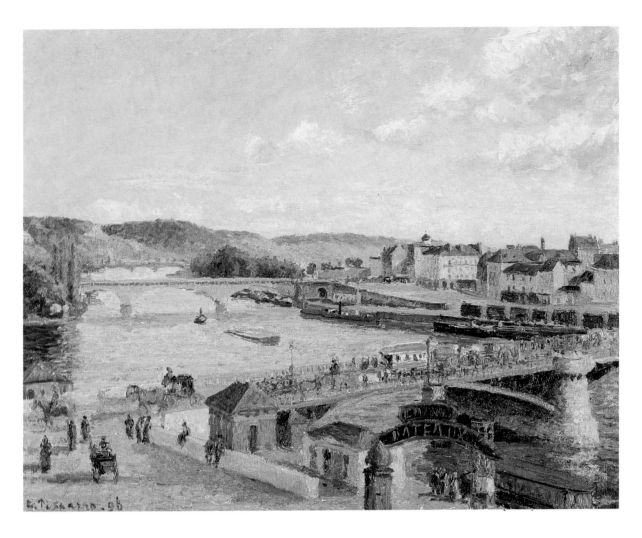

9　NOT EXHIBITED

Afternoon, Sun, Rouen　1896

Après-midi, soleil, Rouen
P&V 949
55 × 65.8 cm

Private Collection

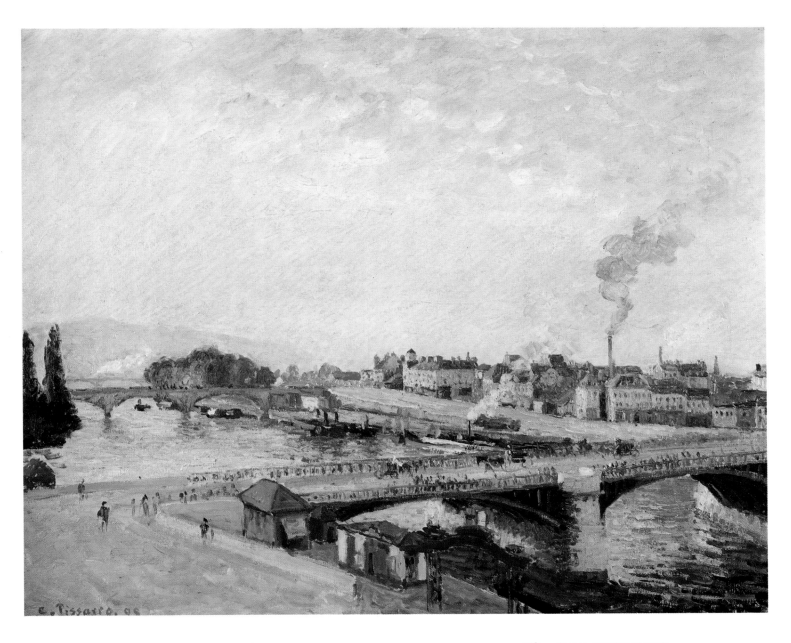

10 NOT EXHIBITED

Sunrise, Rouen 1898

Lever du soleil à Rouen
P&V 1043
65 × 81 cm

Private Collection

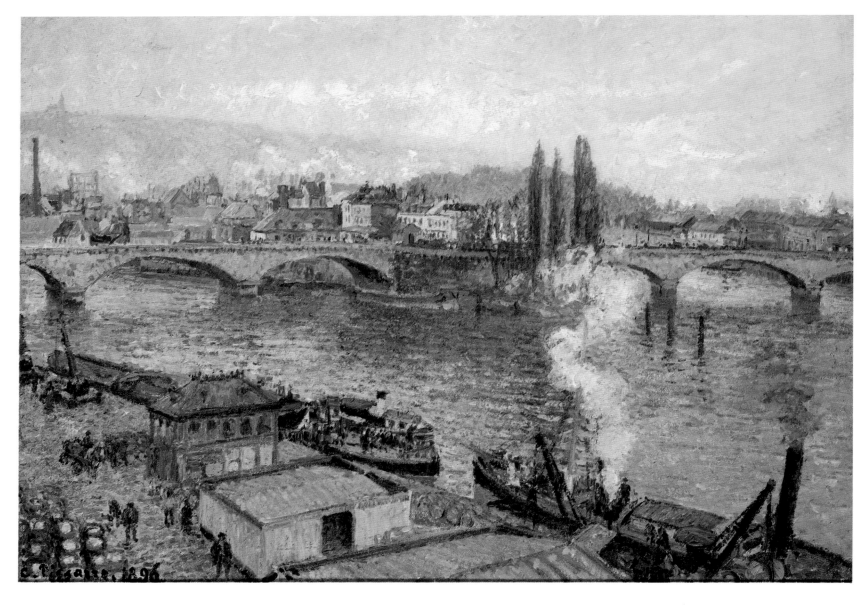

II EXHIBITED

The Pont Corneille, Rouen: Grey Weather 1896

Le Pont Corneille, Rouen, temps gris
P&V 963 (known as *Le Pont de Pierre à Rouen, temps gris*)
66.1 × 91.5 cm
Signed and dated lower left: *C. Pissarro. 1896*

National Gallery of Canada, Ottawa/Musée des beaux-arts, Ottawa

PROVENANCE Galerie Durand-Ruel, Paris 1896; transferred to Durand-Ruel Galleries, New York, 1896 (no. 1686); bought by the National Gallery of Canada, Ottawa, 1923

EXHIBITIONS Paris 1896, no. 5; New York 1897, no. 15; New York 1923, no. 5; Toronto 1926, no. 122; Ottawa 1934, no. 90; Detroit 1954, no. 53; Calgary 1957, no. 8; Memphis 1980, no. 11 (repr. col.); Vancouver 1983, p. 52 (repr. col. p. 53)

LITERATURE 'Pissaro' (*sic*), *Arts & Décoration*, vol. VII, 3 January 1917 (repr. p. 136); Dick 1928, p. 2 (repr.); Rewald 1943, p. 282; *The National Gallery of Canada: Catalogue of Paintings,* II: *Modern European Schools*, Ottawa, 1959, p. 41 (repr.); Hubbard 1962, p. 156; Boggs 1971, p. 15 (repr. fig. 48)

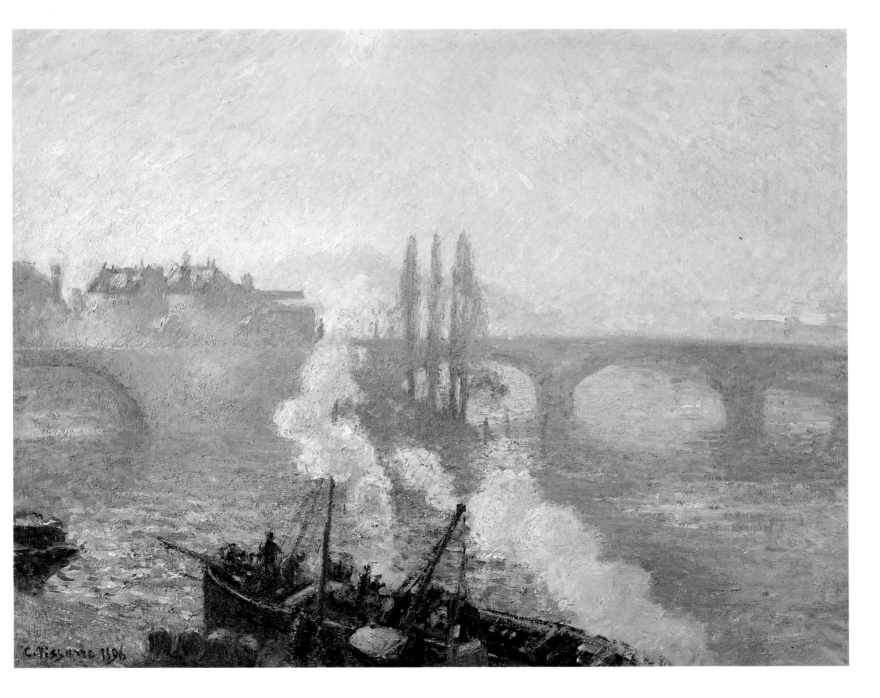

12 EXHIBITED

The Pont Corneille, Rouen: Morning Mist 1896

Le Pont Corneille, Rouen, brume du matin
P&V 961 (known as *Pont de Pierre à Rouen, brume du matin*)
72 × 93 cm
Signed and dated lower left: *C. Pissarro. 1896*

Private Collection. Courtesy of Didier
Imbert Fine Art, Paris

PROVENANCE Georges Feydeau, Paris; sale,
Collection Georges Feydeau, Paris, 9
February 1901 (76; repr.); Durand-Ruel
Galleries, New York; bought by L. L.
Coburn, 4 October 1926; Sam Salz, Inc.,
New York (no. 4528); Didier Imbert Fine
Art, Paris; Private Collection

EXHIBITIONS Paris 1896, no. 3; Paris 1904,
no. 98; Paris 1930, no. 87

LITERATURE Thornley n.d.; *Die Kunst*,
May 1930; *Prométhée*, February 1939

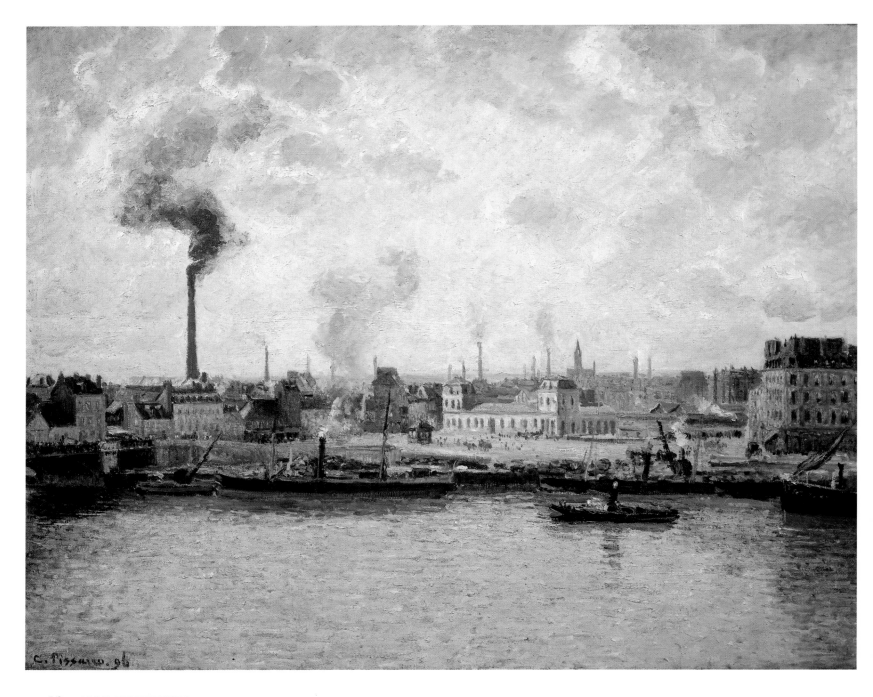

13 NOT EXHIBITED

The Saint-Sever Quay, Rouen
1896

Quai Saint-Sever à Rouen
P&V 970
73 × 92 cm

Private Collection

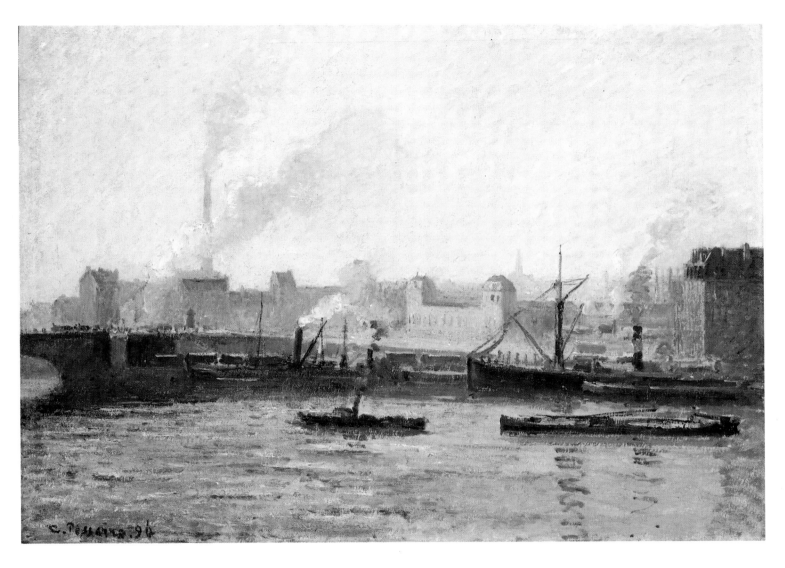

14 NOT EXHIBITED

The Pont Boïeldieu, Rouen: Fog
1896

Le Pont Boïeldieu, Rouen, brouillard
P&V 971 (known as *Le Pont de Saint-Sever à Rouen, brouillard*)
60.3 × 87 cm

North Carolina Museum of Art, Raleigh, Gift of the Wachovia Bank and Trust Company

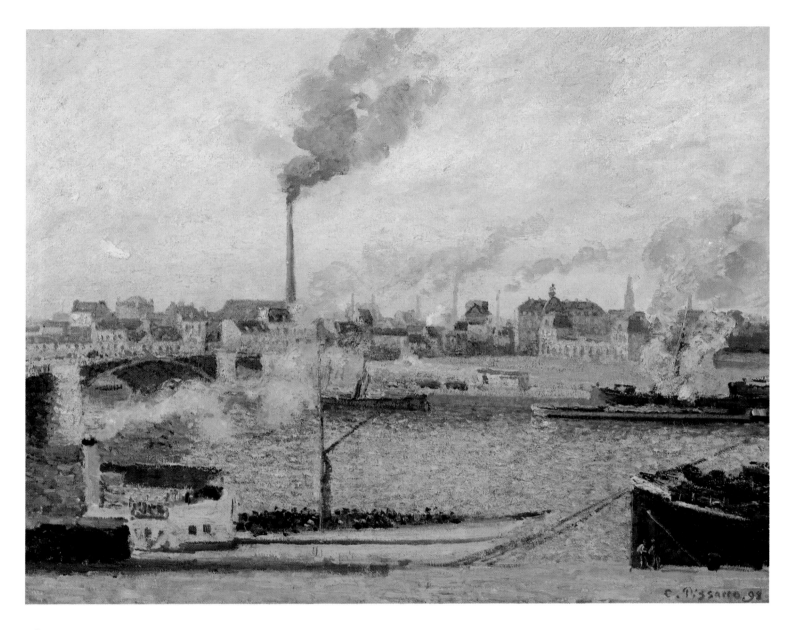

15 EXHIBITED

Saint-Sever, Rouen: Morning,
Five o'clock 1898

Saint-Sever, Rouen, matin, cinq heures
P&V 1048
65 × 81 cm
Signed and dated lower right: *C. Pissarro. 98*

Isetan, Tokyo

PROVENANCE Wildenstein & Co., New
York (no. 28200); Isetan, Tokyo

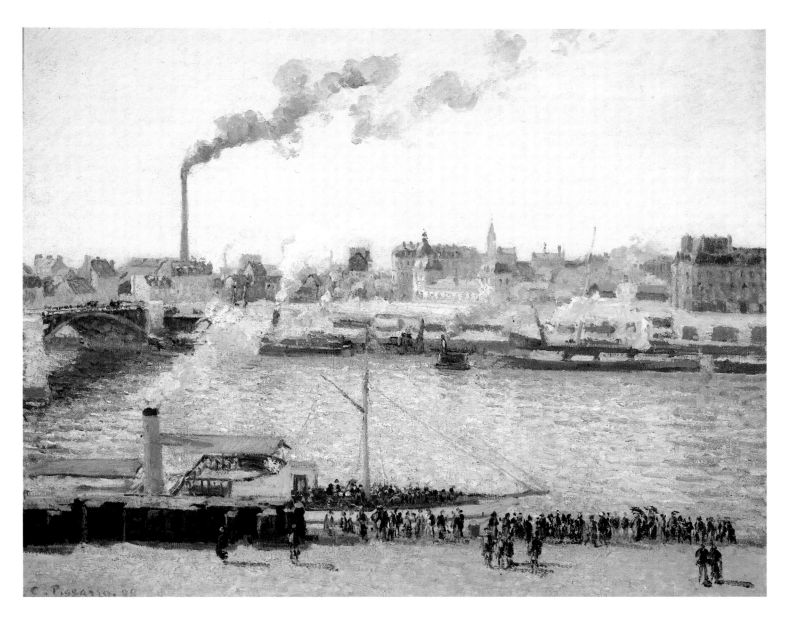

16 EXHIBITED

Rouen, Saint-Sever: Morning
1898

Rouen, Saint-Sever, le matin
P&V 1049
63.5 × 79.4 cm
Signed and dated lower left: *C. Pissarro 98*

Honolulu Academy of Arts, Gift of Mrs
Charles M. Cooke, 1934 (4110)

PROVENANCE Galerie Durand-Ruel,
Paris; Mme Freudenberg, Berlin; sale,
Galerie Georges Giroux, Brussels, 5
November 1932 (105; repr.); Paul
Rosenberg, Paris (no. 3095); Mrs Charles
M. Cooke, Honolulu; given by Mrs
Charles M. Cooke to the Honolulu
Academy of Arts, 1934

EXHIBITIONS Paris 1901, no. 1; Berlin
1901 (repr.)

LITERATURE *La Gazette de l'Hôtel
Drouot*, 27 October 1932 (repr.);
*Honolulu Academy of Arts: Catalogue of the
Collection*, Honolulu, 1937, p. 77 (repr.);
*Honolulu Academy of Arts: Academy
Album*, Honolulu, 1968, p. 55 (repr.);
Honolulu Academy of Arts: Selected Works,
Honolulu, 1990, p. 187 (repr. col. p. 187)

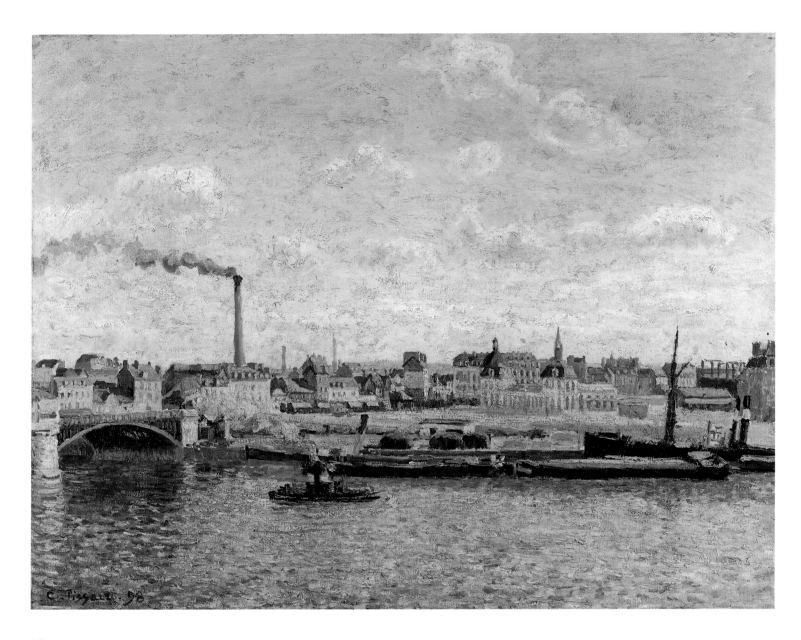

17 NOT EXHIBITED

Rouen, Saint-Sever: Afternoon
1898

Rouen, Saint-Sever, après-midi
P&V 1050
65 × 81 cm

Private Collection

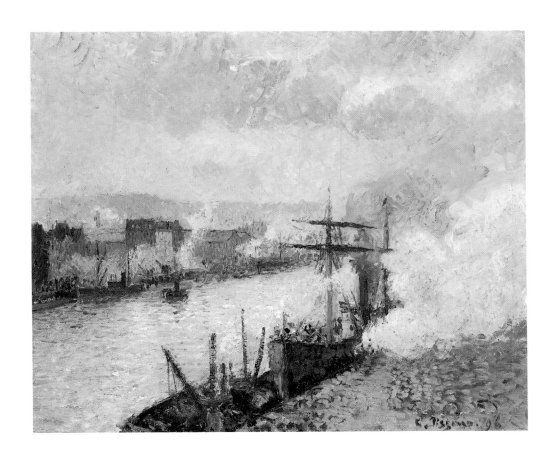

18 NOT EXHIBITED

Steamboats in the Port of Rouen
1896

Les Fumées dans le Port de Rouen
P&V 958
45.7 × 54.6 cm

The Metropolitan Museum of Art, New
York, Gift of Arthur J. Neumark, 1958

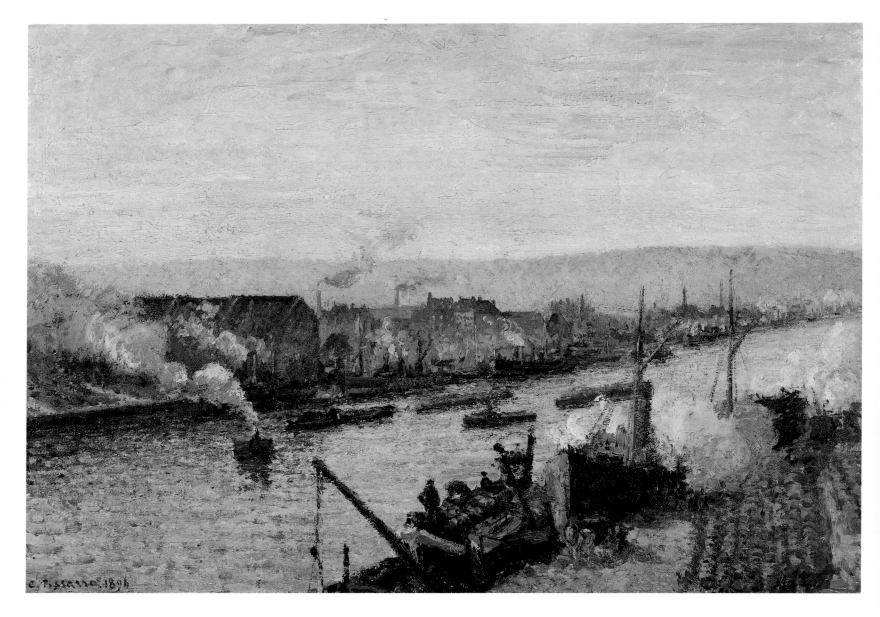

19 EXHIBITED IN LONDON

The Port of Rouen, Saint-Sever
1896

Le Port de Rouen, Saint-Sever
P&V 957
65.5 × 92 cm
Signed and dated lower left: *C. Pissarro 1896*

Musée d'Orsay, Paris

PROVENANCE Sale, Private Collection, 25 April 1901 (41; repr.); Dr Eduardo Mollard, Paris; bequeathed by Enriqueta Alsop, in the name of Dr Eduardo Mollard, to the Musée du Louvre, Galerie du Jeu de Paume, Paris, 1972; Musée d'Orsay, Paris, from 1986

EXHIBITIONS Septentrion 1980–81; Los Angeles 1984, no. 28

LITERATURE Jeu de Paume 1984, p. 122 (repr. col.); Compin 1986, vol. IV, p. 139 (repr.)

facing page: detail of cat. 19

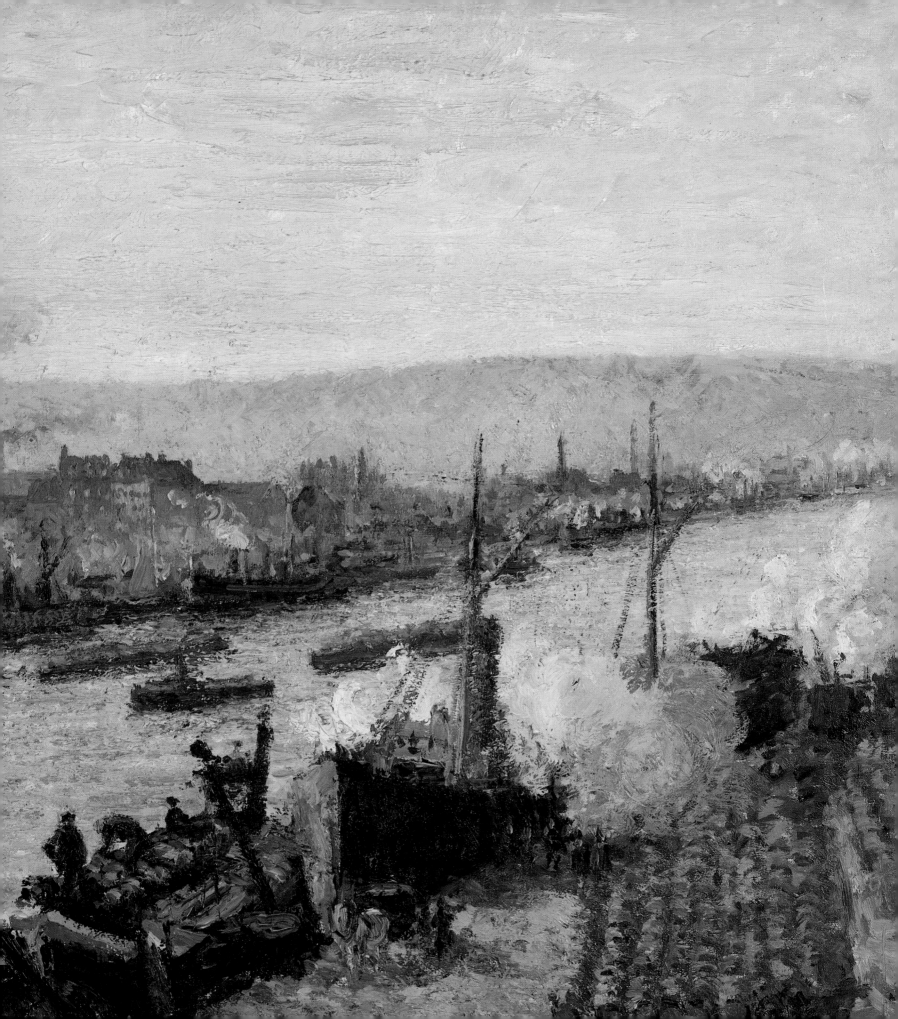

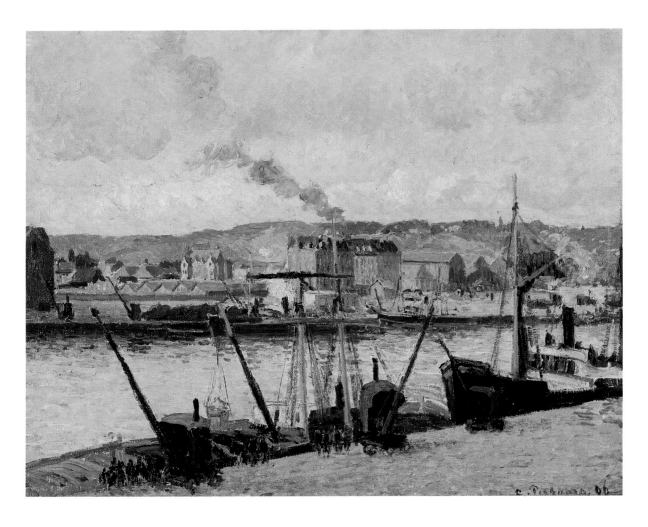

20 EXHIBITED

Morning, Rouen, the Quays
1896

Le Matin, Rouen, les quais
P&V 959
50 × 61 cm
Signed and dated lower right: *C. Pissarro. 96*

The Durand-Ruel Family Collection

PROVENANCE Offered by the artist to
Joseph Durand-Ruel (eldest son of Paul
Durand-Ruel) and Jenny Lefébure on their
marriage, 22 September 1896, accompanied
with a letter of congratulation from the artist
(reproduced on this page); deposited
successively at Durand-Ruel, Paris (no. 9134,
photo no. 3469), Durand-Ruel, New York
(no. 8048) and Durand-Ruel Paris (no.
15847); The Durand-Ruel Family Collection

LITERATURE Unpublished letter from
Pissarro to Joseph Durand-Ruel, 18
September 1896 (Durand-Ruel Family
Collection); *Les Annales Politiques et
Littéraires*, 22 November 1903 (repr.)

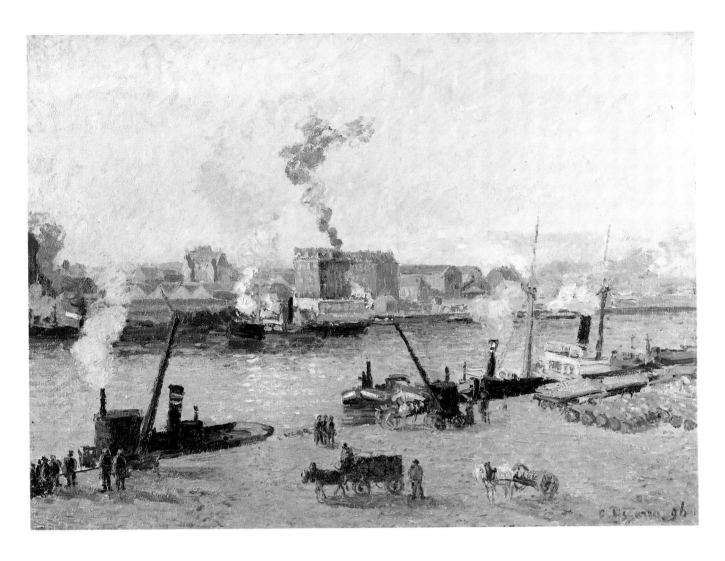

21 NOT EXHIBITED

Foggy Morning, Rouen 1896

Matin brumeux, Rouen
P&V 960
54 × 73 cm

Hunterian Art Gallery, University of
Glasgow

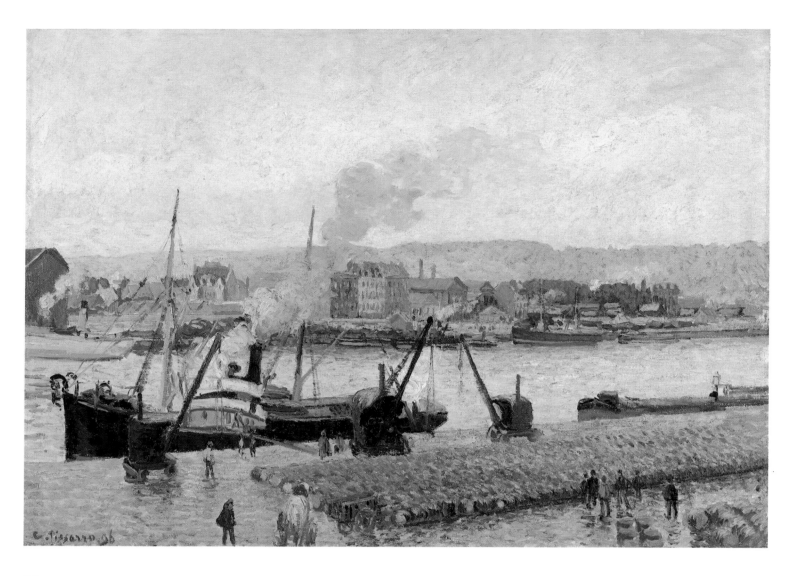

22 NOT EXHIBITED

Morning, after the Rain, Rouen
1896

Matin après la pluie, Rouen
P&V 969
60 × 82 cm

Private Collection

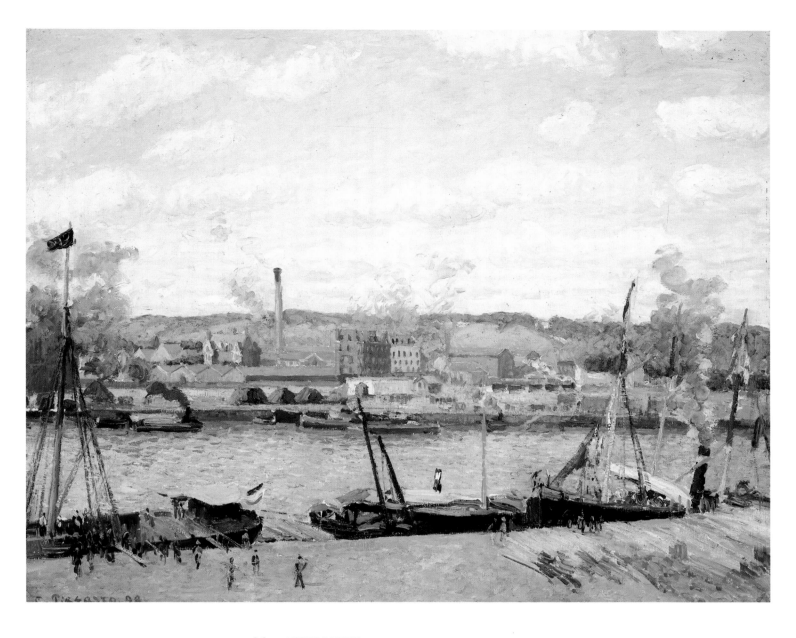

23 EXHIBITED

View of the Cotton Mill at Oissel, near Rouen 1898

Vue de la cotonnière d'Oissel, environs de Rouen
P&V 1054
65.3 × 81 cm
Signed and dated lower left: *C. Pissarro. 98*

The Montreal Museum of Fine Arts,
Purchase, John W. Tempest Funds

PROVENANCE Durand–Ruel Galleries, New York, by 1921; bought by The Montreal Museum of Fine Arts, 1921

EXHIBITIONS Toronto 1926, no. 112; Montreal 1952, p. 26, no. 51 (repr.); Toronto 1954, p. 20, no. 59; Ottawa 1962, no. 21; Hamilton 1964, no. 24; New York 1965, no. 145 (repr. pl. 70); Montreal 1966, p. 29 (repr. pl. 70); Montreal 1970; Ottawa 1975

LITERATURE *The Montreal Museum of Fine Arts: Paintings, Sculpture, Decorative Arts*, Montreal, 1960, p. 115 (repr.); Steegman 1960, p. 97, no. 145; Hubbard 1962, pp. xxvi, 156; Lefebvre 1970, pp. 11, 24 (repr.); Bourget 1974, pl. 77; Lamarche, 1991, no. 45, (repr. col. p. 45)

24 NOT EXHIBITED

Quay in Rouen: Sunset 1896

Quai à Rouen, soleil couchant
P&V 946
45 × 55 cm

Private Collection, Japan

facing page: detail of ill. 24

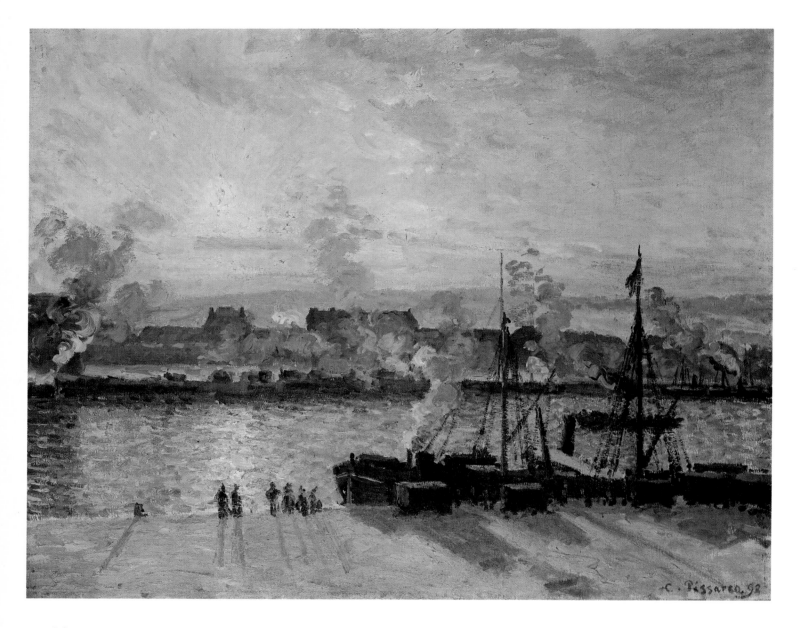

25 EXHIBITED IN LONDON

Sunset, the Port of Rouen (Steamboats) 1898

Soleil couchant, Port de Rouen (fumées)
P&V 1039
65 × 81 cm
Signed and dated lower right: *C. Pissarro 98*

National Museum of Wales, Cardiff

PROVENANCE Leicester Galleries, London, by 1920; bought by Margaret Davies, June 1920; bequeathed by Margaret Davies to the National Museum of Wales

EXHIBITIONS Paris 1914, no. 32; London 1920, no. 90; Aberystwyth 1945, no. 10; Aberystwyth 1946, no. 66; Aberystwyth 1948, no. 49; Aberystwyth 1951, no. 48; London 1979, no. 19; Paris 1979, no. 16; Swansea 1980, no. 2; London 1980–81, no. 83; Sogo 1986, no. 45; Birmingham 1990, no. 82

LITERATURE *National Museum of Wales: Catalogue of the Margaret S. Davies Bequest: paintings, drawings and sculpture*, Cardiff, 1963, no. 101, p. 35; Ingamells 1967, pp. 72–73, pl. 27; Ingamells 1968, pl. 12; Brayer, 1979, p. 28; Lloyd 1981, p. 128; Hughes 1982, no. 43, p. 34

facing page: detail of cat. 25

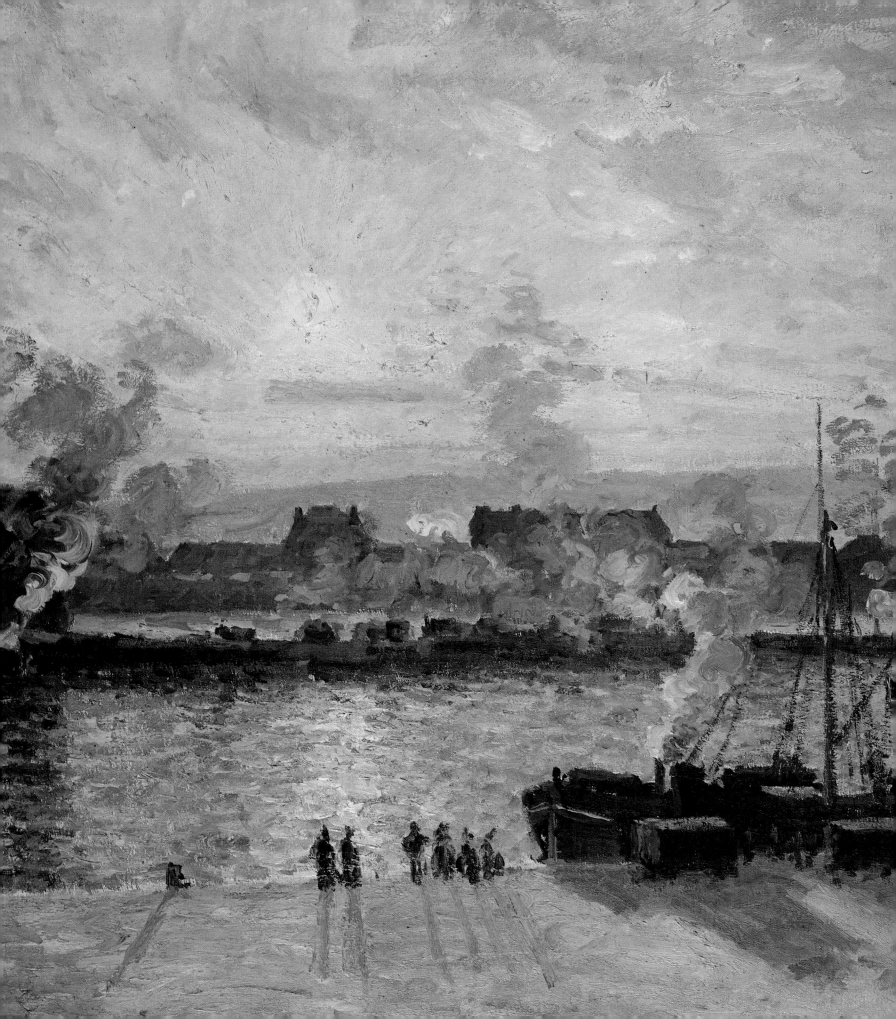

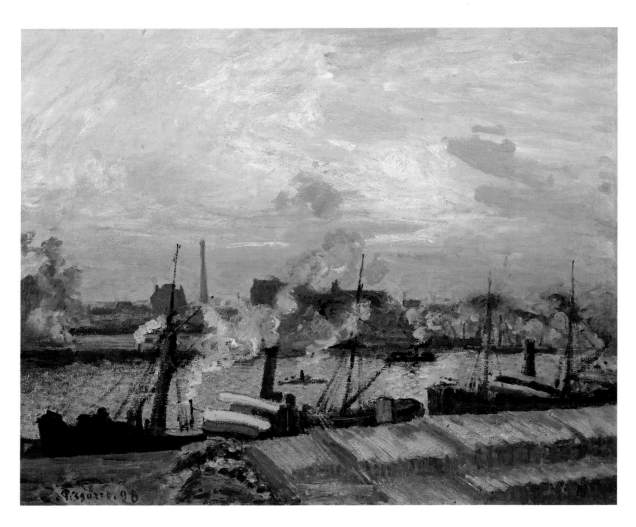

26 NOT EXHIBITED

Boats, Sunset, Rouen 1898

Bateaux, coucher de soleil, Rouen
P&V 1042
54 × 66 cm

Private Collection

facing page: detail of ill. 26

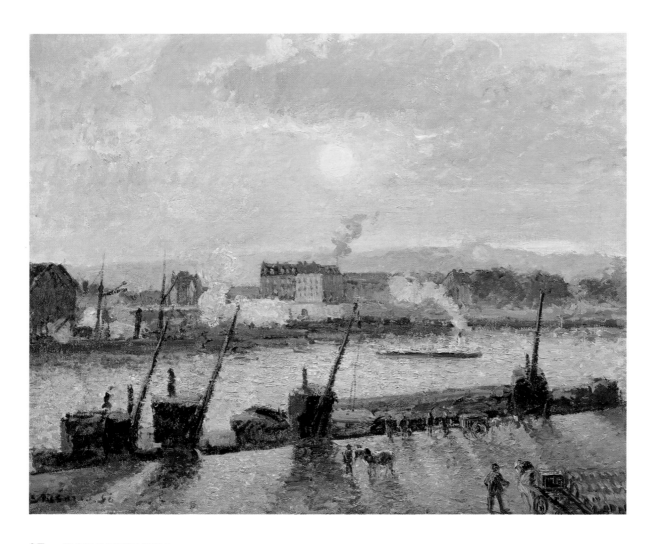

27 NOT EXHIBITED

Sunset, Rouen 1898

Soleil couchant à Rouen
P&V 1053
54 × 65 cm

Private Collection

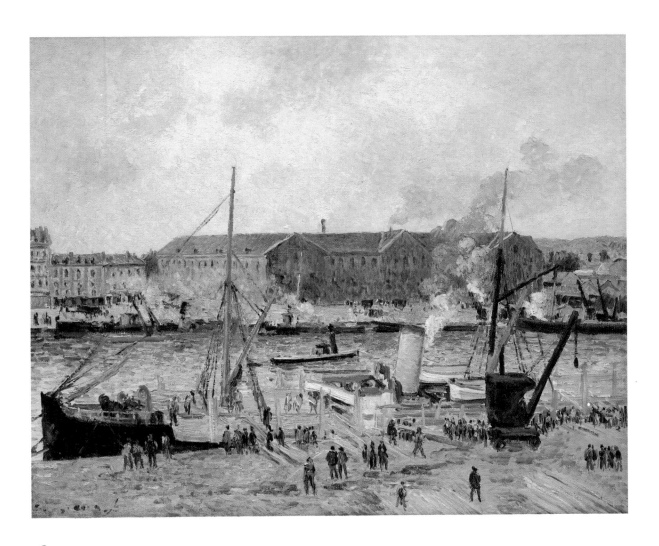

28 NOT EXHIBITED
Unloading Wood, Rouen 1896

Déchargement de bois à Rouen
P&V 968
54 × 65.5 cm

Private Collection, California

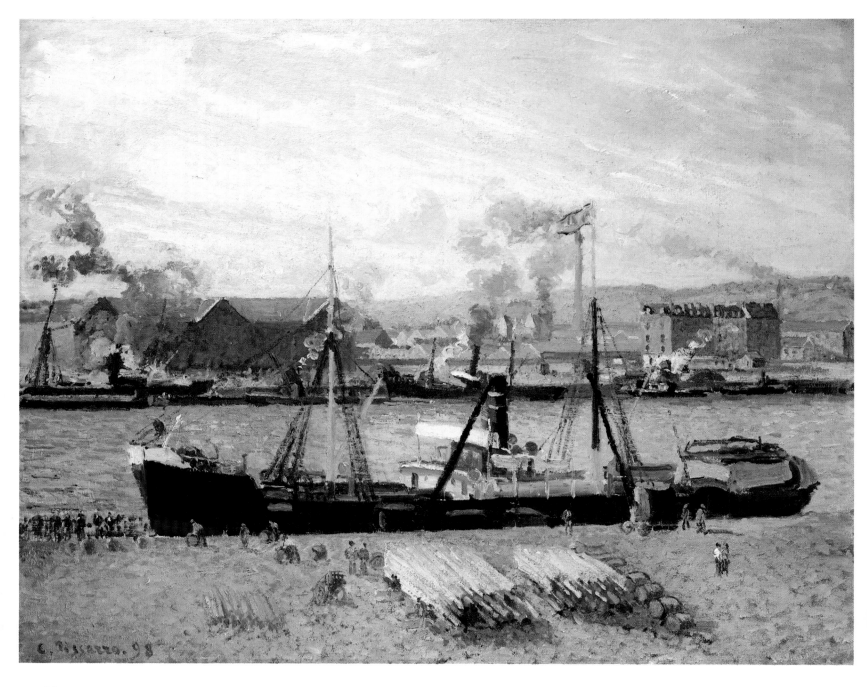

29 EXHIBITED

The Port of Rouen: Unloading Wood 1898

Port de Rouen, déchargement de bois
Non-P&V
73 × 92.1 cm
Signed and dated lower left: *C. Pissarro. 98*

Sterling and Francine Clark Art Institute,
Williamstown, Massachusetts

PROVENANCE Celina Pineyro de Alzaga,
*c.*1903; by descent to Orlando and Enrique
Williams Alzaga; Alex Reid & Lefevre,
London, 1989; Sterling and Francine Clark
Art Institute, Williamstown, Massachusetts

EXHIBITIONS Buenos Aires 1962, no. 53

LITERATURE 'Chronique des arts:
principales acquisitions des musées en 1989',
Gazette des Beaux-Arts, March 1990, p. 59

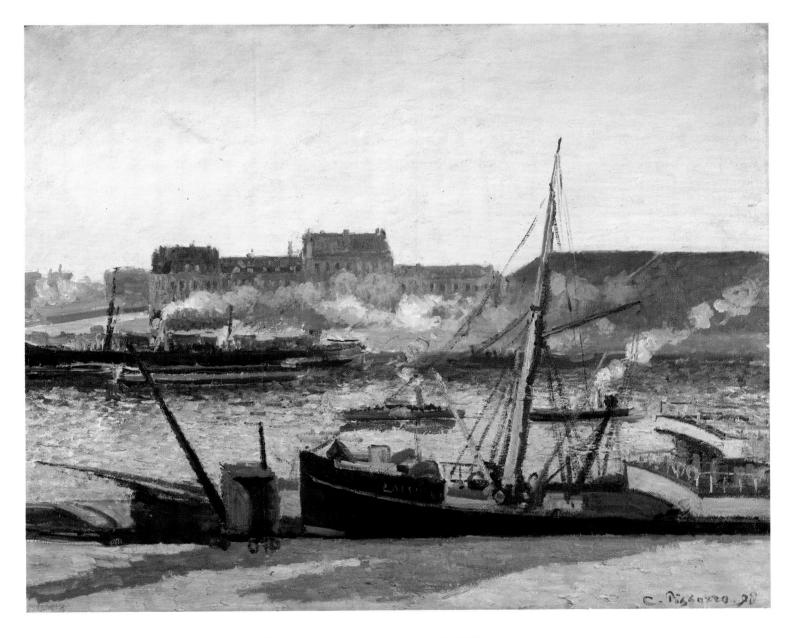

30 EXHIBITED IN DALLAS AND PHILADELPHIA

The Docks, Rouen: Afternoon
1898

Les Docks de Rouen, après-midi
P&V 1047
65 × 81 cm
Signed and dated lower right: *C. Pissarro 98*

Private Collection

PROVENANCE Collection Durand-Ruel, Paris (no. 4783); bought from Dr Fritz Nathan, St Gallen, Zurich, by a private collector, before 1946

EXHIBITIONS Paris 1899(ii), no. 68; Paris 1901, no. 4; Bern 1953, no. 112 (repr.); Winterthur 1955, no. 159; Bern 1957, no. 100; Paris 1959, no. 111; Lausanne 1964, no. 55 (repr.)

LITERATURE Nathan 1946 (repr. p. 37); Daulte 1957, p. 994; Nathan 1961 (repr. p. 32); Kunstler 1967, no. 19

The Roofs of Old Rouen: Grey Weather (the Cathedral) 1896

Les Toits du Vieux Rouen, temps gris (la Cathédrale)
P&V 973
72.3 × 91.4 cm
Signed and dated lower right: *C. Pissarro. 1896*

The Toledo Museum of Art; Purchased with funds from the Libbey Endowment, Gift of Edward Drummond Libbey

PROVENANCE Pissarro estate (inv. no. 125 on stretcher and back of canvas); Galerie Durand-Ruel, Paris; Dr Hans Ullstein, Berlin; Dr and Mrs (née Ullstein) Heinz Pinner; consigned by Frank Perls Gallery, New York, to Knoedler & Co., New York, June 1951 (CA 3887); bought by The Toledo Museum of Art, July 1951

EXHIBITIONS Paris 1896, no. 21; Pittsburgh 1898, no. 46; Toledo 1905, no. 83; Paris 1914, no. 13; New York 1965, no. 64 (repr.); Memphis 1980, no. 8 (p. 24, repr. col. p. 40); London 1980–81, no. 77 (p. 139, repr. p. 140); Pittsburgh 1989, no. 66 (p. 154, repr. col.)

LITERATURE Mourey 1903, p. 40 (repr.); Lecomte 1922, p. 84 (repr.); Mauclair 1923 p. 192 (repr.); Tabarant 1924, (repr. pl. 33); Koenig 1927 (repr.); Waldmann 1927, (repr. p. 460); Rewald 1943, pp. 283–88 (repr. pl. 69); Bazin, 1947 (repr. pl. 38); *Arts Magazine*, vol. XXXVIII, no. 5, February 1963 (book review by John Rewald), p. 66; Rewald 1963, pp. 43, 144 (repr. p. 145); Nochlin 1965, p. 61 (repr. p. 25); *The Toledo Museum of Art: A Guide to the Collections*, Toledo, 1966 (repr.); Lee 1969, p. 69, (repr. p. 68); Tokyo 1972, p. 115 (repr. col. pl. 26); *The Toledo Museum of Arts: European Paintings*, Toledo, 1976, pp. 127–28 (repr. pl. 249); Shikes 1980, pp. 293–94 (repr.); Ravin 1981, p. 21 (repr.); 'The height of devotion', *The Sciences*, vol. XXI, no. 9 (repr. p. 15); Ravin 1984, p. 56 (repr.); Lloyd, 1986, p. 10 (repr. fig. 9); Eitner 1988, vol. I, p. 415, vol. II, repr. p. 221

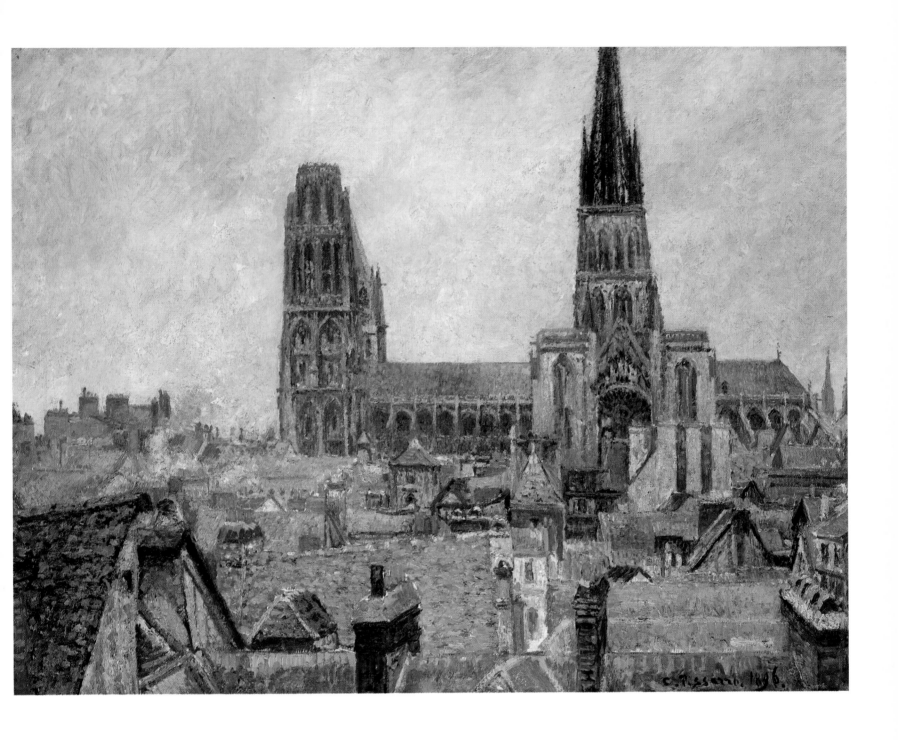

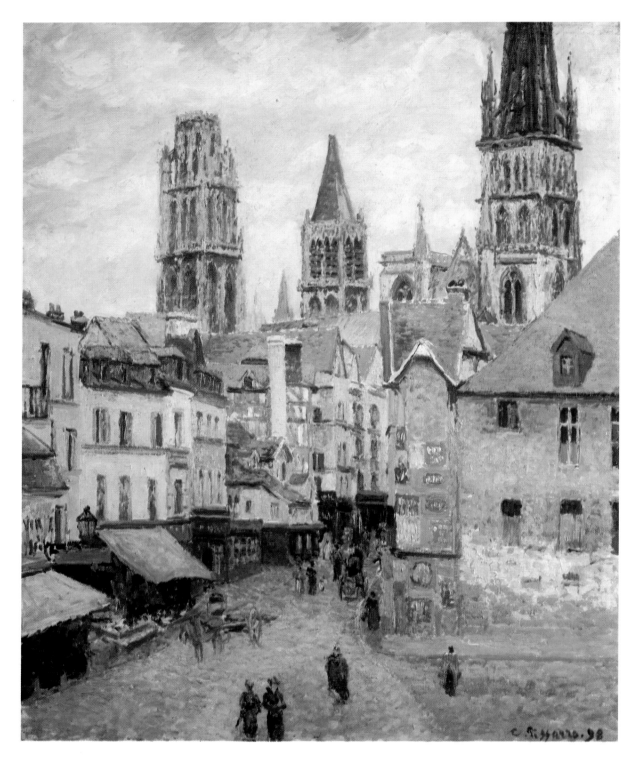

32 NOT EXHIBITED

Rue de l'Epicerie, Rouen:
Morning, Grey Weather 1898

La Rue de l'Epicerie à Rouen, matin, temps gris

P&V 1037
81 × 65 cm

Location unknown

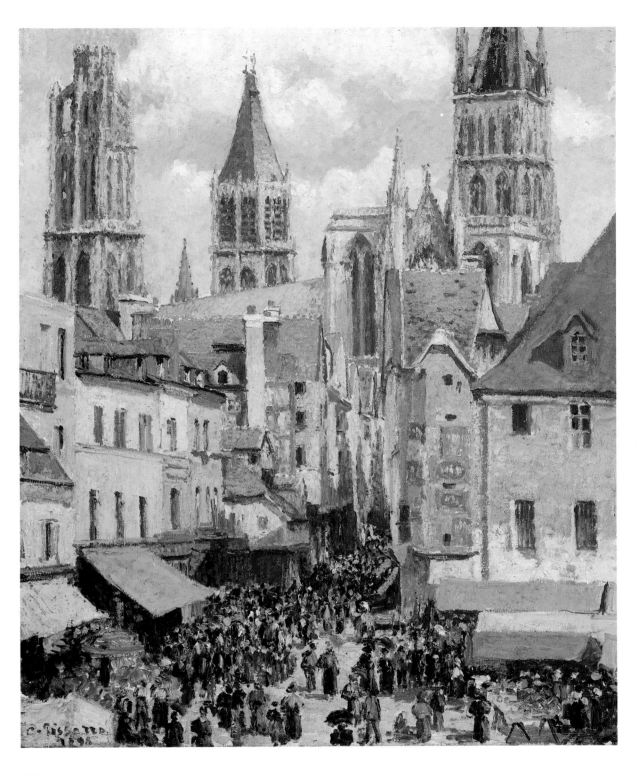

33 NOT EXHIBITED

Rue de l'Epicerie, Rouen 1898

La Rue de l'Epicerie, Rouen
P&V 1036
81.3 × 65.1 cm

The Metropolitan Museum of Art, New
York, Purchase, Mr and Mrs Richard J.
Bernhard Gift, 1960

Sunny Afternoon, Rue de l'Epicerie, Rouen 1898

L'Après-midi, soleil, la Rue de l'Epicerie à Rouen
P&V 1038 (known as *La Rue de l'Epicerie à Rouen*)
81 × 65 cm
Signed and dated lower right: *C. Pissarro 98*

Private Collection, The Netherlands

PROVENANCE F. Moch, Paris; Robert Kahn-Sriber, Paris; sale, Sotheby's, London, 1 July 1975 (6); British Rail Pension Fund; sale, Sotheby's, London, 4 April 1989 (14); Private Collection, The Netherlands

EXHIBITIONS Leeds Castle, Kent, 1977–88 (on loan); London 1980–81, no. 82 (repr.); London 1984, no. 22 (repr.); Den Bosch 1990, p. 168, no. 62 (repr.)

LITERATURE Thornley n.d.; Duret 1906, p. 55 (repr.); Fontainas 1922, p. 167 (repr.); *Letters* 1943, p. 329

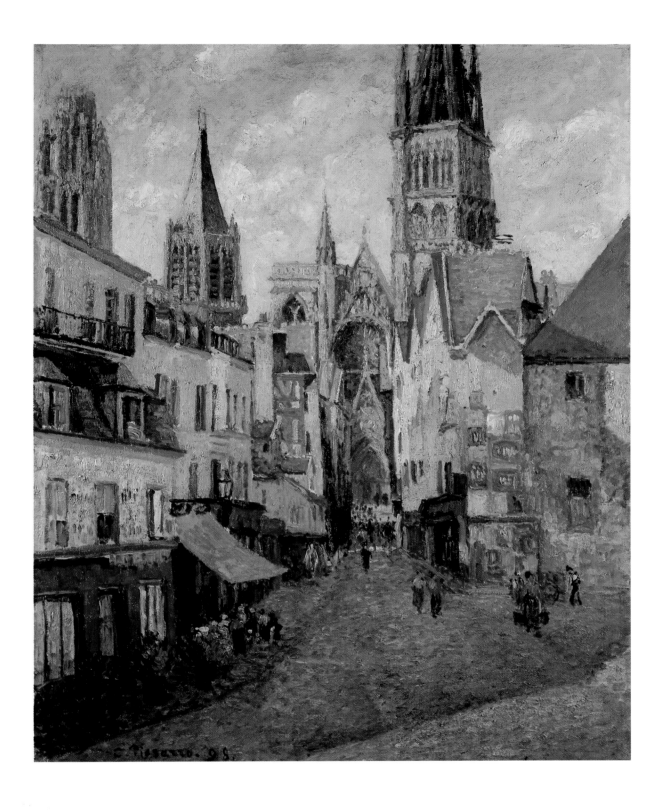

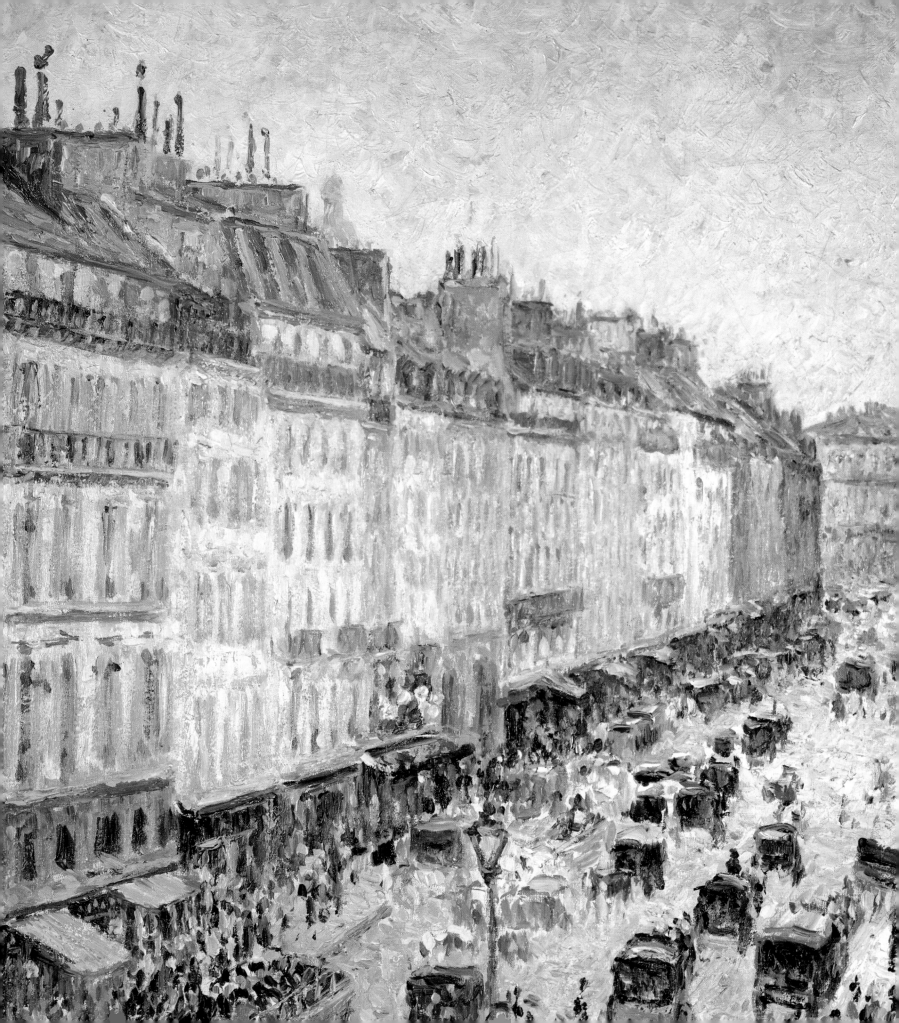

2 PARIS: THE GARE SAINT-LAZARE

'He then became finally what he had been only intermittently: a landscape painter of towns'.[1]

The ten paintings in this group represent the neighbourhood of the Gare Saint-Lazare and were made in 1893 and 1897. The four paintings of 1893, executed from the window of the Hôtel/Restaurant Garnier, where Pissarro stayed intermittently between November 1892 and March 1893, constitute the first series of Paris views. If one excepts the Rouen views of 1883, this group may also be considered to be Pissarro's first attempt at painting a series of cityscapes. It is difficult to know why Pissarro did not venture to execute a larger series, but one explanation may be that, in keeping with their experimental nature, these first Paris views lack some of the audacity and mastery of technique that would be evident in his series paintings only three or four years later. Indeed, it was not until 1896, in Rouen, that Pissarro could be seen to be launching wholeheartedly into serial work (see above, p. 4), and it was not until 1897 that he grappled with the Paris Boulevards serially.

The two groups of works from 1893 and 1897 (disregarding their titles in the *catalogue raisonné*, which are sometimes misleading) represent three motifs, the main one being the Rue Saint-Lazare, which runs eastward along the façade of the Gare Saint-Lazare and crosses the Rue d'Amsterdam. The second motif is the Rue d'Amsterdam itself, and the third is the intersection between these two streets at the Place du Havre (and the Cour du Havre in its prolongation, in front of the eastern wing of the Gare Saint-Lazare).

These three sets of motifs were organised on four different formats of canvas: 20F (73 × 60 cm), 8F (38 × 46 cm) – the two formats used in 1893; 6F (33 × 41 cm) and 5F (35 × 27 cm) – the two formats used in 1897. The whole series, for the sake of clarity, can be reassembled according to motifs, formats and years, and is given in Table 4 in the Appendix.

What becomes apparent from considering the two groups of paintings from 1893 and 1897 *together* is that the problems that arise when one considers them separately are reversed. Taking each group on its own, although there seems to be a consistency in the use of formats, this is offset by considerable fragmentation of the viewpoints. Looking at the two groups together, however, while consistency between the formats is no longer obvious, consistency between the viewpoints is gained, and the harmony of the total series is more readily evident. Each composition falls into one of the three sets of motifs outlined above, and what links these categories is the vertical and horizontal compositions.

The most noticeable difference between the four paintings of 1893 and the six paintings of 1897 is the size: the formats of 1893 are almost twice the size of those of 1897. Another distinctive feature is that the smallest paintings made in 1893 (*Cour du Havre (Gare Saint-Lazare)* (ill. 40) and *Place Saint-Lazare* (ill. 41), both 38 × 46 cm) are larger than the largest painting done in 1897 (*Place du Havre, Paris: Rain Effect* (ill. 42), 33 × 41 cm). This variation in size offers one way of expressing the fragmentation of external reality – other means employed by Pissarro being the passage of time, changes in weather conditions, movements of people and traffic. These variables are used by the artist again and again to illustrate his belief that the representation of external reality as a definable, closed, firmly controlled totality is no longer achievable; it is, in fact, in process of disintegration. Thus – and this is the main paradox of this series – Pissarro's first Paris paintings remain more than any others, unfinished, open, incapable of completion. The series manifests at its core the transience of everyday reality in its urban context.

This is indeed what is demonstrated in an

1 G. Geffroy, article in *La Dépêche de Toulouse*, 20 November 1903, cited in Bailly-Herzberg 1989, p. 386: 'Il devint donc définitivement ce qu'il n'avait été que par intermittence: une paysagiste de ville'.

facing page: detail of cat. 35

article by Robert de la Villehervé, who was probably the last journalist to interview Pissarro, only a few weeks before his death.[2] This account of Pissarro's last weeks of work, evoking the tenacity, as well as the circularity, of the artist's working methods as he was finishing the Le Havre series and had just completed the Square du Vert-Galant series (see below, pp. 123–45), indicates that his thoughts were turned once again to his first series of 1893/97. The text deserves full quotation:

[Camille Pissarro] was about to move house in the month of October, leaving his flat on the Place Dauphine, where, for three years, he had successfully completed his famous series of the Pont-Neuf, the Pont des Arts and the statue of Henri IV. His plan was to set himself up on the Boulevard Morland, where he would have done a series of the Panthéon. However, the apartment that he had chosen was not available, and he temporarily took lodgings at the Hôtel Garnier on the Rue Saint-Lazare, thinking that from there he could execute a new series of this Place du Havre, which kept him entertained with its continual hubbub of carriages and people, and to which he was already indebted for some delightful canvases.

Unfortunately, Pissarro died of an abscess in the prostate, and the resumption of his first Paris series never took place: the circle remained open; the paradox was never resolved; the very small paintings of 1897 succeeded the much larger paintings of 1893, inverting the traditional order of things in painting: from small to large, from sketch to finish.

2 Cited in Bailly-Herzberg 1989, p. 370: '[Camille Pissarro] devait déménager au mois d'octobre, quitter son appartement de la place Dauphine où, pendant trois ans, il avait mené à bien ses célèbres séries du Pont Neuf, du Pont des Arts et de la Statue de Henri IV. Son projet était de s'installer boulevard Morland, d'où il aurait fait une série du Panthéon. Mais l'appartement qu'il avait choisi n'était pas libre, et provisoirement il avait pris gîte à l'Hôtel Garnier, rue Saint-Lazare, pensant y exécuter une nouvelle série de vues de cette place du Havre, qui l'amusait de son continuel tohu-bohu de voitures et de gens, et à laquelle il était redevable déjà de toiles exquises.'

35 EXHIBITED
Rue Saint-Lazare 1893

La Rue Saint-Lazare
P&V 836
73 × 60 cm
Signed and dated lower left: *C. Pissarro. 93*

Private Collection

PROVENANCE Bought from the artist by
Galerie Durand-Ruel, Paris, 17 March 1893;
Durand-Ruel Galleries, New York,
December 1893; bought by A. W. Kingman,
New York, 20 January 1894; bought by
Durand-Ruel Galleries, New York, 5 March
1896; bought by A. Filmore Hyde,
Morristown, New Jersey, 10 May 1904;
Acquavella Galleries, New York; Private
Collection

EXHIBITIONS Paris 1893, no. 41;
Maastricht 1983, no. 23 (repr. col.); London
1983, no. 23 (repr. col.)

LITERATURE Bailly-Herzberg 1988,
pp. 312, 315, 317, 318, 387

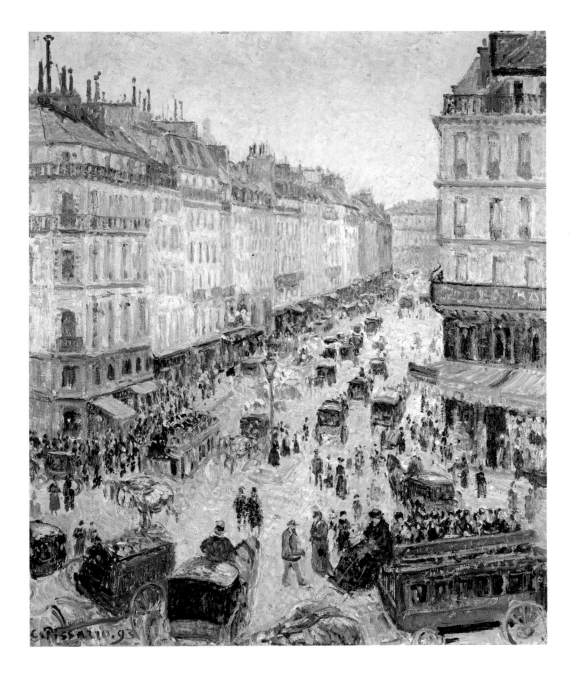

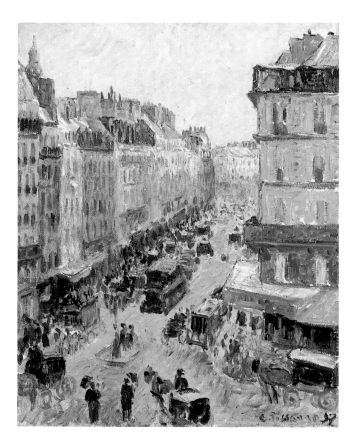

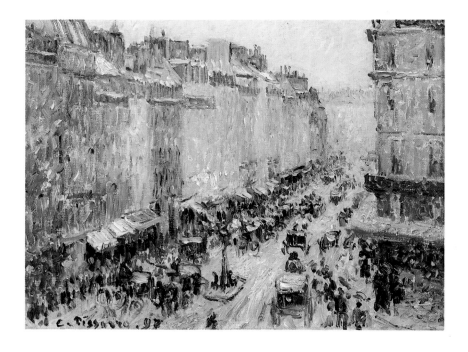

36 NOT EXHIBITED

Rue Saint-Lazare 1897

La Rue Saint-Lazare
P&V 981
35 × 27 cm

The Ordrupgaard Collection, Copenhagen

37 NOT EXHIBITED

Rue Saint-Lazare under Snow
1897

Rue Saint-Lazare sous la neige
Non-P&V
27 × 35 cm

Private Collection

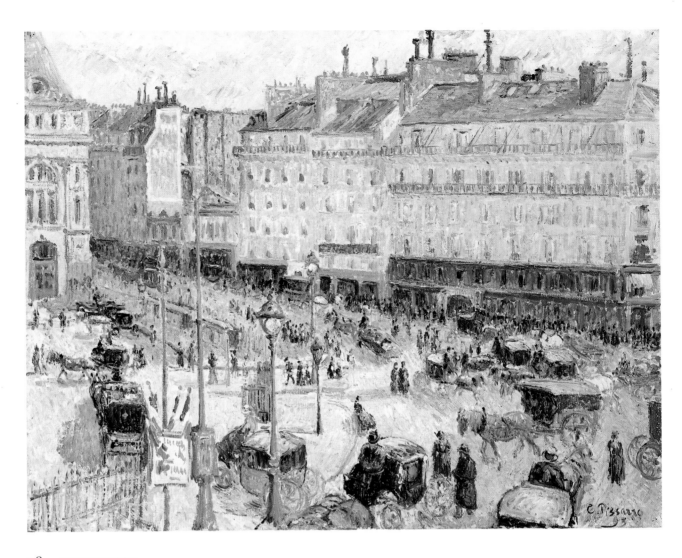

38 EXHIBITED

Place du Havre, Paris 1893

Place du Havre, Paris
P&V 838
60.1 × 73.5 cm
Signed and dated lower right: *C. Pissarro/93*

The Art Institute of Chicago, Potter Palmer
Collection

PROVENANCE Galerie Durand-Ruel, Paris;
Durand-Ruel Galleries, New York; Potter
Palmer Collection, Chicago; presented by
Mrs Potter Palmer to the Art Institute of
Chicago, 1922

EXHIBITIONS Paris 1893, no. 40; Chicago
1933, no. 3; Chicago 1946, no. 5; Chicago
1953; Albi 1980, no. 25 (repr.); London
1980–81, no. 73 (repr.); Los Angeles 1984–85,
no. 34 (repr.); Tokyo 1985–86, no. 62 (repr.)

LITERATURE Slocombe 1938, pp. 19–28
(repr. p. 23); Evans 1939, p. 99 (repr. detail);
Daniels 1939, pp. 98–102, 135 (repr. p. 99);
Coe 1954, p. 95 (repr.); *Paintings in The Art
Institute of Chicago*, Chicago, 1961, p. 359;
Maxon 1970, p. 98 (repr.); Lloyd 1982, p. 62
(repr.); Brettell 1987, p. 113 (repr.); Bailly-
Herzberg 1988, pp. 312, 315, 387

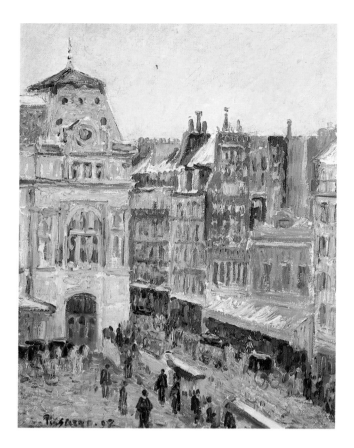

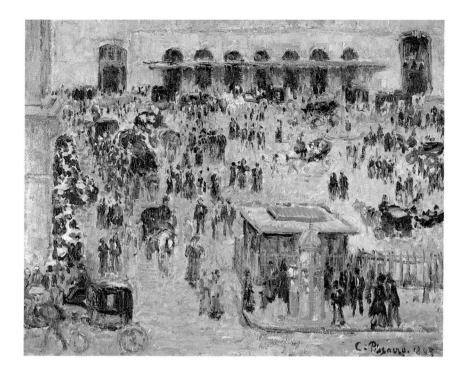

39 NOT EXHIBITED

View of Paris, Rue d'Amsterdam
1897

Vue de Paris, Rue d'Amsterdam
P&V 984
35 × 27 cm

Private Collection

40 NOT EXHIBITED

Cour du Havre (Gare Saint-Lazare) 1893

Cour du Havre (Gare Saint-Lazare)
P&V 839
38 × 46 cm

Private Collection

Place Saint-Lazare 1893

Place Saint-Lazare
P&V 837
38 × 46 cm

Private Collection

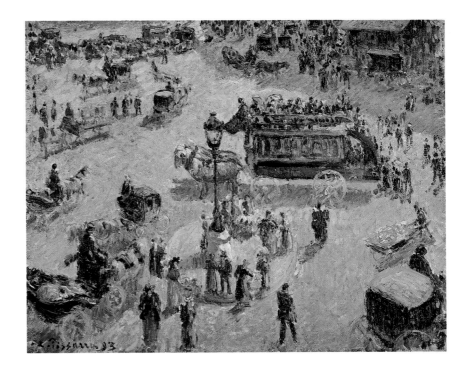

*Place du Havre, Paris: Rain
Effect* 1897

Place du Havre, Paris, effet de pluie
P&V 982
33 × 41 cm

Private Collection

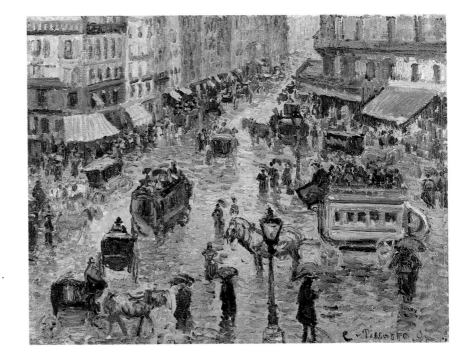

3 PARIS: THE BOULEVARD MONTMARTRE PERSPECTIVE, ROWS AND COLUMNS

1 Bailly-Herzberg 1989, p. 321 (Paris, 3 February 1897; to Lucien Pissarro): 'des effets de neige des rues Saint-Lazare et Amsterdam'.

2 Pissarro sold all six, as a group, to Paul Durand-Ruel.

3 Bailly-Herzberg 1989, p. 323 (Eragny par Gisors, 8 February 1897; to Georges Pissarro): 'pour commencer une série de Paris.'

4 Bailly-Herzberg 1989, p. 323 (Eragny par Gisor, 8 February 1897; to Georges Pissarro): 'Je retourne à Paris le 10 de ce mois, après demain, pour commencer une série de Paris. J'ai arrêté une chambre au Grand Hôtel de Russie, 1 rue Drouot à partir du 10, j'espère y faire une dizaine de toiles. Les petites que j'ai faites ont plu beaucoup à Durand, il m'a conseillé d'en faire des boulevards, mais grandes bien entendu.'

5 Bailly-Herzberg 1989, p. 324 (Eragny-Bazincourt par Gisors, 8 February 1897; to Lucien Pissarro): 'Je vois toute l'enfilade des boulevards jusqu'à la porte Saint-Denis presque, dans tous les cas jusqu'au boulevard Bonne-Nouvelle.'

6 Bailly-Herzberg 1989, 325 (Paris, 13 February 1897; to Georges Pissarro): 'j'ai commencé ma série des *Boulevards*, j'ai un motif épatant qu'il va falloir interpréter par tous les effets possibles, à ma gauche, j'ai un autre motif mais qui est terriblement difficile, c'est presque à vol d'oiseau, des voitures, des omnibus, des personnages entre de grands arbres, de grandes maisons qu'il faut mettre d'aplomb, c'est roide! . . . il n'y a pas à dire, il faut que je m'en tire quand même.'

7 Bailly-Herzberg 1989, p. 347 (Paris, 17 April 1897; to Lucien Pissarro): 'Je fais mes paquets pour expédier mes seize Toiles à Eragny'.

8 Bailly-Herzberg 1989, p. 347 (Paris, 17 April 1897; to Lucien Pissarro): 'Je vais aller à la recherche d'un endroit pour travailler cet automne aux quais, peut-être près du jardin du Luxembourg.'

facing page: detail of cat. 43

At the beginning of February 1897, having completed and sold his six small canvases representing 'snow effects on the Rues Saint-Lazare and Amsterdam',[1] which 'paid for his monthly expenses',[2] Pissarro returned to Eragny. These six paintings not only paid for his expenses, they paved the way for further series works: within days Pissarro was back in Paris 'to begin a series of Paris'.[3] This was the group that would begin with *Boulevard Montmartre: Foggy Morning* (cat. 43) and end with *Boulevard des Italiens: Morning, Sunlight* (ill. 57). Durand-Ruel had been seduced by the earlier group of six canvases and encouraged Pissarro to pursue this course, this time using larger formats and focusing on the boulevards rather than the intersection of streets in front of the Gare Saint-Lazare: 'I am returning to Paris on the tenth of this month, the day after tomorrow, to begin a series of Paris. I have booked a room in the Grand Hôtel de Russie, 1 Rue Drouot as from the tenth and I hope to paint about ten canvases there. Durand was very pleased with the small ones that I did – he advised me to do the boulevards, but larger of course.'[4]

The Boulevard Montmartre series constitutes the first fully fledged series of views of a Paris boulevard in Pissarro's *oeuvre*. Pissarro had come to Paris with the intention of completing a series; previously, in 1893 and in February 1897, he had been visiting the capital primarily to attend to other matters. The Boulevard Montmartre series was also the first Paris series to be commissioned from Pissarro by Durand-Ruel. Moreover, it appears to be the most systematic and rigorously composed of all Pissarro's series. The perspective is strictly defined by the plunging, inverted 'V' of the Boulevard Montmartre, firmly delineated laterally by two rows of trees and houses on each side of the road, and thrusting eastward towards the Porte Saint-Denis. Turning slightly, he could also observe the Boulevard des Italiens. This is how Pissarro described his vista: 'I can see the lines of the boulevards almost right up to the Porte Saint-Denis, or certainly up to the Boulevard Bonne-Nouvelle.'[5]

Pissarro painted fourteen views of the Boulevard Montmartre, which he could see to the left of the window of his spacious hotel room, plus two large, 'terribly difficult views' of the Boulevard des Italiens: *Boulevard des Italiens: Morning, Sunlight* (ill. 57) and *Boulevard des Italiens: Afternoon* (cat. 58). The latter two constitute exceptions, in that, here, Pissarro looked to his right; these are the only views among this group for which Pissarro shifted his vantage point: 'I have begun my series of Boulevards. I have a splendid motif which I am going to explore under all possible effects [cats 43–48, 50–51, 54–56, and ills 49, 52, 53], to my left; I have another motif, which is terribly difficult: almost as the crow flies, looking over the carriages, buses and people milling about between the large trees and big houses which I have to set up right – it's tricky . . . it goes without saying that I must solve it all the same.'[6]

On 12 February, Pissarro announced to Georges, 'I have started my series of Boulevards', and two months and four days later, he was able to tell Lucien, 'I have packed up my sixteen canvases to be sent to Eragny.'[7] As soon as this series was finished, and by now having completed two series within less than four months, Pissarro was already thinking about a different motif for another series: 'I am going to look for a place to work near the embankment this autumn, perhaps near the Luxembourg Gardens.'[8] It is fascinating to notice that Pissarro, having just completed his first systematic Paris series, was already contemplating a

series whose execution was, in fact, to be begun, only to be forestalled by his death in 1903 – the *quais* of Paris.

The Boulevard Montmartre series uses variations in canvas size and explores so fully changes in season, light and weather, that it would seem that the artist was motivated in this series by a desire to exhaust the pictorial resources offered by all the effects. As with all the series, the formats of the canvases vary. Here Pissarro used four formats: mainly sizes 15, 25 and 30 (see Editorial Note, p. 1), and then one canvas of size 8 (*Boulevard Montmartre: Spring* (ill. 52)). The change of seasons and the contrast between winter and spring records the period of creation of the series which spanned the passage from winter (*Boulevard Montmartre: Foggy Morning* (cat. 43), *Boulevard Montmartre: Winter Morning* (cat. 44), *Boulevard Montmartre: Morning, Grey Weather* (cat. 45), *Boulevard Montmartre* (ill. 53)) to spring (*Boulevard Montmartre: Spring* (cat. 51), *Boulevard Montmartre: Spring* (ill. 52)). The change of light according to the progression of the day was also of sustained interest to Pissarro in the elaboration of this series. Morning is represented in *Boulevard Montmartre: Foggy Morning* (cat. 43) *Boulevard Montmartre: Winter Morning* (cat. 44), *Boulevard Montmartre: Morning, Grey Weather* (cat. 45), *Boulevard Montmartre: Morning, Sunlight and Mist* (cat. 46), *Boulevard Montmartre: Spring* (ill. 52), *Boulevard Montmartre*, (ill. 53), *Boulevard des Italiens: Morning, Sunlight* (ill. 57). Noon features in *Boulevard Montmartre: Spring* (cat. 51), and afternoon in *Boulevard Montmartre: Afternoon, Sunshine* (cat. 47), *Boulevard Montmartre: Rainy Weather, Afternoon* (cat. 48), *Boulevard Montmartre: Sunset* (ill. 49), *Shrove-Tuesday, Sunset, Boulevard Montmartre* (cat. 56). The only representation of night in Pissarro's series work occurs in *Boulevard Montmartre: Night* (cat. 50). Likewise, the weather conditions are recorded in all their various guises. These include: mist/fog (*Boulevard Montmartre: Foggy Morning* (cat. 43), *Boulevard Montmartre: Morning, Sunlight and Mist* (cat. 46)); rain (*Boulevard Montmartre: Rainy Weather, Afternoon* (cat. 48), *Boulevard Montmartre* (ill. 53; note the umbrellas)); grey weather (or after-rain) (*Boulevard Montmartre: Morning, Grey Weather* (cat. 45)); sunshine (*Boulevard Montmartre:*

Afternoon Sunshine (cat. 47), *Shrove-Tuesday, Sunset, Boulevard Montmartre*, (cat. 55), *Boulevard des Italiens: Morning, Sunlight* (ill. 57), *Boulevard Montmartre: Spring* (ill. 52)).

Finally, as in the Gare Saint-Lazare series, the human element appears to be in the foreground of the artist's pictorial concern, as, for example, with the crowds of *Boulevard Montmartre: Shrove Tuesday* (cat. 54) and *Shrove-Tuesday, Sunset, Boulevard Montmartre* (cat. 55), as well as the ceaseless movement to-and-fro of carriages and pedestrians.

The specific characteristics of the paintings that make up this series are given in Table 5 in the Appendix. Several general observations can, however, be made here. Pissarro on the whole seems to have kept the larger formats for 'special effects': *Boulevard des Italiens: Morning, Sunlight* (ill. 57) and *Boulevard des Italiens: Afternoon* (cat. 58) depict the Boulevard des Italiens, the 'terribly difficult' motif; *Boulevard Montmartre: Shrove Tuesday* (cat. 54) and *Shrove-Tuesday on the Boulevards* (cat. 56) show the Shrove Tuesday procession; and *Boulevard Montmartre: Spring* (cat. 51) represents his long-awaited spring effect. His recordings of late winter effects were executed mostly on standard formats (15F), with two major exceptions where a larger format was employed, *Boulevard Montmartre: Morning, Grey Weather* (cat. 45), *Boulevard Montmartre: Morning, Sunlight and Mist* (cat. 46). The considerable variation of light and weather effects suggests that Pissarro was working all day. This is confirmed by his comment to his doctor: 'Every morning I am at my observation post until twelve noon and even until half past twelve, and in the afternoons from two until half past five.'[9]

As his most systematic and homogeneous compositions, and his most clearly focused series, as well as one of his most rapidly achieved, the Boulevard Montmartre series addresses elementary issues inherent in serial procedures. While representing a single motif seen under different combinations of light, weather and seasonal change, Pissarro's approach to this series was capable of producing an infinite number of possibilities. The sixteen views he brought back to Eragny can represent only a superb fragment.

9 Bailly-Herzberg 1989, p. 327 (Paris, 13 February 1897; to Dr Parenteau): 'je suis tous les matins à mon poste d'observation jusqu'à midi et même midi et demie, et l'après-midi de deux à cinq heures et demie'.

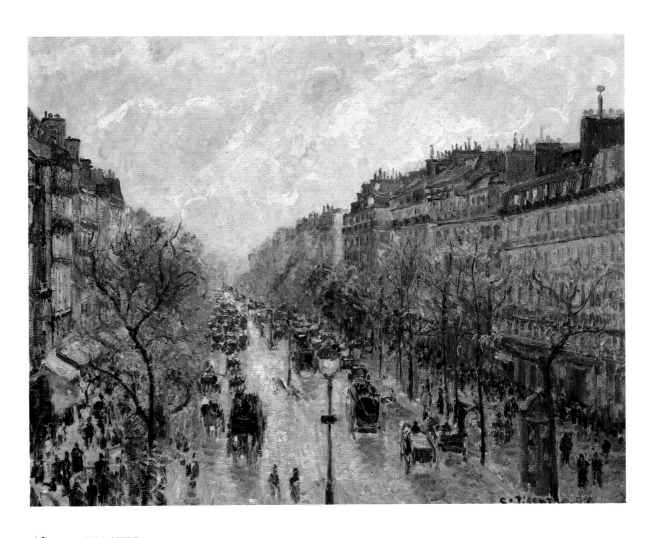

43 EXHIBITED

Boulevard Montmartre: Foggy Morning 1897

Le Boulevard Montmartre, matin brumeux
P&V 986
55 × 65 cm
Signed and dated lower right: *C. Pissarro. 97*

Private Collection, Switzerland. Courtesy of Thomas Gibson, Fine Art Ltd, London

PROVENANCE François Depeaux, Rouen; sale, Collection Depeaux, Galerie Georges Petit, Paris, 31 May–1 June 1906 (34; repr.); Mary T. Chambers and Caroline Rakestraw; sale, The Property of the Estate of Mary T. Chambers and Caroline Rakestraw, Christie's, London, 29 November 1982 (12; repr.); Thomas Gibson Fine Art, London; Private Collection, Switzerland

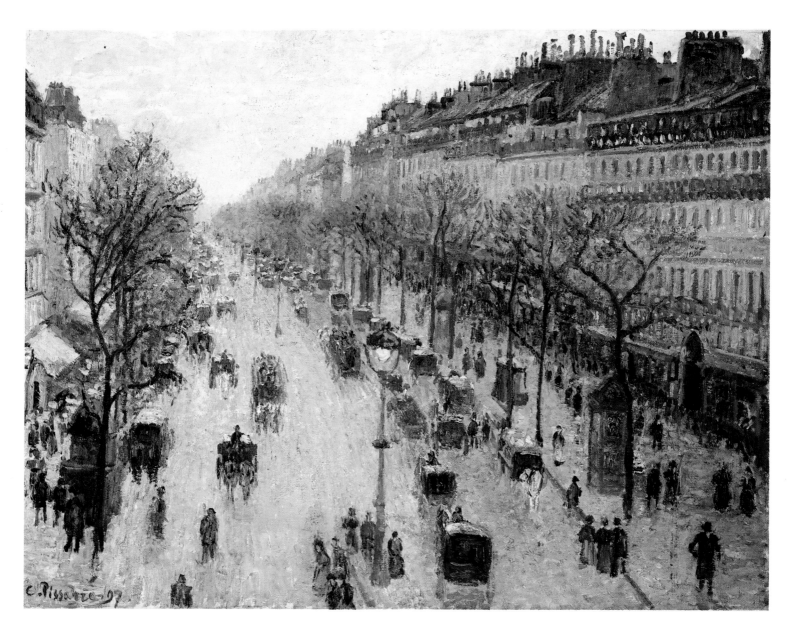

44 EXHIBITED IN DALLAS AND
PHILADELPHIA

*Boulevard Montmartre: Winter
Morning* 1897

Le Boulevard Montmartre, matin d'hiver
P&V 987
65 × 81 cm
Signed and dated lower left: *C. Pissarro 97*

The Metropolitan Museum of Art, New
York, Gift of Katrin S. Vietor, in loving
memory of Ernest G. Vietor, 1960

PROVENANCE Galerie Durand-Ruel, Paris;
bought by the Carstairs Gallery, New York,
28 April 1944; Stanley Newbold Barbee,
Beverly Hills, California; bought by
Knoedler & Co., New York, December 1951
(A 4742); bought by Mr and Mrs Ernest G.
Vietor, New York and Greenwich,
Connecticut, January 1952; Mrs Ernest G.
Vietor, New York and Connecticut, 1959;
given to The Metropolitan Museum of Art,
New York, 1960

EXHIBITIONS Paris 1898, no. 14; Paris
1941, no. 23; New York 1944; Amsterdam
1987, no. 17

LITERATURE Dewhurst 1903 (repr.);
Stephens 1904 (repr.); Sterling 1967, pp. 20 f.
(repr); Varnedoe 1976–77, p. 132, fig. 2;
Schirrmeister 1982, no. 13 (repr.); van
Heugten *et al.* 1987, pp. 17, 60 f., no. 17
(repr.); Kostenevich 1987, p. 298 (repr.)

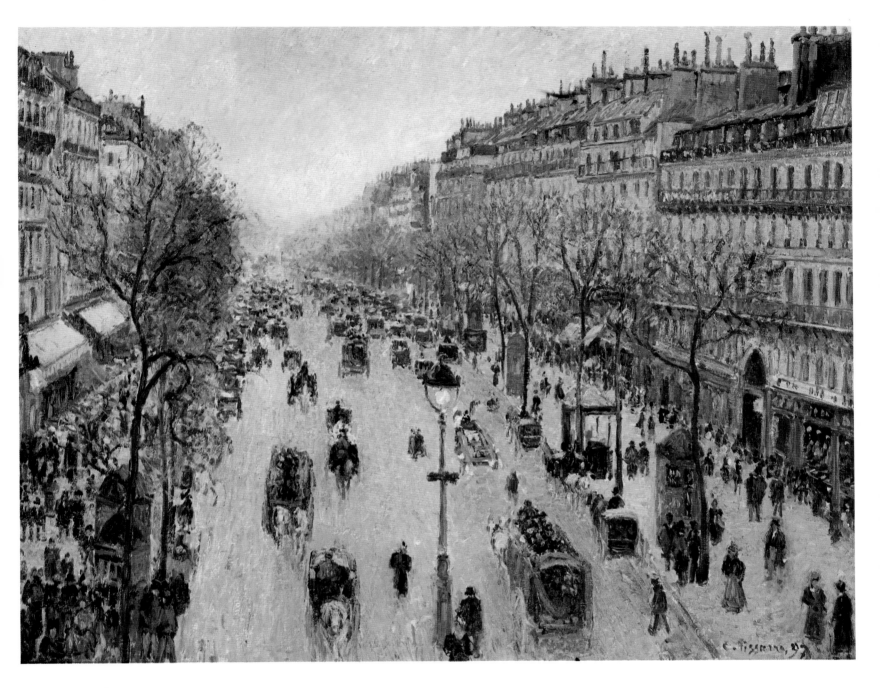

45 EXHIBITED

Boulevard Montmartre: Morning, Grey Weather 1897

Boulevard Montmartre, matin, temps gris
P&V 992
73 × 92 cm
Signed and dated lower right: *C. Pissarro, 97*

National Gallery of Victoria, Melbourne, Australia, Felton Bequest, 1905

PROVENANCE Galerie Durand-Ruel, Paris; acquired by Bernard Hall, Director of the National Gallery of Victoria, from the Grafton Gallery exhibition, under the provisions of the Felton Bequest, for the National Gallery of Victoria, Melbourne

EXHIBITIONS Paris 1899(ii), no. 63; London 1905, no. 171 (exh. by Durand-Ruel); Tokyo 1984, no. 56

LITERATURE Mauclair 1904; Mauclair 1923; *Revue de l'art ancien et moderne*, vol. LVI, June–December 1929; *Reproductions of Selected Pictures and Sculptures in the National Gallery*, Melbourne, 1934, pl. 25; Plant 1976

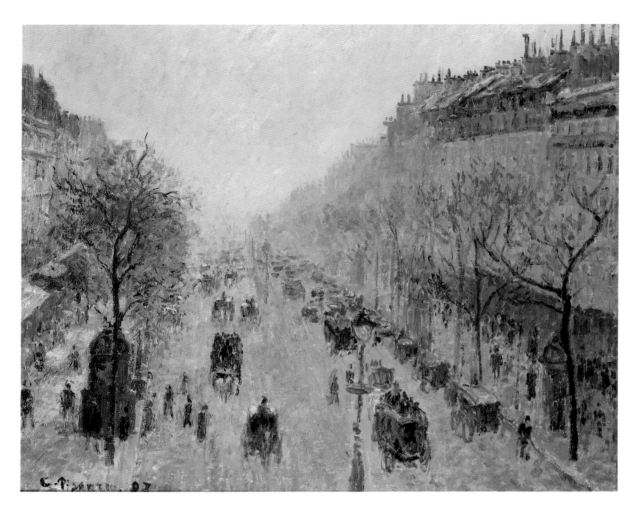

46 EXHIBITED

Boulevard Montmartre: Morning,
Sunlight and Mist 1897

Boulevard Montmartre, matin, brouillard
ensoleillé
P&V 990
54 × 66 cm
Signed and dated lower left: *C. Pissarro. 97*

Private Collection

PROVENANCE Galerie Durand-Ruel, Paris;
Sam Salz, Inc., New York; Etta E. Steinberg;
sale, From the Collection of the Etta E.
Steinberg Trust, Christie's, New York, 19
May 1981 (335); Private Collection

EXHIBITIONS Paris 1898, no. 19; Paris
1899(ii), no. 65; Paris 1910(ii), no. 10; Saint
Louis, City Art Museum, 1975–80 (on loan)

LITERATURE *Art News*, April 1956, p. 75
(repr.)

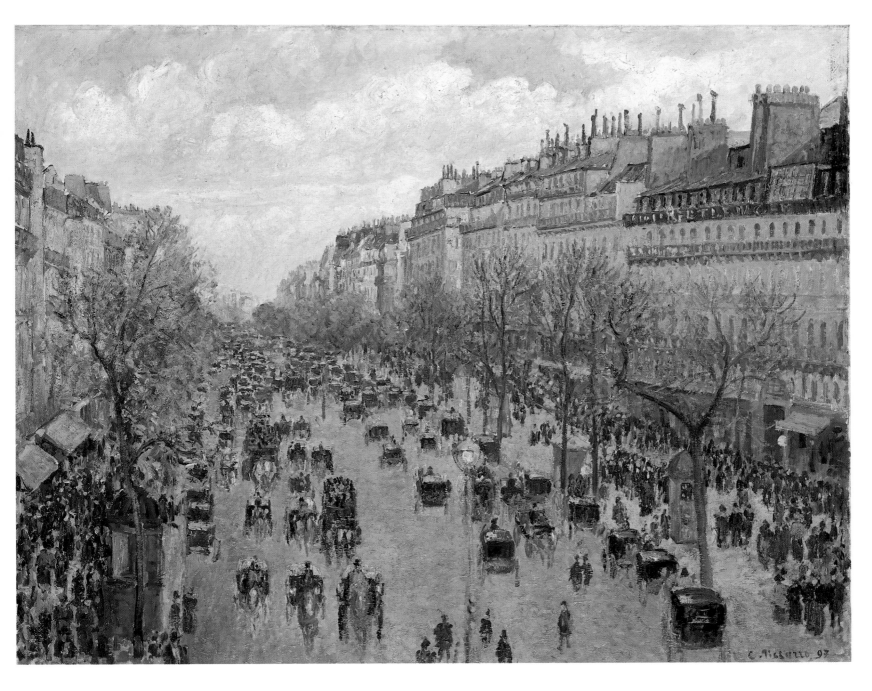

47 EXHIBITED IN DALLAS AND
PHILADELPHIA

*Boulevard Montmartre: Afternoon,
Sunshine* 1897

Le Boulevard Montmartre, après-midi, soleil
P&V 993
74 × 92.8 cm
Signed and dated lower right: *C. Pissarro 97*

The State Hermitage Museum, St Petersburg

PROVENANCE F. Depeaux, Rouen; sale,
François Depeaux, 25 April 1901 (42); M. P.
Ryabushinsky, Moscow; Tretyakov Gallery,
Moscow, 1917; Museum of Modern Western
Art, Moscow, 1925; The State Hermitage,
Leningrad, 1948

LITERATURE *Museum of Modern Western
Art: Illustrated Catalogue*, Moscow, 1928,
no. 466; *The State Hermitage: Catalogue of
Western European Painting*, Leningrad, 1976,
vol. I, p. 285

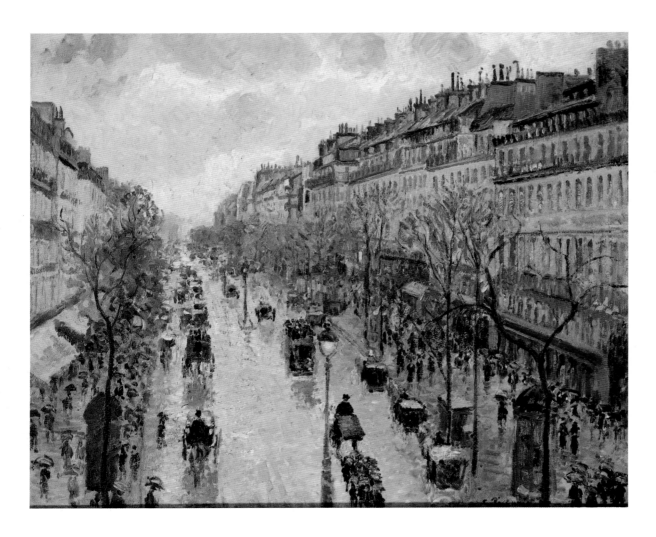

48 EXHIBITED

*Boulevard Montmartre: Rainy
Weather, Afternoon* 1897

*Le Boulevard Montmartre; temps de pluie,
après-midi*
P&V 988
52.5 × 66 cm
Signed and dated lower right: *C. Pissarro 97*

Private Collection. Courtesy of Christie's,
New York

PROVENANCE Paul Durand-Ruel, Paris; G.
Kahn, Detroit; Alex Reid & Lefevre,
London; Wildenstein & Co., New York; sale,
Christie's, New York, 16 May 1977 (12)

EXHIBITIONS Detroit, Museum of Fine
Arts, 1968–69 (on loan)

LITERATURE Kunstler 1971, pp. 58–59
(repr.)

facing page: detail of cat. 48

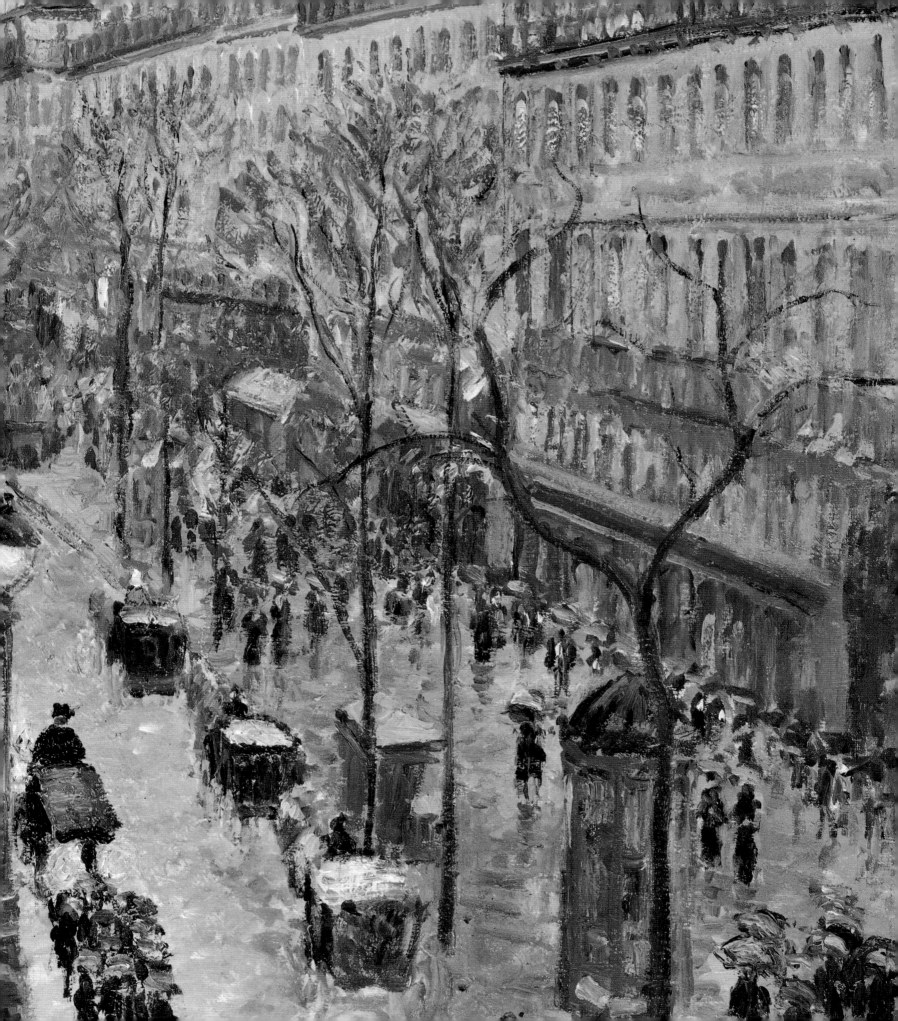

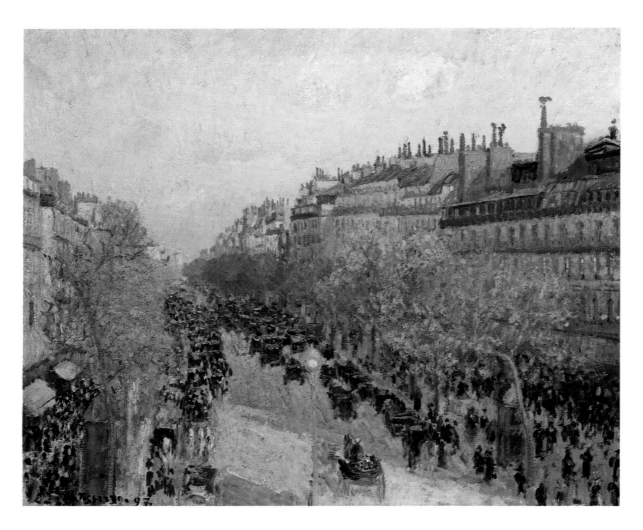

49 NOT EXHIBITED

Boulevard Montmartre: Sunset
1897

Boulevard Montmartre, soleil couchant
P&V 989
54 × 65 cm

Private Collection

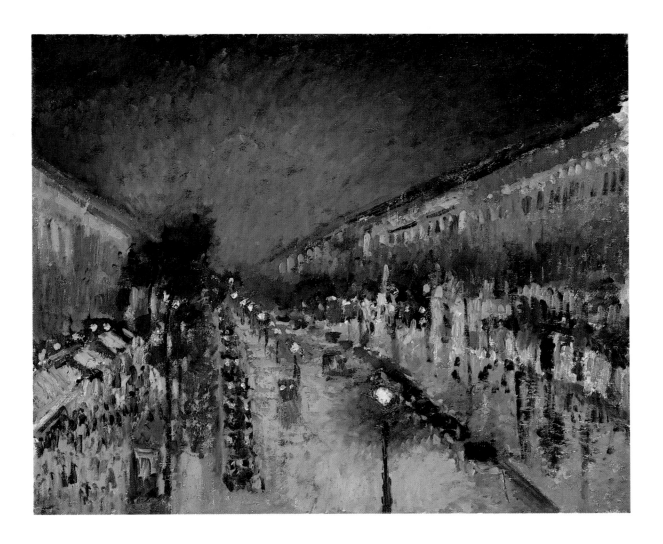

50 EXHIBITED

Boulevard Montmartre: Night
1897

Boulevard Montmartre, effet de nuit
P&V 994
53.5 × 65 cm

National Gallery, London

PROVENANCE Lucien Pissarro, London; the
French Gallery, London; acquired by the
Trustees of the Courtauld Fund and
presented to the Tate Gallery, London, 1925;
transferred to the National Gallery, London,
1950

EXHIBITIONS London 1925, no. 2; London
1931, no. 17; London 1948, no. 53

LITERATURE *Impressionisten*, Phaïdon,
Vienna, 1937 (repr.); Rothenstein 1947,
pl. 33; Cooper 1954(i), no. 49; Cooper
1954(ii), p. 121; Davies 1970, no. 4119, p. 112

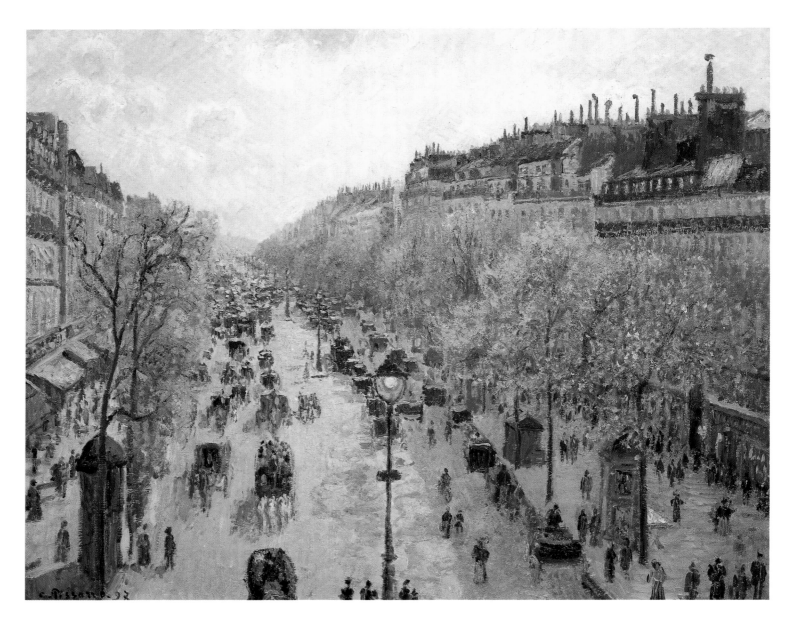

51 EXHIBITED IN PHILADELPHIA

Boulevard Montmartre: Spring
1897

Boulevard Montmartre, Printemps
P&V 991
65 × 81 cm
Signed and dated lower left: *C. Pissarro. 97*

Private Collection

PROVENANCE Collection Adolph Rothermundt, Dresden; sale, Paul Graupe, Berlin, 18, 20, 21, 23 March 1935, no. 27 (repr.); Max Silberberg, Breslau; bought from a German collector by Wildenstein & Co., New York, November 1953; bought by Nat J. Cohn, December 1953; Mrs Sarah H. Cohn; consigned to Knoedler & Co., New York, September 1959 (CA 5801) and bought by Knoedler & Co., November 1959 (A 7363); bought by a private collector, January 1960

EXHIBITIONS Dresden 1914, no. 79 (lent by Adolph Rothermundt); White Plains 1956; New York 1965, no. 66; New York 1970, no. 88 (repr.)

LITERATURE *Kunst und Künstler*, vol. XXI, Heft IV, p. 134 (repr.); Pica 1908, p. 127 (repr.); Mauclair 1923, p. 23; Catalogue Paul Graupe, Paris, 1937 (repr.); Natanson 1948, pl. 39; Jedlicka 1950, pl. 39; Rewald n.d., pl. 53

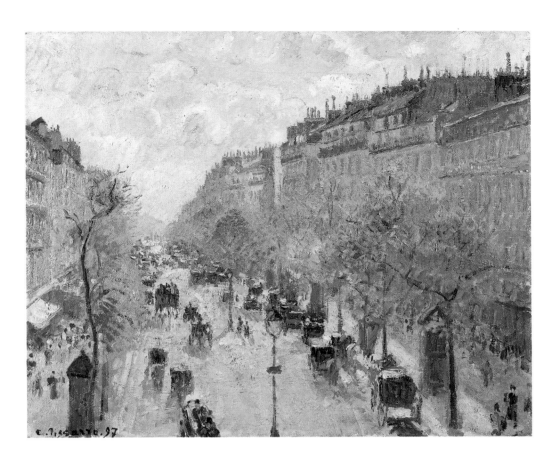

52 NOT EXHIBITED

Boulevard Montmartre: Spring
1897

Le Boulevard Montmartre, printemps
P&V 998
46 × 55 cm

Stiftung 'Langmatt' Sidney und Jenny
Brown, Baden

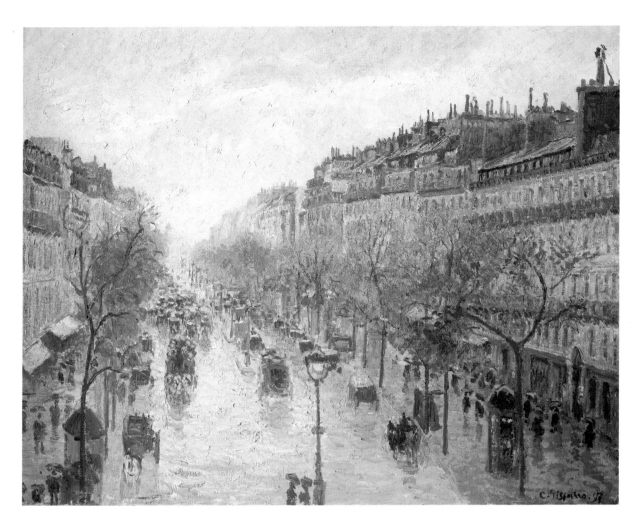

53 NOT EXHIBITED

Boulevard Montmartre: Spring,
Rain 1897

Le Boulevard Montmartre, printemps, pluie
Non-P&V

Private Collection

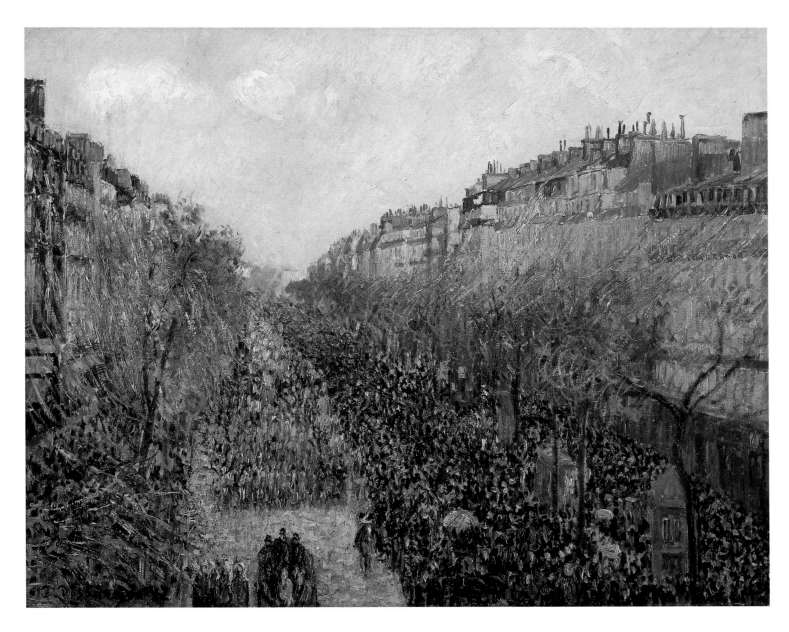

54 EXHIBITED

Boulevard Montmartre: Shrove Tuesday 1897

Boulevard Montmartre, Mardi-Gras
P&V 995
63.5 × 80 cm
Signed and dated lower left: *C. Pissarro. 97*

The Armand Hammer Collection, The Armand Hammer Museum of Art and Cultural Center, Los Angeles

PROVENANCE Maurice Barret-Décap, Paris; Mme Barret-Décap, England; bought by Wildenstein & Co., New York, 1948; Mr and Mrs Henry R. Luce, New York; Marlborough/Alte und Moderne Kunst, Zurich; Norton Simon, Los Angeles; sale, The Private Collection of Norton Simon, Sotheby-Parke-Bernet, New York, 5 May 1971 (24 (wrongly catalogued as P&V 996)); Armand Hammer Collection, 1971

EXHIBITIONS Paris 1898, no. 20; Paris 1921, no. 9; Paris 1928, no. 78, New Haven 1960, no. 58 (repr.); New York 1965, no. 65 (repr.); Pittsburgh 1974;

London 1980–81, no. 78 (repr.), p. 141; Los Angeles 1984–85, no. 35 (repr.), pp. 128, 131, 366

LITERATURE Rewald 1950, pp. 431, 433; Coe 1954, p. 107, Nochlin 1965, pp. 24, 61 (repr.); Kunstler 1972, p. 80 (repr.), trans. Paris, 1974; Lloyd 1981, p. 126 (repr.); Reff 1982, pp. 258–59, no. 97 (repr.); Robinson 1984, pp. 59, 61 (repr.); Georgel 1986, no. 51 (repr. col. p. 77)

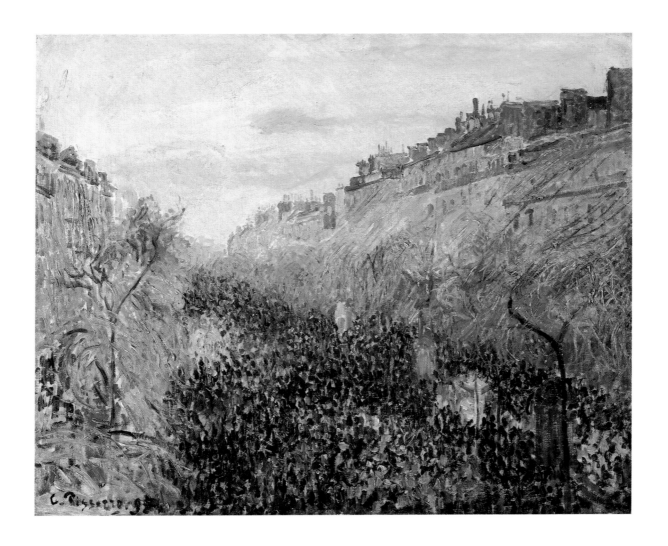

55

Shrove Tuesday, Sunset, Boulevard Montmartre 1897

Mardi-Gras, soleil couchant, Boulevard Montmartre
P&V 997
54 × 65 cm
Signed and dated lower left: *C. Pissarro 97*

Kunstmuseum Winterthur

PROVENANCE Galerie Durand-Ruel, Paris (no. 4244, photo no. 2344); bought by Mme Granoff, Paris, 6 December 1938; bought by Mr Tanner, 1939; Mr Tanner and Mr Schwarzkopf; acquired by the Kunstmuseum Winterthur, 1947

EXHIBITIONS Paris 1936, no. 8 (wrongly catalogued as 1877); Bern 1957, no. 95; Bremen 1973, no. 127

LITERATURE Haustenstein 1949, pp. 73–76; O'Brian 1988, pp. 98–100

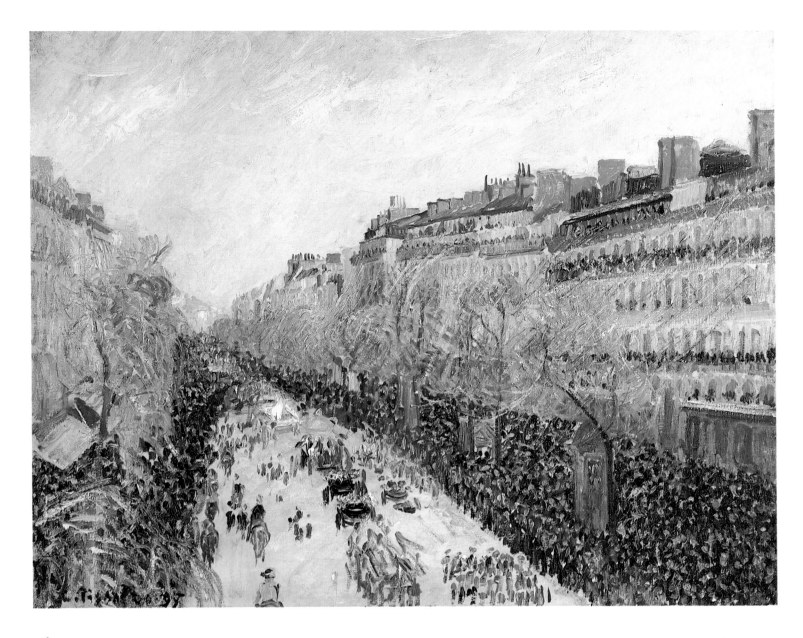

56 EXHIBITED IN DALLAS

Shrove Tuesday on the Boulevards 1897

La Mi-Carême sur les Boulevards
P&V 996
64.9 × 80.1 cm
Signed and dated lower left: *C Pissarro 97*

Fogg Art Museum, Harvard University Art Museums, Bequest-Collection of Maurice Wertheim, Class of 1906

PROVENANCE Mme Camille Pissarro, Eragny; Lucien Pissarro, London; Wildenstein & Co., London–New York; Maurice Wertheim, by 1943; bequeathed with the Collection of Maurice Wertheim to the Fogg Art Museum, Cambridge, Mass., 1951

EXHIBITIONS Paris 1904, no. 101; Paris 1914, no. 31; London 1920, no. 86; Paris 1921, no. 6; Paris 1930, no. 91; London 1931–32; New York 1943–44; New York 1944, no. 6; New York 1945, no. 35; Cambridge 1946; Quebec 1949; New York 1952; Washington 1953; Philadelphia 1957; Minneapolis 1958;

Raleigh 1960; Houston 1962; Baltimore 1963; Manchester 1965; Providence 1968; Montgomery 1971; Augusta 1972; New York 1985; Tokyo 1990

LITERATURE Thornley n.d.; Manson 1920, opp. p. 83 (repr.); Wilenski 1931, (repr. pl. 10); *Art News*, vol. XLII, 15–31 December 1943, p. 21 (repr.); Frankfurter 1946, p. 64; *Think*, September 1952, pp. 18–19, 32 (repr.); Coe 1954, p. 107; Shikes 1980, p. 297 (repr. p. 296); O'Brian 1988, pp. 98–100; Bowron 1990, p. 124 (repr. no. 399)

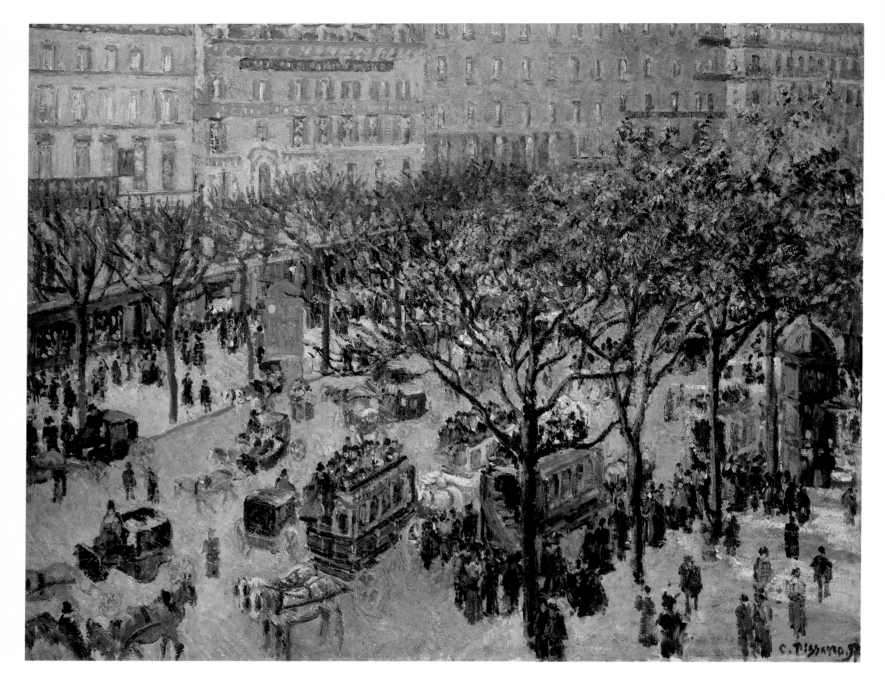

57 NOT EXHIBITED

*Boulevard des Italiens: Morning,
Sunlight* 1897

Boulevard des Italiens, matin, effet de soleil
P&V 1000
73.2 × 92.1 cm

Chester Dale Collection © 1992. National
Gallery of Art, Washington, D.C.

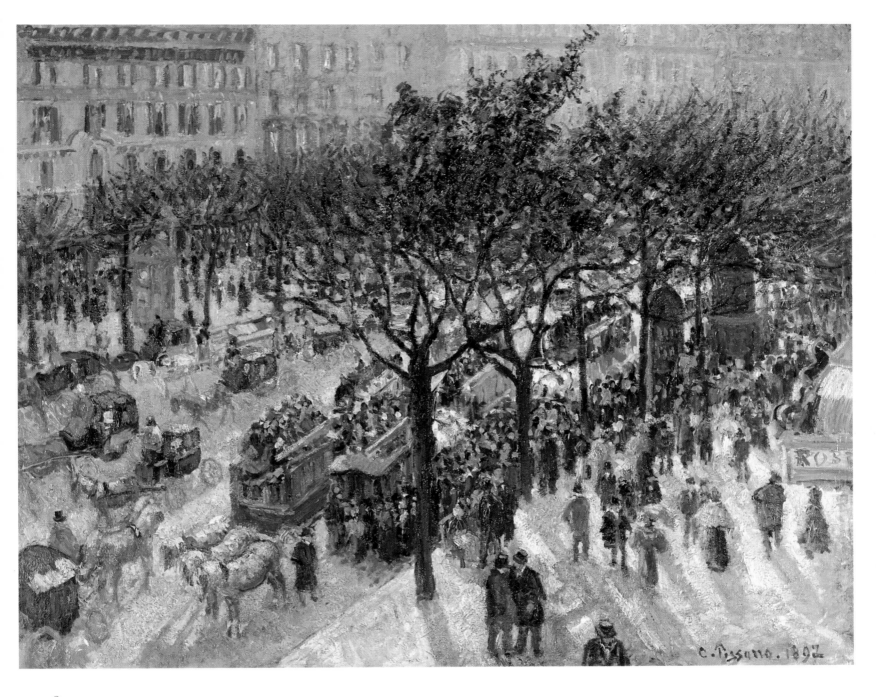

58 EXHIBITED

Boulevard des Italiens: Afternoon
1897

Boulevard des Italiens, après-midi
P&V 999
73 × 92 cm
Signed and dated lower right: *C. Pissarro.*
1897

Private Collection

PROVENANCE Adolph and Samuel
Lewisohn, New York; Mr and Mrs Edward
G. Robinson, Los Angeles; Private Collection

EXHIBITIONS Paris 1898, no. 7; Paris
1899(ii), no. 55; Paris 1914; Los Angeles 1940,
no. 49a; Pomona 1950; New York 1953,
no. 22; Los Angeles 1956–57, no. 41

LITERATURE Meier-Graefe 1907, p. 167;
Hamel 1914, p. 31 (repr. p. 28); *Kunst und
Künstler*, vol. XIX, 1920–21 (repr. p. 351);
L'Art et les artistes, February 1928 (repr.
p. 163); Bourgeois 1928, p. 89 (repr. p. 88);
George 1932, p. 306 (repr. opp. p. 304);
Kelden 1970 (repr. p. 84)

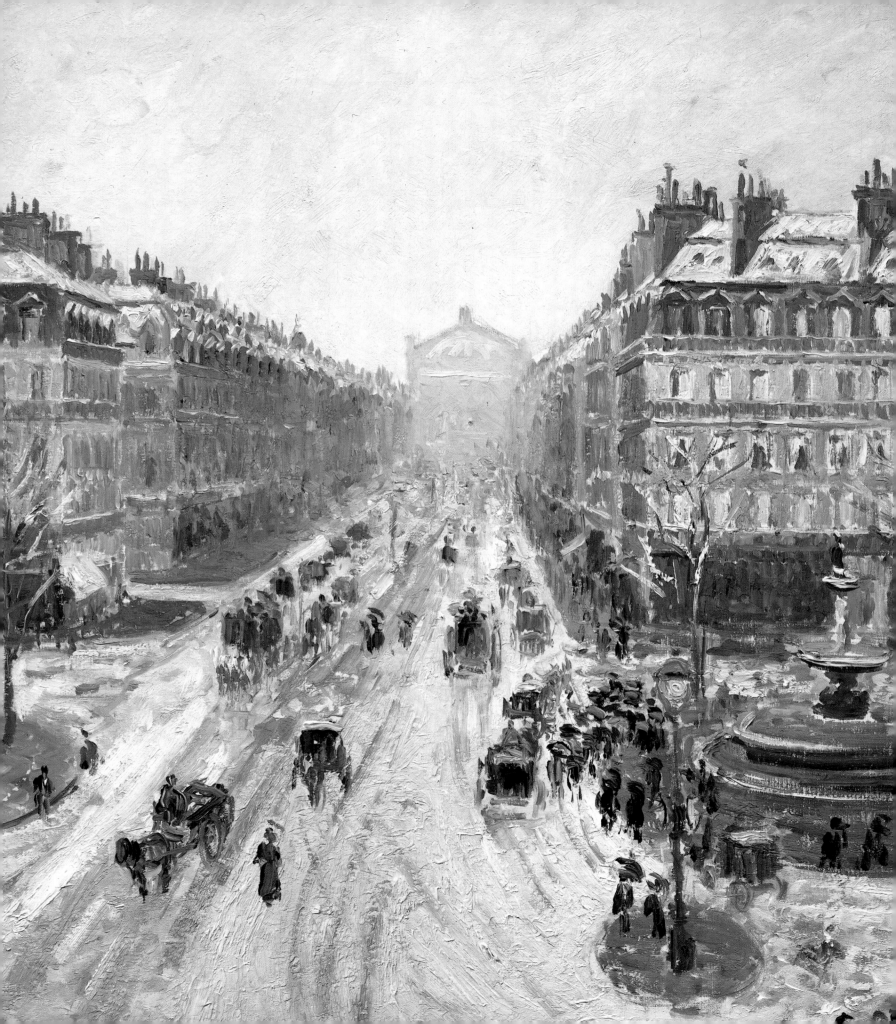

PARIS: THE AVENUE DE L'OPÉRA
PAINTING AND POLITICS

1 Bailly-Herzberg 1989, p. 358 (London, 18 May 1897; to Paul Durand-Ruel).

2 Bailly-Herzberg 1989, p. 357 (London, 13 May 1897; to Julie Pissarro).

3 Bailly-Herzberg 1989, p. 396 (Paris, 9 November 1897; to Lucien Pissarro): 'Je vais donc chercher vers le Trocadéro, Passy, le Cours-la-Reine; je serai donc obligé de rester quelques jours ici.'

4 Bailly-Herzberg 1989, p. 413 (Eragny-Bazincourt par Gisors, 26 November 1897; to Georges Pissarro): 'Oui, mon cher Georges, voilà une année terrible pour nous! Tâchons de surmonter notre mal avec courage afin de ne rien aggraver.'

5 Georges had looked after Félix in London until he died.

6 Bailly-Herzberg 1989, pp. 417–18 (Paris, 15 December 1897; to Lucien Pissarro): 'Je ne saurais te dire combien je suis heureux d'apprendre que tu as pu affronter la désastreuse nouvelle de la mort de notre pauvre Titi que nous aimions tant, notre espoir, notre orgueil, nous craignions de te l'apprendre et ne savions comment te cacher notre grand chagrin. Mais il faut dans de si fatales circonstances se résigner et penser à ceux qui sont autour de nous; se laisser aller au découragement serait terriblement grave, et il faut bien surmonter ce que nous ne pouvons empêcher: dans notre malheur j'ai pu constater combien Georges a été à la hauteur des circonstances, il a fallu qu'il eût une grande fermeté de caractère pour empêcher ta mère de se rendre malade, enfin mon cher Lucien, travaillons pour panser nos blessures, j'espère que tu sera fort et que t'envelopperas, pour ainsi dire, d'art . . . J'oublie de t'annoncer que j'ai trouvé une chambre au Grand Hôtel du Louvre avec une vue superbe sur l'Avenue de l'Opéra et du coin de la place du Palais Royal! C'est très beau à faire! C'est peut-être pas très esthètique, mais je suis enchanté de pouvoir essayer de faire ces rues de Paris que l'on a l'habitude de dire laides, mais qui sont si argentées, si lumineuses et si vivantes, c'est tout différent des boulevards – c'est le moderne en plein!!!

7 Bailly-Herzberg 1989, p. 418 (Paris, 15 December 1897; to Lucien Pissarro): 'malheureusement avec ces vilains temps humides, mon oeil s'est enflammé de nouveau, fort peu il est vrai, mais j'ai dû retourner chez Parenteau qui me cautérise'.

facing page: detail of cat. 66

The year 1897 was one of Pissarro's busiest and at the same time one of the most tragic of his life. In the spring, Lucien, Pissarro's eldest son, suffered a stroke and was 'between life and death'.[1] As a consequence, Pissarro travelled to London to look after him, a situation that exerted additional strain on Pissarro's emotional and financial resources.[2] He stayed in London from 7 May until 19 July, during which time he managed to paint a group of views from Lucien's house, although these do not constitute a series *per se*.

Lucien was only just starting to recover when Pissarro and his wife, Julie, had to face even greater worries, as it became apparent that their third son, Félix, who also lived in London, had tuberculosis. At that time, November 1897, Pissarro was alternating his work in Eragny with the search for a new motif for a Paris series: 'I am going to look near the Trocadéro, Passy, the Cours-la-Reine; I shall therefore have to stay here for a few days.'[3] We learn in the same letter that Durand-Ruel was encouraging him to 'find something to work on here', as he had done previously when he commissioned Pissarro to make the Boulevard Montmartre series. Two weeks later the news reached Pissarro from London that Félix had died on 25 November, aged twenty-three. Pissarro wrote of the tragedy to his second son, Georges: 'Indeed, my dear Georges, this is a terrible year for us. Let us try to get over our difficulties with courage so that we do not make them worse.'[4]

Lucien's health still being fragile, Pissarro had decided to hide the news of Félix's death from him in order to spare him the shock, which the doctor felt might be too great. It was only on 15 December that Pissarro mentioned Félix's death in a fascinating letter in which he also first broached the news about the new series, that of the Avenue de l'Opéra. This letter, one of Pissarro's most moving, merits being quoted at some length:

I cannot tell you how happy I was to hear that you were able to brave the awful news of our poor Titi's death; we loved him so much, he was our hope and our pride; we were afraid of telling you and did not know how to hide our great sorrow from you. But one must resign oneself in such fatal situations and think of those around us; to give into despondency would be very bad and one should come to terms with those things we cannot prevent: in our sadness I can affirm how much Georges[5] rose above the situation, he had to have a great strength of character to stop his mother from becoming ill, in short my dear Lucien, we must work to heal our wounds, I hope that you will be strong and that you will surround yourself, so to speak, with art . . . I forgot to tell you that I have found a room in the Grand Hôtel du Louvre which has a superb view over the Avenue de l'Opéra and that corner of the Place du Palais-Royal. It's going to be beautiful to paint. It is not very aesthetic perhaps, but I am delighted to be able to try to do these Paris streets which are often called ugly, but which are so silvery, so luminous and so lively and which are so different from the boulevards – it's completely modern.[6]

In addition to these two tragedies, Pissarro was suffering from a recurrent eye infection, which prompted him to visit regularly his doctor, Parenteau, in Paris. In the letter just quoted, Pissarro gave an account of the recent return of the infection: 'unfortunately, with this lousy humid weather, my eye is inflamed again, not so badly it's true, but I shall have to go back to Parenteau to have it cauterized'.[7] It has been frequently stated that Pissarro embarked upon his series of urban views because of his eye infection. Two observations suggest that this view should be qualified. First, Pissarro never ceased working outdoors, whether in town or country, unless the effect of

a cold wind was felt too strongly. Second, he is known to have painted his urban series often with his window open. It remains true, however, that the trouble resulting from this infection forced him to come to Paris far more regularly than before, and thus the motivation and the opportunity to search for new urban motifs were felt all the more. However, the questions of why he chose the Avenue de l'Opéra over the Trocadéro, and why he painted fifteen views of the Avenue de l'Opéra and its neighbourhood remain to be addressed in their own pictorial terms.

Another factor must be brought directly to bear on this particular series: the Dreyfus case, or *l'Affaire*, as it was then called, which, during the course of 1897, shook the ideological foundations of French society. The beginning of the Dreyfus Affair was marked, not so much by the condemnation of Dreyfus for alleged treason (on 22 December 1894), but rather by the growing awareness that his sentence had been based on false or forged evidence. This awareness was reinforced by the implicitly self-defeating public denial made on 7 December 1897 by Jules Méline, President of the Government Council, who declared: 'Il n'y a pas d'Affaire Dreyfus'. Two weeks earlier, Pissarro had sent newspapers to Lucien with the following remarks: 'I am sending you some papers which will bring you up to date on the Dreyfus Affair which is gripping public opinion so much; you will see that it is easily possible that he is innocent. In any case, there are some high-up and honourable people who say he is innocent . . . the document that the general leaked to the press is a fake . . . It really is terrible!'[8]

On 13 January 1898, the article by Zola, 'J'Accuse', appeared, and Pissarro wrote:

The Bernard Lazare case has given rise to all sorts of horrible comments; I will send you *l'Aurore*, which has very sensible articles by Clemenceau (and Zola); today Zola indicts the heads of the army. Ajalbert wrote a very brave article in *Les Droits de l'homme*, but the majority of the public is against Dreyfus, in spite of the bad faith exhibited in the Esterhazy case. I heard Guillaumin say that if they had shot Dreyfus straight away there would not be all this trouble; he is not the only one who is of this opinion.[9]

Pissarro unhesitatingly took the side of 'truth' and 'justice' (as Zola put it) against the defenders of 'the Army's honour' and against the attackers of 'the Jewish lobby', which had been slandered with accusations of 'treason'. Pissarro's position, however, had not been automatically in favour of defending Dreyfus; at least, he appeared fairly non-committal in his first letter, reflecting in this the tendency of most anarchists, who at the beginning of the case were neither for nor against the affair. To them, it seemed merely to confirm their belief that corruption was inherent in capitalist society.

When, subsequent to Zola's article and Lazare's pamphlet, Pissarro first clearly stated his own position, he did so following the irrefutably logical argument that if an individual is proved guilty solely on the grounds of forged evidence, the defendant has no need of any proof to have his innocence established. Pissarro's moral and political position was derived from a sound, logical set of rational and humanistic inferences. He, along with the Dreyfusards, condemned injustice, prejudice, the collision of interests between the Church and the Army, dogmatism and calumnious accusations. His position was summarised by Jean Grave, the anarchist newspaper publisher (to whose *Temps nouveaux* Pissarro subscribed at his hotel during his Avenue de l'Opéra campaign), who asserted that the Dreyfus case 'went far beyond the personality of Dreyfus himself'; it had become the arena for a 'struggle between clarity and obscurantism'.[10] In fact, Pissarro, contrary to what is often said, did not take the side of Dreyfus merely because he was Jewish. His stance, in accordance with his anarchist principles, was one of opposition to the clerics and the army, who were seen to represent reactionary values, prejudice and authoritarianism:

You are right not to get flustered about all the fuss over the Dreyfus Affair. For the moment, there are only little squealers, but beneath this business there is a second Sixteenth of May in the making, a *coup d'état* of the church and a *coup d'état* of the army . . . Unfortunately, the people cannot see further than the ends of their noses. They suspect that there is a social struggle against the rule of capital without worrying who will be

8 Bailly-Herzberg 1989, p. 403 (Paris, 14 November 1897; to Lucien Pissarro): 'Je te remets quelques journaux qui te mettront au courant de l'affaire Dreyfus qui passionne tant l'opinion publique; tu verras qu'il se pourrait bien qu'il soit innocent. Dans tous les cas, il y a de hauts et honorables personnages qui le disent innocent . . . le document que le général a livré à la presse est faux! . . . C'est vraiment affreux!!!'

9 Bailly-Herzberg 1989, p. 429 (Paris, 13 January 1898; to Esther (Mme Lucien) Pissarro): 'L'affaire B. Lazarre fait dire bien des horreurs ici, je vous enverrai, *l'Aurore*, avec des articles très sensés de Clemenceau (et Zola); aujourd'hui Zola accuse les chefs de l'armée. Ajalbert a fait un article dans *Les Droits de l'homme* fort courageux, mais le gros du public est contre Dreyfus, malgré la mauvaise foi déployée dans l'affaire Estérazy. J'ai entendu Guillaumin dire que si on avait fusillé Dreyfus immédiatement on ne serait pas dans l'embarras, il n'y a pas que lui de cette opinion.'

10 Cited in Bailly-Herzberg 1989, p. 430.

defeated; they do not like the Jewish banks, and with good reason, but they have a weakness for the Catholic banks which is stupid.[11]

Pissarro's position was complex and not devoid of paradox. As an anarchist, his opposition to capitalism remained a principal tenet of his politics; as a passionate supporter of human rights, he could not but vehemently oppose the condemnation of any given individual – whether Jewish, Catholic, Protestant or Moorish, whether a capitalist or a socialist – in the name of an allegedly untouchable and deeply heteronomous 'raison d'état'. Throughout, Pissarro's aim was 'to see clearly' – that is, without prejudice.[12]

Pissarro's repeated references in the letters written at this time to both his series of the Avenue de l'Opéra and the Dreyfus Affair suggest a more than passing relationship between the two. To be sure, pictorial and political arenas are governed by their own laws, but in so far as they inhabit the same period in time and are acted out within the same city, Pissarro seemed aware of the need to address their possible correlation. His conclusion, as demonstrated in a letter of November 1898, rests on their intrinsic separateness: 'Despite the serious events that are unravelling in Paris, I am forced, in spite of my worries, to work at my window *as if nothing were happening*; to be brief, let us hope that it ends with smiles all round' (my emphasis).[13] It is worth stressing here the redundant use of the double concession ('Despite the serious events . . . in spite of my worries') which demonstrates the dichotomy between the artist's political concerns on the one hand, and his pictorial practice on the other. This marked separation between politics and painting, present throughout Pissarro's correspondence, is confirmed by the lack of any trace of social demonstration or political grouping in the paintings. Of the current socio-political situation in relation to his work Pissarro wrote, 'Let's hope that this does not stop me from working; it would be a shame as I am well under way.'[14] He does not reject or ignore history – he simply asserts the autonomy of the separate spheres of painting and politics, while at the same time fully engaging himself in the flow of history.

*　　*　　*

Pissarro's series of the Avenue de l'Opéra presents a number of different compositional procedures. The series consists of fifteen paintings which focus on three motifs: the Rue Saint-Honoré, which is to the left of the Avenue de l'Opéra (*Rue Saint-Honoré: Afternoon, Rain Effect* (ill. 59), *Rue Saint-Honoré: Morning Sun Effect, Place du Théâtre Français* (cat. 60), *Rue Saint-Honoré: Sun Effect, Afternoon* (ill. 61)); the Avenue de l'Opéra itself, with the Palais Garnier in the background (*Avenue de l'Opéra, Place du Théâtre Français: Misty Weather* (cat. 63), *Place du Théâtre Français: Foggy Weather* (ill. 62), *Avenue de l'Opéra: Rain Effect* (cat. 64), *Place du Théâtre Français: Rain Effect* (cat. 65), *Avenue de l'Opéra: Snow Effect* (cat. 66), *Avenue de l'Opéra: Snow Effect* (ill. 67), *Avenue de l'Opéra: Morning Sunshine* (cat. 68), *Avenue de l'Opéra: Sunshine, Winter Morning* (cat. 69), *Place du Théâtre Français: Sun Effect* (ill. 70), *Place du Théâtre Français: Afternoon Sun in Winter* (ill. 71)); and the Place du Théâtre Français, situated to the right of the Avenue (*Place du Théâtre Français* (cat. 73) and *Place du Théâtre Français: Spring* (cat. 72)). The series can also be divided vertically into two groups: those pictures that incorporate a representation of the sky (cats 60, 63–66, 68–70, and ills 59, 61–62, 67, 71), and those that crop the sky and focus on the street level (cats 72, 73). The series also sets up an opposition between the rectilinear perspective of the Avenue and the circularity of the Place du Théâtre Français.

Pissarro consistently used only three formats for this series, sizes 15, 25 and 30 (see Editorial Note, p. 1). These formats could have been symmetrically exploited to suit the three different vantage points. Pissarro, however, chose not to do this; even in the case of the motif of the Place du Théâtre Français, which required only two canvases, Pissarro used two different formats: size 30 for *Place du Théâtre Français* (cat. 73) and size 25 for *Place du Théâtre Français: Spring* (cat. 72). The single steadfast principle in the overall organisation of the series is Pissarro's use of vertical formats only for the left vantage point (the Rue Saint-Honoré, branching off the Place du Théâtre Français (cats 60–61 and ill. 59). The verticality of the format in these three pictures is motivated by the tall, cropped corner of the building at the angle of the Rue de Rohan and the Rue Saint-Honoré. The building's verticality is seen at closer range than that of any

11 Bailly-Herzberg 1989, p. 441 (Paris, 27 January 1898; to Lucien Pissarro): 'Tu as raison de ne pas te troubler pour tout le tapage que l'on fait à propos de l'Affaire Dreyfus. Pour l'instant, il n'y a que des petits braillards, mais sous cette affaire il y a un second Seize Mai qui se prépare, un coup d'état clérical et un coup d'état de l'armée . . . Malheureusement le peuple n'y voit plus goutte. Il se doute qu'il y a une lutte sociale contre le capital sans se préoccuper qui sera vaincu; il n'aime pas la banque juive avec raison, mais il a des faiblesses pour la banque catholique ce qui est idiot.'

12 Bailly-Herzberg 1989, p. 446 (Paris, 3 February 1898; to Lucien Pissarro).

13 Bailly-Herzberg 1989, p. 435 (Paris, 19 [?January] 1898; to Lucien Pissarro): 'Malgré les événements graves qui se déroulent à Paris, je suis obligé, malgré mes préoccupations, de travailler à ma fenêtre, comme si de rien n'était; enfin espérons que tout cela finira par des chansons!'

14 Bailly-Herzberg 1989, p. 436 (Paris, 21 January 1898; to Lucien Pissarro): 'Pourvu que cela ne m'arrête pas dans mon travail, ce serait dommage car je suis bien en train.'

other building in this series, and Pissarro chose to heighten the effect by selecting a narrow band of the building (taller than trees and other buildings) and running it parallel to the left-hand edge of the picture.

The paintings in this series as a whole not only deal with verticality versus diagonal perspective, but they also address the counter-rhythm of circularity, metonymically suggested by the circular pedestrian island, which can be found in every single one of these fifteen pictures. This notion of circularity commands the structure of this series in several ways. Pissarro's compositional tactics proceed from left to right, as though intent on enclosing the circle of the Place du Théâtre Français with his gaze. It is also significant to note that, in the letter in which he first mentioned Félix's death to Lucien, he recommended that one remedy against grief was 'to *surround oneself* with art' (my emphasis). The paintings of the Avenue de l'Opéra certainly evoke this all-enveloping effect, whereby the artist is seen to wrap himself up in his own series.

The traffic itself ('circulation' in French) no longer follows the orthogonal, orderly pattern as seen in the Boulevard Montmartre series. Here, it moves around sets of roundabouts. Yet there is something organic in the way the individual components (pedestrians, carriages, omnibuses, wheelbarrows) form a set of patterns all of their own, free, yet organised, autonomous, yet limited. The cycles of light and weather and seasonal effects gain a new resonance in this particular context.

In fact, there is an analogy between Pissarro's work on the Avenue de l'Opéra series and the process of the gradual enlightening of society as it uncovers its own injustice. It took twelve years for the French judicial administration to realise and redress the judicial blunder that had been made – Dreyfus was exonerated in 1906, three years after Pissarro's death. The concept behind this long process is the benefit to be derived from reflection. An analogous equivalent of such reflection, in pictorial terms, is precisely what is needed 'for a painter to paint a good picture.'[15] The process was further defined by Pissarro as he was painting the Avenue de l'Opéra series: 'looking for our elements in what surrounds us, with the help of our own senses'.[16] This reflective process is never far from tautology; using Cézanne as an

The Avenue de l'Opéra before 1900

example, Pissarro wrote, 'Take Cézanne: while he has a lot of character, does this stop him from being himself?'[17] The concept of critical reflection was used by Pissarro in his letters to define the process of discussion experienced by French society as the Dreyfus case unfolded: 'we begin to think matters over'.[18] Out of this reflection comes the light of knowledge that dissipates prejudice, obscurantism, traditionalism: 'it would be amazing if a dozen jurors were able to see clearly in this case . . . only independent people can see straight . . . one should hope that [the people] will see clearly where they are being led.'[19] However, as Pissarro pointed out, the end result of this reflection cannot be obvious, since, 'unfortunately, the people cannot see further than the ends of their noses'.[20]

What is fascinating in this corpus of letters written while the Avenue de l'Opéra series was being painted is the correlation of metaphors used to describe the political situation and the act of painting itself, so that, out of context, a comment such as 'one can't see very much' could serve as a visual metaphor for the political confusion of the time, or equally be taken as a literal description of a fog effect, or of the painting representing that effect.[21] The artist's eye is at the centre of a network of significations and concerns throughout his life; in an astonishing letter Pissarro referred to the eye (*oeil*) in three different senses: 'I have to go and see Parenteau again for my eye [literal sense]; it's nothing, but it has to be done and I don't need a microscope to see that my work is progressing ['avance à vue d'oeil'; hyperbole]; I am having great fun, the light is so splendid – it's a feast for the eyes [metaphor].'[22]

In no other series does the interaction of light and sight play such a major role. In the Rouen series, the sunlight is occasionally represented scorching the whole picture plane; in the Avenue de l'Opéra series, it is light that floods the canvases – the sun itself is never seen. It is

15 Bailly-Herzberg 1989, p. 465 (Paris, 27 March 1898; to Lucien Pissarro): 'pour un peintre faire un beau tableau'.

16 Bailly-Herzberg 1989, p. 458 (Paris, 7 March 1898; to Lucien Pissarro): 'en cherchant nos éléments dans ce qui nous entoure, avec nos propres sens'.

17 Bailly-Herzberg 1989, p. 458 (Paris, 17 March 1898; to Lucien Pissarro): 'Et Cézanne, tout en ayant du caractère cela empêche-t-il qu'il soit lui?'

18 Bailly-Herzberg 1989, p. 446 (Paris, 3 February 1898; to Lucien Pissarro): 'on commence à réfléchir'.

19 Bailly-Herzberg 1989, p. 446 (Paris, 3 February 1898; to Lucien Pissarro): 'ce serait extraordinaire que douze jurés vissent clair dans cette affaire . . . il n'y a guère que les indépendants qui voient juste . . . on peut espérer que [le peuple] verra clair où on le mène'.

20 Bailly-Herzberg 1989, p. 441 (Paris, 27 January 1898; to Lucien Pissarro): 'Malheureusement le peuple n'y voit plus goutte.'

21 Bailly-Herzberg 1989, p. 443 (Paris, 28 January 1898; to Georges Pissarro): 'on [n']y voit pas grand chose'.

22 Bailly-Herzberg 1989, p. 457 (Paris, 7 March 1898; to Lucien Pissarro): 'J'ai dû aller encore chez Parenteau pour mon oeil; c'est rien, mais il faut que ce soit fait, en mon travail avance à vue d'oeil; cela m'amuse énormément, les lumières sont si splendides, c'est une fête des yeux!'

facing page: detail of ill. 70

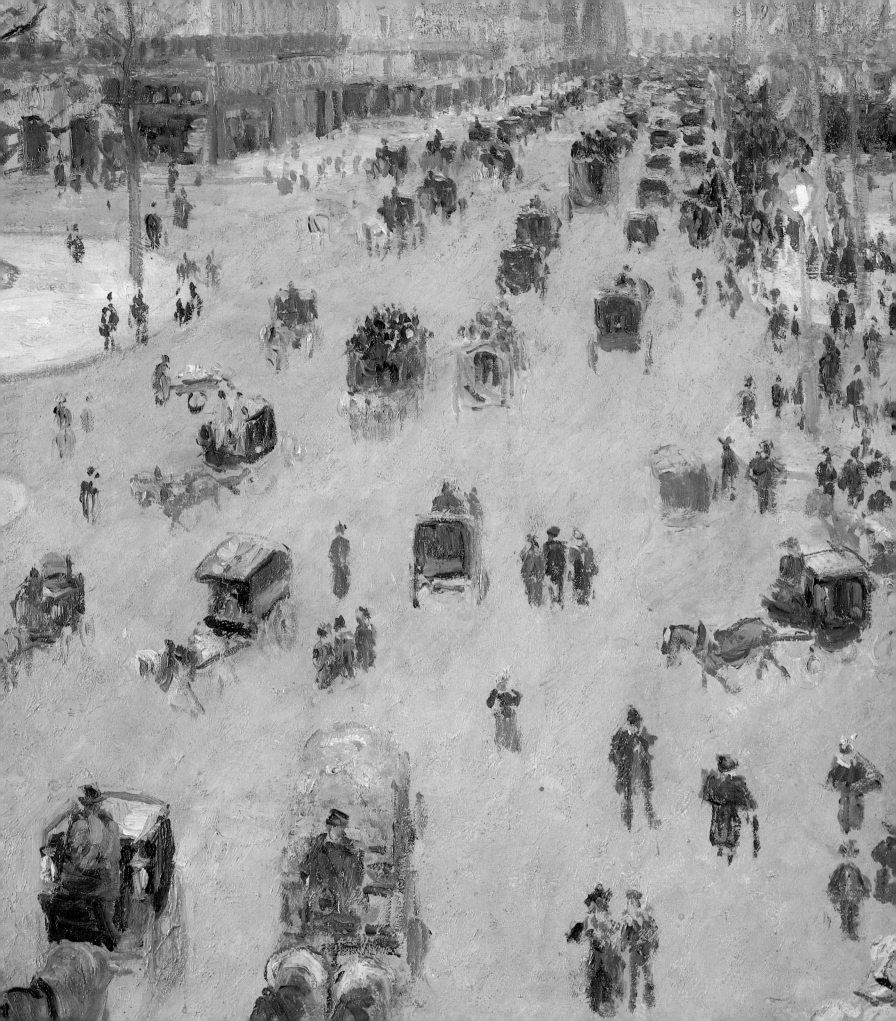

light that heightens the delicate balance between winter and spring (cats 69 and 72), or between rain and clouds (cat. 64), fog and buildings (cat. 63, ill. 62), snow and traffic (ill. 67). It is light that unites these pictures and that keeps the individual preoccupations and reflections alive. Just before embarking upon the series, Pissarro described his new motif to Lucien: 'these Paris streets which are often called ugly, but which are so silvery, so luminous and so lively'.[23] Silver, light and life are invoked in a poetic succession of attributes in anticipation of the splendour of the series to come.

23 Bailly-Herzberg 1989, p. 418 (Paris, 15 December 1897; to Lucien Pissarro): 'ces rues de Paris que l'ou a l'habitude [de] dire laides, mais qui sont si argentées, si humineuses et si vivantes'.

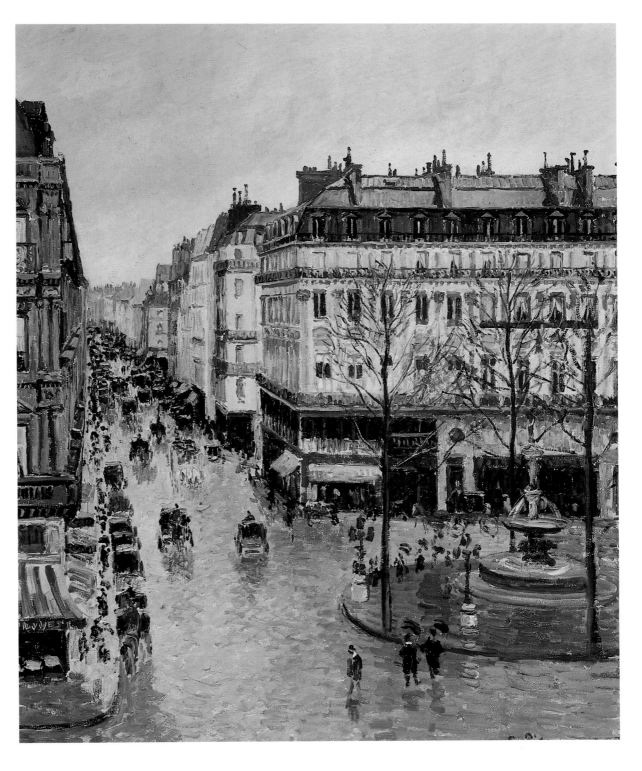

59 NOT EXHIBITED

*Rue Saint-Honoré: Afternoon,
Rain Effect* 1897

Rue Saint-Honoré, après-midi, effet de pluie
P&V 1018
81 × 65 cm

Thyssen–Bornemisza Collection, Lugano,
Switzerland

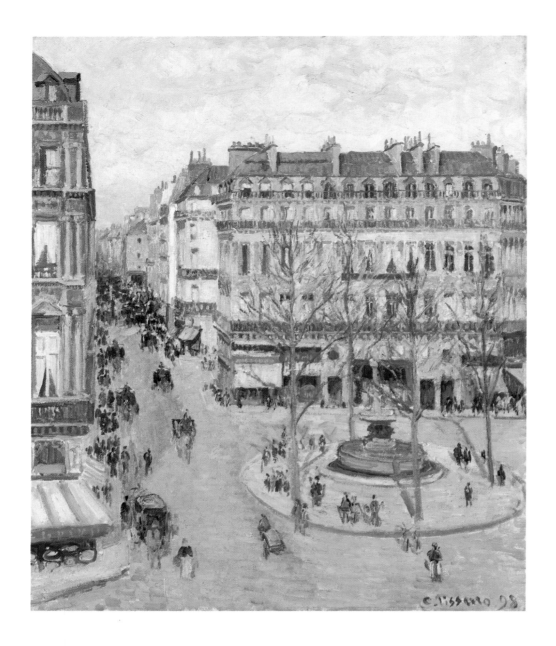

Rue Saint-Honoré, Morning-Sun Effect, Place du Théâtre Français
1898

*La Rue Saint-Honoré, effet de soleil, matin,
Place du Théâtre Français*
P&V 1020
65.5 × 54 cm
Signed and dated lower right: *C. Pissarro 98*

The Ordrupgaard Collection, Copenhagen

PROVENANCE Bought by Wilhelm Hansen
for the Ordrupgaardsamlingen, Copenhagen,
after 1923

EXHIBITIONS Paris 1898, no. 23; Tokyo
1989, no. 40 (repr. p. 130)

LITERATURE Swane 1954, no. 92; Rostrup
1966, no. 92; Stabell 1982, no. 90

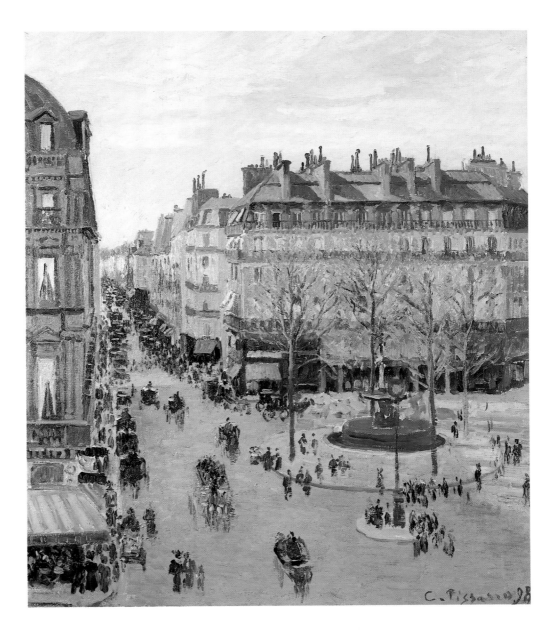

61 NOT EXHIBITED

Rue Saint-Honoré: Sun Effect,
Afternoon 1898

La Rue Saint-Honoré, effet de soleil, après-midi
P&V 1021
65 × 54 cm

Henry and Marion Bloch

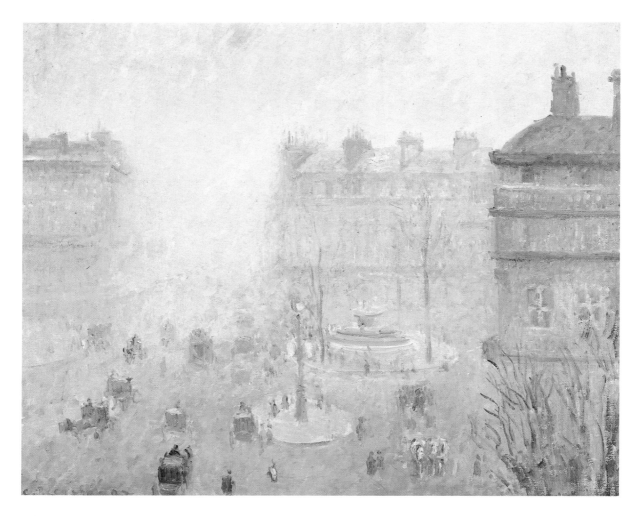

62 NOT EXHIBITED

*Place du Théâtre Français: Foggy
Weather* 1898

La Place du Théâtre Français, temps de brouillard
P&V 1019
54 × 65 cm

Dallas Museum of Art, The Wendy and
Emery Reves Collection

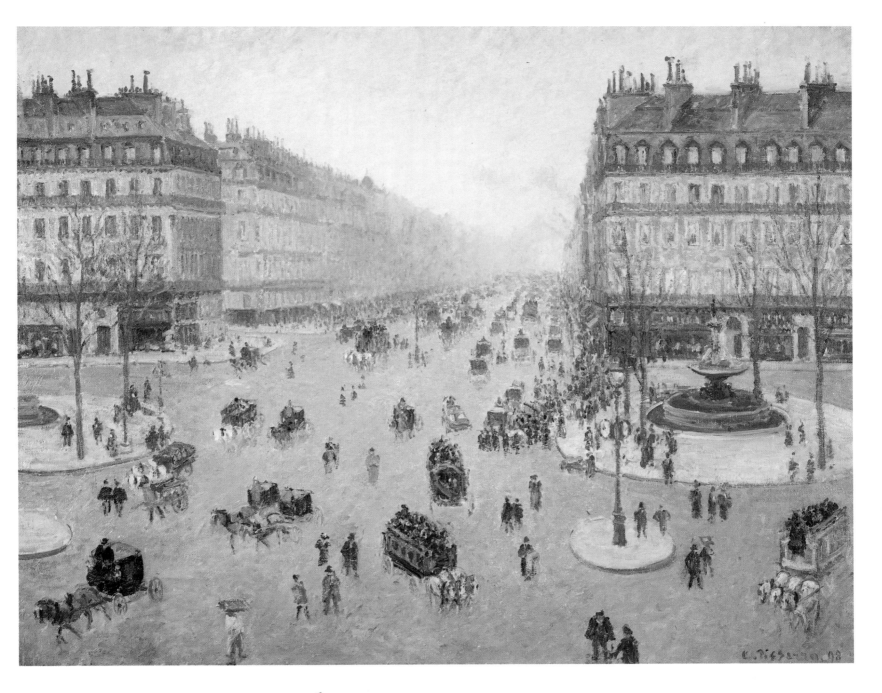

63 EXHIBITED IN DALLAS AND
PHILADELPHIA

*Avenue de l'Opéra, Place du
Théâtre Français: Misty
Weather* 1898

*Avenue de l'Opéra, Place du Théâtre Français,
temps brumeux*
P&V 1028
74 × 91.5 cm
Signed and dated lower right: *C. Pissarro. 98*

Private Collection, New York

PROVENANCE Museum der bildenden
Künste, Leipzig; Private Collection,
Germany; Stephen Hahn Gallery, New York;
Bakalar Collection, New York; sale,
Sotheby's, New York, 13 May 1986 (1B);
Private Collection, New York

EXHIBITION Paris 1898, no. 3

LITERATURE *Berliner Illustrierte Zeitung*,
1903–4 (repr.)

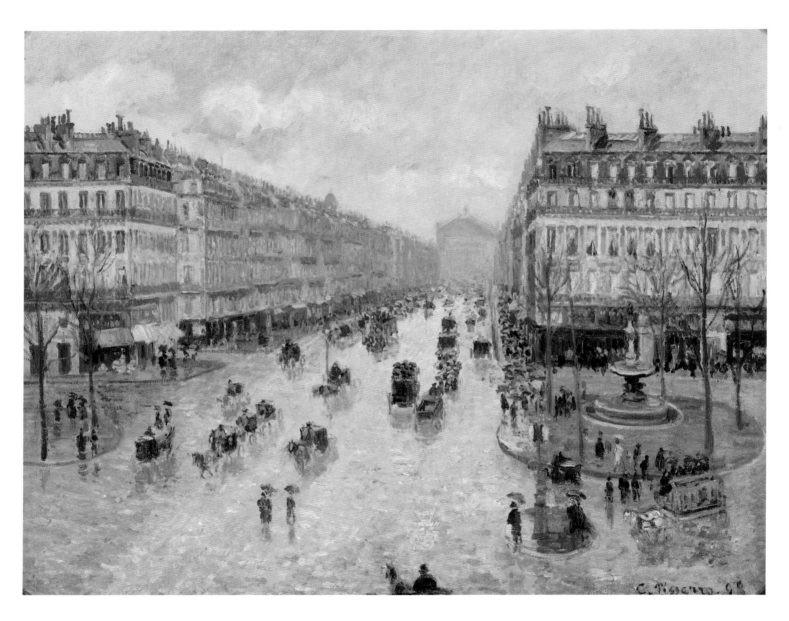

64 EXHIBITED

Avenue de l'Opéra: Rain Effect
1898

L'Avenue de l'Opéra, effet de pluie
P&V 1026
65 × 83 cm
Signed and dated lower right: *C. Pissarro. 98*

Private Collection

PROVENANCE A. Guttmann, Berlin; sale,
Collection A. Guttman, Berlin, 18 May 1917
(74; repr.); Wildenstein; Richard Semmell,
Berlin, by 1930; sale, Amsterdam, 13 June
1933 (28; repr.); Joseph Stransky; bought by
Wildenstein & Co., New York, 1936 (no.
16480); bought by Arthur Sachs, 1942;
Private Collection

EXHIBITIONS Paris 1930, no. 137; Paris
1956, no. 91

65 EXHIBITED

*Place du Théâtre Français: Rain
Effect* 1898

La Place du Théâtre Français, effet de pluie
P&V 1030
73.7 × 91.5 cm
Signed and dated lower right: *C. Pissarro. 98*

The Minneapolis Institute of Arts, The
William Hood Dunwoody Fund

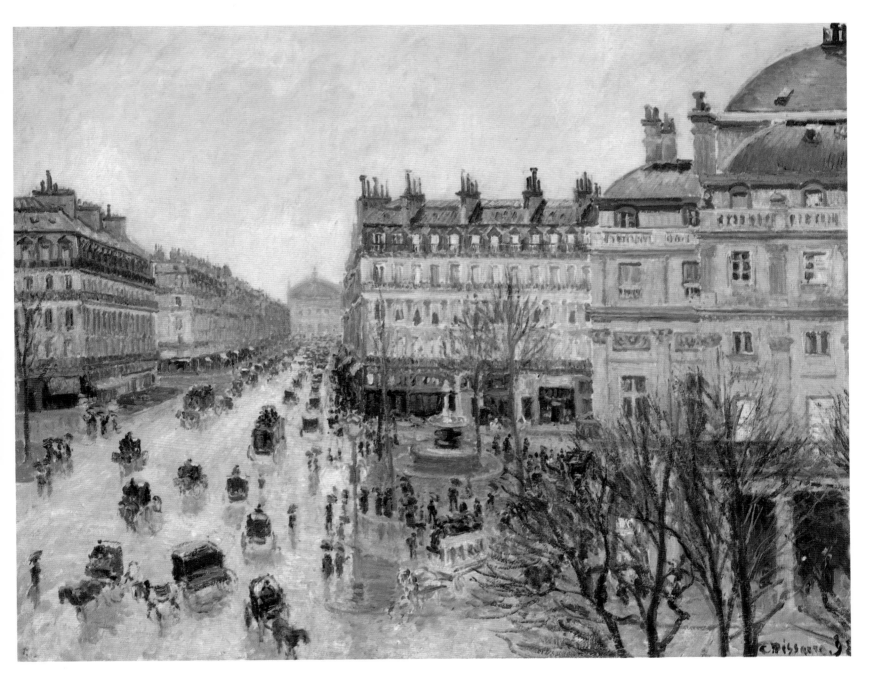

PROVENANCE Durand-Ruel Galleries, New York; The Minneapolis Institute of Arts

EXHIBITIONS Paris 1898, no. 4; The Hague 1901, no. 162; New York 1957; Palm Beach 1960, no. 21 (repr. p. 24); Montreal 1967, p. 103, (repr. opp. p. 216); Minneapolis 1979, no. 12 (repr. no. 12); Memphis 1980, no. 12 (repr. col. p. 44); Tokyo 1984, no. 58 (repr.), p. 138; Pittsburgh 1989, no. 68, pp. 158–59 (repr. col. p. 159)

LITERATURE *Vu*, 3 February 1937; *La Renaissance*, January–February 1937; *Letters*, 1943, pp. 317, 319, 322, 324–25; *The Minneapolis Institute of Arts Bulletin*, vol. XXXIII, 1 April 1944 (repr. p. 50); Rewald 1963, p. 150 (repr. col. p. 117); Schneider, 1968, p. 187 (repr. col. p. 117); Canaday 1969 (repr. col. p. 118); *Masterpieces of Impressionism*, Paris, 1971; Handlin 1971; Schwartz 1971; Courthion 1972, p. 124 (repr. col. p. 125); Lloyd 1979, p. 10 (repr. col. pl. 38); Canaday 1981, p. 232 (repr. p. 276); Lloyd 1981; Kostof 1985, p. 645 (repr. fig. 25.11); Skira n.d. (repr. p. 54)

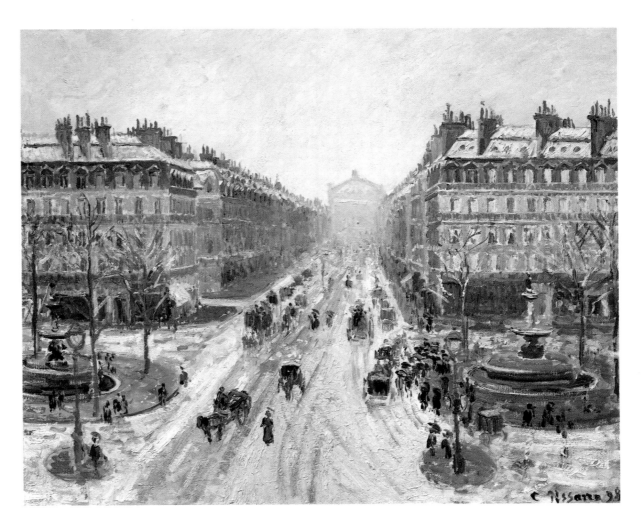

66 NOT EXHIBITED

Avenue de l'Opéra: Snow Effect
1898

Avenue de l'Opéra, effet de neige
P&V 1022
54 × 65 cm

Private Collection

facing page: detail of ill. 66

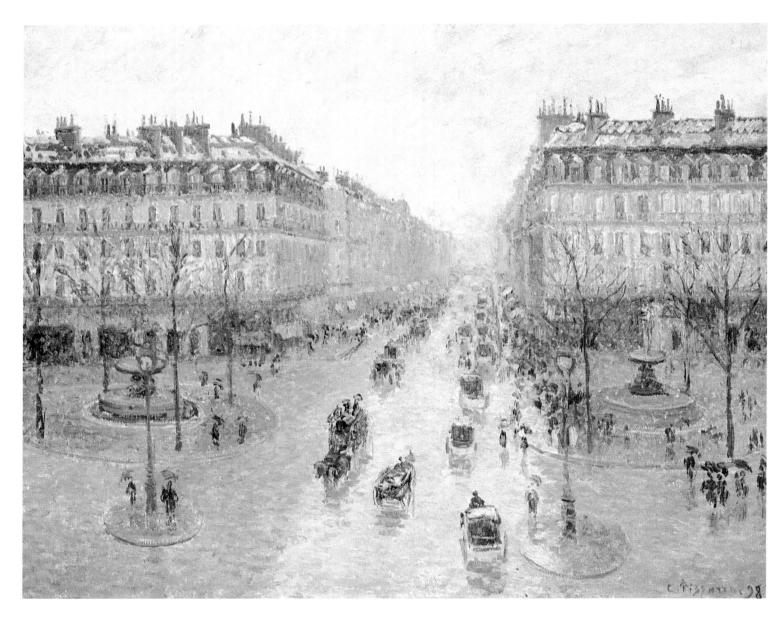

67 NOT EXHIBITED
Avenue de l'Opéra: Snow Effect
1899

L'Avenue de l'Opéra, effet de neige
P&V 1029
65 × 81 cm

Pushkin State Museum of Fine Arts

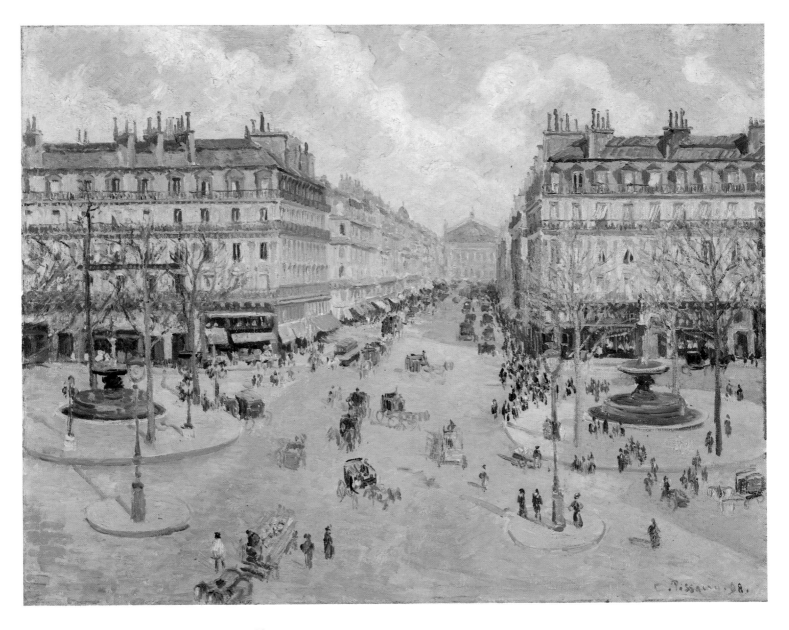

68 EXHIBITED IN LONDON

*Avenue de l'Opéra: Morning
Sunshine* 1898

L'Avenue de l'Opéra, soleil du matin
P&V 1025
65 × 81 cm
Signed and dated lower right: *C. Pissarro. 98.*

Private Collection, Philadelphia

PROVENANCE A. M. Carroll Tyson;
Private Collection, Philadelphia

EXHIBITIONS Paris 1898, no. 27; Zurich
1913, no. 1

LITERATURE Thornley n.d. (repr.)

Avenue de l'Opéra: Sunshine, Winter Morning 1898

Avenue de l'Opéra, soleil, matinée d'hiver
P&V 1024
73 × 91.8 cm
Signed and dated lower right: *C. Pissarro 98*

Musée des Beaux-Arts, Reims

PROVENANCE Bought from the artist by
Galerie Durand-Ruel, Paris, 2 May 1898
(2,000 francs; no. 4630); bought by H.
Vasnier, 1902; bequeathed by Henry Vasnier
to the Musée des Beaux-Arts, Reims,
November 1907

EXHIBITIONS Paris 1898, no. 1; Reims
1948, no. 96; Berlin 1963, no. 55 (repr.);
Troyes 1969, no. 83 (with error) (repr.
pl. VIII); Leningrad 1970, p. 34 (repr. p. 91);
Madrid 1971, no. 58 (repr. p. 122); Reims
1973; Salzburg 1973, no. 22 (repr. p. 24); La
Courneuve 1974, no. 21, p. 51; Memphis
1980, no. 12 (repr. p. 45); London 1980–81,
no. 79 (repr.); Paris 1988(i), no. 251, p. 288
(repr.)

LITERATURE *Catalogue Sartor Vasnier*,
Musée du Louvre, Paris, n.d., no. 208;
Atalone 1909, p. 67; Tabarant 1924, (repr.
pl. 37); Uhde 1937 (repr. pl. 53); Duret 1939,
p. 62; Rewald n.d. (repr. pl. 56); Coe 1954,
p. 108; Vergnet-Ruiz 1962, p. 182 (repr.
pl. 184); *Musica moderna*, February 1968,
p. 41; Adhémar 1970, (repr. pp. 393–4);
Pomarède 1970; *Alpha*, no. 222, March 1972;
Histoire de la vie française, vol. VII, 1972,
p. 311 (repr.); *Pissarro*, 1972, p. 65; *Formule 1*,
no. 10, March 1973, p. 43; Gabanizza 1976,
p. 40; Nakamura 1978, pp. 104–5; Haberman
1987 (repr. jacket); Reidemeister n.d. (repr.
p. 10a)

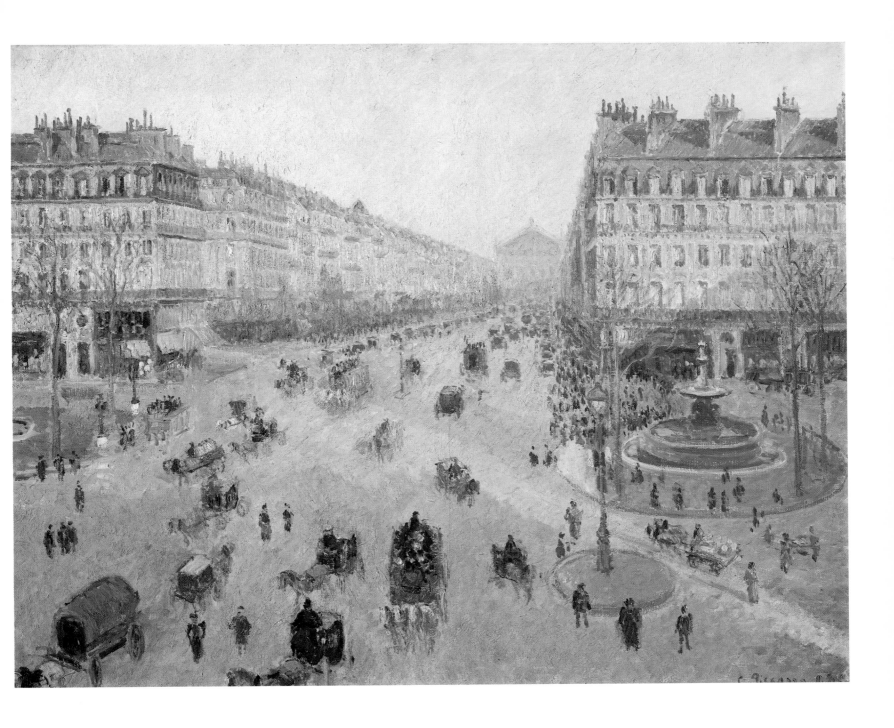

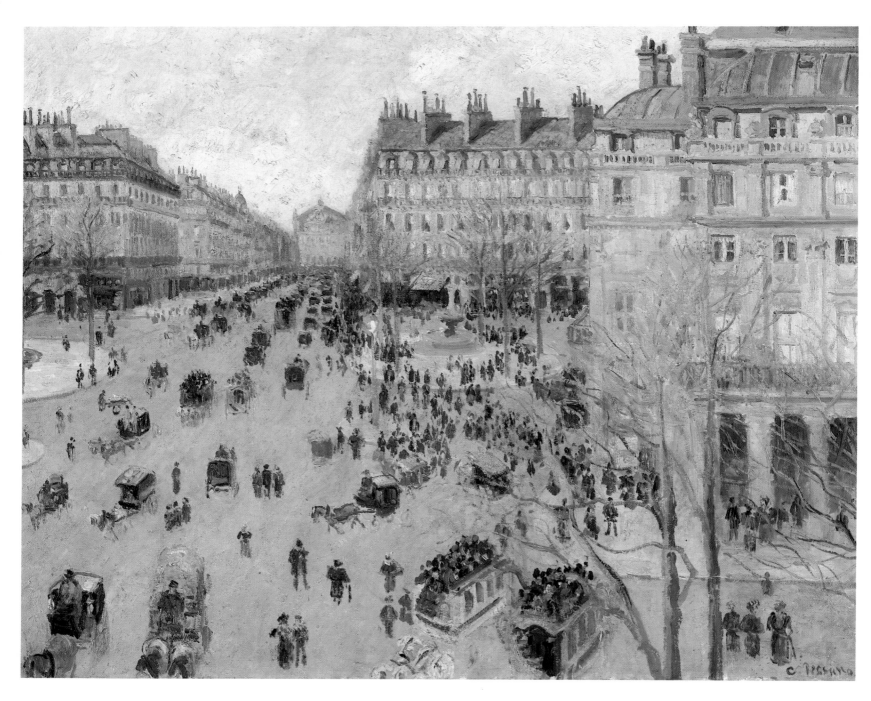

70 NOT EXHIBITED

Place du Théâtre Français: Sun Effect 1898

Place du Théâtre Français, effet de soleil
P&V 1023
75 × 94 cm

National Museum of Belgrade

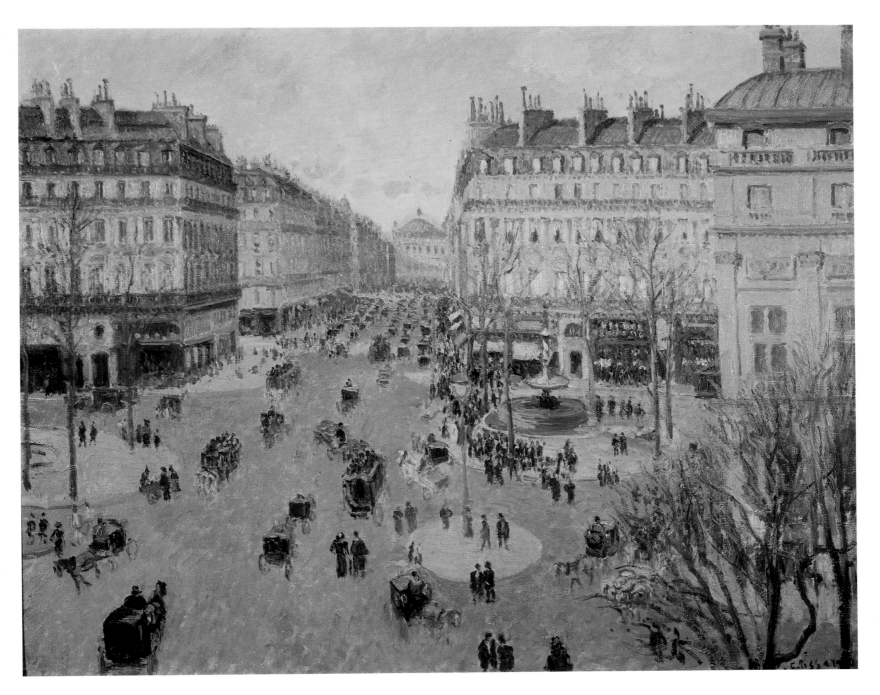

71 NOT EXHIBITED

Place du Théâtre Français:
Afternoon Sun in Winter 1898

Place du Théâtre Français, soleil d'après-midi en
hiver
P&V 1027
73 × 92 cm

Private Collection

99

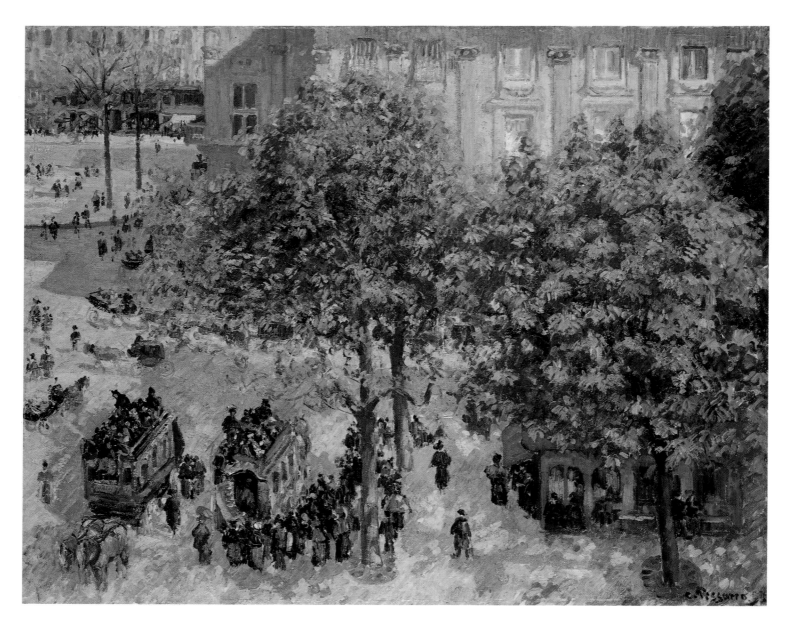

72 NOT EXHIBITED

*Place du Théâtre Français:
Spring* 1898

Place du Théâtre Français, printemps
P&V 1032
65.5 × 81.5 cm

The State Hermitage Museum, St Petersburg

73 EXHIBITED

Place du Théâtre Français 1898

La Place du Théâtre Français
P&V 1031
72.4 × 92.6 cm
Signed and dated lower right: *C. Pissarro. 98*

Los Angeles County Museum of Art, Mr and
Mrs George Gard de Sylva Collection

PROVENANCE Bought from the artist by
Galerie Durand-Ruel, Paris, 2 May 1898;
Paul Rosenberg Collection, Paris; Galerie
Durand-Ruel, Paris; Durand-Ruel Galleries,

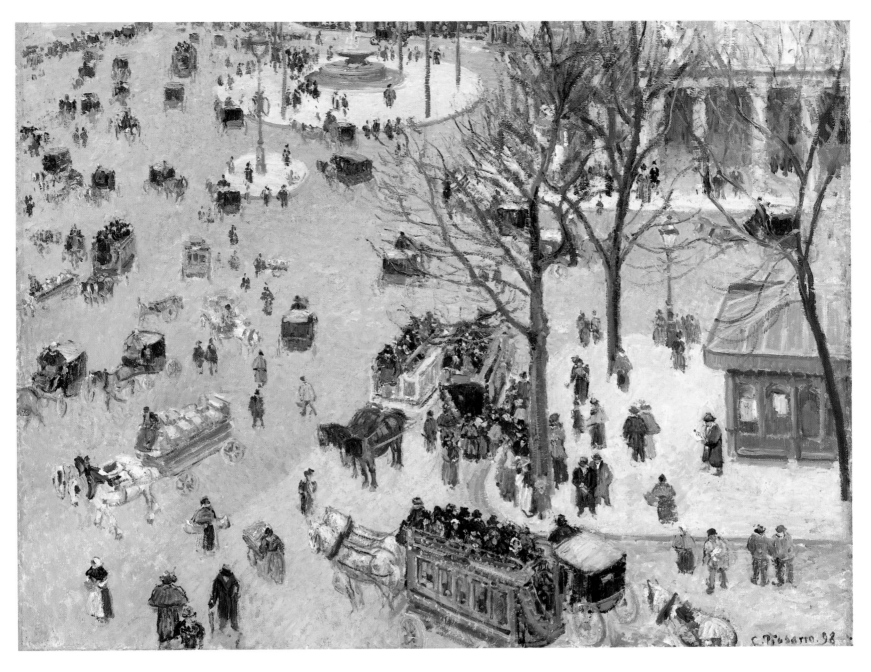

New York; Mr and Mrs George Gard de Sylva; presented by Mr and Mrs George Gard de Sylva to the Los Angeles County Museum of Art, 1946

EXHIBITIONS Paris 1898, no. 5; Paris 1921, no. 9; San Francisco 1935, no. 32; San Francisco 1939, no. 155; New York 1940, no. 19; New York 1943; Los Angeles 1946, no. 13; Raleigh 1959, no. LXVI; Eugene 1962; New York 1966(ii), no. 37, p. 33; Leningrad 1976; Memphis 1980, no. 13 (repr. col. p. 46); London 1980–81, no. 80 (repr. p. 142); Los Angeles 1984, no. 36 (repr. col. p. 133)

LITERATURE Stephens 1904, p. 434; Gotthard 1924; Tabarant 1924; *Art Digest*, 1 November 1940, p. 11; Rewald 1943, pp. 317, 319, 325; *Art News*, vol. XLII, part 1, February–September 1943; Loucheim 1946, pp. 28–33, 53; Millier 1946, p. 13; Jedlicka 1950; *Los Angeles County Museum of Art; The Mr and Mrs George Gard de Sylva Collection of French Impressionists and Modern Paintings and Sculpture*, Los Angeles, 1950, p. 37, pl. 13; *Thirty-Five Paintings from the Collection of the Los Angeles County Museum of Art*, Los Angeles, 1950, no. 25; Wechsler 1952, p. 7; Bernier 1965, pp. 30–37; Werner 1965, pp. 30–35; *McCall's*, April 1965, pp. 116–27; Nochlin 1965, pp. 24–27; *Illustrated Handbook of the Los Angeles County Museum of Art*, Los Angeles, 1965, p. 87; Rubin 1967 (repr. p. 33); Elsen 1972, p. 290, no. 419; Hubbard 1972, p. 87; Denvir 1974, pp. 36, 63, pl. 29; Gardner, 1975, p. 696; Gatto 1975, pp. 5–7; *The Franklin Mint Almanac*, vol. XVI, no. 1, January–February 1985, p. 8; Adler 1986, pp. 99–116; Varnedoe 1989, p. 222 (repr. fig. 222)

5 PARIS: THE TUILERIES GARDENS
PANORAMA AND STRUCTURE OF GARDENS

'that great open space'[1]

After finishing his Avenue de l'Opéra series, Pissarro contemplated leaving Paris in order to make a series in Cluny or Lyon. He finally decided to go back to Rouen, which would keep him closer to his eye-doctor, in order to extend and complete his 1896 Rouen campaigns. His third Rouen campaign took place in the summer of 1898 (see above, p. 4). In November, the lure of a more distant venue as a source for a new series was again explored in a letter to Lucien: 'I am hoping, if my good health holds up, to go to Holland to do a nice, beautiful series.'[2]

Late in 1898, instead of looking for a hotel room in Paris from which to execute another series, Pissarro decided to rent an apartment, partly for financial reasons, partly for reasons of comfort. He found that Eragny was cold and damp in winter and damaged his canvases,[3] and he wanted to keep his family (his wife and younger children) together: 'I am going to buy some furniture so that we can go to Paris every winter as soon as the bad weather returns. I am also hoping that your mother, Cocotte and Paul will be less bored than if they stayed on their own in Eragny, which is really not very jolly in winter.'[4]

The question of finding a motif remained a prevailing concern – and was not easy to reconcile with Julie's views of where she wanted to live: 'It's going to be difficult to satisfy your mother and my work . . . if you see something that would suit me, with plenty of Parisian character, beautiful to paint, let me know.'[5] Pissarro rejected an apartment found by his wife on the Quai de Béthune, on the grounds that it was not suitable as a source of motifs, but he and his wife finally found a compromise – a comfortable family apartment which provided a suitable vista for his next series:

We have secured an apartment, 204 Rue de Rivoli, opposite the Tuileries, with a magnificent view of the garden, the Louvre to the left, the houses at the bottom, the embankments behind the trees in the garden, the dome of the Invalides to the right, the spires of Sainte-Clothilde behind the clump of chestnut trees – it's most attractive. I shall have a beautiful series to work on. It's going to be expensive, but I hope to get the money back with the series.[6]

One can note here the way in which Pissarro plots his motif in words and the way in which he mentally constructs the series as he describes it from left to right, dividing it into several sub-sections. From this point on, Pissarro would be painting his Paris series from stable, permanent bases rather than short-term, rented hotel rooms. Consequently, he would have time to meditate on and absorb his work. The sheer number of works he produced for a series thus doubled or tripled. The Tuileries series includes (according to the *catalogue raisonné*) two groups of fourteen works each, one executed in 1899 and one in 1900. Simultaneously, the greater diversity of formats, motifs, techniques and effects was a result of the fact that Pissarro could now take more time over his series.

Another considerable difference between working from an apartment rather than an hotel room was that Pissarro was not only able to extend the periods of time covered in his series, but was also able to extend his visual field, laterally and in depth, as he moved from room to room.

Lastly, a final defining feature of Pissarro's Paris series from this time on was that his work focused on the Louvre and its vicinity. This is a crucial aspect of Pissarro's strategy in the selection of motifs from 1899 onwards. In January 1899, at the behest of Durand-Ruel, he initially shunned the prospect of doing a series of paintings of the Seine banks in Paris: 'From January onwards, I have to do a good series of things that Durand will be interested in.'[7] One year later, however, it was the view of the

1 Bailly-Herzberg 1991, p. 9 (Paris, 22 January 1899: to Lucien Pissarro): 'ce grand espace ouvert'.
2 Bailly-Herzberg 1989, p. 518 (Eragny-Bazincourt par Gisors, 16 November 1898; to Lucien Pissarro): 'J'espère, si ma santé continue à être bonne, aller en Hollande faire une belle et bonne série.'
3 Bailly-Herzberg 1989, p. 518 (Eragny-Bazincourt par Gisors, 16 November 1898: to Lucien Pissarro).
4 Bailly-Herzberg 1989, p. 518 (Eragny-Bazincourt par Gisors, 16 November 1898: to Lucien Pissarro): 'Je vais acheter des meubles afin que tous les hivers nous allions à Paris aussitôt le mauvais temps revenu. J'espère qu'ainsi ta mère, Cocotte et Paul s'ennuieront moins à rester seuls à Eragny, qui n'est vraiment pas gai en hiver.'
5 Bailly-Herzberg 1989, p. 519 (Eragny-Bazincourt par Gisors, 18 November 1898; to Georges Pissarro): 'ce sera difficile de contenter ta mère et mon travail . . . Si vous voyez quelque chose dans le sens qu'il me faut, ayant bien le caractère parisien, beau à faire, signale-le-moi.'
6 Bailly-Herzberg 1989, p. 522 (Eragny-Bazincourt pars Gisors, 4 December 1898; to Lucien Pissarro): 'Nous avons arrêté un appartement rue de Rivoli, 204, en face des Tuileries, avec une vue superbe du jardin, du Louvre à gauches, au fond les maisons, des quais derrière les arbres du jardin, à droite le dôme des Invalides, le clochers de Sainte-Clothilde derrière les massifs de marroniers, c'est très beau. J'aurai une belle série à faire. (Cela va me coûter cher, mais j'espère m'en tirer avec ma série.)'
7 Bailly-Herzberg 1989, p. 518 (Eragny-Bazincourt par Gisors, 16 November 1898; to Lucien Pissarro): 'à partir du mois de janvier il faudra que je fasse une bonne série de choses qui intéressent Durand'.

facing page: detail of cat. 76

Louvre, seen precisely from these 'Seine banks' that he was to focus upon for series created over the last three years of his life.

Pissarro was now looking for new contrasts, new oppositions of themes. The Tuileries series develops the non-urban aspect of metropolitan space – the parks where the city negates itself, opens itself on to nature. The contrast between architecture and nature had already been partly addressed in the Boulevard Montmartre series (see, in particular, *Boulevard Montmartre: Spring* (cat. 51) or *Boulevard Montmartre: Spring* (ill. 52)); in the Avenue de l'Opéra as well as in the Rouen series, on the other hand, signs of the presence of nature were scarce (except in *Place du Théâtre Français: Spring* (cat. 73)). In the Tuileries series nature takes over, rampantly so in several cases.

Pissarro's apartment on the Rue de Rivoli was located almost at the corner of the present Rue du 29 juillet; his windows were thus almost directly facing the Grand Bassin. As he turned gradually to his left (eastward), he could see part of the southern wing of the Louvre (the Aile Denon) with its Pavillon de Flore. When he turned due east, he could see the Pavillon de Marsan, crowning the northern wing of the Louvre (the Aile Richelieu), this view excluded the Pavillon de Flore, and focussed on the Jardin du Carrousel, with the longer part of the south wing in the background. These three define the three vantage points from which Pissarro evolved his three sub-groups within the Tuileries–Louvre series: 1) a frontal viewpoint (Bassins des Tuileries); 2) an oblique left view (Pavillon de Flore and the start of the Aile Denon in the background; 3) a sharp left view (Pavillon de Marsan seen at close range and the Jardin du Carrousel, with the Aile Denon in the background). (For an analysis of the motifs of each picture in the series, see Table 6 in the Appendix.)

The fact that Pissarro was now working from a large space was reflected immediately in the possibility of manipulating and stocking a greater number of large-format canvases; out of twenty-eight paintings of the Tuileries listed in the *catalogue raisonné*, fifteen are size 30 formats, ten are size 15 formats (see Editorial Note, p. 1). For the first time in his series, Pissarro introduced two types of size 30 formats (30F: 92 × 73 cm and 30P: 92 × 65 cm).

The compositional procedures in the Tuileries–Louvre series also present a sharp contrast to his other Paris series. The Boulevard Montmartre series articulated a compositional opposition between a single axis of rectilinear perspective enclosing columns of carriage traffic, waves of pedestrians and rows of trees set off against the austere Haussmannian façades. The Avenue de l'Opéra series was concerned with the circular dynamics of a large metropolitan road junction, with stelliform streets and axes branching off in all directions.

The Tuileries Gardens series, however, offered a a chance to study the interaction of the rectangular and the circular. A succession of rectangles are seen interlocked with each other: the *anciens jardins réservés* lead into the Jardin du Carrousel and to the Place du Carrousel and the Cour Napoléon through the Arc du Carrousel. These rectangles stretching along the Seine and confined between the Allé des Orangers and the Terrasse du Bord de l'Eau are offset by circular structures: the Grand Bassin Rond (motif 1) or the other smaller *bassins*, as well as by strong cruciform or orthogonal structures, which confer on these views a solid, architectonic strength. These structures are themselves counter-balanced by foliage or entangled branches. The marvellously symmetrical layout of the Gardens was fragmented, disrupted and pluralised in Pissarro's paintings of them.

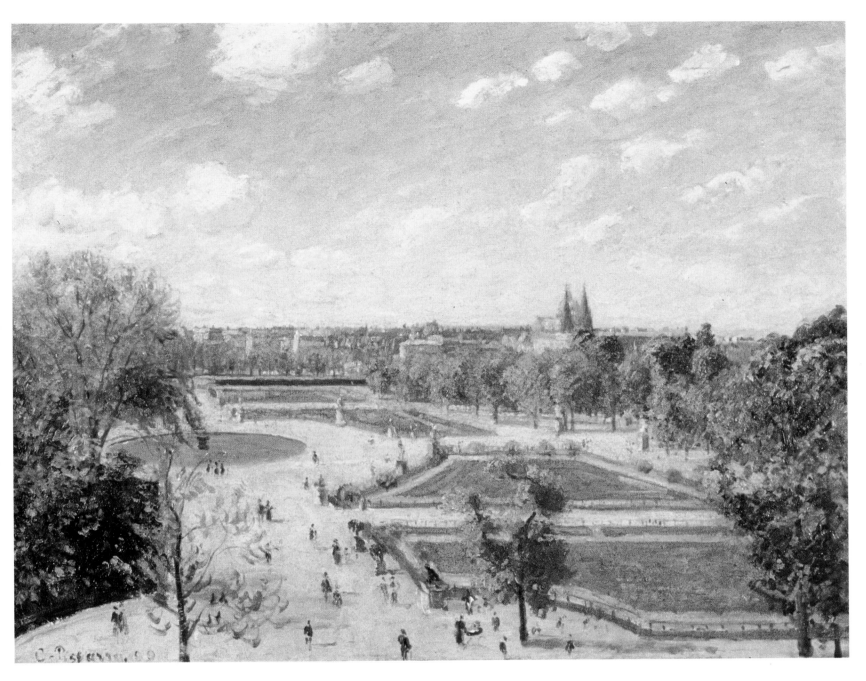

74 NOT EXHIBITED

The Tuileries Gardens: Morning, Spring, Sun 1899

Jardin des Tuileries, matinée, printemps, soleil
P&V 1099
73 × 92 cm

Private Collection

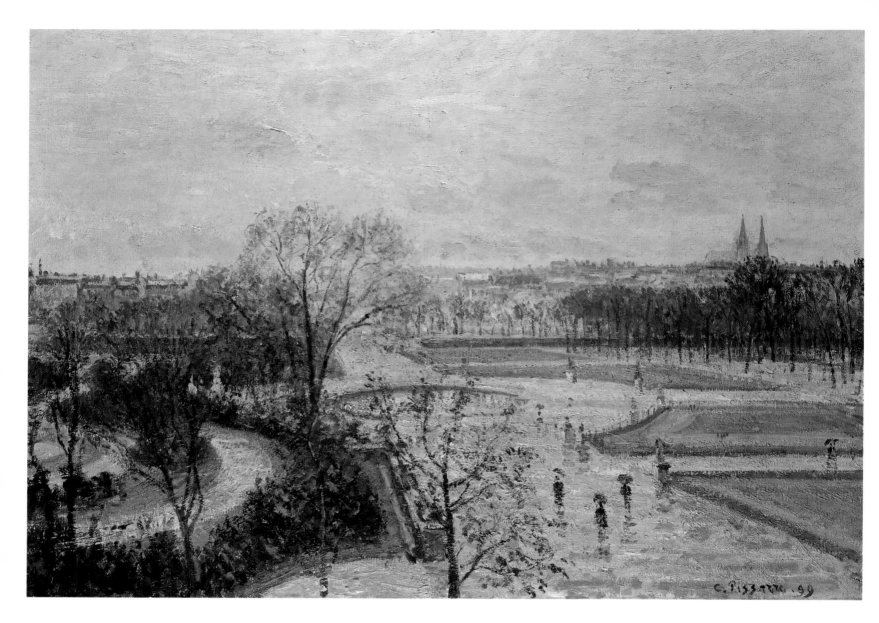

75 NOT EXHIBITED

*The Tuileries Gardens: Rainy
Weather* 1899

Le Jardin des Tuileries, temps de pluie
P&V 1102
65 × 92 cm

Ashmolean Museum, Oxford

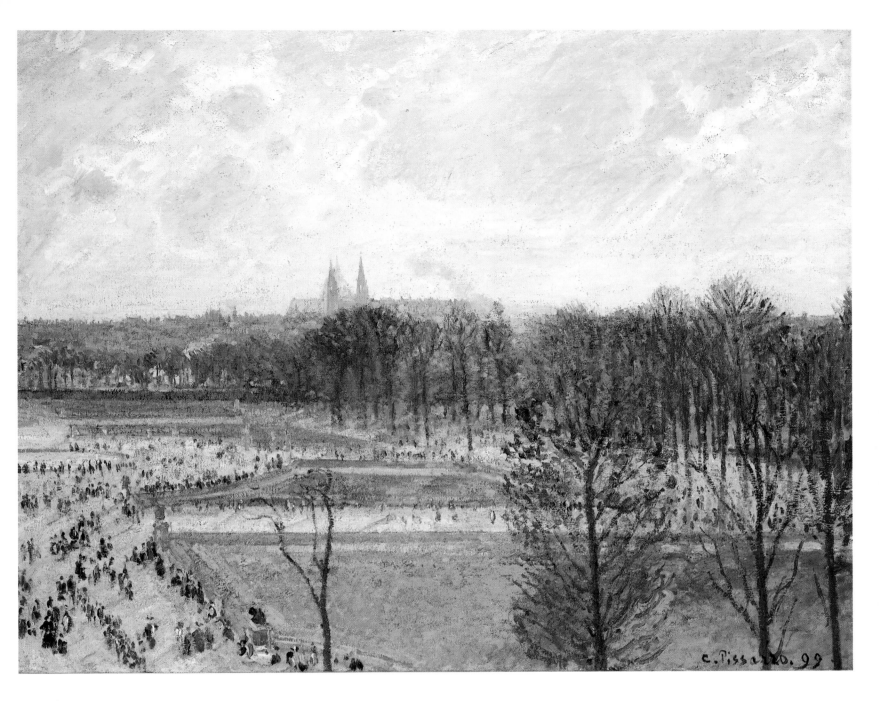

76 EXHIBITED IN DALLAS AND
PHILADELPHIA

*The Tuileries Gardens: Winter
Afternoon* 1899

Le Jardin des Tuileries, après-midi d'hiver
P&V 1097
73.3 × 92.4 cm
Signed and dated lower right: *C. Pissarro. 99*

The Metropolitan Museum of Art, New
York, Gift from the Collection of Marshall
Field III, 1979

PROVENANCE The Carstairs Gallery, New
York, 1945; Mr and Mrs Marshall Field III,
New York, until 1956; Mrs Marshall Field
III, New York, 1956; given from the
Collection of Marshall Field III to The
Metropolitan Museum of Art, 1979

EXHIBITIONS Paris 1912; New York 1945,
no. 38; New York 1962, no. 50 (catalogued
erroneously as *Champs de Mars aux Tuileries*);
New York 1965, no. 75; New York 1968(ii)

LITERATURE Alexandre 1912, no. 128
(repr. p. IX); Koenig 1927; Lloyd 1980, p. 146
(not in exhibition)

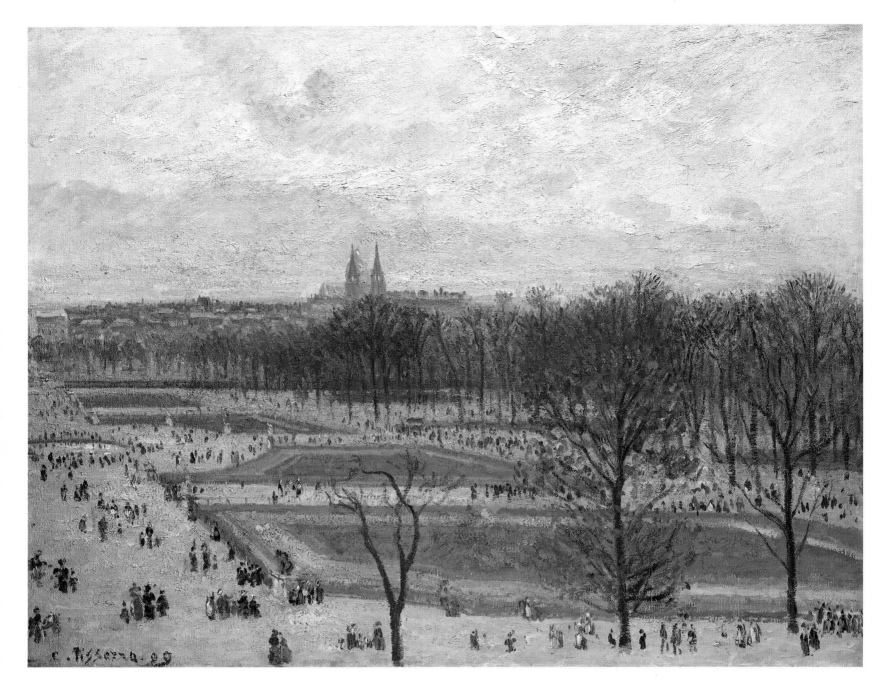

77 NOT EXHIBITED

The Tuileries Gardens: Winter Afternoon 1899

Le Jardin des Tuileries, après-midi d'hiver
P&V 1098
73 × 92 cm

The Metropolitan Museum of Art, New York, Gift of Katrin S. Vietor in loving memory of Ernest G. Vietor, 1966

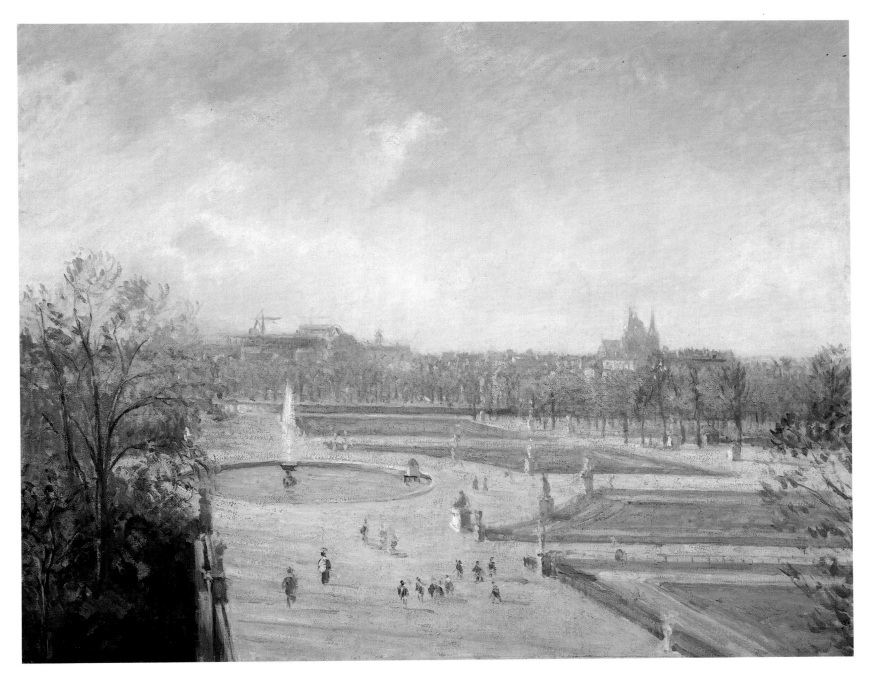

78 EXHIBITED

The Bassin des Tuileries:
Afternoon, Sun 1900

Le Bassin des Tuileries, après-midi, soleil
P&V 1125
73 × 92 cm
Signed and dated lower left: *C. Pissarro 1900*

The Israel Museum, Jerusalem (permanent
loan from the Casalla Stiftung, Vaduz)

EXHIBITION Paris 1901, no. 32

LITERATURE J. Meier-Graefe,
Entwicklungsgeschichte der Modernen Kunst,
Munich, 1915 (repr.)

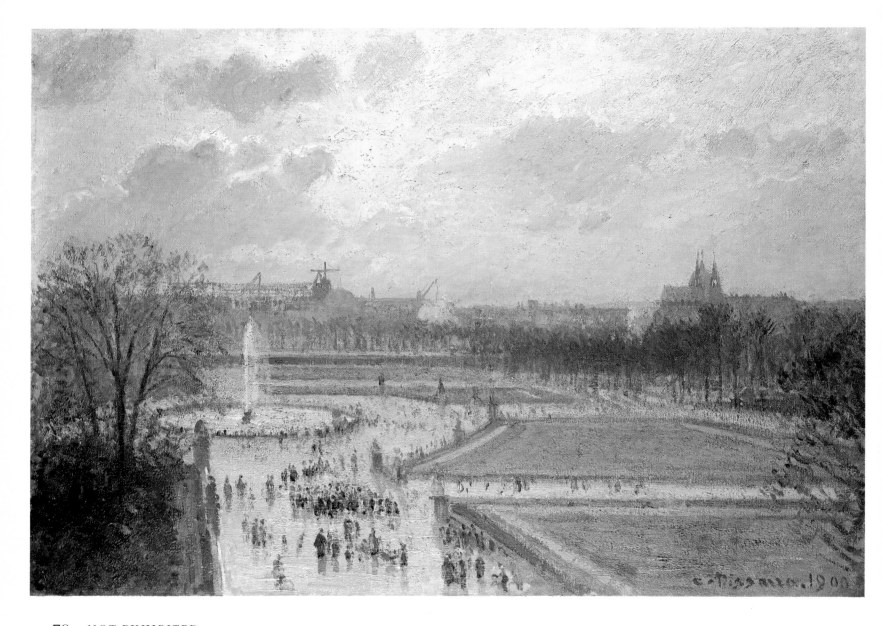

79 NOT EXHIBITED

*The Bassin des Tuileries:
Afternoon* 1900

Le Bassin des Tuileries, après-midi
P&V 1123
65 × 92 cm

Private Collection, Japan

facing page: detail of ill. 79

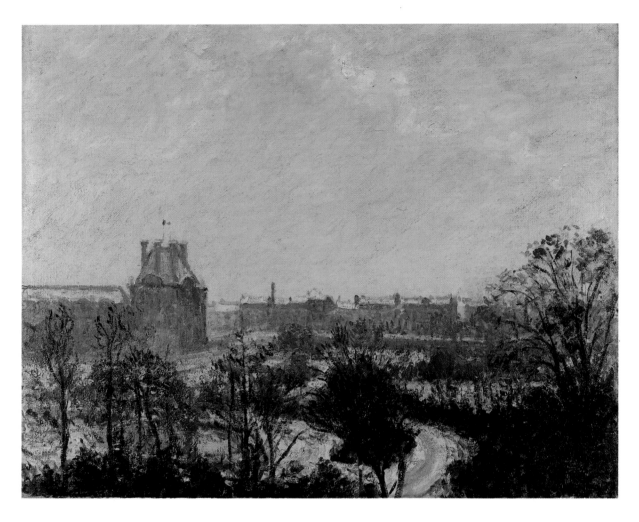

80 NOT EXHIBITED

Garden of the Louvre: Snow
Effect 1899

Jardin du Louvre, effet de neige
P&V 1103
54 × 65 cm

Private Collection

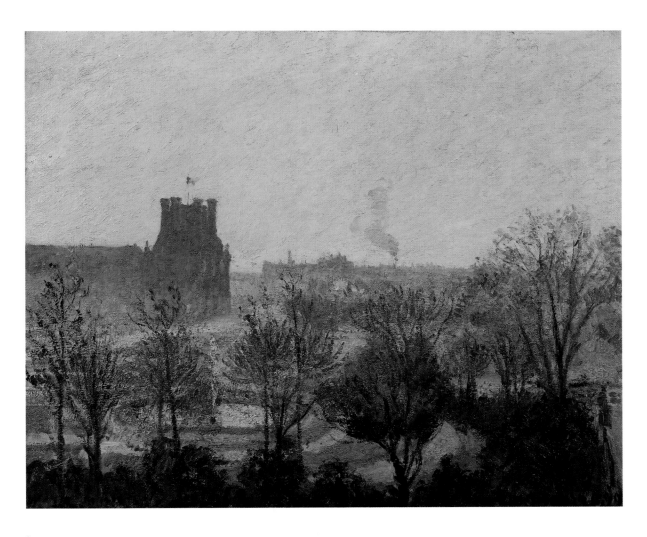

81 EXHIBITED

Garden of the Louvre: Fog Effect
1899

Jardin du Louvre, effet de brume
P&V 1104
54 × 65 cm
Signed and dated lower right: *C. Pissarro. 99*

Private Collection

PROVENANCE Galerie Durand–Ruel, Paris;
Jean d'Alayer; bought by Sam Salz Inc., New
York, 18 July 1978; Acquavella Galleries,
New York; Goddard Collection; sale,
Sotheby's, New York, 11 November 1979
(514; repr.); Private Collection

EXHIBITIONS Paris 1901, no. 15; Paris
1910(ii), no. 56; New York 1945, no. 39
(repr. p. 37); Zurich, Kunsthaus, 1959–79 (on
loan)

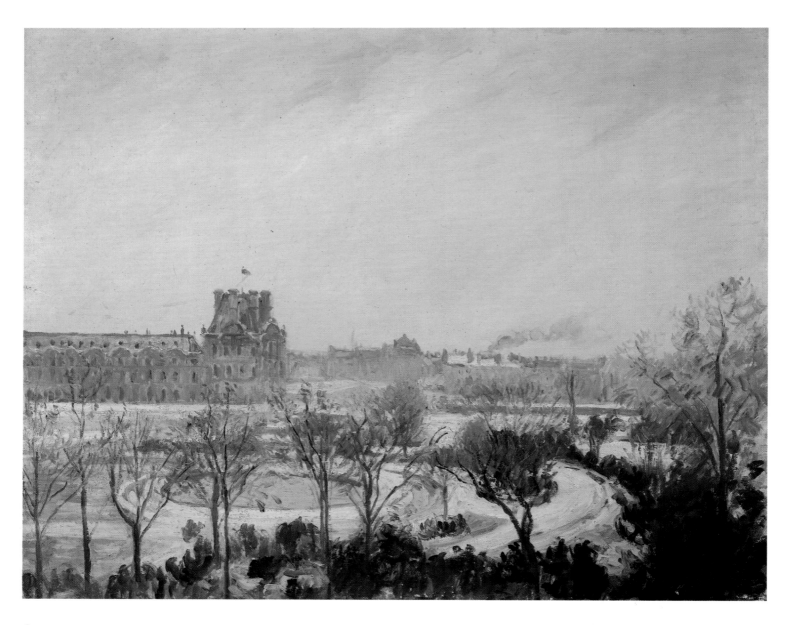

82 EXHIBITED IN PHILADELPHIA
AND LONDON

*The Tuileries Gardens: Snow
Effect* 1900

Jardin des Tuileries, effet de neige
P&V 1128
65 × 81 cm
Signed and dated lower right: *C. Pissarro.
1900*

Private Collection

PROVENANCE Durand-Matthiessen,
Geneva; Private Collection

EXHIBITIONS Paris 1901, no. 31; Paris
1910, no. 28; Paris 1937; London 1950, no. 32

114

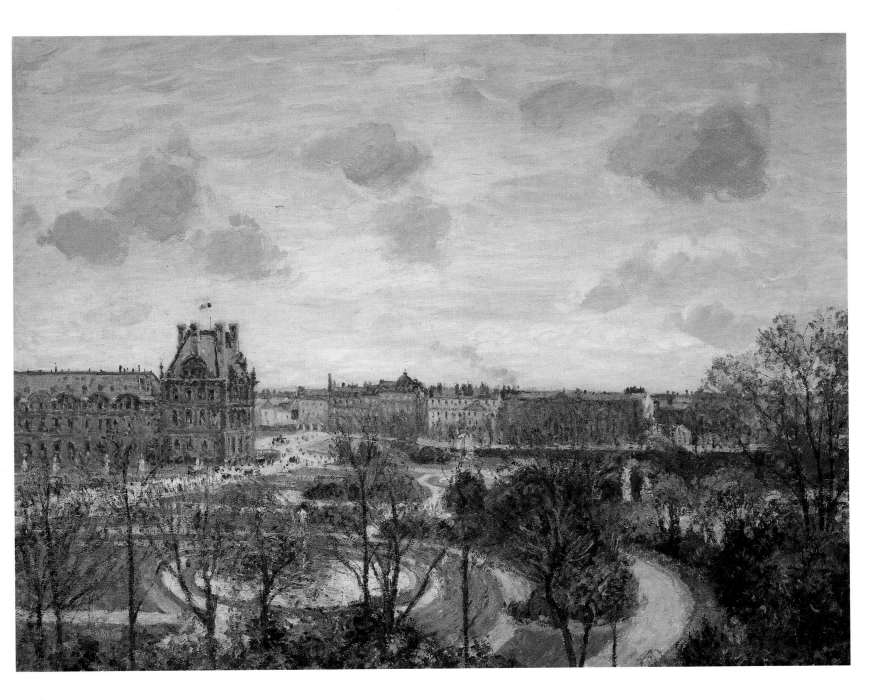

83 EXHIBITED IN PHILADELPHIA

Garden of the Louvre: Morning, Grey Weather 1899

Jardin du Louvre, matin, temps gris
P&V 1107
73 × 92 cm
Signed and dated lower right: *C. Pissarro. 1899*

Private Collection, New York

PROVENANCE Galerie Durand-Ruel, Paris; Sam Salz, Inc., New York; bought by a private collector, New York, 26 January 1968

EXHIBITIONS Paris 1921, no. 29; Paris 1923; Paris 1928, no. 86; Paris 1930, no. 76; Paris 1936, no. 15; London 1936, no. 59; New York 1968(i), no. 164 (repr. col. pl. 62); New York 1968(ii), no. 62

LITERATURE *Le Bulletin de la vie artistique*, 15 February 1921 (repr.); Tabarant 1924 (repr.); *L'Art et les artistes*, February 1928, no. 84; *Art News*, 2 May 1936 (repr.)

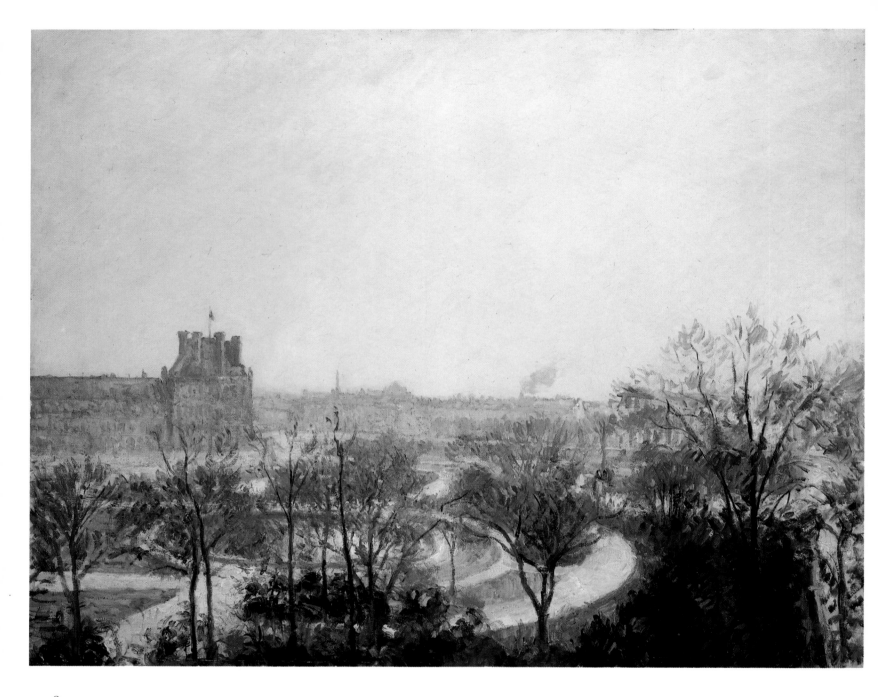

84 EXHIBITED IN LONDON

The Tuileries Gardens 1900

Jardin des Tuileries
P&V 1133
73 × 92 cm
Signed and dated lower right: *C. Pissarro, 1900*

Glasgow Art Gallery and Museum

PROVENANCE Alex Reid, London; bought by Sir John Richmond, 1911; presented by Sir John Richmond to Glasgow Art Gallery and Museum, 1948

EXHIBITIONS Glasgow 1943, no. 26; Edinburgh 1944, no. 187; Edinburgh 1949, no. 276; London 1949, no. 279; Paisley 1952; Glasgow 1967, no. 36 (repr.); Edinburgh 1968, no. 15 (repr. col.); London 1980–81, no. 85 (repr. p. 147)

LITERATURE Honeyman 1953, p. 43 (repr.); Macaulay 1953, p. 13 (repr.); Storrock 1953, p. 42; *Scottish Art Review*, vol. VI, no. 3, 1957 (repr. p. 2)

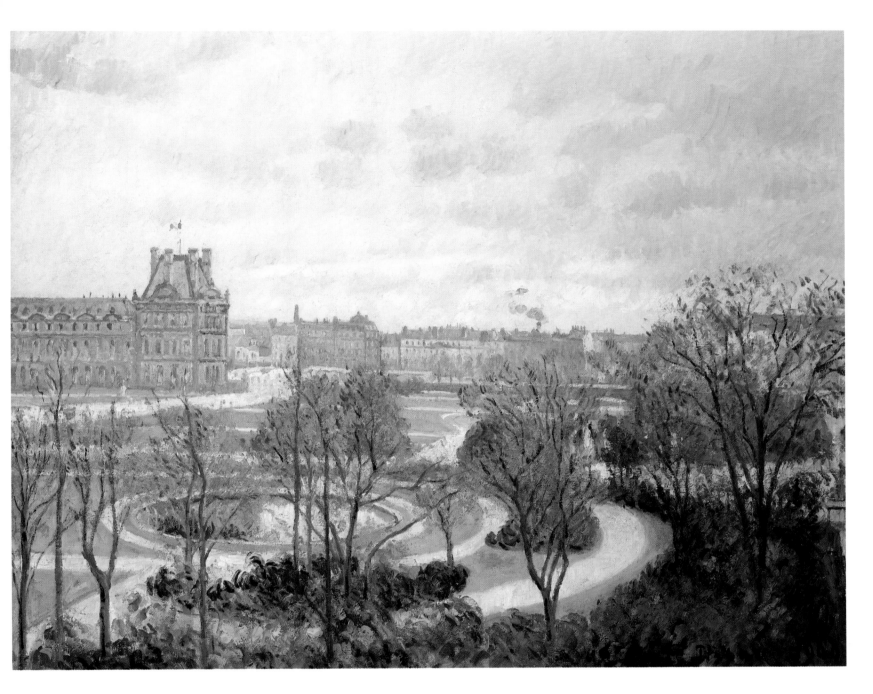

85 NOT EXHIBITED

View of the Tuileries: Morning

1900

Vue des Tuileries, matin
P&V 1132
73 × 92 cm

Private Collection

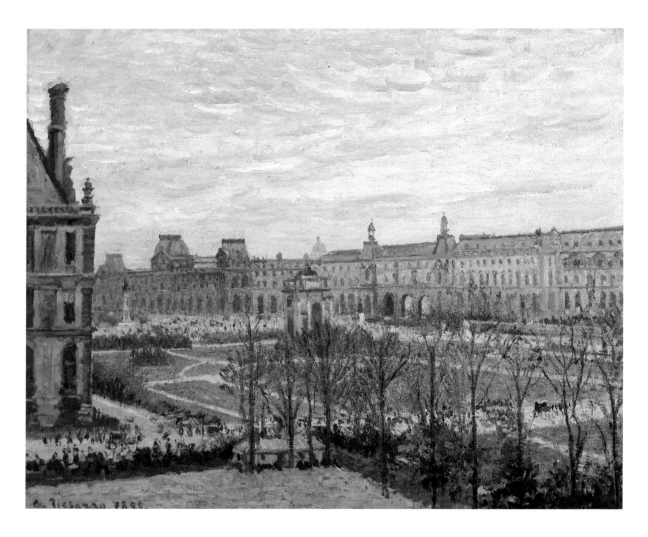

86 EXHIBITED

The Carrousel: Grey Weather
1899

Le Carrousel, temps gris
P&V 1109
54 × 65 cm
Signed and dated lower left: *C. Pissarro. 1899.*

Lorraine Pritzker

PROVENANCE Bought privately by
Wildenstein & Co., New York; bought by
Mr R. Pollack, October 1944; Mr Grégoire
Tarnopol, New York, 1965; Maxwell
Davidson III, New York; Lorraine Pritzker

EXHIBITION New York 1965, no. 76

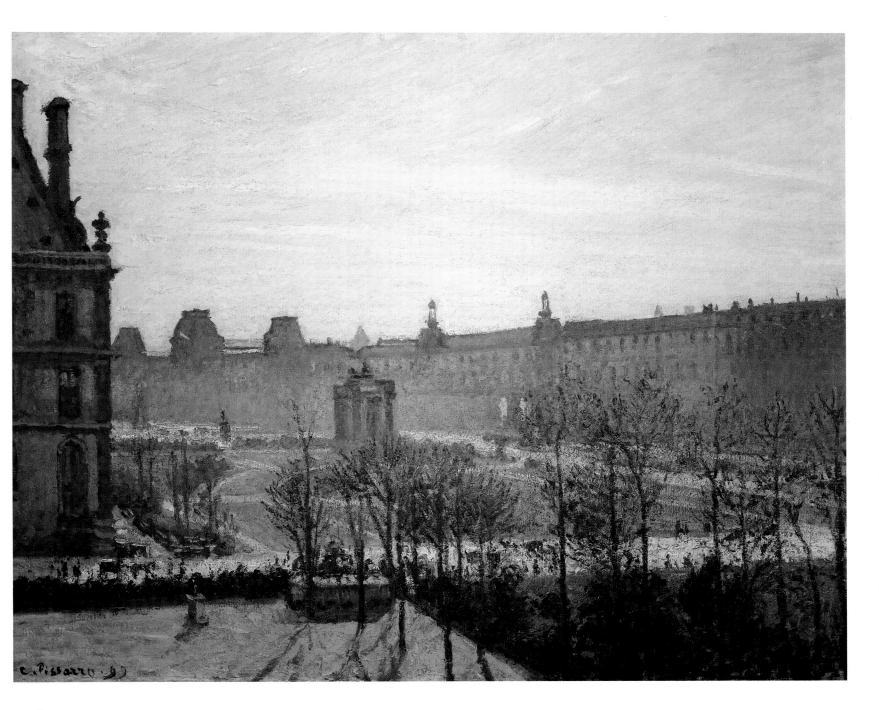

87 EXHIBITED IN LONDON

The Carrousel: Autumn Morning 1899

Le Carrousel, matin d'automne
P&V 1110
73 × 92 cm
Signed and dated lower left: *C. Pissarro. 99*

Private Collection, London

PROVENANCE Sam Salz, Inc., New York; Wildenstein & Co., New York, 5 March 1948; bought from Wildenstein & Co., London, by Sir Alexander Korda, 17 May 1954; Mrs David Metcalfe (formerly the wife of Sir Alexander Korda); sale, Sotheby's, London, 14 June 1962 (23; repr.); Marlborough Fine Art, London; Private Collection, London

EXHIBITIONS Paris 1901, no. 17; London 1955, no. 24

LITERATURE Holl 1928, no. 84 (repr.); Rewald 1943, pp. 334–35; Rewald, n.d. (repr. pl. 57)

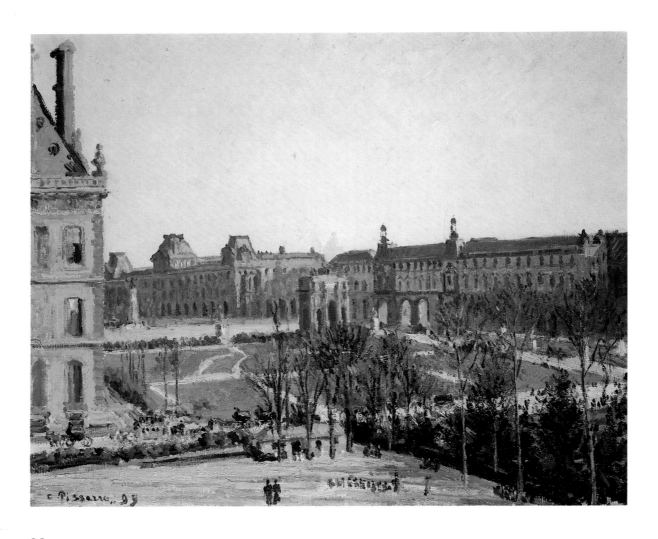

88 EXHIBITED

The Carousel: Afternoon Sun
1899

Le Carrousel, soleil d'après-midi
P&V 1108
54 × 65 cm
Signed and dated lower left: *C. Pissarro 99*

Mrs Edythe C. Acquavella

PROVENANCE Galerie Durand–Ruel, Paris;
November 1965; Paul Rosenberg, New York
(no. 6098); bought by Alex Maguy, Paris,
September 1965; A. Tooth, London (no.
7968); Charles Wolfson, November 1965;
Mrs Nicholas Acquavella, New York; Mrs
Edythe C. Acquavella

EXHIBITIONS Paris 1901, no. 16; Paris
1904, no. 115; Paris 1910(ii), no. 20; Paris
1930, no. 99; Paris 1956, no. 101; Paris 1961,
no. 89; Paris 1962, no. 45; Memphis 1980,
no. 16 (repr. col. p. 49)

LITERATURE Lloyd 1981, p. 123

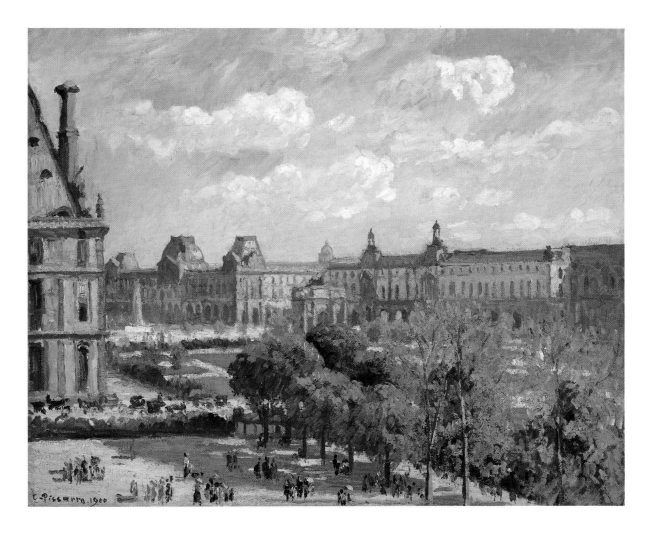

89 EXHIBITED

Place du Carrousel, the Tuileries Gardens 1900

La Place du Carrousel, Tuileries
P&V 1136
54.9 × 65.4 cm
Signed and dated lower left: *C. Pissarro. 1900*

National Gallery of Art, Washington, Ailsa Mellon Bruce Collection, 1970.17.55

PROVENANCE Mme Camille Pissarro, Eragny; sale, Galerie Georges Petit, Paris, 3 December 1928 (44; repr. p. 46); Bruno Stahl, Berlin and Paris, 1928; confiscated during World War II by Hermann Goering for his personal collection; returned to Bruno Stahl, after 1945; bought by Wildenstein & Co., New York, 1949; Ailsa Mellon Bruce, New York, 1949; given by Ailsa Mellon Bruce to the National Gallery of Art, Washington, D.C.

LITERATURE Paris 1901, no. 33; Paris 1914, no. 50; Paris 1946, no. 33; San Francisco 1961, no. 35; Washington 1966, no. 37; London 1980–81, no. 86 (repr. p. 148); Leningrad 1986, no. 24; Naples 1986, no. 38; Venice 1989, pp. 40–41; Munich, 1990, no. 43

LITERATURE Kunstler 1928(i), p. 506 (repr. p. 506); Walker 1976, p. 514, no. 774 (repr. col. p. 514); Vaizey 1981 (repr. col. p. 59); Coman 1991, no. 8 (repr. col.)

6 PARIS: THE SQUARE DU VERT-GALANT

In the last letter that refers to the Tuileries series, Pissarro announced his intention to move to an apartment by the raised terrace (*terre-plein*) of the Pont-Neuf, where he had found 'a very beautiful view'. In the same letter he also expressed his apprehension at the thought of missing his chance to complete another major series if he had to return to the country and spend too much time there: 'I am afraid of losing this opportunity of painting a picturesque corner of Paris!'[1] This comment raises the important question of what Pissarro understood by the term 'picturesque' in relation to his series. The answer had been given by Pissarro himself in a letter of two weeks earlier which gave some stern advice to Lucien: 'You shouldn't do what one is in the habit of calling picturesque; in my opinion, simplicity is far more picturesque than fantasy. People have some funny ideas about the word picturesque, the bad romantic is the cause of it. Rembrandt was picturesque and had a tremendous character, just as much as those who follow the Italian style . . . Botticelli and others.'[2]

A declared attachment to simplicity was a recognisable trait of Pissarro's aesthetic ideas throughout his career. As he developed his thoughts to his son in the same letter, he wrote: 'One may be simple, natural, and have lots of character! I think that it would be more profitable to see French works, the Le Nains, the Chardins'.[3] Pissarro's sojourn in the close vicinity of the Louvre could not but have offered him the frequent opportunity of visiting the museum, probably more often than he had ever previously been accustomed to in his life. As a result, his letters abound (unusually) with references to the Old Masters, while, at the same time, his painting seemed to remain serenely and consciously detached from any direct quotations (see pp. xlii–xliv for a more detailed analysis of this aspect of Pissarro's work). Nevertheless, the fragile balance between simplicity and 'fantasy', or between

simplicity and 'picturesque' remains a crucial problem addressed by Pissarro in his art. It is in this context that the reference to 'picturesque' (with its intrinsic ambiguity) should be understood when he first described the 'beautiful view' that he found on the Ile de la Cité. The subject, with its panoramic vista, its thrusting perspective on to the banks of the Seine, its successive rows of bridges, and its view of the whole length of the façade of the Louvre (Aile Denon), which in many instances in this series serves as a metonym for the whole city, could have easily yielded the 'picturesque' results that Pissarro considered demonstrated 'le mauvais romantique'. The problem was thus not to lose track of simplicity. As Flaubert, an author greatly admired by Pissarro, had put it, 'It is not a simple matter to be simple.' Pissarro was therefore equivocating before taking the new apartment. Complaining about the potentially damp atmosphere, he wrote: 'I am still looking to see if I cannot find anything better, but there is nothing, absolutely nothing. I cannot see even in abstract any point in Paris that would suit me.'[4]

The series of the Square du Vert-Galant was begun in 1900, shortly after the opening of the Exposition Universelle – sarcastically referred to by Pissarro as the 'Bazar Universel', that is, the universal mess. While the earlier Paris Boulevard series had concentrated on the movements of crowds and traffic within the streets of the capital, the Square du Vert-Galant series shows little visible trace of Pissarro's earlier interests in the to-ing and fro-ing of passers-by and traffic. In fact, Pissarro seldom spent any time in the capital during summer, and his declared aversion to the oppressive feeling of crowds and heat appears quite in contrast to his earlier, pictorial statements:

July is so hot and so disagreeable in Paris, particularly this year which is being called a terrible year. You have no idea of the

1 Bailly-Herzberg 1991, p. 77 (Paris, 16 March 1900; to Lucien Pissarro): 'une vue très belle'; 'je crains de manquer cette occasion de faire encore un côté pittoresque de Paris'.
2 Bailly-Herzberg 1991, p. 75 (Paris, 28 February 1900; to Lucien Pissarro): 'il ne faut pas faire ce que l'on est convenu d'appeler pittoresque; selon moi, le simple me paraît autrement plus pittoresque que la fantaisie. On se fait une drôle d'idée sur le mot pittoresque, le *mauvais romantique* en est cause. Rembrandt est pittoresque et a un grand caractère, tout autant que ceux qui suivent le style italien . . . Botticelli et autres.'
3 Bailly-Herzberg 1991, p. 75 (Paris, 28 February 1900; to Lucien Pissarro): 'On peut être simple, nature, et avoir beaucoup de caractère! Je crois qu'il y aurait plus de profit à voir les oeuvres françaises, les Le Nain, les Chardin'.
4 Bailly-Herzberg 1991, p. 79 (Paris, 2 [April] 1900; to Lucien Pissarro): 'Je cherche encore si je ne trouverais pas mieux, mais rien, absolument rien. Je ne vois pas même en idée quel point de Paris me pourrait convenir.'

facing page: detail of cat. 108

conglomeration of all types of people and the difficulty that they have and which they will continue to have more and more as the season advances. The trains never cease to unload the innumerable crowds that come from all over. I hope that in July we shall be in some out-of-the-way corner, far from the crowds, to work in peace and quiet on my summer series.[5]

Another notable feature of the Square du Vert-Galant series and inherent in all of Pissarro's series from 1898 on, is the presence of water: river banks, sea harbours and bridges supersede his interest in avenues, streets and boulevards. The flow of water (and its cargo of ships) parallels and interacts with the flow of human life.

As Pissarro put it, the problem was to find what 'point' in Paris would suit him. It must be acknowledged that in the Square du Vert-Galant paintings he secured the ultimate point from which he could create an extraordinary perspective for his series. Painting from the tip of the Ile de la Cité, Pissarro's view encompassed three juxtaposed perspectival axes: the left arm of the Seine, the right arm of the Seine, or both. With one single exception (*Square du Vert-Galant, Sunny Morning* (ill. 107)), Pissarro did not address the issue of traffic in these paintings: the *terre-plein* offers a platform (a *point* of view) for the few strollers who pass by on the island to rest and gaze, to watch the two arms of the Seine meet downstream and the two flows of river traffic divide on either side of the island. The Square du Vert-Galant series is the only one in which Pissarro addresses pictorially the presence of gazers; he superimposes his own gaze on that of the strollers who stop and look.

Pissarro's position on the island at this particular point can be seen as ambivalent. Looking at the two mutually exclusive banks of Paris, the artist focused on the dividing line of the city: the Seine, which separates the city physically, as well as ideologically, economically and politically. An interpretation could be ventured that this particular 'point' is the one that 'in abstract' best suits Pissarro's position pictorially, but also ideologically – and even personally, in the way he conducted his life *vis-à-vis* his friends, colleagues, children and wife – as he continued to denounce prejudice and narrow-mindedness, whether emanating from the political left or right.

We saw (see above, pp. xliii–xlvi) how Pissarro throughout his series cultivated oppositions and contrasts. The oppositions in this penultimate Paris series are expressed climactically: left bank versus right bank, the bridges perpendicularly joining the two opposite banks, while breaking the flowing continuum of the downstream perspective; the old versus the new (the Louvre versus the steamboats and the barges – although one must bear in mind that the Louvre façade had just been extensively renovated); the modern representation of the traditional, seen in the early nineteenth-century statue by Lemot of Henri IV, which faced Pissarro's window. If the first two Paris series focused upon the Haussmannian aspects of Paris, it could be said that the last series depict the Paris of Henri IV, after whose nickname (a reference to his notable sexual activity), the Square du Vert-Galant was called. He had presided over the enlargement and decoration of the Louvre and the completion of the Pont-Neuf, among other numerous significant architectural projects, and it was he who, on 13 April 1598, signed the Edict of Nantes, thus putting an end to the murderous conflict between Catholics and Protestants, and establishing *de jure* freedom of thought and religion for each individual. Exactly three hundred years before the beginning of the Dreyfus Affair, Henri IV laid the cornerstone of the development of civil rights: for the first time in Europe a monarch legalised freedom of religion. He himself had been a Protestant before converting to Catholicism, and his aversion to fanaticism made him a symbol of tolerance. Henri IV was equally well known for his humility, his fraternal and simple conviviality with peasants of his native southwest France, and for his devotion to his children. Such commendable characteristics, which Pissarro could not have ignored, must have kindled a certain empathy within the artist for this 'pre-modern' monarch.

* * *

As with the Rouen series, the Square du Vert-Galant series was made up of three groups of works and articulated around three vantage points: 1) right: focusing on the right bank and on the façade of the Louvre running alongside

5 Bailly-Herzberg 1991, p. 102 (Eragny-Bazincourt par Gisors, 8 June 1900; to Lucien Pissarro): 'juillet est si chaud à Paris, si désagréable surtout cette année que l'on pourra appeler l'année terrible. Tu n'as pas une idée de l'agglomération de toute espèce de monde, et la difficulté que l'on a et que l'on aura de plus en plus à mesure que la saison s'avance. Les trains ne cessent de dégorger d'innombrables foules qui viennent de partout. J'espère qu'en juillet, nous serons dans quelque coin retiré, loin de la foule, pour travailler tranquillement à ma série d'été.'

the Seine; 2) centre: focusing on the statue of Henri IV with the two branches of the Seine on each side of the island and the row of bridges seen in perspective; 3) left: focusing obliquely on the Hôtel de la Monnaie and the dome of the Institut in the background.

Pissarro moved into his new apartment on the Place Dauphine on 14 November 1900, but did not begin work on the series immediately: 'I am doing nothing for the moment, but I will not delay in starting my work.'[6] By January 1901, he had evidently started work: 'one is so rushed off one's feet and disrupted by these holidays, and I also have some quite beautiful effects quite well done'.[7] The pictures referred to here are *The Louvre: Winter Sunshine, Morning* (cat. 92), *The Louvre: Afternoon, Rainy Weather* (ill. 98), *The Pont-Neuf, the Statue of Henri IV: Sunny Winter Morning* (cat. 110) and possibly *The Louvre: Morning, Sun* (ill. 93).

At the end of February, Pissarro drew up the list of his winter sub-series:

I have finished, so to speak, my series of winter: four canvases of [size] 30, nearly completed [presumably *The Louvre: Winter Sunshine, Morning* (cat. 90), *Morning, Winter Sunshine, Frost, the Pont-Neuf, the Seine, the Louvre* (ill. 95), *The Pont-Neuf, the Statue of Henri IV: Sunny Winter Morning* (cat. 106), *Snow Effect, Morning, the Louvre* (P&V 1161)], five of 25 [*The Louvre: Afternoon, Rainy Weather* (ill. 96), *The Pont-Neuf, Statue of Henri IV: Mist* (cat. 109) and a Pont-Neuf painting, *The Pont-Neuf: Rainy Afternoon* (cat. 116), *The Pont-Neuf: Snow Effect* (P&V 1178), *Pont-Neuf, (Shipwreck of the 'Bonne Mère')* (P&V 1180)], two gouaches, five canvases of 6 [mistake: Pissarro used only one canvas of size 6, but in fact five of 8: *The Louvre* (ill. 93), *The Seine, The Louvre, and The Pont des Arts* (P&V 1163), *The Louvre: Springtime, Sunset* (P&V 1169), and the Pont-Neuf paintings, *The Pont-Neuf* (cat. 113), *The Pont-Neuf* (cat. 114); additionally, he used one more 8 in spring (*The Statue of Henri IV: Trees in Bloom* (P&V 1174)], four canvases of 10, more or less finished [*View of the Seine from the Raised Terrace of the Pont-Neuf* (ill. 91), *The Pont-Neuf and the Statue of Henri IV* (cat. 110), *The Raised Terrace of the Pont-Neuf and the Statue of Henri IV* (cat. 112), *The Hôtel de la Monnaie, Paris* (P&V 1156)].[8]

This letter is important as it gives a useful clue as to Pissarro's procedures, and it contains his last reference to the Square du Vert-Galant series. The letter suggests that Pissarro divided his work – more systematically with the Square du Vert-Galant series than with any other series – into seasonal sub-series. He stayed at Place Dauphine from 14 November 1900 until 22 April 1901. During his five months in Place Dauphine he completed what he called his 'série d'hiver' and started his 'série de printemps'. He returned to Place Dauphine after the summer, having completed a totally different summer series featuring the church of Saint-Jacques and the market in Dieppe.

During his second stay in his Paris apartment from 27 September 1901 to 21 January 1902, he completed his 1901 Square du Vert-Galant sub-series and sent it to Galerie Bernheim-Jeune for exhibition. He had produced over twenty-one works of the Square du Vert-Galant and several of the Pont-Neuf, many more than he had in any other single campaign. He was to continue working on the same series for two more consecutive years.

Pissarro also freely experimented with more formats in this series than in any other, and, working at a sustained pace, he could announce to his son: 'As you can see, I have not wasted my time, thanks to the regularity of my working hours.'[9] Having met the deadline for the exhibition entitled 'Série des tableaux de C. Pissarro, 1901' which was to be held at Bernheim-Jeune on 15 February 1902, he went on to produce fourteen more works throughout 1902. These fourteen focus predominantly on the right corner of the *terre-plein*, with the façade of the Louvre in the background (*The Seine from the Pont-Neuf: Winter* (P&V 1221) (format 15), *The Raised Terrace of the Pont-Neuf* (cat. 97) (format 30M), *The Louvre: Afternoon* (ill. 99) (format 6), *The Louvre: Grey Weather, Afternoon* (ill. 98) (format 6), *The Louvre* (ill. 103) (format 10), *The Louvre: Morning, Snow Effect, 2nd Series* (P&V 1215) (format 25), *The Pont des Arts and the Louvre* (P&V 1216) (format unknown), *The Louvre, 2nd Series: Morning, Eleven o'clock* (P&V 1217) (format 15), *The Louvre: Morning Effect* (P&V 1218) (format 15), *The Louvre from Above: Afternoon, 2nd Series* (P&V 1220) (format 8) and *The Seine: Morning, Springtime* (P&V 1225) (format 15)). *The Raised Terrace of the Pont Neuf: Afternoon, Thaw*

6 Bailly-Herzberg 1991, p. 142 (Paris, 14 November 1900; to Lucien Pissarro): 'Je ne fais rien pour l'instant, mais je ne tarderai pas à commencer mon travail.'

7 Bailly-Herzberg 1991, p. 154 (Paris, 7 January 1901; to Lucien Pissarro): 'on est si bousculé et dérangé par ces temps de fêtes, et j'ai aussi eu de si beaux effets que j'ai pas mal travaillé'.

8 Bailly-Herzberg 1991, p. 165 (Paris, 21 February 1901; to Lucien Pissarro): 'J'ai fini pour ainsi dire, ma série d'hiver, quatre toiles de trente, cinq de vingt-cinq, deux gouaches, cinq toiles de six, quatre toiles de dix, à peu près finies.'

9 Bailly-Herzberg 1991, p. 165 (Paris, 21 February 1901; to Lucien Pissarro): 'Comme tu vois, je n'ai pas perdu trop mon temps, grâce à la régularité de mes heures de travail . . .'

(illustrated right) (format 25) focuses on the left bank, while *The Raised Terrace of the Pont-Neuf, Place Henri IV: Afternoon, Rain* (cat. 108) (format 30) and *Square du Vert-Galant: Sunny Morning* (ill. 107) (format 30) concentrate on the whole platform, surrounded by both banks. The latter painting is exceptional in that its composition includes a column of the pedestrian traffic that can be seen in the Pont-Neuf series but that is otherwise always omitted from the Square du Vert-Galant series. Pissarro also used one oddly oblong 30M format (a large marine format) which links the composition (*The Raised Terrace of the Pont-Neuf* (cat. 97)) with the *vedute* tradition (see above, pp. xix–xxii).

Finally, he added even more variety to this surprising series by executing seven more views of the Square du Vert-Galant the following year, thus bringing the number (not exhaustive) to forty-two. However, by the third year of working on the same series, Pissarro did not quite feel the same enthusiasm as he had initially: 'I cannot start again on the same motifs

of the Pont-Neuf; I have the flat on the Rue Dauphine for another year; it's quite embarrassing, should I go to the South of France?'[10]

The extraordinary flexibility of his vision and working methods is best summarised in *The Louvre, Morning* (ill. 100), the smallest format he ever used in any of his series; yet that picture contains quintessentially, in miniature, all the ingredients of the series, while eloquently exposing Pissarro's continuously lush and supple painting technique.

Pissarro, *The Raised Terrace of the Pont-Neuf: Afternoon, Thaw* (P&V 1222), 1902, 65 × 81 cm, Courtesy of Christie's, London

10 Bailly-Herzberg 1991, p. 263 (Dieppe, 5 September 1902; to Lucien Pissarro): 'Je ne pourrai pas recommencer les mêmes motifs du Pont-Neuf, j'ai encore pour un an l'appartement de la rue Dauphine, c'est assez embarrassant, irai-je dans le midi???'

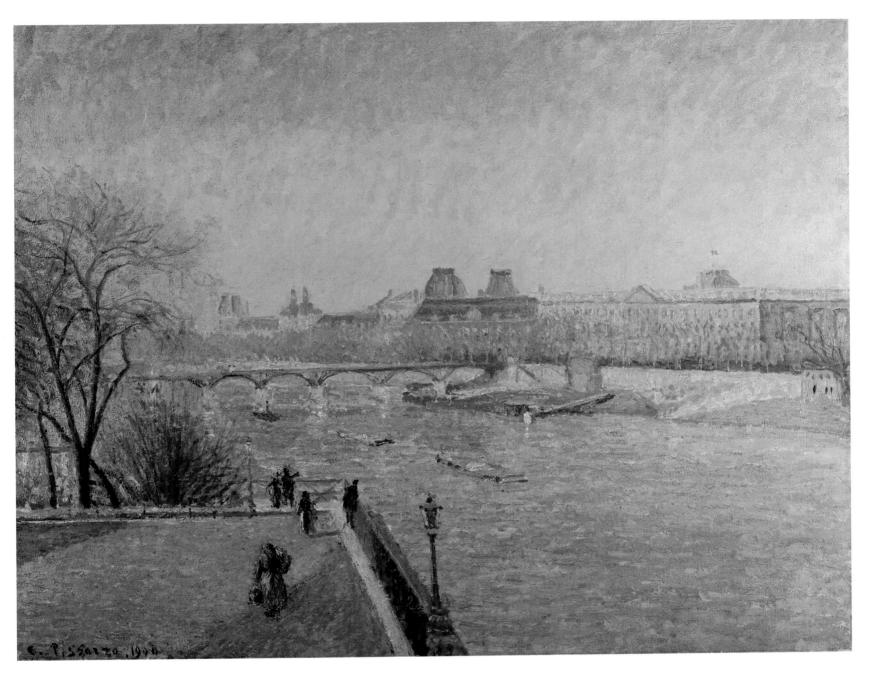

90 EXHIBITED

The Louvre: Winter Sunshine, Morning 1900

Le Louvre, soleil d'hiver, le matin
P&V 1158
73 × 92 cm
Signed and dated lower left: *C. Pissarro. 1900*

Private Collection

PROVENANCE Bought from the artist by Galerie Durand-Ruel, Paris, 28 December 1901 (no. 6878); Private Collection

EXHIBITIONS London 1905, no. 198; Paris 1910, no. 19; Paris 1928, no. 95; Paris 1956, no. 104; Paris 1962, no. 47; Memphis 1980, no. 19 (repr. col. p. 52); London 1980–81, no. 87 (repr. p. 149)

LITERATURE Borgmeyer 1913, p. 191

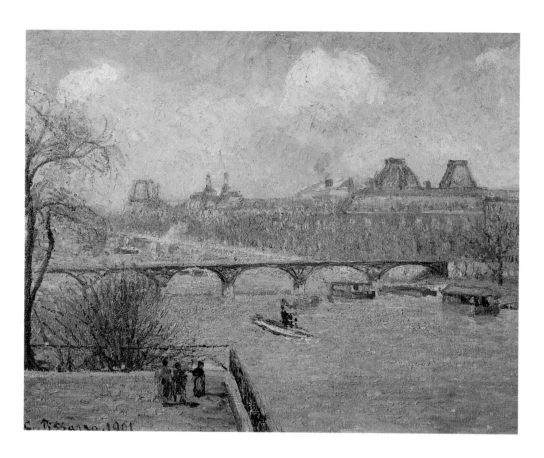

91 NOT EXHIBITED

View of the Seine from the Raised Terrace of the Pont-Neuf 1901

Vue de la Seine, prise du Terre-Plein du Pont-Neuf
P&V 1160
46 × 55 cm

Rudolf Staechelin Family Foundation, Basel

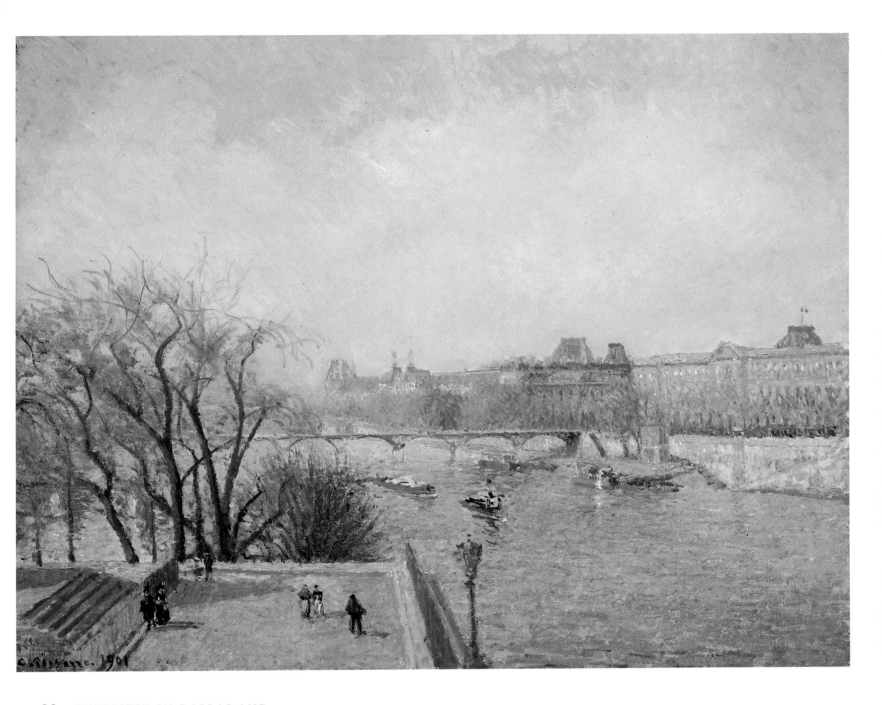

92 EXHIBITED IN DALLAS AND
PHILADELPHIA

The Louvre: Morning, Sun

1901

Le Louvre, matin, soleil
P&V 1159
73.7 × 92.7 cm
Signed and dated lower left: *C. Pissarro 1901*

Saint Louis Art Museum: Museum Purchase

PROVENANCE Durand-Ruel Galleries, New
York; bought by the Saint Louis Art
Museum, 1916

EXHIBITIONS Paris 1912, no. 7; Pittsburgh
1989, no. 69, pp. 160–61 (repr. p. 161)

LITERATURE *Bulletin of the City Art
Museum of Saint Louis*, vol. II, no. 3,
November 1916, pp. 6–7 (repr.); *Saint Louis
City Art Museum: Catalogue of Painting*, 1918,

p. 130; *Saint Louis City Art Museum:
Catalogue of Painting*, 1924, p. 70; *Saint Louis
City Art Museum: Catalogue of Painting*, 1937,
p. 132; *Saint Louis City Art Museum:
Catalogue of Painting*, 1944, p. 136; *Saint Louis
City Art Museum: Catalogue of Painting*, 1953,
p. 140; *Saint Louis City Art Museum:
Catalogue of Painting*, 1975, p. 163; Cowart
1982, p. 27

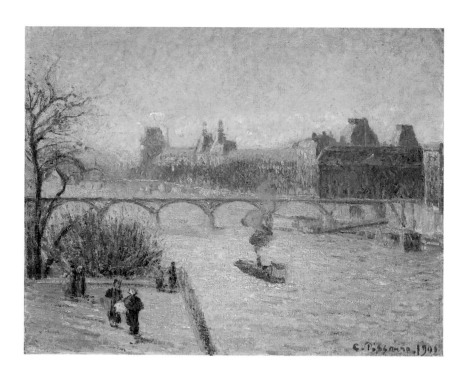

93 NOT EXHIBITED

The Louvre 1901

Le Louvre
P&V 1164
38 × 46 cm

The Davlyn Gallery, New York

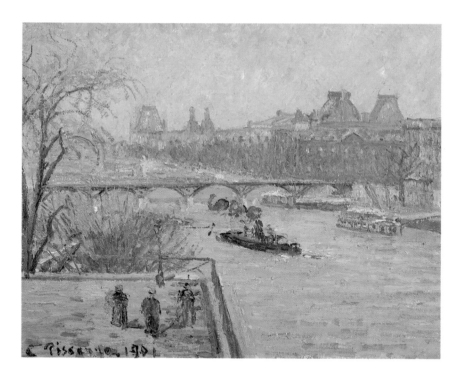

94 EXHIBITED IN LONDON

The Louvre 1901

Le Louvre
P&V 1167
38 × 46 cm
Signed and dated lower left: *C. Pissarro. 1901*

Private Collection, Switzerland

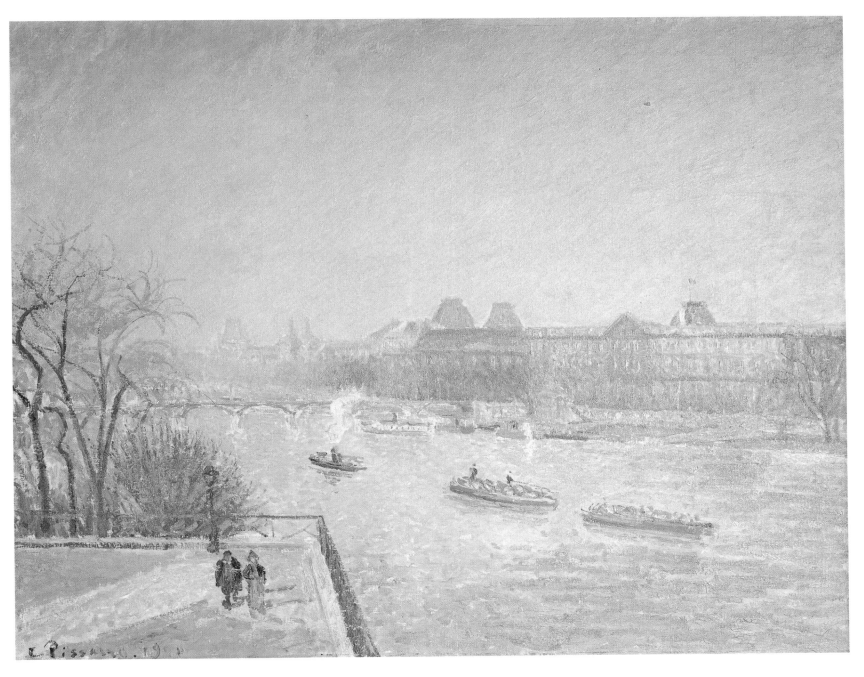

95 NOT EXHIBITED

Morning, Winter Sunshine, Frost, the Pont-Neuf, the Seine, the Louvre 1901

Matin, soleil d'hiver, gelée blanche, le Pont-Neuf, la Seine, le Louvre
P&V 1162
73 × 92 cm

Private Collection

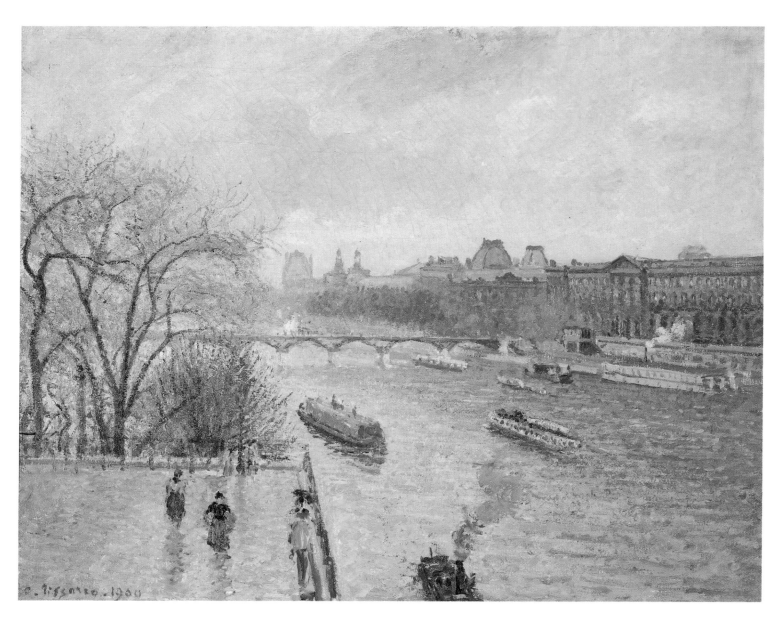

96 NOT EXHIBITED

The Louvre: Afternoon, Rainy Weather 1900

Le Louvre, après-midi, temps de pluie
P&V 1157 (known as *Le Louvre, matin, temps de pluie*)
65 × 81 cm

Corcoran Gallery of Art, Edward C. and Mary Walker Collection

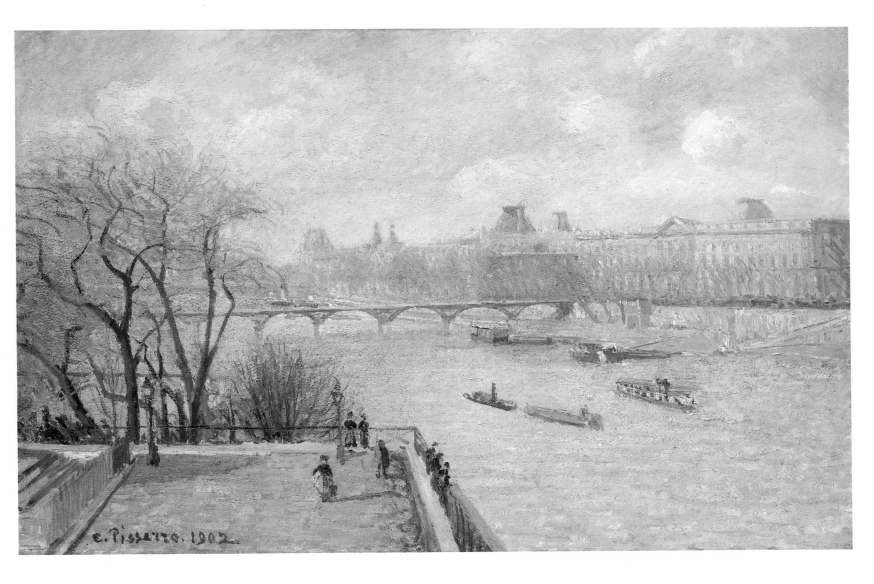

97 EXHIBITED

The Raised Terrace of the Pont-Neuf 1902

Terre-Plein du Pont-Neuf
P&V 1219
60.4 × 92.3 cm
Signed and dated lower left: *C. Pissarro. 1902*

Sterling and Francine Clark Art Institute, Williamstown, Massachusetts

PROVENANCE The Van de Velde Collection, Le Havre; Paul Rosenberg; Marquis de Rochecouste, Paris; Mrs Grossi, Cairo; Knoedler & Co., New York; bought by Robert Sterling Clark, 31 March, 1950; Sterling and Francine Clark Art Institute, Williamstown, Massachusetts

EXHIBITIONS Amsterdam 1929, no. 42; Amsterdam 1932, no. 86; Brussels 1935, no. 60; Williamstown 1956, no. 121; New York 1967, no. 30

LITERATURE *International Studio*, August 1930 (repr. p. 64); *Art News*, 5 March 1932 (repr. p. 8); *Les Beaux-Arts* (Brussels), June 1935, cat. no. 54, pp. 26–27; Courthion 1957, p. 55; 'Paris en Parle', *French News*, January 1962, no. 15 (repr. p. 1); Hamilton 1970, no. 90, p. 107; Rewald 1984, pp. 220–41

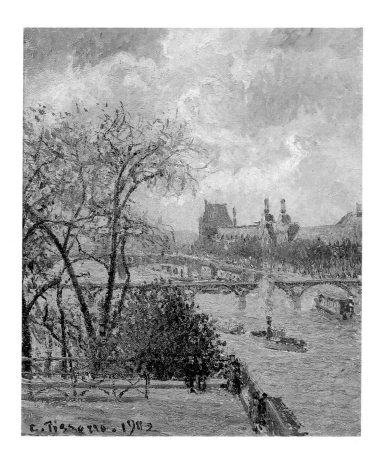

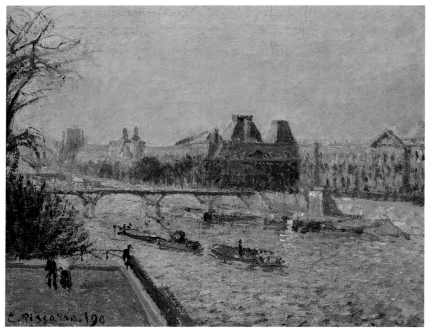

98 NOT EXHIBITED

The Louvre: Grey Weather,
Afternoon 1902

Le Louvre, temps gris, après-midi
P&V 1224 (known as *Le Louvre, temps gris,*
en hauteur, après-midi, 2e série)
41 × 33 cm

Private Collection. Courtesy of Galerie
Schmit, Paris

99 NOT EXHIBITED

The Louvre: Afternoon 1902

Le Louvre, après-midi
P&V 1223
33 × 41 cm

Private Collection

100 NOT EXHIBITED

The Louvre: Morning 1903

Le Louvre, matin
P&V 1281
16.5 × 22 cm

Private Collection

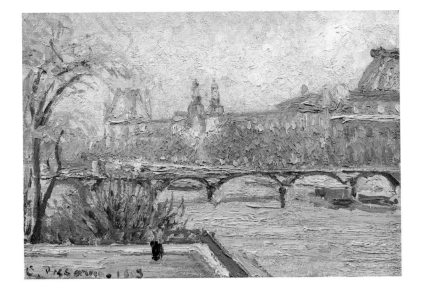

101 NOT EXHIBITED

*The Louvre: Morning, Snow
Effect* 1903

Le Louvre, matin, effet de neige
P&V 1279 (known as *3e série, Le Louvre,
matin, effet de neige*)
46 × 55 cm

Location unknown

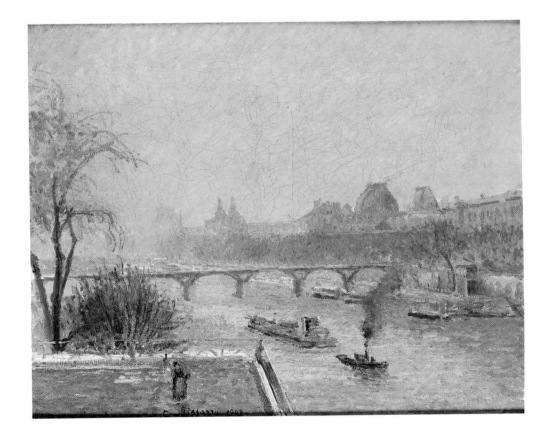

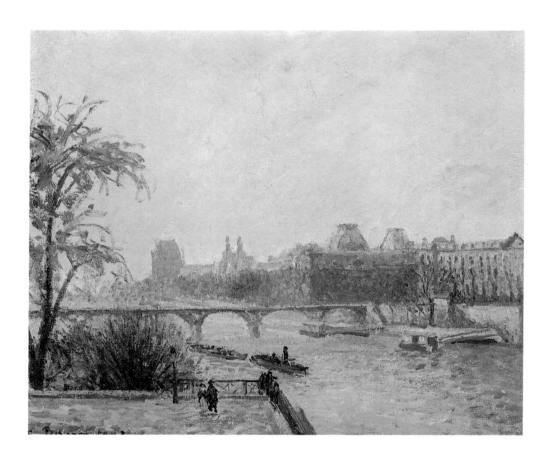

The Seine and the Louvre 1903

La Seine et le Louvre
P&V 1278
46 × 55 cm

Musée d'Orsay, Paris

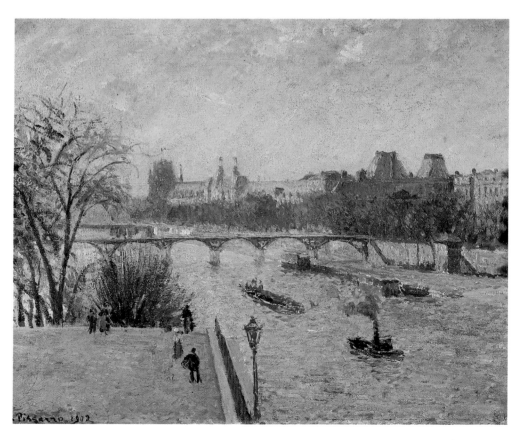

103 NOT EXHIBITED

The Louvre 1902

Le Louvre
P&V 1228
46.2 × 55.6 cm

Musée des Beaux-Arts, Reims

136

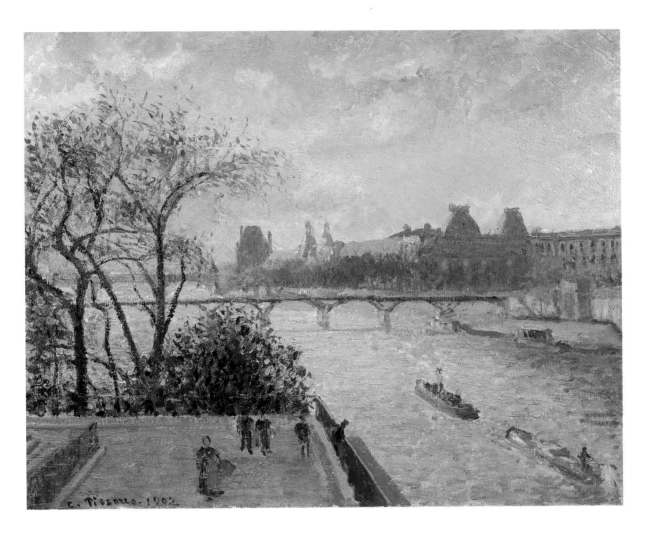

104 NOT EXHIBITED

The Louvre and the Seine from the Pont-Neuf 1902

Le Louvre et la Seine pris du Pont-Neuf
Non-P&V
56 × 66 cm

Private Collection

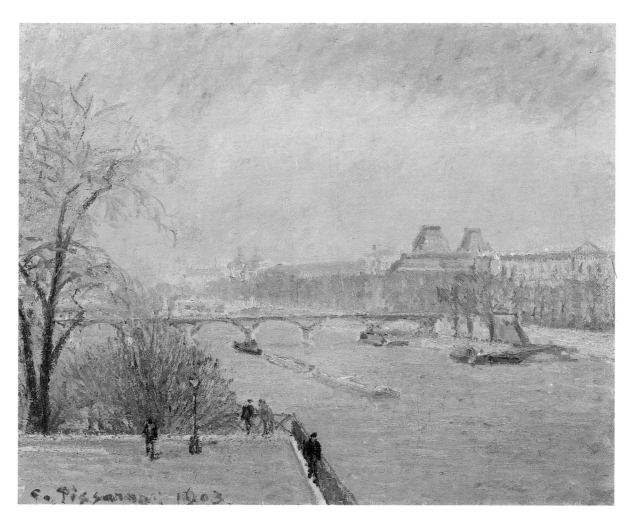

105 NOT EXHIBITED

The Louvre: March Mist 1903

Le Louvre, brume de mars
P&V 1280
54 × 65 cm

Ny Carlsberg Glyptotek, Copenhagen

106 EXHIBITED

The Pont-Neuf, the Statue of Henri IV: Sunny Winter Morning 1900

Le Pont-Neuf, la statue d'Henri IV, matin, soleil d'hiver
P&V 1155
73 × 92 cm
Signed and dated lower left: *C. Pissarro. 1900*

Krannert Art Museum, University of Illinois at Urbana-Champaign, Gift of Mr and Mrs Merle J. Trees, 1951 (51-1-2)

PROVENANCE Wallraf Richartz, Cologne; E. and A. Silberman Galleries, New York; Mr and Mrs Merle J. Trees, Chicago; given by Mr and Mrs Merle J. Trees to the Krannert Art Museum, University of Illinois at Urbana-Champaign, 1951

EXHIBITIONS Paris 1910(ii), no. 29; Paris 1912; *Exhibition of Old Master and Modern Paintings from the Collection of Merle J. and Emily N. Trees*, University of Illinois, Urbana, 1950, no. 57; Urbana 1961, no. 25; Alburquerque 1964; *Paintings from Midwestern University Collections*, Committee on Institutional Cooperation, 1973, p. 98; Memphis 1980, no. 17, pp. 27–28 (repr. p. 50)

LITERATURE *Les Arts*, no. 128, August 1912; Hope 1974, pp. 264–72

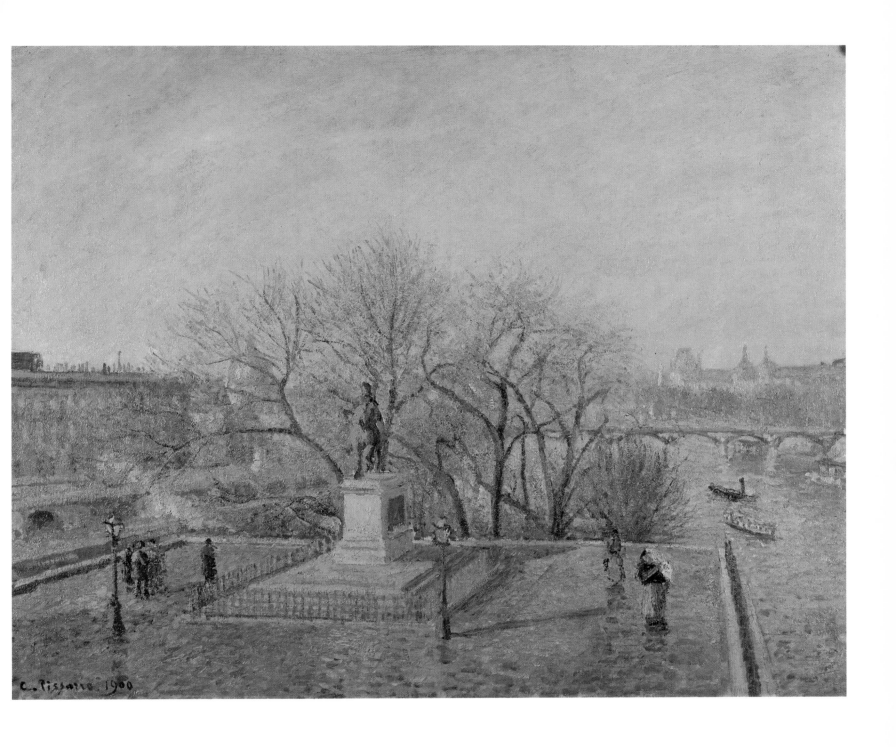

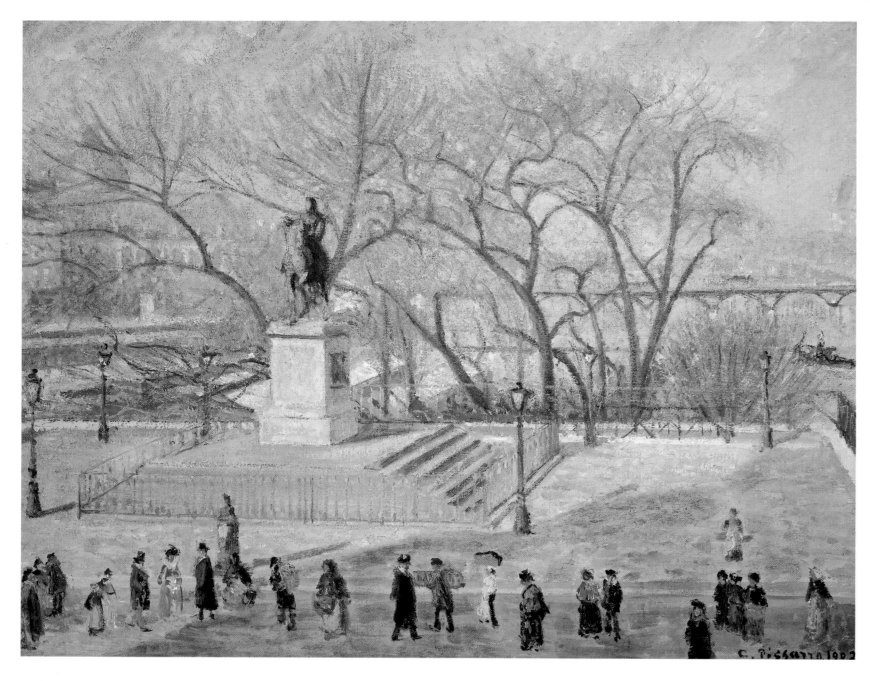

107 NOT EXHIBITED

Square du Vert-Galant: Sunny Morning 1902

Place du Vert-Galant, matin de soleil
P&V 1227
73 × 92 cm

Private Collection

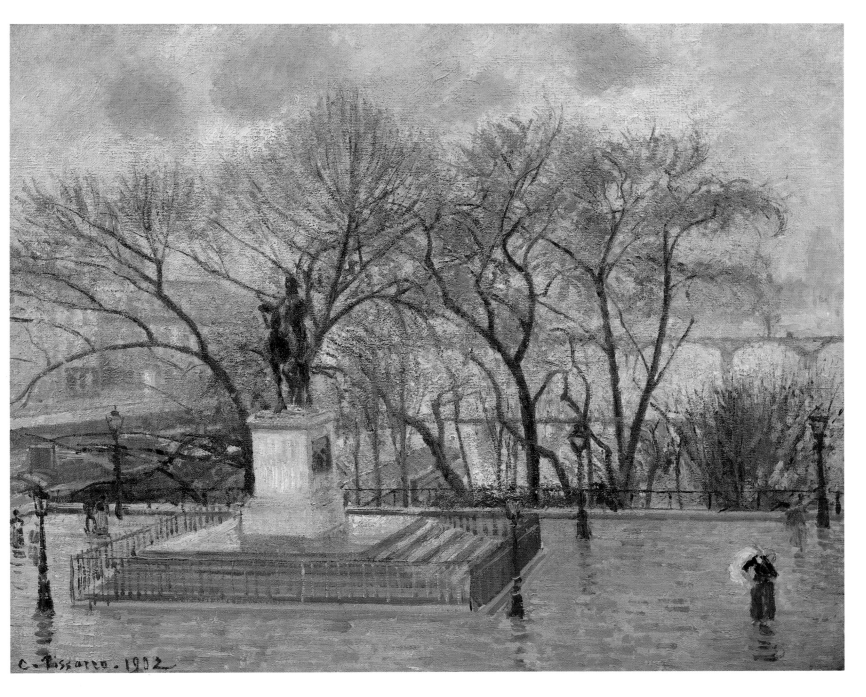

108 EXHIBITED IN DALLAS AND
PHILADELPHIA

The Raised Terrace of the Pont-Neuf, Place Henri IV: Afternoon, Rain 1902

Le Terre-Plein du Pont-Neuf, Place Henri IV, après-midi, pluie
P&V 1226 (known as *Le Terre-Plein du Pont-Neuf, Place Henri IV, matin, pluie*)
73 × 92 cm

Signed and dated lower left: *C. Pissarro. 1902*

Carlos Hank

PROVENANCE Mme Camille Pissarro, Eragny; Lucien Pissarro, London; sale, Sotheby's, London, 6 December 1978 (233); sale, Sotheby's, New York, 7 November 1979 (550); sale, Sotheby's, London, 23 March 1983 (23); sale, Galerie Koller,

Zurich, 3 June 1983; sale, Christie's, New York, 13 November 1984 (117); Mr H'Schnabel, autumn 1986; Carlos Hank

EXHIBITIONS Paris 1914, no. 16; Paris 1921, no. 2; Amsterdam 1930, no. 252; Paris 1937, no. 386

LITERATURE Lecomte 1922, p. 98

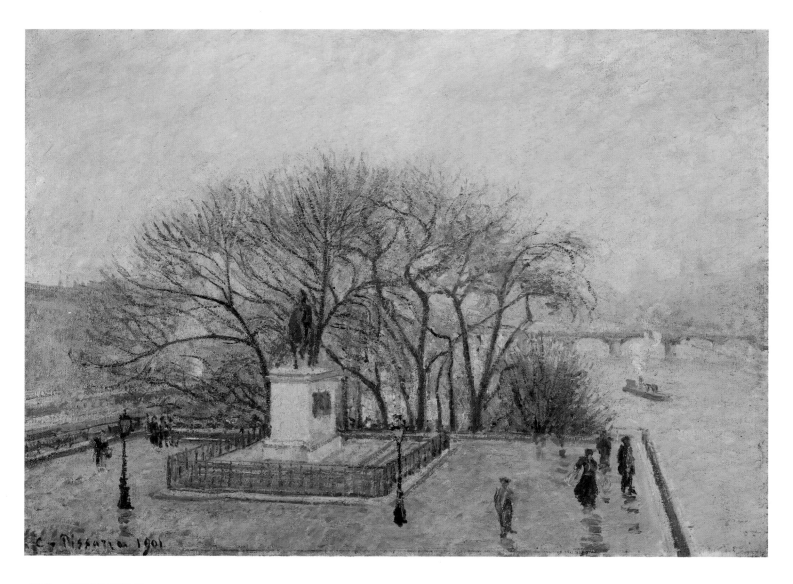

109 EXHIBITED

*The Pont-Neuf, Statue of
Henri IV: Mist* 1901

Le Pont-Neuf, statue de Henri IV, brume
P&V 1175
60 × 81 cm
Signed and dated lower left: *C. Pissarro 1901*

Rudolf Staechelin Family Foundation, Basel

PROVENANCE Mario Arbini, Munich, 14
February 1920; Rudolf Staechelin, by 1939;
Rudolf Staechelin Family Foundation, Basel

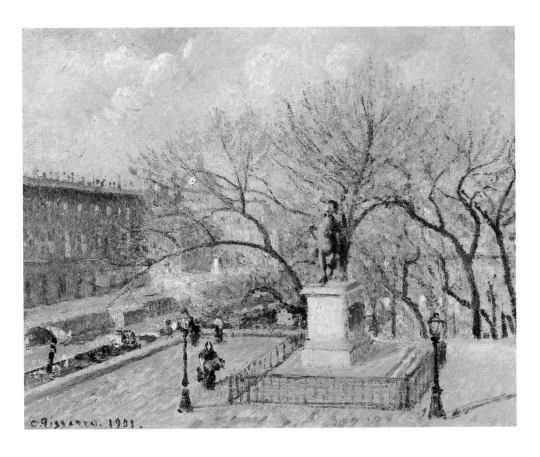

110 EXHIBITED

The Pont-Neuf and the Statue of Henri IV 1901

Pont–Neuf et statue de Henri IV
P&V 1173
46.4 × 54.3 cm
Signed and dated lower left: *C. Pissarro. 1901*

Private Collection

PROVENANCE Dr D. Parenteau, Paris;
Galerie de l'Elysée, Paris; Sam Salz, Inc.,
New York; sale, Sotheby's, London, 26
March 1985 (12); sale, Christie's, London, 29
June 1987 (19); Private Collection

LITERATURE *Letters* 1943, p. 340; Rewald
1963, p. 154

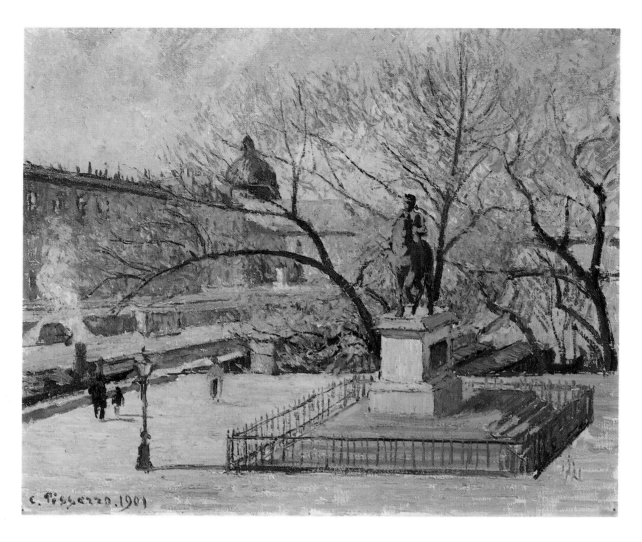

III EXHIBITED

The Statue of Henri IV: Morning,
Sun 1901

La Statue d'Henri IV, matin, soleil
P&V 1171
46 × 55 cm
Signed and dated lower left: *C. Pissarro. 1901*

Private Collection

PROVENANCE Olivier Senn, Paris; by
descent to the present owners

EXHIBITION Paris 1930, no. 116 bis

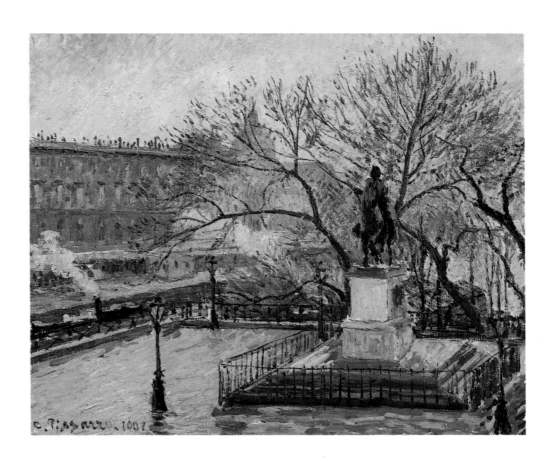

112 NOT EXHIBITED

The Raised Terrace of the Pont-Neuf and Statue of Henri IV

1901

Terre-plein du Pont-Neuf et statue de Henri IV
P&V 1172
46.5 × 55 cm

Ny Carlsberg Glyptotek, Copenhagen

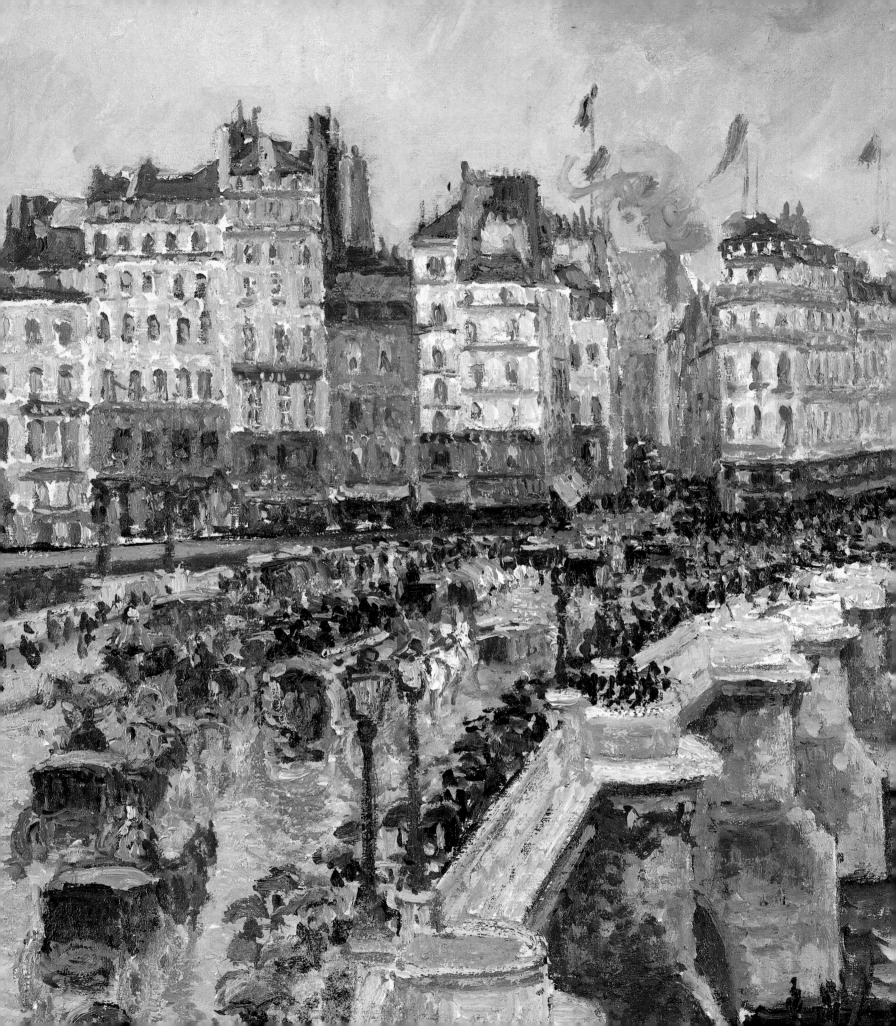

7 PARIS: THE PONT-NEUF

This series of thirteen paintings (including one not in the *catalogue raisonné*) focuses on the right arm of the Pont-Neuf, which links the tip of the Ile de la Cité (where Pissarro lived in a rented apartment at 28 Place Dauphine from 1900 to 1903) to the right bank. The Pont-Neuf is one of two bridges in Paris that cut across an island, linking right and left banks; the other is the Pont de Sully, at the eastern extreme of the Ile Saint-Louis. Pissarro's last address in Paris, to which he moved a few days before his death, was on the Boulevard Morland, a block away from the Pont de Sully.

The Pont-Neuf series was executed during the same period as the Square du Vert-Galant series and from the same apartment, but from a window with a totally different orientation. The 'Pont-Neuf window' looked northward, whilst the 'Square du Vert-Galant window' faced north-west. A question is thus posed as to whether the Pont-Neuf series constitutes a series in itself, as opposed to being simply a sub-series of the Square du Vert-Galant series, since they were painted simultaneously and from the same location. Yet, unlike sub-groups of other series, the Pont-Neuf group does not present any point of intersection with the more numerous paintings of the Square du Vert-Galant. The two groups act in complete opposition to each other. Their orientational axes form a wide, open 'V', whose two bars never connect: in the Pont-Neuf series the bridge is never attached to the island, and in the Square du Vert-Galant series the terrace of the square is only once faintly attached to the Pont-Neuf.

In the Square du Vert-Galant series, the terrace is usually cropped, so that only a fraction of it seems to protrude over the Seine, and there is certainly never any sense of immediate connection with the rest of the city and its traffic. However, even more markedly, the scenes are distanced from the bustle and buzz of the traffic that is passing by, only a few yards away, on the Pont-Neuf itself. The

exception is *Square du Vert-Galant, Sunny Morning* (ill. 107). The Square du Vert-Galant series is about a meditative, contemplative resting place in the city, where one or two strollers (*flâneurs*) or dreamers can come and gaze at the Seine and the Louvre. These paintings explore the Seine and the amazing viewpoint that the terrace offers; the Square du Vert-Galant is a spot where one *stops* and looks.

The Pont-Neuf is quite the reverse. It is one of the oldest, most historically and strategically important thoroughfares in the city. The Pont-Neuf series deals with a bridge whose rôle is that of carrying the milling crowds from one side of the river to the other, via the Ile de la Cité, by-passing (or ignoring) the Square du Vert-Galant. Its stout and massive piers create pools of reflections, such that the bridge seems to adopt the colour of the sky and of the surrounding structures. Its mass contrasts sharply with the intermingling crowds and its fragile lampposts.

Pissarro's vantage point offered a plunging perspective that accentuated the steep difference of levels between roof-tops, bridge, boats and river, in a way somewhat reminiscent of his Rouen series. Yet, one never sees through the arches of the bridge, as one does in the Rouen paintings. There is no levity about these works, no air, no transparency, except perhaps in the almost immaterial flicks of paint representing the people, who melt away into the Rue du Pont-Neuf (seen in perspective) and the Rue de la Monnaie, which branches off to the left, forming another 'V' or, perhaps more accurately, a 'Y'. The traffic dissolves into the network of streets on the right bank which gradually absorbs and disperses it, just as the puffs of smoke seem to be swallowed up by the sky. The diaphanous silhouette of the church of Saint-Germain l'Auxerrois hovering above the left-hand block of buildings, and the flags waving about on top of the roofs of the Samaritaine, introduce two elements of levity

147

into these pictures otherwise conspicuous for their density.

This series seems to be coloured by reflection and reminiscence. Monet's and Renoir's earlier views of Saint-Germain l'Auxerrois loom behind the roof-tops in the Pont-Neuf scenes. Unlike his other pictures of Paris bridges (see ills 123, 124, 126, 128, and cats 125, 127), the series also seems to contain echoes of Pissarro's Rouen bridge paintings. The prominent down-ward-looking vantage point on the bridge and its diagonal position in the layout of the pictures, the interaction of the bridge traffic and the river traffic, the perspective vanishing onto the opposite bank, the milling crowds, the smoke puffs in the sky and the dramatic clouds are features of both the Pont-Neuf and the Rouen series. Here again, one of Pissarro's last series reflects one of his first. A photograph in the Durand-Ruel Archives of an oil sketch, dated 1901 (when Pissarro was passing through Rouen, from Dieppe), represents a view of Rouen, with its succession of bridges, as seen from the River Seine, indicating Pissarro's continuing interest in this motif.

Significantly, part of the motif of the Pont-Neuf series appears – seen through the window of the Place Dauphine apartment and reflected in a mirror – in Pissarro's last self-portrait of 1903 (frontispiece and cat. 154). The building in the reflection behind the artist is the right-hand section of the middle block of buildings, as seen in *The Pont-Neuf: Rain Effect* (illustrated right), which was probably executed virtually at the same time as the self-portrait (the position of the flag poles is inverted from right to left as a result of the mirror reflection). This upright, deeply moving self-portrait exposes several constitutive gestures that are inherent in Pissarro's series paintings, as he looks up and down (through his semi-circular glasses), back and forth, right and left. This multi-dimensional, pluri-directional, enquiring gaze, searching for new angles and aspects, for the effects of external reality and its polymorphous reflections, constructed a world – a cosmos – within which everything (every picture, every effect) carries a certain relationship with each other and with the whole.

Pissarro, *The Pont-Neuf: Rain Effect* (P&V 1282), 1903, 55 × 65 cm

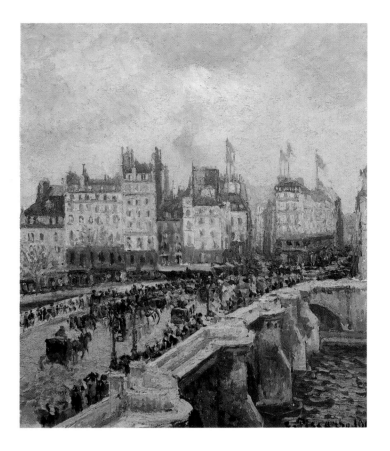

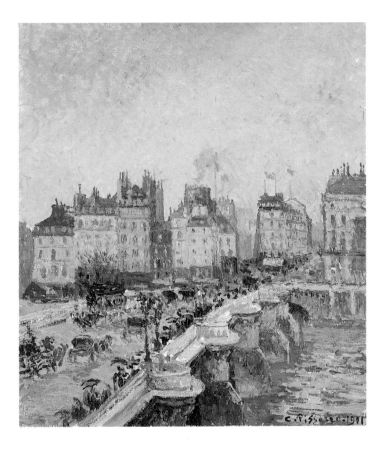

113 EXHIBITED

The Pont-Neuf 1901

Le Pont-Neuf
P&V 1179
45 × 38 cm
Signed and dated lower right: *C. Pissarro.*
1901

Private Collection. Courtesy D. Nisinson
Fine Art, New York

PROVENANCE Ernest Cognacq; Gabriel
Cognacq; sale, Collection Gabriel Cognacq,
Hôtel Drouot, Paris, 14 May 1952 (53); Mr
and Mrs Joseph S. Gruss; by descent to the
present owners

EXHIBITIONS Paris 1945, no. 108; New
York 1965, no. 79

LITERATURE Wilhelm 1961, p. 71

**114 EXHIBITED IN DALLAS AND
PHILADELPHIA**

The Pont-Neuf 1901

Le Pont-Neuf
P&V 1177
46 × 39 cm
Signed and dated lower right: *C. Pissarro.*
1901

Allen Memorial Art Museum, Oberlin
College, R. T. Miller, Jr. Fund 1941

PROVENANCE Mark Oliver; Alex Reid &
Lefevre, London, 24 October 1934; Galerie
Tanner, Zurich, 24 October 1934; Paul
Rosenberg, Paris (no. 4072); J. Helft, Paris,
1939; Sam Salz, Inc., New York; bought by
the Allen Memorial Art Museum, Oberlin
College, 1941

EXHIBITIONS New York 1941, no. 3;
Pittsfield 1946; Columbia, 1960, nos. 9, 25;
New York 1965, no. 79; Memphis 1980,
no. 20

LITERATURE *Allen Memorial Art Museum
Bulletin*, vol. I, no. 2; *Allen Memorial Art
Museum Bulletin*, vol. XVI, no. 2, winter 1959,
pp. 73–74; *Allen Memorial Art Museum
Catalogue*, Oberlin, 1967, pp. 122–23; Lloyd
1981

The Pont-Neuf: Afternoon Sun

1901

Le Pont-Neuf, après-midi, soleil
P&V 1181
73 × 92 cm
Signed and dated lower right: *C.Pissarro. 1901*

Philadelphia Museum of Art, Bequest of
Charlotte Dorrance Wright

PROVENANCE Wildenstein & Co., New
York; bought by Georges Lurcy, before
1944; sale, The Georges Lurcy Collection,
Parke–Bernet Galleries, New York, 7
November 1957 (22); Mr and Mrs William
Coxe Wright, 1957; bequeathed by Charlotte
Dorrance Wright to the Philadelphia
Museum of Art

EXHIBITIONS New York 1944, no. 2; New
York 1945, no. 44; New York 1950(ii),
no. 22; New York 1958; New York 1959;
Philadelphia Museum of Art, 1962; New
York 1965, no. 80; San Francisco 1965,
no. 24; Philadelphia Museum of Art, *The
Charlotte Dorrance Wright Collection*, 1978,
p. 33; Palm Beach, Society of the Four Arts,
and Harrisburg, The State Museum of
Pennsylvania, *The Charlotte Dorrance Wright
Collection*, 1989

LITERATURE Pica 1908, p. 128

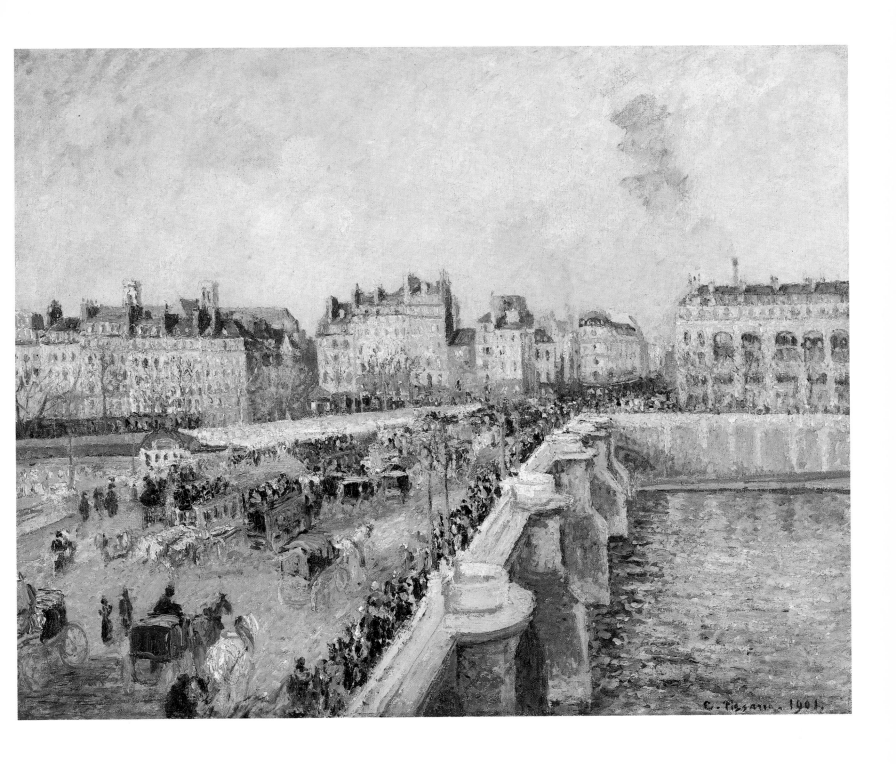

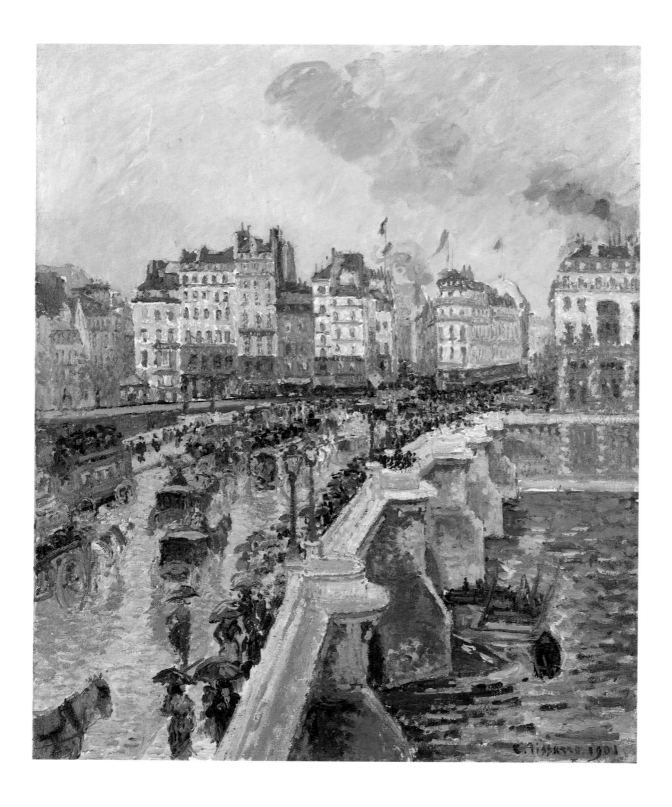

116 EXHIBITED IN LONDON

The Pont-Neuf: Rainy Afternoon 1901

Le Pont-Neuf, après-midi de pluie
P&V 1176
80 × 63 cm
Signed and dated lower right: *C. Pissarro. 1901*

Private Collection

PROVENANCE Galerie Durand-Ruel, Paris;
Mr Schiff, Berlin; Max Moos, Geneva;
consigned by Max Moos to Knoedler & Co.,
New York, June 1940; returned to Max
Moos unsold, March 1941; consigned again
by Max Moos, March 1943; bought by Sam
Salz, Inc., New York, March 1943; André
Meyer, New York; bought by Knoedler &
Co., New York, November 1949; bought by
Sarah C. Blaffer, Houston, December 1953;
by descent to a private collector; sale,
Christie's, New York, 12 May 1992 (111);
Private Collection

EXHIBITIONS New York 1944, no. 1

LITERATURE Stephens 1904; Bazin 1947,
p. 77

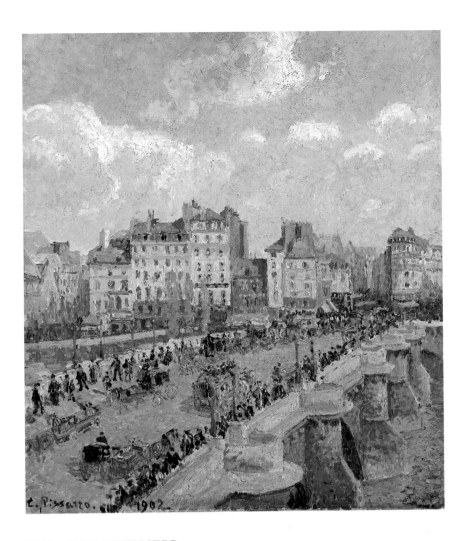

117 NOT EXHIBITED

The Pont-Neuf 1902

Le Pont-Neuf
P&V 1211 (known as *Le Pont-Neuf, 2e série*–
55 × 46 cm

Budapest, Museum of Fine Art. Courtesy of
the Board of Directors

153

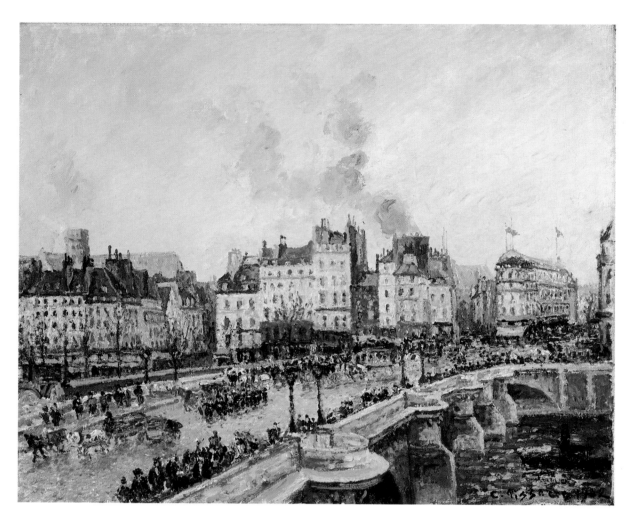

118 EXHIBITED IN DALLAS AND
PHILADELPHIA

The Pont-Neuf 1902

Le Pont-Neuf
P&V 1210
54.6 × 64.8 cm
Signed and dated lower right: *C. Pissarro 1902*

Carlos Hank

PROVENANCE Dr Max Emden, Hamburg,
1931; Mrs Michael M. van Beuren; bought
by Knoedler & Co., New York; Lilli Wulf,
September 1944; bought by Richard N.
Ryan, November 1944; sale, Sotheby Parke-
Bernet, New York, 9 October 1968 (9);
Nathan Cummings, New York; Acquavella
Galleries, New York; Carlos Hank

EXHIBITIONS Washington 1970, no. 5;
Chicago 1973, no. 15

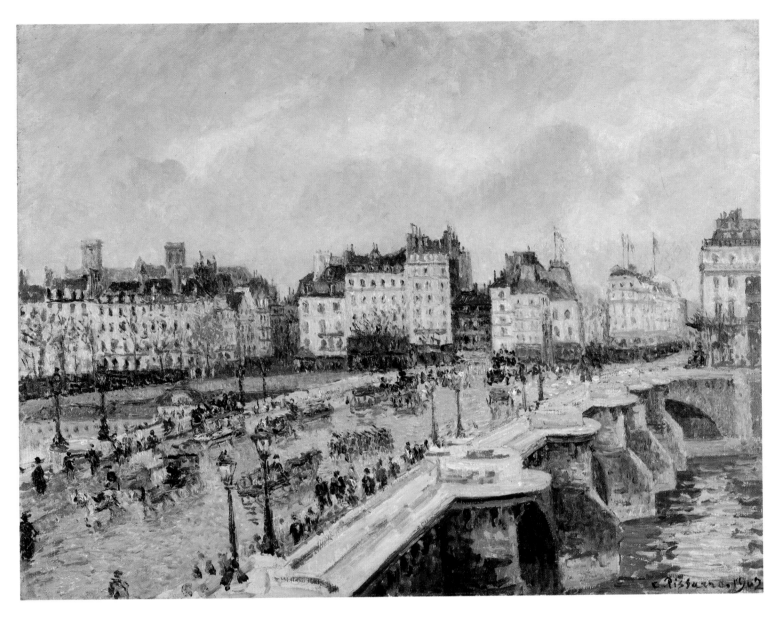

119 EXHIBITED

The Pont-Neuf 1902

Le Pont-Neuf
P&V 1213
65 × 81 cm
Signed and dated lower right: *C. Pissarro.*
1902

Hiroshima Museum of Art

PROVENANCE A. Gergaud; Wildenstein &
Co., Paris; Edward G. Robinson, Los
Angeles; Stavros Niarchos, London; Nichido
Gallery, Tokyo; Hiroshima Museum of Art

EXHIBITION Tokyo 1984, no. 64

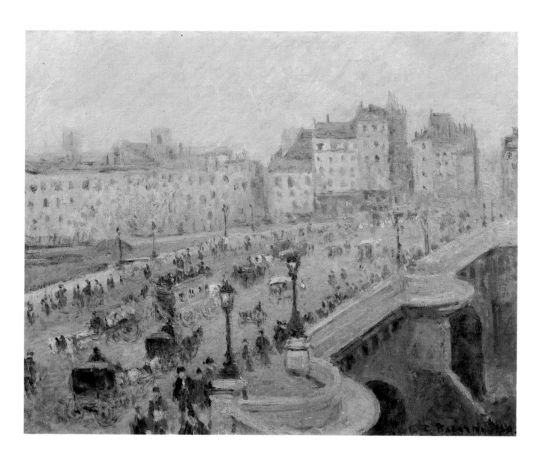

120 NOT EXHIBITED

Pont-Neuf: Fog 1902

Pont-Neuf, brouillard
Non–P&V
46.5 × 55 cm

Private Collection, Courtesy Barbara
Guggenheim Associates

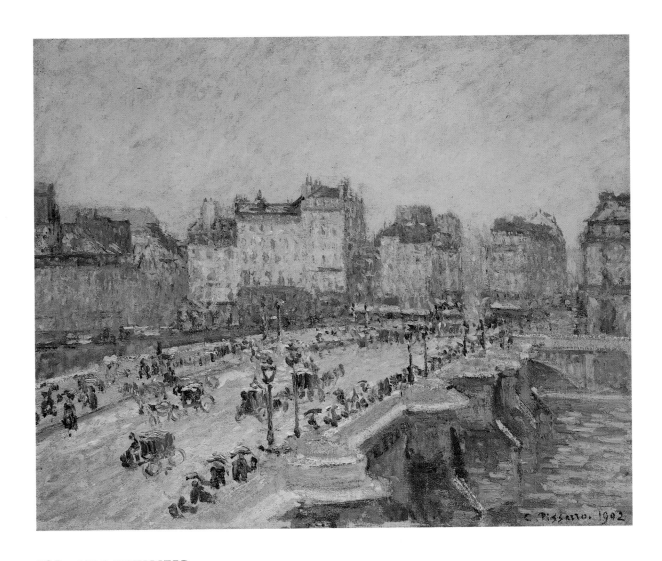

121 NOT EXHIBITED

The Pont-Neuf: Snow 1902

Le Pont-Neuf, effet de neige
P&V 1212 (known as *Le Pont-Neuf, effet de neige, 2e série*)
54 × 65 cm

National Museum of Wales, Cardiff

As discussed above (p. 147), the Square du Vert-Galant and the Pont-Neuf series evolved at the same time, from within the same apartment, but from different windows and viewpoints. During the first two years when the Square du Vert-Galant series was being painted, the Pont-Neuf views seemed to be created as an extension of the Square du Vert-Galant paintings, as though, pictorially as well as in reality, one could not reach the Square du Vert-Galant without passing along the Pont-Neuf. The two series were complementary and yet exclusive of each other.

In 1903, however, Pissarro painted only one view of the Pont-Neuf (*The Pont-Neuf: Rain Effect* (illustrated p. 148). The exceptional nature of this is enhanced by the fact that the last two views of the Square du Vert-Galant listed in the *catalogue raisonné*, contrary to the general trend of that series, focus emphatically on the left bank of the Seine and on the Monnaie (*The Monnaie and the Institut: Grey Weather* (P&V 1284) and *3rd Series. The Monnaie and the Institut: Morning, Sun* (P&V 1285)). Pissarro was largely shifting his interest from right to left. Being at the centre, on neither side, the dynamics of the equilibrium can be of sustained interest only if one can pass from one to the other. Pissarro had never painted on the left bank, but at the age of nearly seventy-three, six months before he died, he launched into what was to be his final Paris series and one on which he was working right up to his death, shortly after his return from Le Havre.

Sales of his paintings at this time were slow; he had broken his exclusive commercial arrangement with Paul Durand-Ruel and had to reduce the sums of money he sent to his three eldest sons, Lucien, Georges and Rodo (Paul and Jeanne were still living with their parents). Despite these hard times, Pissarro was still hopeful that things would improve; this was not the first crisis that he had been through:

I am sending you only three hundred francs this time, I hope that you will not suffer too much from this reduction in your allowance; I have to cut my expenses in spite of the sale of my Dieppe series, the collectors have not as yet bought anything of mine, and I do not know how this crisis will work out. I hope that the dead season here will go better; but in the meantime, one must anticipate a slump.[1]

He announced, almost as part of his campaign to resolve this crisis, his new series: 'At the moment I am doing a series of canvases from the Hôtel du Quai Voltaire, the Pont Royal and the Pont du Carrousel, and also the Quai Malaquais, with the Institut and at the far end to the left the banks of the Seine, superb motifs of light.'[2] Pissarro describes the aspect by his usual method – sweeping across his motif from sharp left to right, giving the reader of his letter (in this case, Lucien) a 180° account of what he could see. Typically, the motifs of this series can be divided into sub-series, even though the whole series comprises only twelve paintings (according to the *catalogue raisonné*). First, looking sharp left (due west), Pissarro painted three paintings of the Quai Voltaire, extended by the Quai Anatole France and divided by the Pont Royal (*The Seine in Paris, Pont Royal* (cat. 122), *The Pont Royal: Grey Weather, Afternoon, Spring* (ill. 123), *The Pont Royal: Afternoon, Grey Weather* (P&V 1294)). Shifting gently to the right, Pissarro almost omits the left bank (Quai Voltaire) from the visual field of his composition and focuses on the Pont Royal as it leads onto the right bank, with the Pavillon de Flore looming monumentally in the background (*The Pont Royal and the Pavillon de Flore* (cat. 125), *The Pavillon de Flore and the Pont Royal* (ill. 124), *The Pont Royal and the Pavillon de Flore* (ill. 126)). These three works clearly constitute the climax of the series. Continually shifting his gaze, Pissarro gradually leaves the opposite bank, to return to the left bank through another bridge, the Pont du Carrousel (*The Louvre, Morning, Sun, Quai Malaquais* (ill. 128), *The Pont du Carrousel:*

1 Bailly-Herzberg 1991, p. 329 (Paris, 30 March 1903; to Lucien Pissarro): 'Je ne te remets que 300F cette fois, j'espère que cette réduction sur ta pension ne te gênera pas trop, je suis forcé de réduire mes dépenses malgré la vente de ma série de Dieppe, les amateurs ne m'ont rien acheté jusqu'à présent, et je ne sais comment la crise se dénouera. J'espère que d'ici la morte-saison cela ira mieux, en attendant il faut prévoir la mévente.'

2 Bailly-Herzberg 1991, pp. 329–30 (Paris, 30 March 1903; to Lucien Pissarro): 'Je fais en ce moment une série de toiles à l'Hôtel du Quai Voltaire, le Pont Royal et le Pont du Carrousel, et aussi l'enfilade de quai Malaquais, avec l'Institut et les fonds à gauche des bords de la Seine, motifs superbes de lumière.'

facing page: detail of cat. 129

Afternoon (cat. 127)). The façade of the Louvre is visible on one side of the bridge, and a segment of the Quai Voltaire appears in the lower left corner of both paintings. Finally, turning sharp right (due east), Pissarro focuses on one arch of the Pont du Carrousel and, as he described it, 'also the corridor of the Quai Malaquais, with the Institut and at the far end, to the left, the banks of the Seine: superb motifs of light'.[3]

These works are about symmetry and circularity. Not only is the semi-circular sweep across the motifs, from left to right, mimetically reproducing the external oval shape of the eye, but, furthermore, this last series brings to an end Pissarro's circular pictorial itinerary around the Louvre. Whether deliberately or not, this series closes the set of reflexive relationships that structure his series from 1899 onwards. In *Garden of the Louvre: Morning, Grey Weather* (cat. 83), the observer's gaze is led past the Pavillon de Flore through to the Pont Royal (the motifs of cat. 125 and ills 124, 126), and in the background he painted the Quai Voltaire (to the left of the bridge), from which he would paint his last series in 1903. In cat. 125 and ills 124 and 126, to the left of the Pavillon de Flore, a horizontal row of trees and houses can be seen in the background: this is the Rue de Rivoli,

behind the Tuileries Gardens, from where the Tuileries series was painted four years previously. In between came paintings such as *The Statue of Henri IV: Morning, Sun* (cat. 111) or *The Pont-Neuf and the Statue of Henri IV* (cat. 110), painted from the Ile de la Cité and showing the dome of the Institut in the background. Reflexively, the dome is represented from the symmetrically opposed direction in cat. 129 and P&V 1290–92. Through the trees can be surmised the silhouette of the Pont des Arts, another intersection point that binds the Square du Vert-Galant and Quai Voltaire series together.

Finally, pictures such as *The Louvre, Morning, Sun, Quai Malaquais* (ill. 128) and *The Pont du Carrousel: Afternoon* (cat. 127) represent the southern side of the Aile Denon of the Louvre, running along the Seine River. *The Carrousel: Autumn Morning* (cat. 87), *The Carrousel: Afternoon Sun* (cat. 88) and *Place du Carrousel, Paris* (cat. 89), painted three or four years earlier, focus on the northern side of the Aile Denon. Furthermore, in most of the paintings of the Square du Vert-Galant series, the terrace is detached against the background of the same Aile Denon (its southern side; see ill. 95 and P&V 1165), thus completing the links between these three extraordinarily cohesive series.

3 Bailly-Herzberg 1991, pp. 329–30.

facing page: detail of ill. 128

122 EXHIBITED

The Seine in Paris, Pont Royal

1903

La Seine à Paris, Pont Royal
P&V 1293
54.6 × 64.4 cm
Signed and dated lower right: *C. Pissarro 1903*

Simone and Alan Hartman

123 NOT EXHIBITED

The Pont Royal: Grey Weather,
Afternoon, Spring 1903

Le Pont Royal, temps gris, après-midi, printemps
P&V 1295
46 × 55 cm

Private Collection

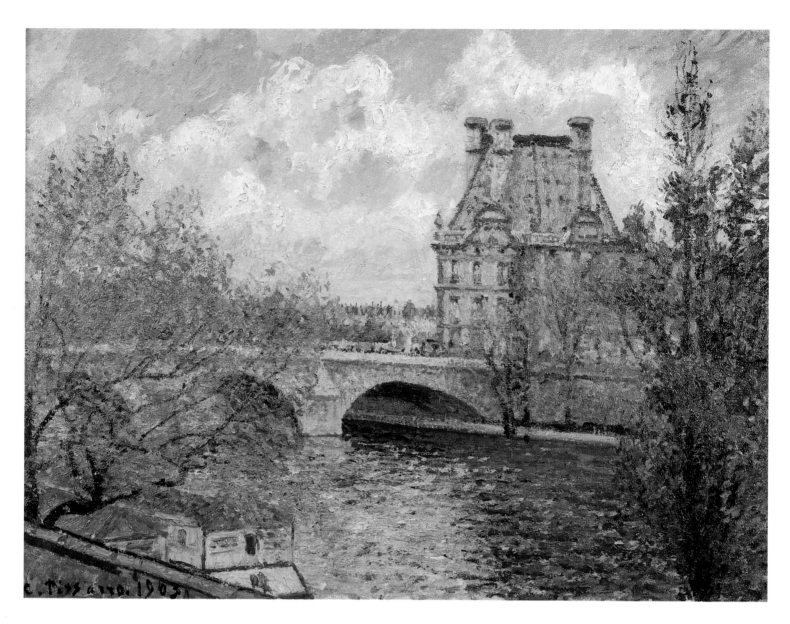

124 NOT EXHIBITED

The Pavillon de Flore and the Pont Royal 1903

Pavillon de Flore et Pont Royal
P&V 1288
65 × 81 cm

Private Collection, Japan

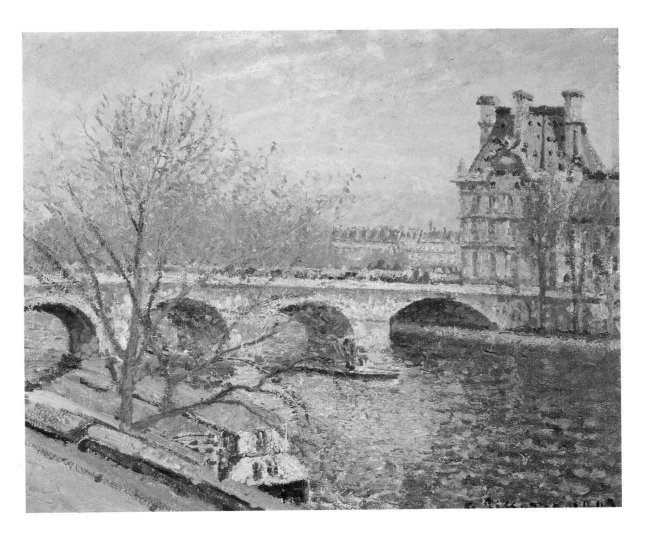

125 EXHIBITED

The Pont Royal and the Pavillon de Flore 1903

Pont Royal et Pavillon de Flore
P&V 1286
54.5 × 65 cm
Signed and dated lower right: *C. Pissarro. 1903.*

Musée du Petit-Palais, Paris

PROVENANCE Acquired by the Musée du Petit-Palais, Paris, 1905

EXHIBITIONS Paris 1937; Reims 1951, no. 34; Paris 1951, no. 35; Rotterdam 1952, no. 103; Paris 1953, no. 415; Annecy 1958, no. 42; Dieppe 1955 (no cat.); Paris 1961, no. 90; Berlin 1963, no. 57; Atlanta 1968; Bucharest 1971, no. 41; New Delhi 1977–78, no. 45; Tokyo 19769, no. 62; London 1980–81, no. 90; Tokyo 1983, no. 39; Tokyo 1985–86, no. 20; Nagoya 1991, no. 36

LITERATURE Lapauze 1906, no. 100; Gronkowski 1927, no. 352; Rewald 1963, p. 158; Kunstler 1974, p. 71; Preutu 1974 (repr. col. p. 67); Lloyd 1979, p. 10

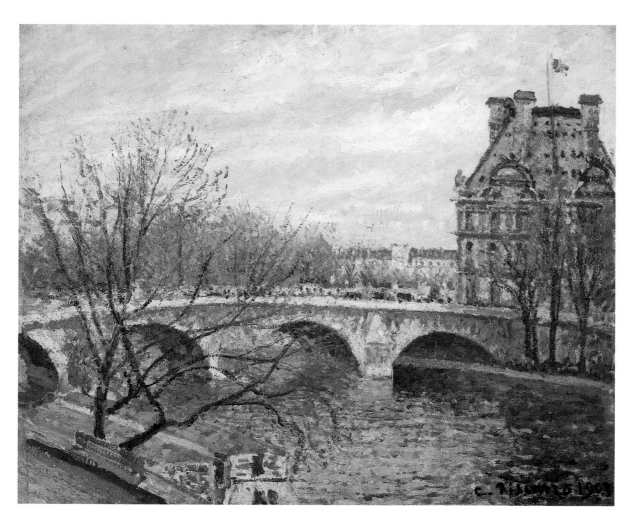

126 NOT EXHIBITED

The Pont Royal and the Pavillon de Flore 1903

Pont Royal et Pavillon de Flore
P&V 1287
54 × 65 cm

Private Collection

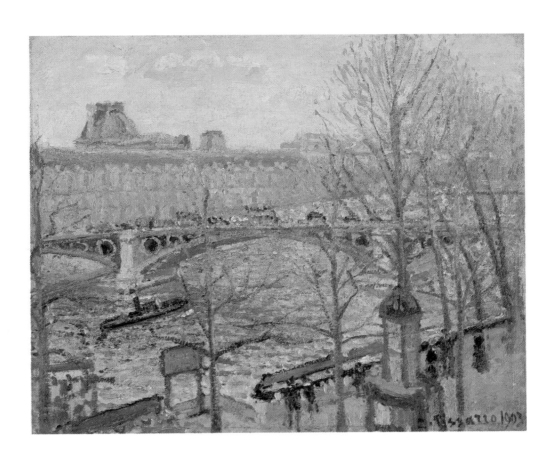

127 EXHIBITED

*The Pont du Carrousel:
Afternoon* 1903

Le Pont du Carrousel, après-midi
P&V 1297
54 × 65 cm
Signed and dated lower right: *C. Pissarro 1903*

Matsuoka Museum of Art, Tokyo

PROVENANCE Galerie Durand-Ruel, Paris,
18 September 1940; Sam Salz, Inc., New
York, 16 October 1940; S. Oestreich,
Montreal; Gertrude Baer, Montreal; sale,
Sotheby's, New York, 13 May 1986 (14A);
Matsuoka Museum of Art, Tokyo

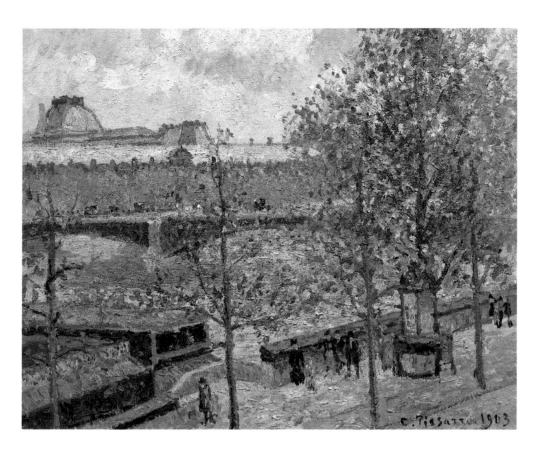

128 NOT EXHIBITED

The Louvre, Morning, Sun, Quai Malaquais 1903

Le Louvre, matin, soleil, Quai Malaquais
P&V 1296
47 × 55.5 cm

Private Collection

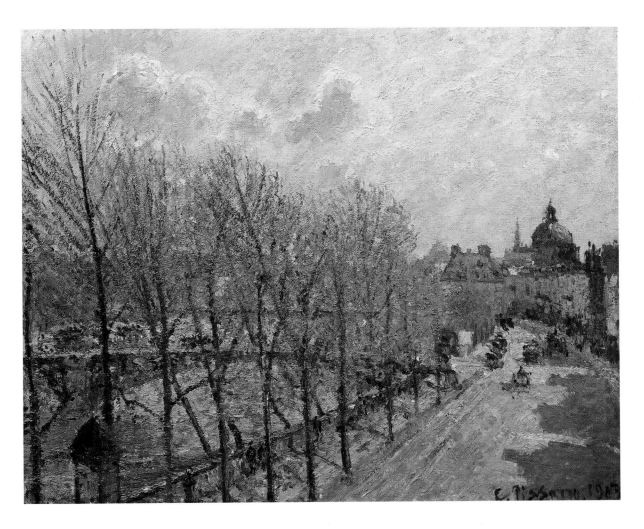

129 EXHIBITED

Quai Malaquais: Morning, Sun

1903

Quai Malaquais, matin, soleil
P&V 1289
54.5 × 65.5 cm
Signed and dated lower right: *C. Pissarro.*
1903

Private Collection. Courtesy of Galerie
Odermatt et Cazeau, Paris

PROVENANCE Sale, Collection G. Urion,
Paris, 16 May 1934 (12); Private Collection,
La Chaux-de-Fonds, in 1967; Galerie
Odermatt et Cazeau, Paris; Private Collection

EXHIBITION Paris 1967, no. 49

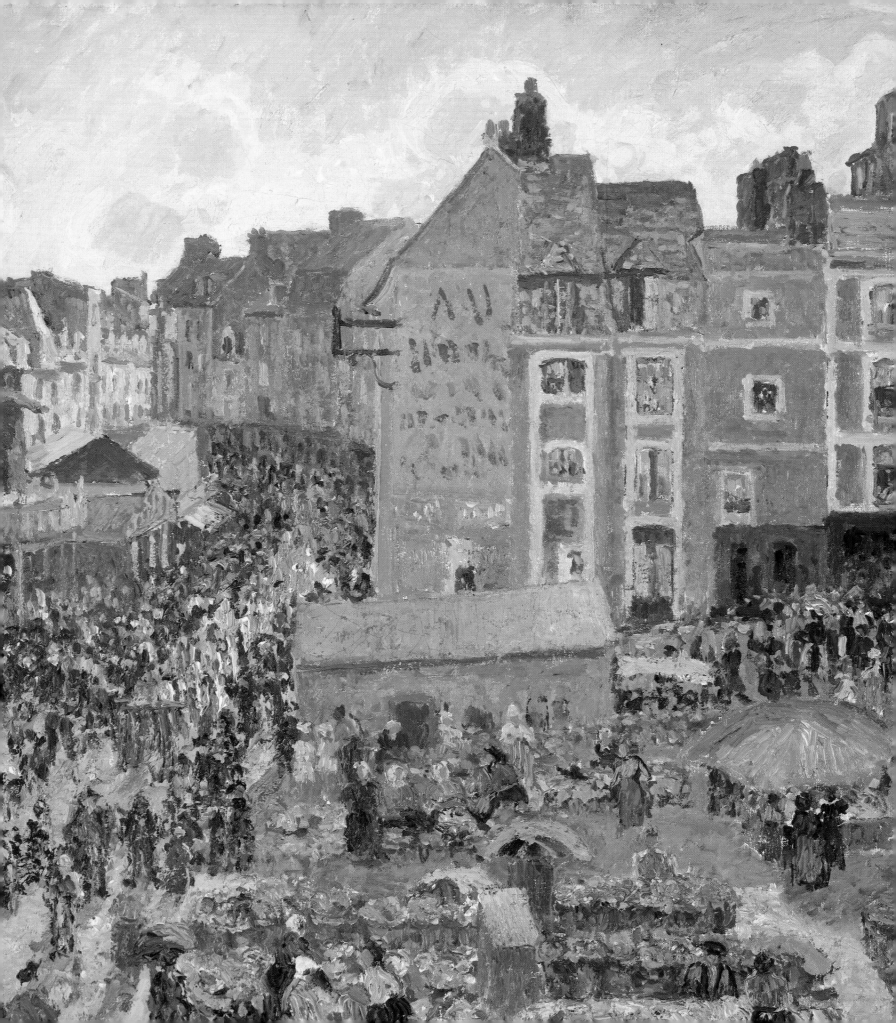

9 DIEPPE: THE CHURCH OF SAINT-JACQUES

Anticipating his view from the Hôtel du Commerce in Dieppe, where he had just reserved a room in July 1901, Pissarro wrote: 'I am going to have a window that looks out over the market.'[1] From this window, Pissarro executed *The Market by the Church of Saint-Jacques, Dieppe* (cat. 131) and *The Church of Saint-Jacques, Dieppe: Rainy Weather, Morning* (P&V 1194), as well as *The Fair at Dieppe: Morning, Sun* (P&V 1198) and *The Fair at Dieppe: Sunny Afternoon* (cat. 134). He could see from the same window a section of the church, the view up the street beside it, and the row of old houses bordering the street. Through his left window, Pissarro could observe the full length of the church's side elevation and the square running alongside. Pissarro described this view in the same letter: 'to the left, I have the portal of the church of Saint-Jacques and quite picturesque towers and houses'[2] (cats. 130–32, and ill. 133).

This small series of nine paintings of the church is reminiscent of Monet's series of Rouen cathedral, as well as of Pissarro's small group of paintings of the Rue de l'Epicerie, Rouen, of 1898 (ills. 32, 33 and cat. 34). However, unlike Monet's series, Pissarro examined several sets of contrasts, and these, paradoxically, bind these works together. One of the main oppositions explored is that established between the church building and the people around it. The church is seen in its human context, a context that occasionally overwhelms it, as in the market scenes (*The Market by the Church of Saint-Jacques, Dieppe* (cat. 131), *The Fair by the Church of Saint-Jacques, Dieppe* (ill. 133), *The Fair at Dieppe: Sunny Afternoon* (cat. 134), *The Fair at Dieppe, Morning, Sun* (P&V 1198)). The bustling crowd, assembled on market days, is temporary; on other days the church is seen almost in isolation, with only a few, interspersed figures present (*The Church of Saint-Jacques, Dieppe:*

Morning, Sun (cat. 130), *The Church of Saint-Jacques, Dieppe* (cat. 132)). The spiritual, the eternal, the greyness of stone are offset by movement, noise, garish colours, market sheds; or, on the contrary, the church appears daunting, a huge character on a grotesquely empty stage, counterbalanced by only a few lost figures and the 'picturesque houses'.

The composition of the paintings cuts vertically through the church, focusing on either the tower, its buttresses and ribbed vaults (cat. 131, and P&V 1194, 1197), or on its porch (P&V 1199); or it encompasses a larger section of the building and emphasises the scanning rhythm of its arches which rhyme with the trees (cats. 130, 132, and P&V 1196). Elsewhere it echoes the pointed, temporary structures of the market tents (ill. 133). Remarkably tight and compact as an ensemble, the paintings in this series mark a departure from the principal motifs of Pissarro's other post-1898 series: there are no allusions to either river or harbour. Instead, the motif recalls that of *The Roofs of Old Rouen: Grey Weather (the Cathedral)* (cat. 31) of 1896, a painting that Pissarro thought much of: 'I have kept for myself the *Vieux toits de Rouen*, which is to my mind my most important work, and Zando, Degas, etc agree . . . I reckon on asking ten thousand francs or else I will keep it.'[3]

In this series, in contrast to those that focus upon the industrial and modern developments of the urban world, Pissarro was able to explore his long-standing interest in the Gothic, an interest that is reflected in his letters over the years. In 1883 he had written to Lucien: 'I have also done some little drawings of wooden sculpture, pure gothic in style with tiny ornaments – it's wonderful.'[4] Six years later he advised Georges, 'I think that it would be useful for you to compare nature with the work of the Gothics, who in short, as artists, drew all their elements from nature with an incomparable boldness.'[5]

1 Bailly-Herzberg 1991, p. 188 (Eragny-Bazincourt par Gisors, 19 July 1901; to Lucien Pissarro): 'j'aurai une fenêtre qui donne sur le marché'.

2 Bailly-Herzberg 1991, p. 188 (Eragny-Bazincourt par Gisors, 19 July 1901; to Lucien Pissarro): 'à gauche, j'ai le portail de l'église Saint-Jacques, tours et maisons assez pittoresques'.

3 Bailly-Herzberg 1989, p. 189 (Paris, 16 April 1896; to Lucien Pissarro): 'Je me suis réservé pour moi les *Vieux toits de Rouen* qui est à mon sens, à celui de Zando, Degas, etc., l'oeuvre capitale . . . je compte demander dix mille ou le garder.'

4 Bailly-Herzberg 1980, p. 252 (Rouen, 20 November 1883; to Lucien Pissarro): 'J'ai dessiné aussi quelques petits motifs de sculpture en bois, du gothique pur avec des petits ornements, c'est merveilleux.'

5 Bailly-Herzberg 1986, p. 306 (Eragny par Gisors, 21 October 1889; to Georges Pissarro): 'Je crois qu'il y aurait du profit pour toi à comparer la nature avec les oeuvres des Gothiques, qui en somme sont des artistes qui ont puisé dans la nature tous leurs éléments et cela avec une hardiesse incomparable'.

facing page: detail of cat. 134

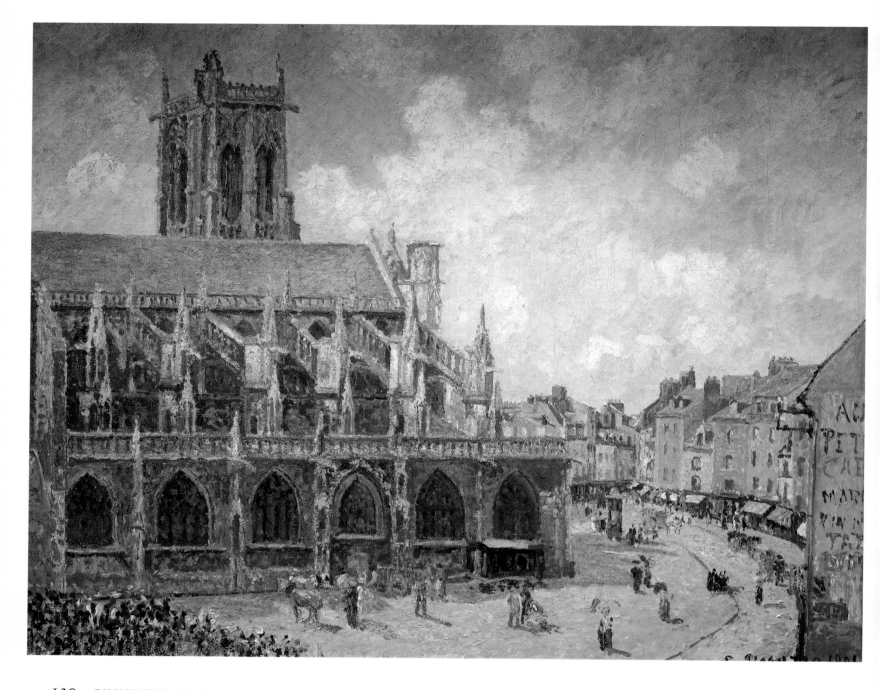

130 EXHIBITED IN DALLAS AND PHILADELPHIA

The Church of Saint-Jacques, Dieppe: Morning, Sun 1901

L'Eglise Saint-Jacques à Dieppe, matin, soleil
P&V 1193
73.3 × 92.4 cm
Signed and dated lower right: *C. Pissarro 1901*

Private Collection

PROVENANCE In the artist's collection; Mme Camille Pissarro; sale, Collection Camille Pissarro, Galerie Georges Petit, Paris, 3 December 1928 (31); Dr Max Emden, Hamburg; sale, Collection Dr Max Emden, Hamburg, 9 June 1931 (42); Dr Alexander Lewin, Guben; sale, Christie's, New York, 15 November 1988 (25); Private Collection

EXHIBITIONS Paris 1907, no. 17; Paris 1914, no. 21; Paris 1921, no. 7

LITERATURE *La Renaissance*, December 1928; *Figaro Artistique*, 10 January 1929

facing page: detail of cat. 130

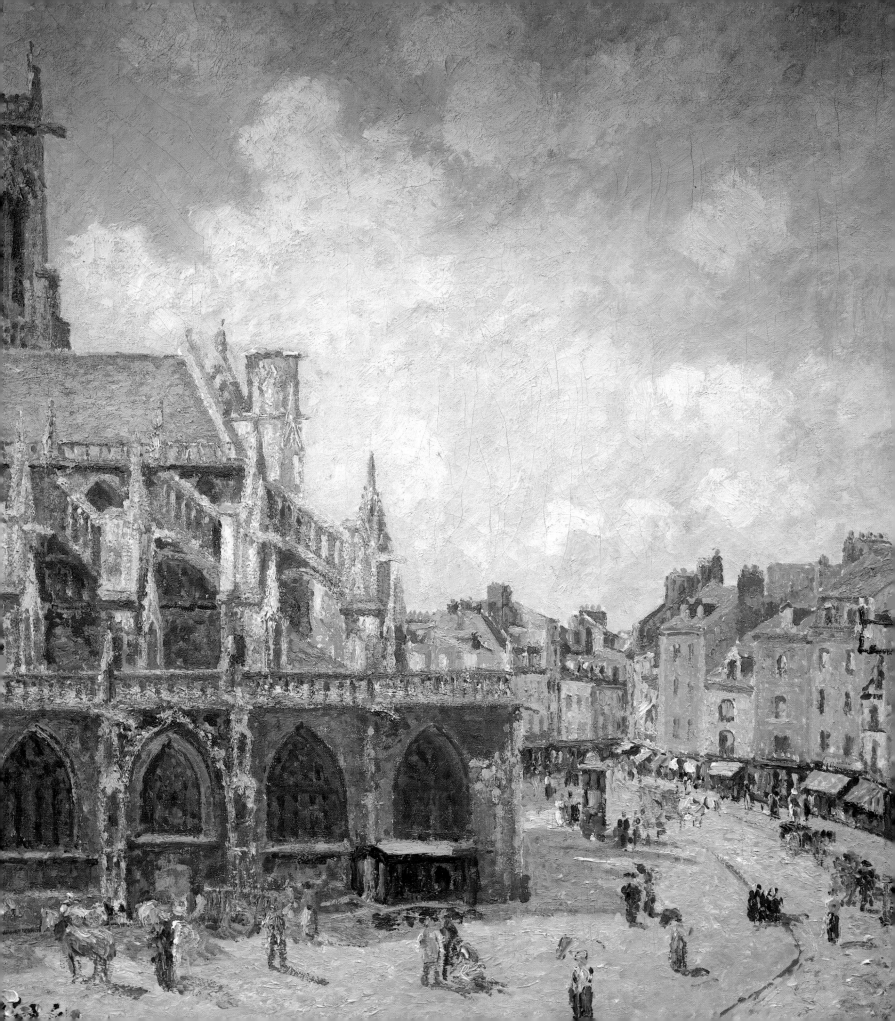

131 EXHIBITED

The Market by the Church of Saint-Jacques, Dieppe 1901

Le Marché autour de l'Eglise Saint-Jacques, Dieppe
P&V 1195
91 × 73 cm
Signed and dated lower left: *C. Pissarro. 1901*

Private Collection

PROVENANCE L. Payen; sale, Collection Léon Payen, Paris, 29 and 30 June 1916, no. 94 (repr.); Goldast, Paris; sale, Succession de M. Goldast, Paris, 8 and 9 February 1939 (21); Georges Bernheim, Paris; Private Collection; bought by Wildenstein & Co., New York, 1939; bought from Wildenstein & Co., New York, by a private collector, 27 August 1943

EXHIBITIONS Paris 1902(ii), no. 1; Paris 1904, no. 118

LITERATURE Rocheblave n.d., p. 57

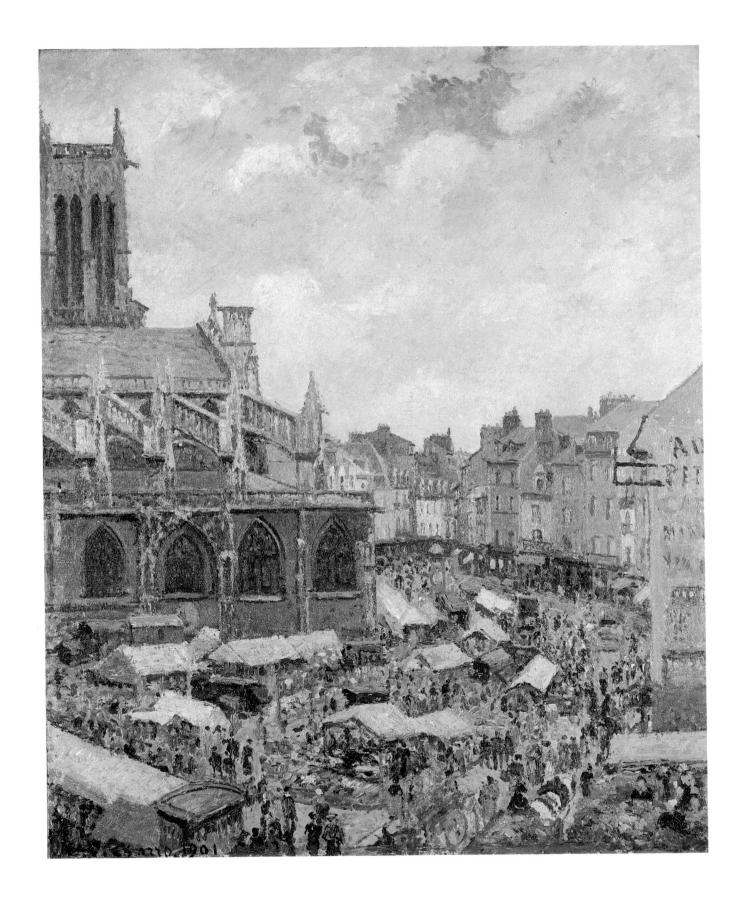

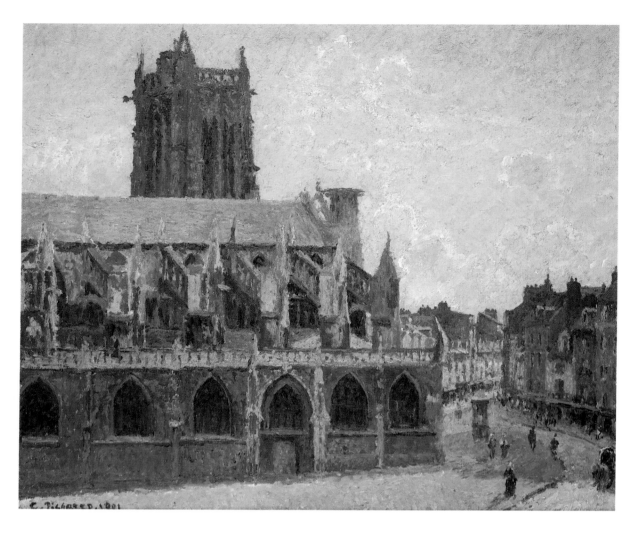

132 EXHIBITED

The Church of Saint-Jacques, Dieppe 1901

L'Eglise Saint-Jacques à Dieppe
Non-P&V
54.5 × 65.5 cm
Signed and dated lower left: *C. Pissarro 1901*

Musée d'Orsay, Paris

PROVENANCE Galerie Durand-Ruel, Paris;
entrusted by the Office des Biens privés to
the Musée du Louvre, 1950; transferred to the
Musée d'Orsay, Paris, 1976

EXHIBITIONS Brussels 1935, no. 56;
Dieppe 1955; travelling exhibition in France,
*Le Paysage français de Poussin aux
Impressionnistes*, 1956, no. 19; Limoges 1956,
no. 23; Pontoise 1985, no. 38; Brighton 1992,
no. 54 (repr.)

LITERATURE Cogniat 1974, p. 81; Compin
1986, vol. IV, p. 139

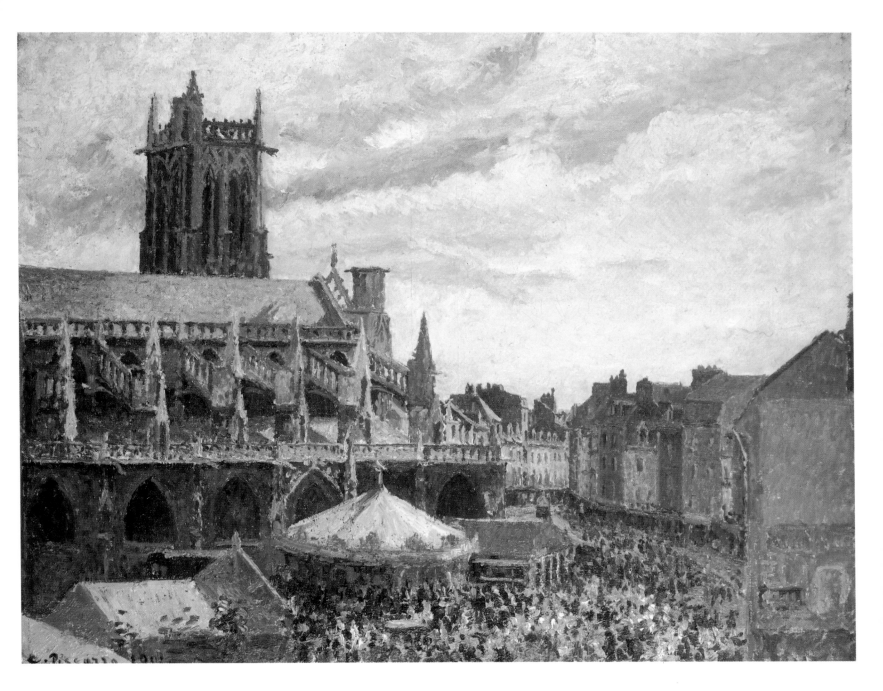

133 NOT EXHIBITED

The Fair by the Church of Saint-Jacques, Dieppe 1901

La Foire autour de l'Eglise Saint-Jacques, Dieppe
P&V 1197
73.5 × 92.5 cm

Private Collection

The Fair, Dieppe: Sunny Afternoon 1901

La Foire à Dieppe, soleil, après-midi
P&V 1200
73.7 × 92.7 cm
Signed and dated lower right: *C. Pissarro, 1901*

Philadelphia Museum of Art, Bequest of Lisa Norris Elkins (Mrs. William M. Elkins)

PROVENANCE Bought from the artist by Galerie Durand-Ruel, Paris, 6 November 1901; bought by Bernheim-Jeune et Cie., Paris, 16 January 1902; Van der Velde Collection, Le Havre; Duncan Phillips Memorial Gallery, Washington, D.C.; Gaston Lévy Collection, Paris; Paul Rosenberg, Paris; J. Hessel Elkins, Paris; H. S. Southam Collection, Ottawa; bought by the French Art Galleries, New York, and Knoedler & Co., New York, February 1944; bought by Mr and Mrs William M. Elkins, Philadelphia, (March 1944); bequeathed by Lisa Norris Elkins to the Philadelphia Museum of Art

EXHIBITIONS Paris 1902(ii), no. 4; Paris 1930, no. 11; London 1937, no. 26; Galerie Aktuaryus, Zurich, 1938, no. 1; Philadelphia 1947; London 1980–81, no. 88; Brighton 1992, no. 55 (repr.)

LITERATURE Fontainas 1902, p. 246; Stephens 1904 (repr. p. 429); Tabarant 1924, pl. 38; Phillips 1926, p. 33; Jedlicka 1950, pl. 49; Natanson 1950, pl. 49

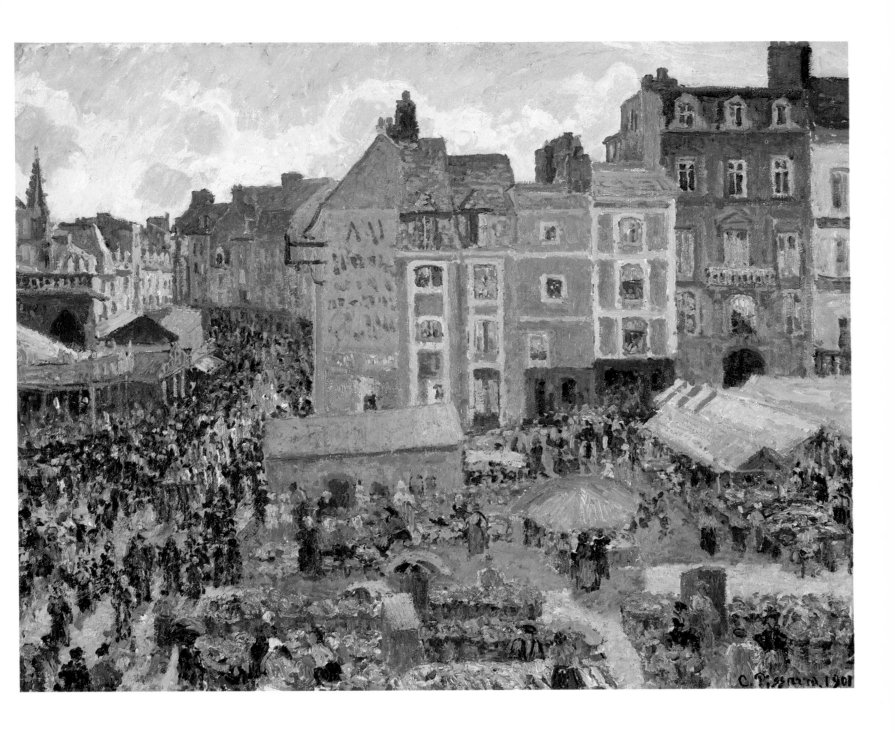

10 DIEPPE: THE HARBOURS
LIFE, MOVEMENT AND COLOUR

The two Dieppe series perhaps most clearly and succinctly exemplify the dichotomies at the heart of Pissarro's work and of his pictorial aesthetics. The Church of Saint-Jacques series had again brought to the fore his interest in Gothic art. In the Dieppe Harbours series he once more explored his pictorial interest in the shipping and industrial activities in and around the port. The first eight paintings given to the series in the *catalogue raisonné* represent the *avant-port* (inner harbour) with the distant silhouette of the Neo-gothic church of Bon-Secours looming on the hilltop beyond.

As he was starting to grapple with this, his penultimate series, Pissarro voiced a vivid concern at the threatened destruction of Gothic monuments or ruins. An article had been published in *l'Aurore* (17 August 1902) by Elie Faure entitled 'Les Ruines', in which it was suggested that 'the ruins should be allowed to die'.[1] This article infuriated Pissarro who, from his hotel room overlooking the harbour, wrote to Jean Grave, the editor of the anarchist newspaper *Les Temps nouveaux*, registering his disagreement with Faure's view: 'What do you think of the articles [sic] in *l'Aurore* on Gothic art? I find them ill thought-out and too political. The question is far more difficult to resolve; should one destroy the masterpieces of the Gothics? I do not think so!'[2] By 'political' Pissarro means a traditional, conventional, bi-partisan political attitude, which approaches problems from one of two opposing positions. The conservatives regarded Gothic art as a symbol of a tradition that embodied religious values; the socialists held any such symbols to be dispensable, if not despicable. Pissarro, an anti-conservative, took the opposite stance to the socialists, asserting that he loved Gothic art and would fight to preserve such 'chefs d'oeuvres'. He thereby illustrated once more that the world cannot be assimilated or understood in simple confrontational terms. Between the sanctification of tradition and the destruction of tra-

dition, there are, in fact, a myriad number of other possible stances; for instance, the desire to look at Gothic art not as a repository of moral codes, but as an aesthetic equivalent of contemporary art. Pissarro remained throughout his life passionately interested in Gothic art – and even while he was painting the fishmarket in Dieppe's harbour, turning his back on the church of Saint-Jacques, his interest was acute.

In a letter of 8 July 1902 to an unnamed collector, Pissarro explained his reasons for choosing Dieppe for a second series: 'I leave tomorrow for Dieppe to look for a hotel there; Dieppe is a *wonderful place for a painter* who enjoys life, movement, colour. I have some friends there and I know the motifs I would like to do. In spite of the dense crowds, I have decided to go back there again this year.'[3] When Pissarro gives the key to a series, he usually does so by emphasising a few themes that are of major pictorial importance and that hold the series together. The Dieppe Harbours series is about life, movement and colour. In this series he is concerned with familiarity and sociability, with the fact that he had good friends in the town and that he knew Dieppe's highways and byways.

He therefore settled at the Hôtel du Commerce, taking also a room at 7 Arcades de la Poisonnerie, so that he could vary his motifs. On 11 August he described the series to Lucien: 'My motifs are very beautiful, the fishmarket [left], the inner harbour, the Duquesne port [right], the village of Le Pollet . . . in the rain, sun and smoke.'[4] In this list, Pissarro proceeded systematically from left to right, indicating that his gaze swept across the whole harbour space, encompassing it completely. Table 8 in the Appendix analyses the series, following Pissarro's indications.

When Georges came to visit his parents (who were looking after Tom, Georges's son, that summer), he, too, gave a short account of the series: 'I was in Dieppe seeing Tom and all the

1 Cited in Bailly-Herzberg 1991, p. 260.
2 Bailly-Herzberg 1991, p. 258 (Dieppe, 27 August 1902; to Jean Grave): 'Comment appréciez vous les articles de *l'Aurore* sur l'art gothique? Je les trouve peu étudiés, trop politiques. La question est autrement difficile à résoudre; doit on détuire les gothiques, les chefs d'oeuvre? Je ne le pense pas!'
3 Bailly-Herzberg 1991, p. 247 (n.p., 8 July 1902; to 'Monsieur'): 'Je pars demain pour Dieppe pour y chercher . . . un hôtel . . . Dieppe est un *endroit admirable pour un peintre* qui aime la vie, le mouvement, la couleur. J'y ai des amis et je connais les motifs que j'aimerais faire. Malgré l'affluence du monde, je me suis décidé à y retourner encore cette année.'
4 Bailly-Herzberg 1991, p. 255 (Dieppe, 11 August 1902; to Lucien Pissarro): 'Mes motifs sont très beaux, la Poissonnerie, l'avant-port, le port Duquesne, le Pollet . . . par la pluie, le soleil, les fumées, etc.'

facing page: detail of cat. 139

Pissarro, *The Fishmarket, Dieppe* (P&V 1504), 1901, gouache, 17 × 25 cm, Private Collection. Courtesy of Galerie Schmit, Paris

family who are spending their holidays quarrelling by the seaside – as good an entertainment as any. Papa was working hard; he has done some marvellous things: the port with all the comings and goings of crowds, and boats leaving and departing, the smoke etc., etc. It's stunning and even more beautiful than last year's churches.'[5]

The very rapidly and dramatically changing weather (quite typical of the Normandy coast) became an important component, particularly within the sub-series of the docks. In early September Pissarro noted: 'The weather is hopeless here; luckily I have a window overlooking the docks which means that I can work regardless.'[6] A comment made two days later suggests in what way he thought of his work and the weather as a continuum: 'The weather continues to be inexorably bad and I have begun to avoid the beach; it is beautiful none the less and the fleeting effects are superb, and so I have a terrible time keeping up with them.'[7] He poetically referred in the same letter to 'the inclemency of the season'.

As with the Pont-Neuf series, Pissarro seems to have been concerned to fill his works with a multitude of anecdotal visual data. In one letter he mentioned a dredger and expressed the hope that it would look good in one of his pictures of low tide and rain effect, though he added that he had not yet been able to obtain the wished-for conditions.[8] The dredger is, however, visible in *The Port of Dieppe, The Duquesne and Berrigny Basins: High Tide, Sunny Afternoon* (cat. 137), which presents exactly opposite characteristics (high tide and fair weather).

At the end of September Pissarro returned to Eragny, having completed one of his most intensively produced series – eighteen canvases in less than three months, and at the age of seventy-two. He noted, on arrival in Eragny, that his crates were full of canvases to be retouched.[9]

The Dieppe Harbours series constitutes an impressive achievement not only so far as the output was concerned; it also deals with a whole gamut of new variations and effects. The series was the result of an extraordinary conglomeration of different but juxtaposed themes. Pissarro not only looked at the interpenetration of industrial smoke, steam and clouds, the to-ing and fro-ing of crowds, which also are structural components reminiscent of the Rouen series. He also introduced into them new elements: streams of people are represented in a complex spatial and economic web – a source of acute visual interest. The Rouen bridge series (though depicting the crowds crossing the bridges over the Seine's barge and steamboat traffic) was essentially created on an orthogonal structure – on the model of a Saint Andrew's cross. The Dieppe series resists such simplification. A river (the Arcq) meets the sea – their intersection defines the ambiguous and complicatedly compartmented harbours, while the river divides Dieppe from Le Pollet (as Pissarro noted). The railway ends on the Quai de la Poissonerie, on the edge of the harbours, by the fishmarket. Out of the train pour people from inland. The space nearby is wide open; the people are free to form any configuration and are depicted in lines, in groups, in circles, one by one, *en masse*. They work, shop, gaze, fish, queue, chat, wait, stroll, pass by, merge. The ships are sailing-boats, ferries (to and from England, as in *Afternoon, Sun, the Inner Harbour at Dieppe* (cat. 141)), steamboats. The harbour is divided into rectangular sections (inner harbour, docks, jetties, bridges) which surround, enclose and control the sea. Analogously, the artist's gaze surrounds the whole harbour, cuts through it, lays down his own pictorial boundaries and edits while he paints. Yet, from one compartment to the next, from one dock to the other, from one picture to another, things flow – the passage of communication works.

5 Cited in Bailly-Herzberg 1991, p. 258: 'j'étais à Dieppe voir Tom et toute la famille qui passent leurs vacances à se disputer au bord de la mer. Distraction comme une autre. Papa, lui, a travaillé dur, il a fait des merveilles: le port avec tout le remue-ménage de la foule et des bateaux qui partent et arrivent, les fumées, etc., etc. C'est épatant, c'est plus beau que les églises de l'année dernière.'

6 Bailly-Herzberg 1991, p. 261 (Dieppe, 1 September 1902; to Paul Durand-Ruel): 'Il fait ici un temps désespérant, heureusement, je possède une fenêtre sur les bassins qui me permet de travailler quand-même.'

7 Bailly-Herzberg 1991, p. 262 (Dieppe, 3 September 1902; to M. Durenne): 'Le temps continue à être inexorablement mauvais, on commence à fuir la plage: c'est beau tout de même, les *effets fugitifs* sont admirable, aussi ai-je un mal terrible à les suivre.'

8 Bailly-Herzberg 1991, pp. 266–67 (Dieppe, 12 September 1902; to Julie Pissarro).

9 Bailly-Herzberg 1991, p. 270 (Eragny-Bazincourt par Gisors, 3·October 1902; to Lucien).

135 NOT EXHIBITED

*Dieppe, the Duquesne Basin: Low
Tide, Sunny Morning* 1902

*Dieppe, Bassin Duquesne, marée basse, soleil
matin*
P&V 1253
54 × 65 cm

Musée d'Orsay, Paris

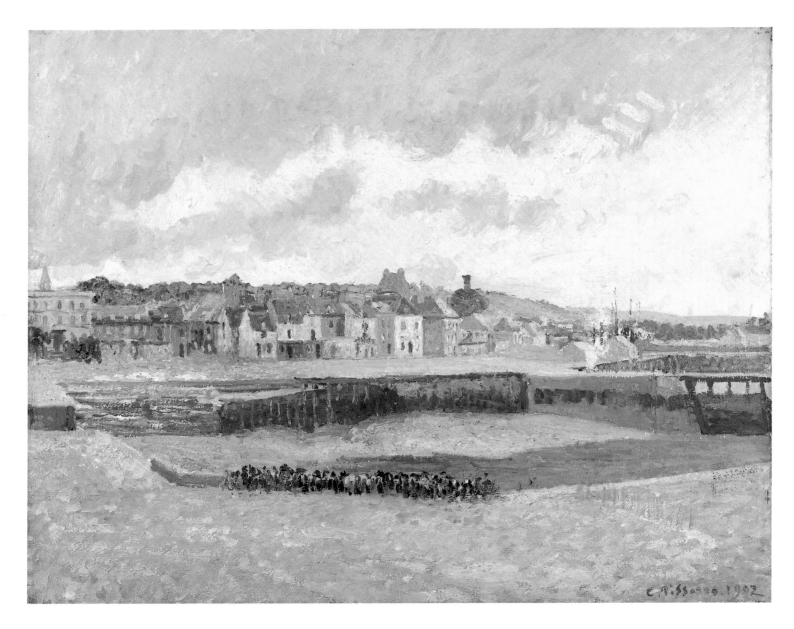

136 NOT EXHIBITED

Afternoon, the Duquesne Basin,
Dieppe, Low Tide 1902

Après-midi, Bassin Duquesne à Dieppe, marée
basse
P&V 1255
65 × 81 cm

Montreal Museum of Fine Arts

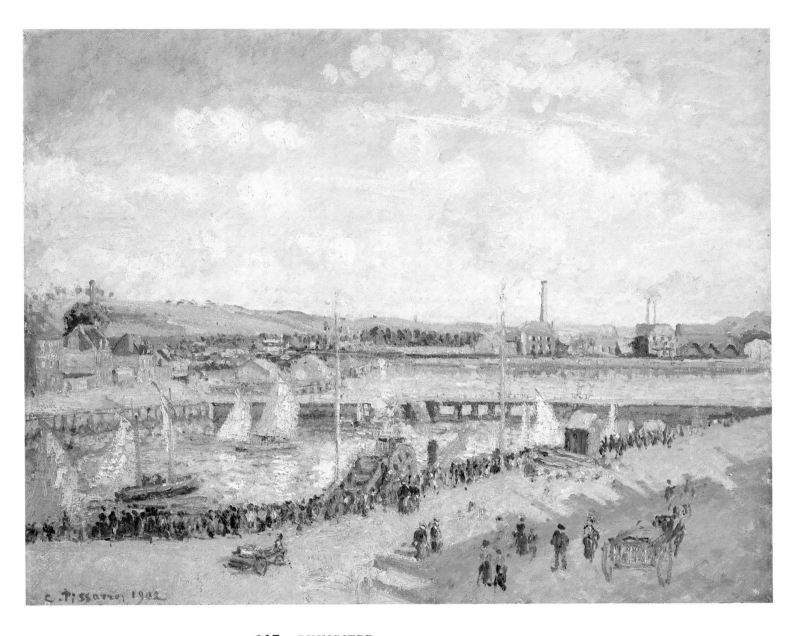

137 EXHIBITED

*The Port of Dieppe, the Duquesne
and Berrigny Basins: High Tide,
Sunny Afternoon* 1902

*Port de Dieppe, Bassins Duquesne et Berrigny,
marée haute, après-midi ensoleillée*
P&V 1252
65 × 81 cm
Signed and dated lower left: *C. Pissarro. 1902*

Private Collection

PROVENANCE A. Bonin, Paris; Marc
François, Paris; sale, Collection Marc
François, Hôtel Drouot, Paris, 20 March 1935
(9); Paul Rosenberg & Co., Paris and New
York (3805); Le Bas Collection, London; A.
Tooth, London; David Rockefeller, New
York; Sam Salz, Inc., New York; Albert J.
Dreitzer Collection, New York; sale,
Sotheby's, New York, 13 November 1985
(11); Private Collection

EXHIBITIONS Paris 1930; New York
1966(iii), no. 131

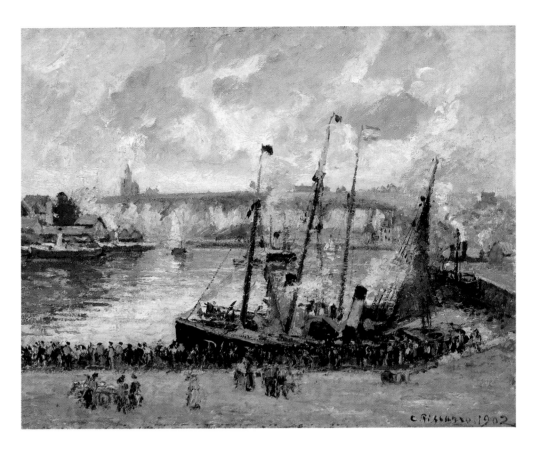

138 NOT EXHIBITED

The Inner Harbour, Dieppe: High Tide, Morning, Grey Weather

1902

L'Avant-port de Dieppe à marée haute, le matin, temps gris
P&V 1242
46.5 × 55.3 cm

The Fine Arts Museums of San Francisco, Mildred Anna Williams Collection, 1940.52

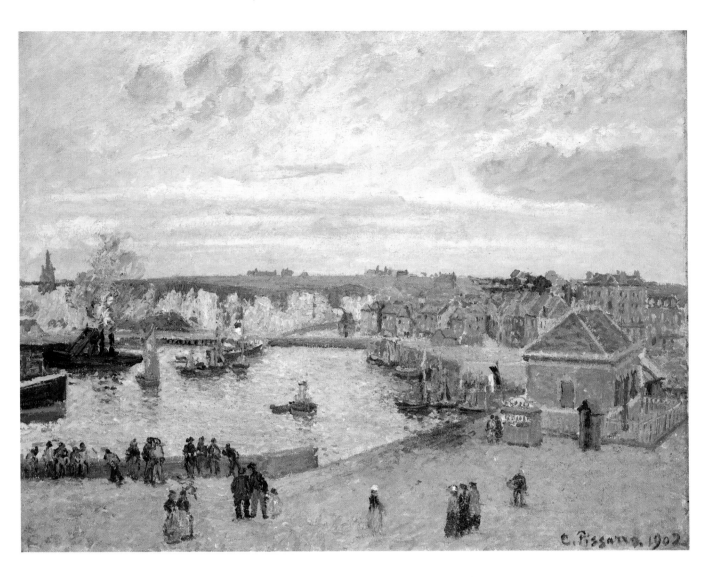

139 EXHIBITED

The Port of Dieppe 1902

Port de Dieppe
P&V 1248
60 × 73 cm
Signed and dated lower right: *C. Pissarro.*
1902

Private Collection

PROVENANCE Elie Mousseri, Paris; by
descent to a private collector, Switzerland;
sale, Sotheby's, London, 30 June 1992 (14A);
Private Collection

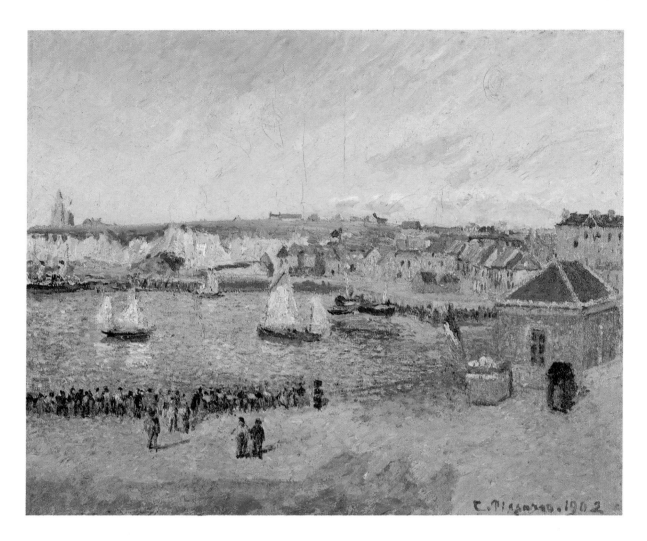

140 NOT EXHIBITED

The Inner Harbour, Dieppe:
Afternoon, Sun, Low Tide 1902

Avant-port à Dieppe, après-midi, soleil, marée
basse
P&V 1247
53.5 × 65 cm

Collections du Château-Musée de Dieppe

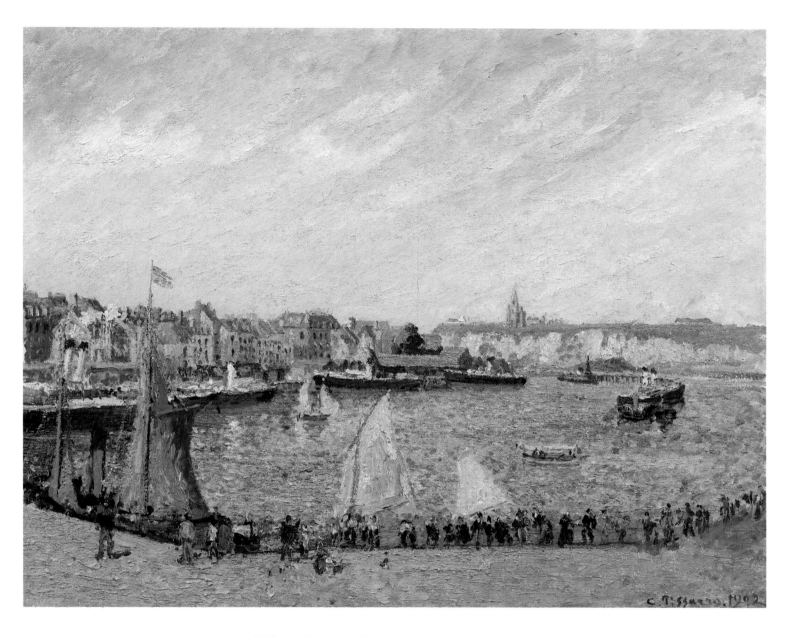

141 EXHIBITED

Afternoon, Sun, the Inner Harbour, Dieppe 1902

Après-midi, soleil, avant-port de Dieppe
P&V 1245
65.5 × 81.3 cm
Signed and dated lower right: *C. Pissarro.
1902*

Private Collection. Courtesy of Galerie
Schmit, Paris

PROVENANCE Galerie Durand-Ruel, Paris;
Galerie Rosengart, Lucerne; Private
Collection, Switzerland; sale, Christie's,
London, 1 December 1987 (34); Galerie
Schmit, Paris; Private Collection

EXHIBITIONS Paris 1910(i), no. 33; Paris
1910(ii), no. 53; Berne 1957, no. 115;
Schaffhausen 1963, no. 98; Paris 1988(ii),
no. 55; Paris 1990, no. 53

LITERATURE Stephens 1904; *Die Kunst*, 15
January 1913; Schumann 1914; Duret 1939

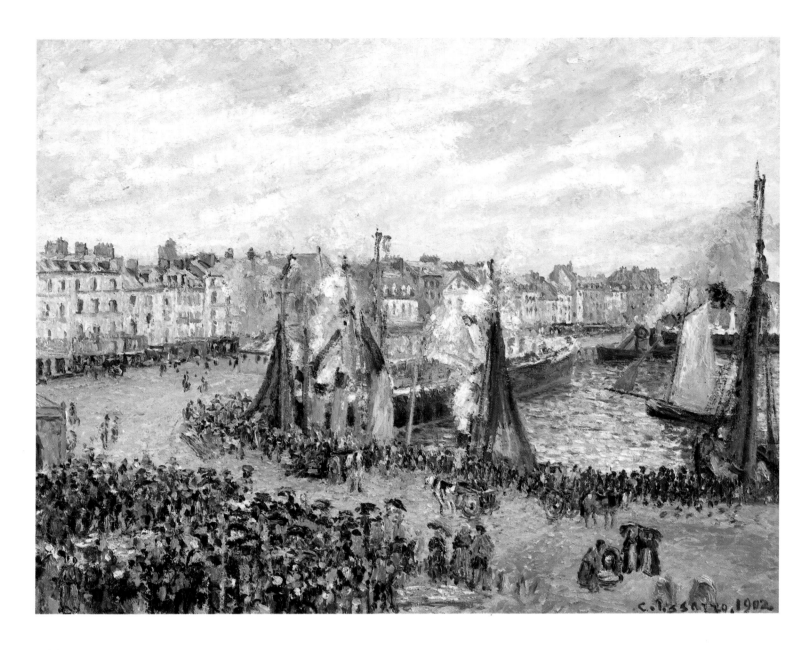

142 EXHIBITED

The Fishmarket, Dieppe: Grey Weather, Morning 1902

Le Marché aux poissons, Dieppe, temps gris, matin
P&V 1250
65 × 81 cm
Signed and dated lower right: *C. Pissarro 1902*

Private Collection

PROVENANCE Dr Julius Elias, Berlin; bought privately by Wildenstein & Co., New York, August 1966 (no. 90284); bought by Eugene McDermott, March 1967; Private Collection

EXHIBITIONS Dallas 1978, no. 9; Dallas 1989, no. 81

LITERATURE Waldmann 1927, p. 631; Kunstler 1967, p. 55

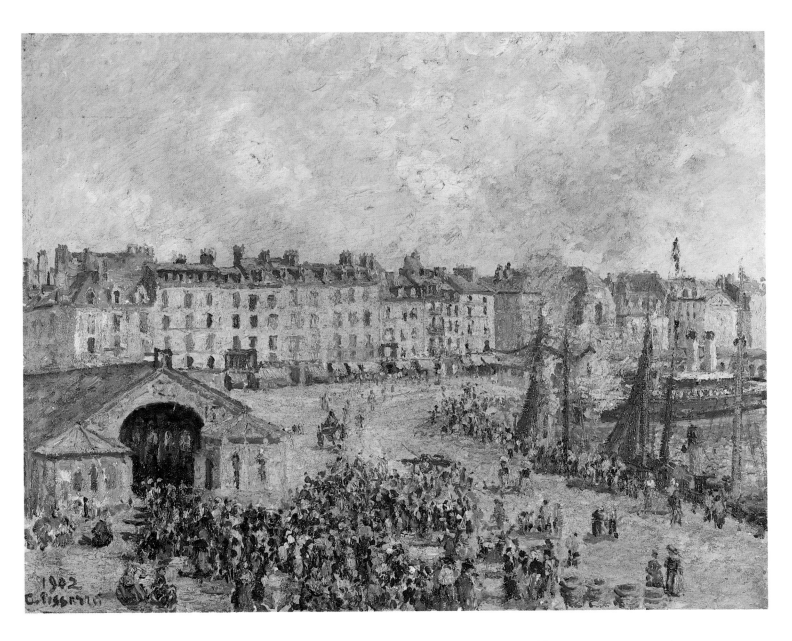

143 NOT EXHIBITED

The Fishmarket, Dieppe 1902

Le Marché aux poissons à Dieppe
P&V 1249 (known as *La Poissonerie à Dieppe*)
66 × 81 cm

Private Collection, Japan

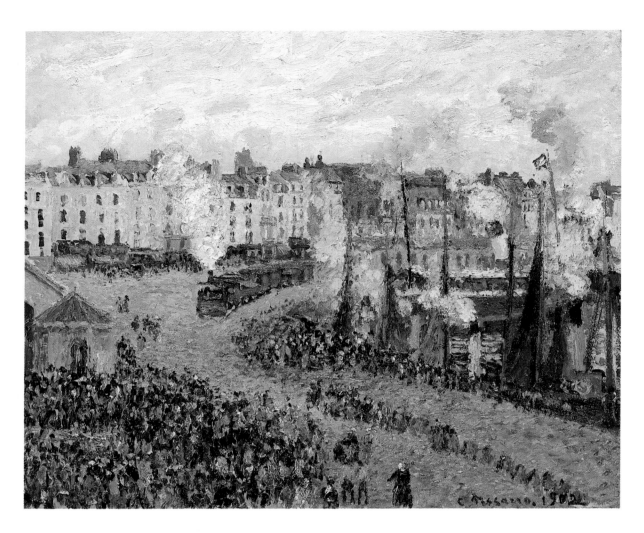

The Fishmarket, Dieppe 1902

Le Marché aux poissons à Dieppe
Non-P&V
54 × 64 cm (approx.)
Signed and dated lower right: *C. Pissarro.
1902*

Private Collection, Switzerland

PROVENANCE Collection Cassirer, Berlin;
Collection Gertr. Roemer, Berlin; Collection
Mrs Brozio, Berlin; Galerie Theo Fischer,
Lucerne; Mr Alfred Schwabacher, Zurich and
New York; Private Collection, Switzerland

EXHIBITIONS New York 1956; New York
1966(iii)

facing page: detail of cat. 144

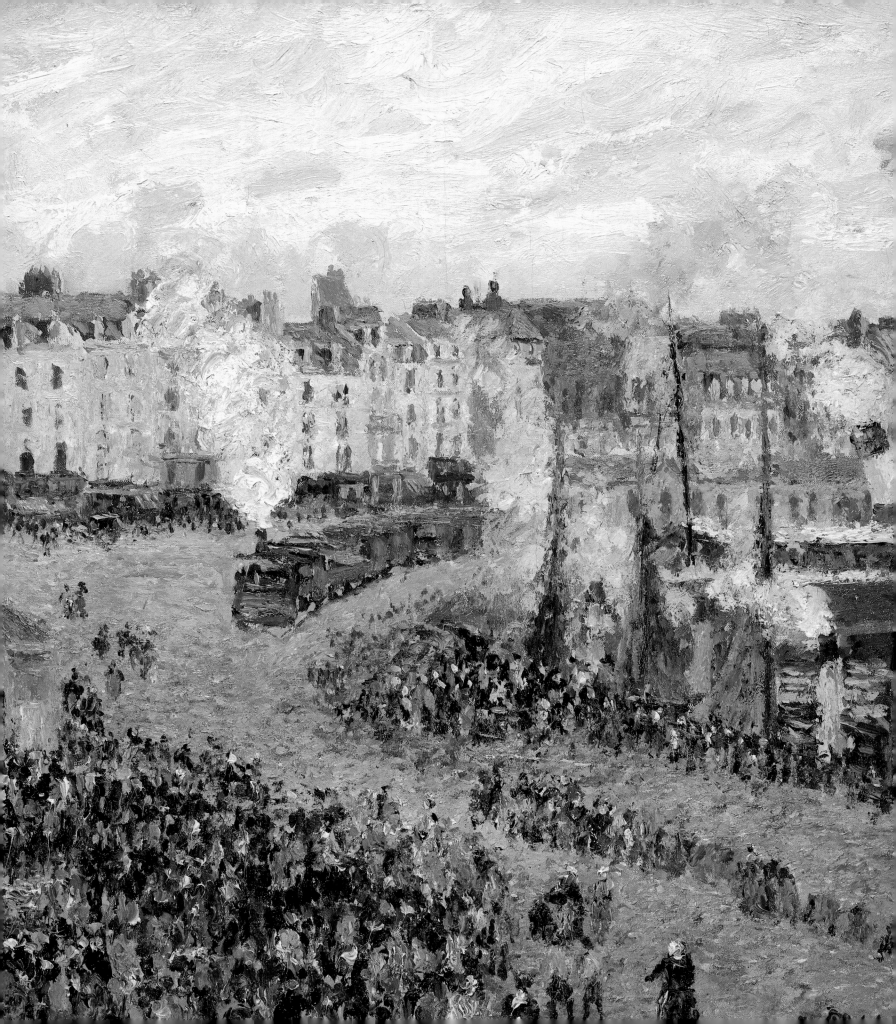

11 LE HAVRE

1 Bailly-Herzberg 1991 pp. 351–53 (Le Havre, 6 July 1903; to Rodolphe Pissarro).

2 Bailly-Herzberg 1991 p. 351 (Le Havre, 6 July 1903; to Rodolphe Pissarro).

3 Bailly-Herzberg 1991 p. 352 (Le Havre, 6 July 1903; to Rodolphe Pissarro): 'Le pays est beau, il y aurait certainement de jolies choses à faire, mais ce sont les moyens pratiques qui fond défaut. Les hôtels ne sont pas situés aux bons endroits'.

4 Bailly-Herzberg 1991 p. 356 (Le Havre, 10 July 1903; to Lucien Pissarro): 'Nous avons couché à l'Hôtel Saint-Siméon, renommé par le séjour de tous les peintres depuis 1830 jusqu'à nos jours. C'était autrefois une ferme sous des pommiers plantés dans des prés verts, avec vue sur la mer. Boudin, Corot, Cals, Daubigny, Monet, Jongkind y ont passé'.

5 Bailly-Herzberg 1991 p. 356 (Le Havre, 10 July 1903; to Lucien Pissarro): 'ces imbéciles de nouveaux propriétaires y ont mis bon ordre!! . . . C'est affreusement peigné, astiqué, les allées rectilignes sablées, on ne voit la mer que dans les salles à manger, des fenêtres des chambres, on ne voit même plus la mer, en un mot c'est arrangé pour les Anglaises qui affluent.'

6 Bailly-Herzberg 1991 p. 356 (Le Havre, 10 July 1903; to Lucien Pissarro): 'Selon à moi, notre pré à Eragny est un merveille à côté de tout ce que je vois.'

7 Bailly-Herzberg 1991 p. 352 (Le Havre, 6 July 1903; to Rodolphe Pissarro): 'mon bon, tout bonnement parce que j'aime mieux la Normandie, que c'est à deux pas de Paris et d'Eragny, et qu'il faut *penser* à satisfaire mes amateurs.'

facing page: detail of cat. 152

Le Havre was the last series undertaken by Pissarro. It was also one that raised serious difficulties. First, the choice of Le Havre as a source of motifs was not an obvious one for him. He explained his doubts in a letter (unknown and unpublished until recently) written to his fourth son, Ludovic-Rodo, in July 1903.[1] It is apparent from this letter that Pissarro had originally been thinking of doing a third Dieppe series. What had deterred him, however, was the food served by the hotel in which he had stayed during his previous visits – a certain cook's assistant had left and the quality of the food had become considerably worse: 'It's become impossible!' was Pissarro's verdict. Apparently for the first time, therefore, food was one of the factors that determined his choice of motif. In Le Havre, Pissarro, his wife and youngest children were served 'de la grande cuisine française', perfectly suited to the taste of 'the English and the rich', but which Pissarro nevertheless thought 'quite bad'.[2] Julie was from Burgundy, and in her opinion, simple, provincial cooking was more palatable.

Having found suitable accommodation, with decent meals, the Pissarros drove with their friends (and collectors) the Van der Veldes in a landau through the town and its environs, near Sainte-Adresse, looking for new motifs. Pissarro found it impossible to reconcile the separate demands of the search for comfortable accommodation and good food, and the search for suitable motifs: 'The countryside is beautiful and there are certainly nice things to do, but it is the practicalities that are lacking. The hotels are never situated in good places'.[3] He feared, therefore, that he would have to give up Le Havre; he had not even started painting, with the exception of two small exploratory oil sketches. From Le Havre they went to Honfleur, to stay at the Auberge Saint-Siméon, returning to the source of Impressionism: 'We are sleeping at the Hôtel Saint-Siméon, famous for all the painters who have stayed here since 1830 up to the present day. In former times there was a farm under the apple trees planted in the green meadows, overlooking the sea. Boudin, Corot, Cals, Daubigny, Monet, Jongkind all passed through here'.[4] Things had changed considerably since 1830, however: there was nothing to be found of its glorious past: 'the stupid new proprietors have tidied it all up! . . . It is atrociously neat, sparkling clean, the ruler-drawn alleys are spread with sand, you cannot see the sea but from the dining-rooms; you cannot even any longer look at the sea from the bedroom windows. In brief, it has been made up to suit the taste of English ladies, who flock there.' The return to the source of Impressionism was, in Pissarro's word, 'heart-breaking'.[5] He therefore decided to settle for Le Havre, which seemed then the lesser of two evils, although, he admitted to Lucien, 'In my opinion, our meadow at Eragny is a marvel compared to all that I see here.'[6] Hoping to overcome his father's hesitations and doubts about Le Havre as a suitable motif for a series, Rodo suggested that he come to paint in Brittany, where he himself was staying and painting. Pissarro gave three reasons why he adamantly preferred painting in Normandy: 'my good man, simply because I prefer Normandy; because it is only two steps away from Paris and Eragny; because I have to *think* of satisfying my collectors'.[7] This is the first time throughout Pissarro's correspondence that he so clearly emphasises the rôle of his collectors in influencing the choice of location for a series. Practical considerations had never taken up so much space in his reflection either. He was now seventy-three years old. Although generally in good health, he was regularly troubled by his eye infection, which needed frequent attention from his eye doctor in Paris. His age was another reason why he chose not to explore far-off regions like Brittany: 'I am too old to go far

195

to find my luck. I am stopping here [Le Havre], I will paint the coming and going of the boats, and (as that terrible monster Murer put it) the beautiful and great skies of France!'[8] Pissarro was still financially supporting all his children, including the eldest, Lucien, who was then forty years old and just buying a house in Hammersmith. All these factors taken together made Pissarro feel very vulnerable. Responsible for too many people and too many things, he could not turn down what actually was to be his first major commission from a group of admirers. This series, which Van der Velde had largely encouraged, also resulted in the purchase by the Le Havre museum of his first paintings in the series (the first and only paintings purchased by any French museum during the artist's lifetime). Today the Musée des Beaux-Arts in Le Havre is one of a very small number of museums in the world that own more than one painting from a single series by Pissarro.[9]

Pissarro finally settled in Le Havre (in the hotel that he found the most acceptable) on his birthday, 10 July 1903. The next day he thanked all his children for their good wishes in a particularly vibrant letter, all the more moving as one knows in retrospect that he had only four months left to live: 'Thank you for having thought of writing to me on my birthday; I hope and I will do my best to follow calmly my destiny and slog away as much as possible as the thread that keeps me down here has nearly completely run out.'[10]

These concerns of family, age and commerce were intricately interwoven with his aesthetic concerns while he was in Le Havre. A further aspect of Pissarro's biography was brought to the fore during this visit: this was the first town in France that he had ever set eyes upon, when, aged eleven, he alighted from his first transatlantic voyage to begin his studies in France. He saw Le Havre again in 1855 when he decided to settle in France permanently and start his career as an artist. Pissarro's last series, therefore, constituted a kind of retracing of his early steps. His latest impressions are seen to merge with his first impressions of nearly half a century earlier: 'I see the big transatlantic steamers passing beneath my window all day long'.[11] Those transatlantics (as depicted in *The Jetty, Le Havre, Transatlantic Departure 'La Lorraine': Afternoon, Grey Weather, Rough Weather* (P&V

1302)) which shuttled between the Old and the New Worlds could not but have reminded Pissarro of his original journeys from Saint Thomas – except that when Pissarro had first travelled as a youth, it was on a sailing-ship. Furthermore, an important meteorological event in Le Havre recalled his birthplace to him: a violent storm raged in the port on 13 September: 'Oh yes! we had a hurricane! And one such that nobody in the hotel could sleep. It was a little like Saint Thomas.'[12]

There is throughout this series a clear element of autobiography: Le Havre constitutes a moment of return, of speculative reflection upon his past and, as Pissarro put it, upon his 'destiny'. The Le Havre letters, very emotional and intense, are of an extraordinary density and richness. During this time he was providing constant encouragement, advice and criticism for his three eldest sons, who were all painting: 'One must want to find, and end up knowing, what one wants.'[13] In the same letter he articulated a genuine aesthetic creed which sheds light on his motivations and interests throughout the series:

> You know that motifs are completely secondary for me: I am more interested in the atmosphere and its effects. A nothing would be up my street. If I had any sense, I would stay in the same town, or village, over a number of years, unlike many other painters; I end up by finding in the same spot effects that I do not know, and that I have never tried or succeeded with.[14]

As one looks at Pissarro's last series, and looks back also at his other series, one is tempted to say that he indeed painted only one city, in the sense, as defined by Michelet, that 'Paris, Rouen, Le Havre (built as we know by François I in 1517) are one and the same city of which the Seine is the main street.'[15] Situated at the mouth of the Arcq, Dieppe, it could be argued, is not part of this 'city'. However, it is interesting to follow through Michelet's metaphor. Le Havre was chosen by Pissarro because it was the less banal, more convenient equivalent of what he had painted in Dieppe. Dieppe itself reminded Pissarro of Rouen: 'it is in the same mould as Rouen'.[16] By the end of his 1902 sojourn in Dieppe, he was already thinking about the Pont-Neuf,[17] relating Dieppe's motifs back to those of Paris. When he first

8 Bailly-Herzberg 1991 p. 355 (Le Havre, 10 July 1903; to Rodolphe Pissarro): 'Je suis trop vieux pour aller au loin chercher mon affaire. Je m'arrête ici [Le Havre], je ferai l'entrée et la sortie des bateaux, c'est beau et grand des ciels (comme dit cet affreux monstre de Murer) de France!! . . .'

9 The Musée des Beaux-Arts, Le Havre owns cat. 152 and ill. 149.

10 Bailly-Herzberg 1991 p. 358 (Le Havre, 11 July 1903; to Pissarro's children): 'Je vous remercie d'avoir pensé à m'écrire pour mon anniversaire; j'espère et je ferai mon possible de suivre tranquillement ma destinée en bûchant le plus possible car ce fil qui me retient ici-bas est bien près de se dérouler entièrement.'

11 Bailly-Herzberg 1991 pp. 357–8 (Le Havre, 11 July 1903; to Georges Pissarro): 'Je vois passer devant ma fenêtre toute la journée les grands steamers transatlantiques'.

12 Bailly-Herzberg 1991 p. 377 (Le Havre, 14 September 1903; to Rodolphe Pissarro): 'Oh oui! il y en a eu! un ouragan! Personne n'a pu dormir à l'hôtel. C'était presque comme à Saint Thomas'.

13 Bailly-Herzberg 1991 p. 353 (Le Havre, 6 July 1903; to Rodolphe Pissarro): 'Il faut vouloir trouver et finir par savoir ce que l'on veut.'

14 Bailly-Herzberg 1991 p. 352 (Le Havre, 6 July 1903; to Rodolphe Pissarro): 'Tu sais que les motifs sont tout à fait secondaires pour moi: ce que je considère, c'est l'atmosphère et les effets. Un rien ferait bien mon affaire. Si je m'écoutais, je resterais dans une même ville, ou village, pendant des années, au contraire de bien d'autres peintres; je finis par trouver au même endroit des effets que je ne connaissais pas, et que je n'avais pas tentés ou réussis.'

15 J. Michelet, *Histoire de France*, 1833–67, vol. IV, p. 33.

16 Bailly-Herzberg 1991 p. 250 (Dieppe, 18 July 1902; to Paul Durand-Ruel): 'c'est dans le genre de Rouen'.

17 Bailly-Herzberg 1991 p. 263 (Dieppe, 5 September 1902; to Lucien Pissarro).

tackled the Boulevard Montmartre, he referred to Paris, with a slip of the tongue, as 'Rouen'.

Each of the series by Pissarro tends to echo another by means of various similar or complementary components or themes, be they the pedestrian traffic of the boulevards or avenues, or the Seine, or the Louvre or various bridges, or a sea harbour. Likewise, the Le Havre series, with its transatlantic boats and the open sea, bridges the gap between the artist's youth in Saint Thomas, where he had painted his only seascapes[18] until the Le Havre series, and the last few months of his life. This series is structurally very close to the Dieppe series, but nevertheless differs from it in that the horizon line in the Dieppe paintings is blocked by the cliff line, while in the Le Havre series it is open, following a line out to sea. This is particularly obvious in *The Jetty, Le Havre: High Tide, Morning Sun* (cat. 145), *The Jetty and the Signal, Le Havre* (P&V 1300), *The Jetty, Le Havre, Transatlantic Departure, 'La Lorraine': Afternoon, Grey Weather, Rough Weather* (P&V 1302) and *The Jetty, Le Havre: Afternoon, Luminous Grey Weather, High Sea* (P&V 1314).

The Le Havre series closed the circle of all Pissarro's series: it also brought to a close the circle of his life. Pissarro left the town on 26 September, in order to attend the Médan pilgrimage, in honour of Zola, a year after the author's death. He returned to Paris, waiting at the old Hôtel Garnier (facing the Gare Saint-Lazare) until a new flat on the Boulevard Morland (facing the tip of the Ile Saint-Louis) was free to move into. He developed an abscess on the prostate gland, which was diagnosed by incompetent doctors too late to be cured. He died in his apartment on the Boulevard Morland on 13 November.

Eventually Pissarro had become happy with his work in Le Havre: 'Here I am settled down, working at the Hotel Continental on the jetty. Superb and very lively motifs.'[19] A week before he left, he admitted, 'I am very glad that I came here, for one thing it is superb and has not been spoilt, and I have made several acquaintances here who like my painting and who will buy at one time or another.'[20] The Le Havre series had therefore achieved one of Pissarro's aims: it was a commercial success.

At the heart of the Le Havre series lay an apparent paradox: the series received much critical acclaim at the time it was being executed, partly because the jetty and the part of the harbour Pissarro was representing were about to be destroyed. The series presented to the Havrais public an historical document: 'I am waiting for a collector who wants to see my motifs of the port. It seems that they are very important from an historical and documentary point of view! They are about to demolish the port to build a bigger one, when they have demolished this one it will seem unique!'[21] Two points arise from this: first, the depiction of recently constructed buildings and newly laid-out boulevards which provides the dominant theme for so many of his series has here been inverted; Pissarro was depicting what was on the point of destruction. Second, the preoccupation in the series with recording a specific feature seems at first to contradict one of Pissarro's precepts, namely that Impressionism is non-illustrative. In Pissarro's eyes, for example, Burne-Jones was an admirable illustrator, but a terrible painter.[22] In fact, the paradox was only apparent. Although there is specificity in the themes of the Le Havre series, the individual paintings, as in all of Pissarro's other series, were concerned with expressing the 'freedom of the brush', which he repeatedly advocated to his sons, and, even more importantly, the 'right harmonies'.[23] As Pissarro put it, his series all represent a persistent search for a 'harmonious ensemble' or 'harmonic relationship'.[24] The extraordinary cohesiveness that defines specifically the structural relationships within and between each series, and generally Pissarro's life and work, demonstrates that the artist, reaching the end of his life, had completed his ambition. The fact that the Le Havre series was also an historical document was accidental, as is indicated by Pissarro's use of 'seem' in the letter quoted above. It was as though he was not quite aware that his work in Le Havre had an historical illustrative function, as well as a pictorial one. By the same token, he was acknowledging that the illustrative and pictorial functions are not (always) incompatible.

* * *

The Le Havre series, like most of Pissarro's series, consists of three motifs: the inner harbour, the pilots' jetty and the semaphore. The first two motifs were executed from

18 The only known exception is *Falaises aux Petites-Dalles* of 1883 (P&V 599).

19 Bailly-Herzberg 1991 p. 363 (Le Havre, 17 July 1903; to Gaston Bernheim): 'Me voilà installé et en train de travailler à l'Hôtel Continental sur la jetée, suberbes motifs très vivants.'

20 Bailly-Herzberg 1991 p. 379 (Le Havre, 21 September 1903; to Georges Pissarro): 'Je suis bien content d'être venu ici, c'est d'abord superbe et ce qui ne gâte rien, j'ai fait quelques connaissances ici qui aiment ma peinture et qui achèteront à un moment donné.'

21 Bailly-Herzberg 1991 p. 367 (Le Havre, 20 August 1903; to Georges Pissarro): 'J'attends un amateur qui désire voir mes motifs du port. Il paraît que c'est très important au point de vue historique et documentaire! On est en train de démolir le port pour en construire un plus vaste, quand ce sera démoli ce sera paraît-il unique!!'

22 Bailly-Herzberg 1991 p. 282 (Rouen, 20 October 1896; to Lucien Pissarro).

23 Bailly-Herzberg 1991 p. 367 (Le Havre, 20 August 1903; to Georges Pissarro): 'la liberté de ton pinceau'; 'la justesse des rapports'.

24 Bailly-Herzberg 1991 p. 369.

25 Bailly-Herzberg 1991 p. 366 (Le Havre, 29 July 1903; to Pieter Van der Velde): 'obligé d'être à l'affût, suivant de ma fenêtre les brusques changements d'effets; je suis cloué à mon poste!'

Pissarro's hotel window (looking left and right) – 'having to be alert, following the rapid changes of effects from my window, I am stuck to my post!'[25] By 20 August Pissarro had finished eleven canvases and was hoping to reach a dozen. He had already sold two (*The Pilots' Jetty, Le Havre: High Tide, Afternoon Sun* (cat. 152) and *The Inner Harbour, Le Havre: Morning, Sun, Rising Tide* (ill. 149)) to the museum in Le Havre. The third motif was therefore the last to be executed, from a different vantage point, looking towards the jetty itself. Table 9 in the Appendix offers an analysis of individual paintings.

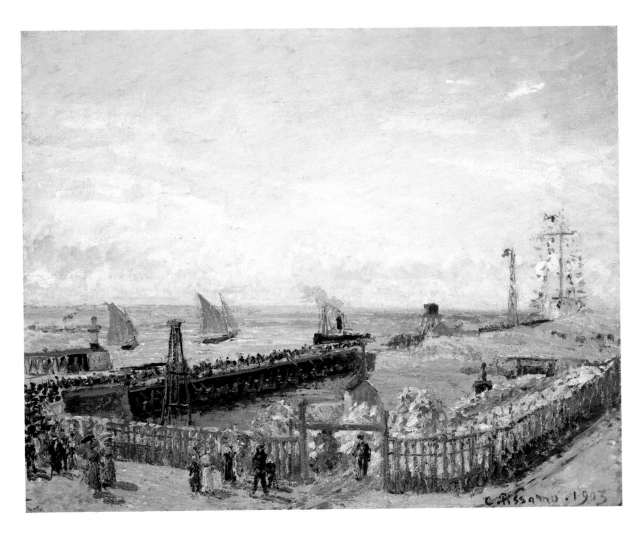

145 EXHIBITED

The Jetty, Le Havre: High Tide,
Morning Sun 1903

La Jetée du Havre, haute mer, soleil, matin
P&V 1298
57.2 × 64.8 cm
Signed and dated lower right: *C. Pissarro.*
1903

The Dixon Gallery and Gardens, Memphis,
Tennessee. Museum Purchase

PROVENANCE Lucien Pissarro, London;
John Quinn, New York; sale, Collection
John Quinn, New York, 28 October 1926
(63); Gabriel Picard, Paris; Hirschl and Adler
Galleries, New York; The Dixon Gallery and
Gardens, Memphis, Tennessee, 1979

EXHIBITIONS New York 1936, no. 5; New
York 1941, no. 2; Memphis 1980, no. 26;
Tampa 1981; Montgomery 1981; Oshkosh
1982; Tokyo 1984, no. 66; Madison 1986,
no. 15

LITERATURE *Bulletin de la vie artistique*, 15
September 1926 (repr.); *Newsletter: Dixon*
Gallery and Gardens (Memphis, Tenn.),
January–February 1980; *Newsletter: Dixon*
Gallery and Gardens (Memphis, Tenn.), May
1980

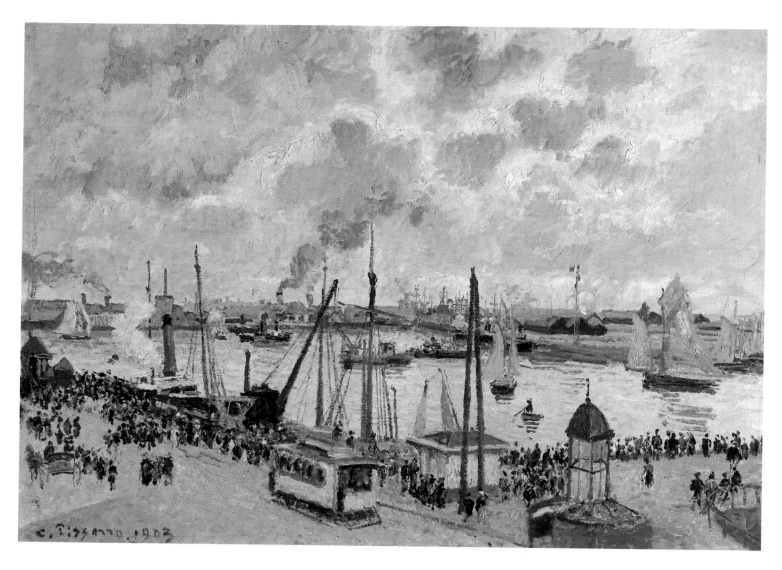

146 NOT EXHIBITED

The Port of Le Havre 1903

Port du Havre
P&V 1305
50 × 81 cm

Private Collection. Reproduced by courtesy
of Richard Nathanson, London

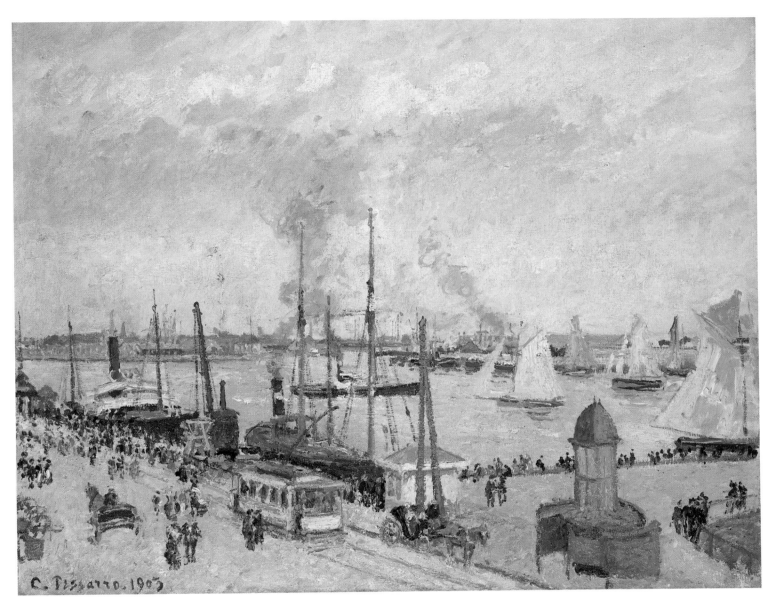

147 EXHIBITED
The Port of Le Havre: High Tide 1903

Port du Havre, marée haute
P&V 1301
65.5 × 81 cm
Signed and dated lower left: *C. Pissarro. 1903*

Private Collection, Japan

PROVENANCE Haegel Collection, Paris; Wildenstein & Co., Tokyo; Private Collection, Japan

LITERATURE Rewald 1950, p. 505; Lloyd 1980, p. 153 (cited under no. 91)

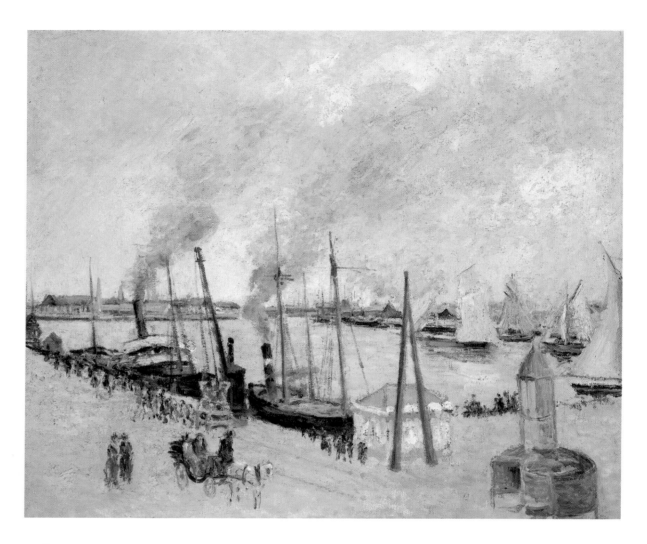

148 EXHIBITED

The Port of Le Havre 1903

Le Port du Havre
P&V 1308
54.6 × 65.1 cm

Private Collection, Palm Beach. Courtesy of
David Ramus Fine Art, New York/Atlanta

PROVENANCE G. Urion; Collection Meny,
1934; Private Collection, Zurich, 1967; David
Ramus Fine Art, New York/Atlanta; Private
Collection, Palm Beach

EXHIBITION Paris, Galerie de l'Elysée,
1966, *Poésie de la mer* (repr.)

LITERATURE Kunstler 1967, p. 59 (repr.
pl. 28)

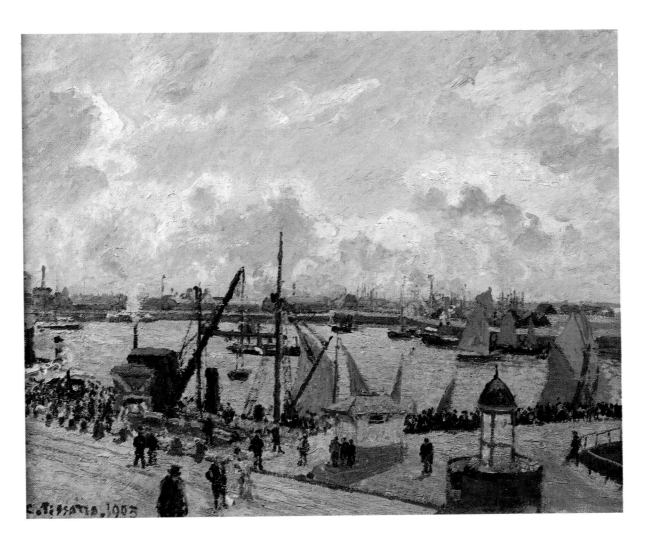

149 NOT EXHIBITED

The Inner Harbour, Le Havre:
Morning, Sun, Rising Tide

1903

L'Avant-port du Havre, matin, soleil, marée
montante
P&V 1315
54 × 65 cm

Musées des Beaux-Arts, Le Havre

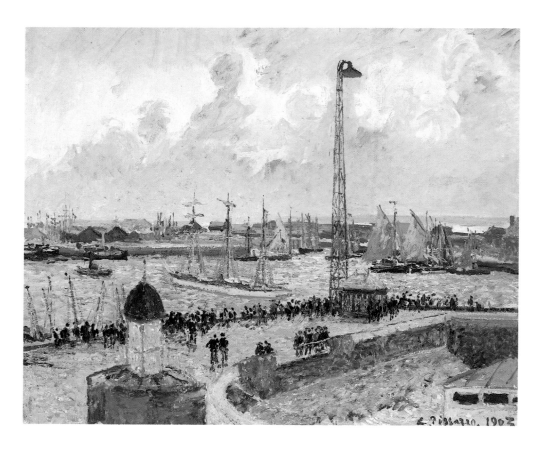

150 EXHIBITED

The Inner Harbour, Le Havre

1903

Avant-port du Havre
P&V 1312
46 × 55 cm
Signed and dated lower right: *C. Pissarro.*
1903

Private Collection

PROVENANCE Otto Zieseniss, Paris;
Christian Zieseniss, Paris; Estate of Christian
Zieseniss; Private Collection, Switzerland;
Private Collection

EXHIBITION Dallas 1989, no. 82 (repr. col.)

LITERATURE Lecomte 1922 (repr.)

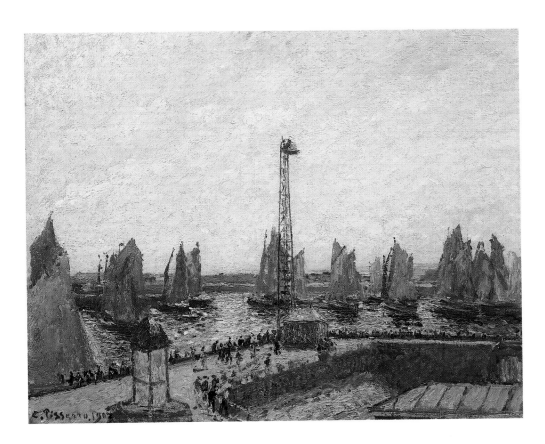

151 NOT EXHIBITED

*Inner Harbour and Pilots' Jetty,
Le Havre* 1903

Avant-port et anse des pilotes, Le Havre
P&V 1313
43 × 52 cm

Private Collection

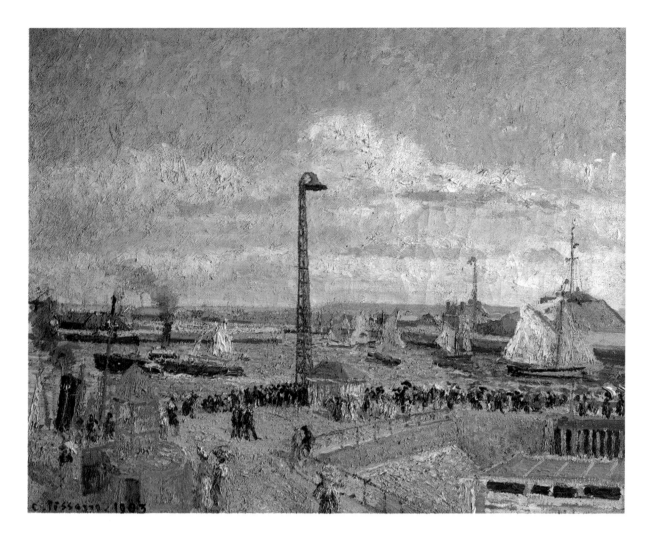

152 EXHIBITED IN DALLAS

The Pilots' Jetty, Le Havre: High Tide, Afternoon Sun 1903

L'Anse des pilotes au Havre, haute mer, après-midi, soleil
P&V 1310
54 × 65 cm
Signed and dated lower left: *C. Pissarro. 1903*

Musées des Beaux-Arts, Le Havre

PROVENANCE Bought from the artist by the Musée des Beaux-Arts, Le Havre, 1903

EXHIBITIONS Paris 1930, no. 135; Paris 1953(ii), no. 86; Le Havre 1958 (no cat.); Paris 1965 (no cat.); Leningrad 1973 (no cat.); London 1980–81, no. 92; Le Havre 1986; Kurashiki 1988, no. 30

LITERATURE de la Villehervé 1904; Lecuyère 1935, p. 430; Shikes 1980, p. 313

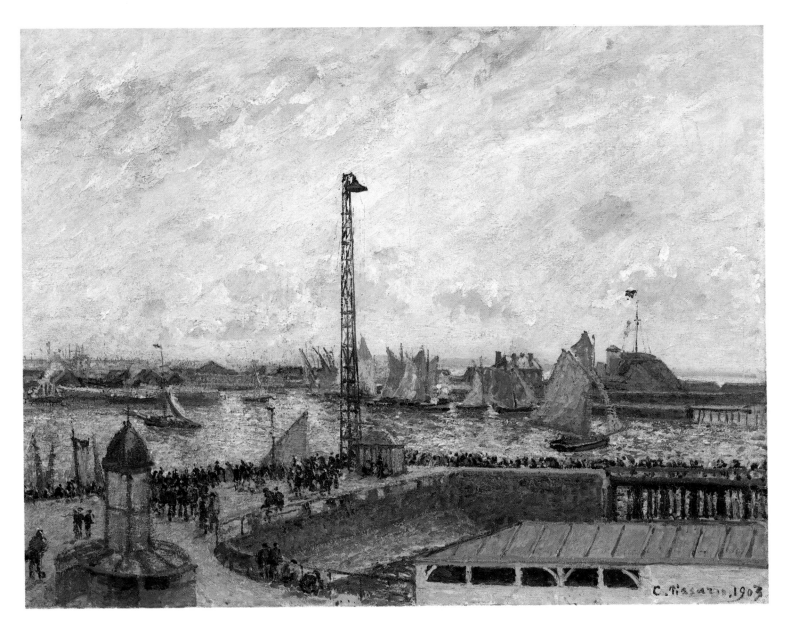

I53 EXHIBITED

The Pilots' Jetty, Le Havre: Morning, Overcast and Misty Weather 1903

Anse des pilotes, Le Havre, matin, temps gris, brumeux
P&V 1309
65 × 81 cm
Signed and dated lower right: *C. Pissarro. 1903*

Tate Gallery, London, presented by Lucien Pissarro, the artist's son, 1948

PROVENANCE Mme Camille Pissarro, Eragny; Lucien Pissarro, London; presented by Lucien Pissarro to the National Gallery, London, 1948; transferred to the Tate Gallery, London, 1953

EXHIBITIONS Paris 1904, no. 131; London 1911, no. 6; London 1913, no. 3; London 1920, no. 95; London 1923, no. 38; London 1931, no. 10; London 1936(ii), no. 11; London 1937, no. 36; National Gallery, London, 1939–48 (on loan)

LITERATURE de la Villehervé 1904, p. 2; *Letters* 1943, pp. 357–59; Alley 1981, no. 5833, pp. 614–15

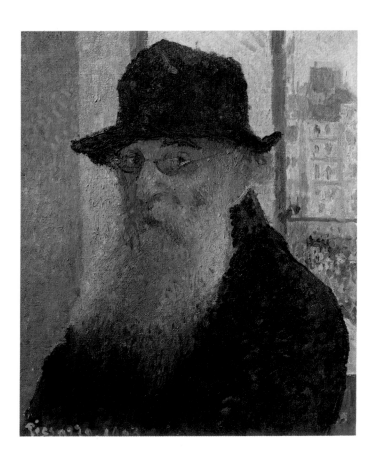

154 EXHIBITED

Self-Portrait 1903

Portrait de Camille Pissarro par lui-même
P&V 1316
41 × 33 cm
Signed and dated lower left: *C. Pissarro. 1903*

Tate Gallery, London, presented by Lucien
Pissarro, the artist's son, 1931

PROVENANCE Mme Camille Pissarro, Eragny;
Lucien Pissarro, London; presented by Lucien
Pissarro to the Tate Gallery, London, 1931

EXHIBITIONS Paris 1904, no. 130; London
1920, no. 84; London 1926 (works not
numbered); Paris 1930, no. 117; Tate Gallery,
London, *Camille Pissarro*, 1931, no. 23; Paris
1956, no. 111; London 1968, no. 32

LITERATURE Hamel 1914, pp. 31–32; Duret
1923, p. 38; Tabarant 1924; Kahn 1930(ii),
p. 699; Jedlicka 1950; Natanson 1950, p. 26;
Alley 1959, pp. 189–90; Bellony-Rewald 1976,
p. 249; Lloyd 1979, p. 3; Alley 1981, p. 614

APPENDIX

The tables below give the variants operating within each series. When these are not known or are not relevant, no table is given. In certain cases, absence of relevant data is indicated by a blank box. For full information on the formats of canvases, see p. 1 above.

Abbreviations: h = horizontal; v = vertical

TABLE 1 ROUEN

YEAR	CAT. OR ILL. NO.	P&V NO.	FORMAT	MOTIF	SPECIFICS	SEASON	WEATHER	TIME OF DAY
1896	1	948	30F (h)	Pont Boïeldieu from upstream	segment of Gare d'Orléans seen upper left; interaction of smoke and steam	21 Jan.–30 Mar.	after rain	
1896	2	952	30 (h)	Pont Boïeldieu from upstream	Gare d'Orléans seen on right of bridge	21 Jan.–30 Mar.	sunset	late
1896	3	953	15 (h)	Pont Boïeldieu from upstream	Gare d'Orléans seen on right of bridge	21 Jan.–30 Mar.	sunset and mist	late
1896	—	954	15 (h)	Pont Boïeldieu from upstream	sketch	21 Jan.–30 Mar.	Seine in flood	
1896	4	955	15 (h)	Pont Boïeldieu from upstream	dry pigment	21 Jan.–30 Mar.	Seine in flood	
1896	19	957	30P (h)	the docks	loading and unloading cargo	21 Jan.–30 Mar.	grey; industrial smoke	
1896	18	958	10 (h)	building cropped on left is the docks; view of the Quai du Havre on right overlooking left bank and Quartier Saint-Sever	steam and smoke partly conceal the activity	21 Jan.–30 Mar.	smoke; clouds; overcast	
1896	12	961	30 (h)	Pont Corneille	interaction of fog and mist; perspective upstream	21 Jan.–30 Mar.	misty morning	early
1896		962	30F (h)	Pont Corneille	perspective upstream	21 Jan.–30 Mar.	morning effect	early
1896	11	963	30P (h)	Pont Corneille	perspective upstream; clear	21 Jan.–30 Mar.	grey	
1896	—	966	15 (h)	Pont Corneille	right branch of bridge	21 Jan.–30 Mar.		

TABLE 2 ROUEN

YEAR	CAT. OR ILL. NO.	P&V NO.	FORMAT	MOTIF	SPECIFICS	SEASON	WEATHER	TIME OF DAY
1896	24	946	10F (h)	section of the docks on left, hidden behind smoke	painted from the Quai du Havre, on right bank, facing left bank	8 Sept.– 12 Nov.	sunset	afternoon
1896	9	949	15F (h)	in foreground, Pont Boïeldieu; mid-ground, half of Pont Corneille from Ile Lacroix to left bank; background, Pont du Chemin de fer from Ile Brouilly to left bank	Pont Boïeldieu observed from downstream	8 Sept.– 12 Nov.	sunny	afternoon
1896	8	950	30F (h)	same as P&V 949	concentrated activity on bridge	8 Sept.– 12 Nov.	rainy	
1896	7	951	12 (h)	Pont Boïeldieu from downstream		8 Sept.– 12 Nov.	fog	
1896	6	956	30F (h)	Pont Boïeldieu	observed at a low level from downstream	8 Sept.– 12 Nov.	overcast	
1896	20	959	12 (h)	Pont Boïeldieu	Canteleu hills in background	8 Sept.– 12 Nov.	clear	morning
1896	21	960	20 (h)	Pont Boïeldieu	Canteleu hills in background	8 Sept.– 12 Nov.	sunset and mist	afternoon
1896	5	964	15 (h)	Pont Boïeldieu seen from CP's hotel window on 2nd floor on the Cours Boïeldieu		8 Sept.– 12 Nov.	grey	morning
c.1896	—	965	20M (h)	Pont Boïeldieu; same motif as P&V 959 and 960	close-up on cargo ship	8 Sept.– 12 Nov.	sunset and smoke	afternoon
1896	—	967	15 (h)	Pont Boïeldieu; same motif as P&V 959 and 960	more distanced from quays	8 Sept.– 12 Nov.	sunset and smoke	afternoon
1896	28	968	15 (h)	only painting to focus on warehouse itself, called 'les docks & entrepôts de Rouen' (1860–1940)	loading and unloading activity	8 Sept.– 12 Nov.		
1896	22	969	25P (h)	Pont Boïeldieu; same motif as P&V 959 and 960; the boat seen left is same as in 959	right-hand building of the docks seen left	8 Sept.– 12 Nov.	after rain; early sunset	afternoon
1896	13	970	30F (h)	focuses on last arch of Pont Boïeldieu as it meets the left bank, leading onto the Place Saint-Sever; the Gare d'Orléans with its 2 small towers in centre	city and its activity distanced by removal of the repoussoir of the right bank	8 Sept.– 12 Nov.		
1896	14	971	25P (h)	same as P&V 970	same as P&V 970			

TABLE 3 ROUEN

YEAR	CAT. OR ILL. NO.	P&V NO.	FORMAT	MOTIF	SPECIFICS	SEASON	WEATHER	TIME OF DAY
1898	25	1039	25F (h)	same motif as P&V 958 and 959	long shadows; limited harbour activity	mid-Aug.–mid-Oct.	sunset; smoke	afternoon
1898	—	1040	25 (h)	Pont Boïeldieu	seen from downstream	mid-Aug.–mid-Oct.	fog	
1898	—	1041	10 (h)	Gare d'Orléans (cf. P&V 970)	oil sketch for P&V 1048, 1049, 1050	mid-Aug.–mid-Oct.		
1898	26	1042	25M (h)	same vantage point as P&V 969	smoke, steam and sunset; work at a standstill	mid-Aug.–mid-Oct.	sunset	afternoon
1898	10	1043	25F (h)	same motif as P&V 950	less traffic than in P&V 950	mid-Aug.–mid-Oct.	sunrise; no rain	morning
1898	30	1047	25 (h)	the docks can be seen on right, on opposite bank	afternoon light, shadows, smoke and silvery reflections on water; traffic almost non-existent	mid-Aug.–mid-Oct.	bright afternoon light	afternoon
1898	15	1048	25 (h)	Gare d'Orléans; same motif as P&V 970, 971, 1041	ferry full of passengers	mid-Aug.–mid-Oct.	bright sunlight	5 a.m.
1898	16	1049	25 (h)	Gare d'Orléans; same motif as P&V 1041	ferry full of passengers	mid-Aug.–mid-Oct.	clear; sun effect	morning
1898	17	1050	25 (h)	Gare d'Orléans; same motif as P&V 1041	does not depict bank from where artist is working (cf. P&V 970)	mid-Aug.–mid-Oct.	sunny, with a few clouds	afternoon
1898	—	1051	15 (h)	same motif as P&V 959 and 969; edge of the docks can be seen left	sketchy paint surface	mid-Aug.–mid-Oct.	rain	afternoon
1898	—	1052	25 (h)	the docks can be seen on opposite bank, through smoke and masts of ships	masts and ropes fragment the composition	mid-Aug.–mid-Oct.	sunny	
1898	27	1053	15 (h)	same motif as P&V 1051, with the edge of the docks at left	dynamics of harbour give way to interaction of sun, smoke and reflections	mid-Aug.–mid-Oct.	sunset	afternoon
1898	23	1054	25 (h)	same motif as P&V 1051, with the edge of the docks at left	loading and unloading cargo; very clear effect	mid-Aug.–mid-Oct.	sunny	morning
1898	29	non-P&V	30 (h)	the three roofs of the docks visible at left	symmetrical reverse of P&V 1052	mid-Aug.–mid-Oct.	sunny; windy	noon

TABLE 4 PARIS: GARE SAINT-LAZARE

YEAR	CAT. OR ILL. NO.	P&V NO.	FORMAT	MOTIF	SPECIFICS	SEASON	WEATHER	TIME OF DAY
1893	35	836	20F (v)	Rue Saint-Lazare	heavy traffic; many pedestrians	late winter	overcast and cold	
1897	36	981	5F (v)	Rue Saint-Lazare	light traffic	late Jan.	thaw; rain	
1897	—	985	5F (v)	Rue Saint-Lazare	2-way traffic; very few pedestrians	late Jan.	snow and mist	
1897	37	non-P&V	5F (h)	Rue Saint-Lazare		late winter	snow	
1893	38	838	8F (h)	Rue d'Amsterdam	traffic to and from station	late winter	sunny and cold	afternoon
1897	—	983	5F (h)	Rue d'Amsterdam	light traffic; umbrellas	late Jan.	thaw; rain	
1897	39	984	5F (v)	Rue d'Amsterdam	light traffic	late Jan.	snow	
1893	41	837	8F (h)	Place du Havre	pedestrians and carriages around roundabout	late winter	sunny and cold	
1893	40	839	8F (h)	Place du Havre	pedestrians to and from station	late winter		
1897	42	982	6F (h)	Place du Havre	interacting patterns of traffic	late Jan.	rain	

TABLE 5 PARIS: BOULEVARD MONTMARTRE

YEAR	CAT. OR ILL. NO.	P&V NO.	FORMAT	MOTIF	SPECIFICS	SEASON	WEATHER	TIME OF DAY
1897	43	986	15 (h)	Boulevard Montmartre	carriages; pedestrians	winter	misty	morning
1897	48	988	15 (h)	Boulevard Montmartre	carriages; pedestrians	winter	rainy	afternoon
1897	49	989	15 (h)	Boulevard Montmartre	carriages; pedestrians			sunset
1897	46	990	15 (h)	Boulevard Montmartre	carriages; pedestrians	winter	fog, sun and snow	morning
1897	50	994	15 (h)	Boulevard Montmartre	carriages; pedestrians; lights		wet	night-time
1897	56	997	15 (h)	Boulevard Montmartre	Shrove Tuesday crowds	end of winter		sunset
1897	44	987	15 (h)	Boulevard Montmartre	light traffic	end of winter	overcast misty	morning
1897	53	non-P&V	25 (h)	Boulevard Montmartre	carriages; busy traffic; umbrellas	spring	rain	morning
1897	51	991	25 (h)	Boulevard Montmartre	orderly columns of traffic	spring	sunshine	early afternoon
1897	54	995	25 (h)	Boulevard Montmartre	crowds	late winter	clear	
1897	55	996	25 (h)	Boulevard Montmartre	crowd procession	late winter	windy	

(continued on next page)

1897	45	992	30 (h)	Boulevard Montmartre	bustling pedestrian traffic on left	winter	overcast misty	morning
1897	47	993	30 (h)	Boulevard Montmartre	carriages	very early spring	cloudy	
1897	58	999	30 (h)	Boulevard des Italiens	omnibus stop	winter	sunshine	afternoon
1897	57	1000	30 (h)	Boulevard des Italiens	omnibus stop	winter	fair	morning
1897	52	998	8 (h)	Boulevard Montmartre	light traffic	spring	sunny and cloudy	morning

TABLE 6 PARIS: THE TUILERIES GARDENS

YEAR	CAT. OR ILL. NO.	P&V NO.	FORMAT	MOTIF	SPECIFICS	SEASON	WEATHER	TIME OF DAY
early 1899	76	1097	30F (h)	Bassins des Tuileries	park crowded with visitors	winter	sun through clouds	afternoon
early 1899	77	1098	30F (h)	Bassins des Tuileries	families and small groups of visitors	winter	sunny but misty	afternoon
early 1899	74	1099	30F (h)	Bassins des Tuileries	very clear effect	spring	sunny	morning
early 1899	—	1100	30P (h)	Bassins des Tuileries	very little traffic	spring	grey	morning
early 1899	—	1101	30P (h)	Bassins des Tuileries	very little traffic	winter	sunny	morning
early 1899	75	1102	30P (h)	Bassins des Tuileries	umbrellas; reflections	winter	rain	noon
1900	79	1123	30P (h)	Bassins des Tuileries	Gare d'Orsay under construction	winter	early sunset	afternoon
1900	—	1124	15F (v)	Bassins des Tuileries		winter	snow	morning(?)
1900	—	1125	30F (h)	Bassins des Tuileries	Gare d'Orsay under construction	spring	sunny	morning (P&V)
1900	—	1126	15F (h)	Bassins des Tuileries	groups of visitors	winter	overcast	
1900	—	1127	15F (h)	Bassins des Tuileries	very sketchy	winter	misty	
1900	—	1134	15F (h)	Bassins des Tuileries		spring	overcast; bright and light	
1900	—	1135	15F (h)	Bassins des Tuileries	Sainte-Clothilde seen through spring trees	spring	sunny	afternoon
1899	80	1103	15F (h)	Pavillon de Flore	2-tonal opposition	winter	snow	morning
1899	81	1104	30P (h)	Pavillon de Flore	hint of industrial activity in background	winter	mist	
1899	—	1105	30P (h)	Pavillon de Flore	hint of industrial activity in background	spring	sunny	afternoon
1899	—	1106	30F (h)	Pavillon de Flore		winter	sunny	morning
1899	83	1107	30F (h)	Pavillon de Flore	tiny lines of traffic by Pavillon de Flore	winter	cloudy; light patches	morning
1900	82	1128	25F (h)	Pavillon de Flore	2-tonal opposition	winter	snow	noon

(continued on next page)

1900	—	1129	25F (h)	Pavillon de Flore	traffic hinted at	spring	clear	morning
1900	—	1130	15F (h)	Pavillon de Flore		winter	hoar frost	morning
1900	—	1131	6F (h)	Pavillon de Flore	sketch	winter	snow	morning
1900	85	1132	30F (h)	Pavillon de Flore	traffic; industrial activity in background	spring	bright	morning
1900	84	1133	30F (h)	Pavillon de Flore	no traffic; static effect	spring	bright, misty	early afternoon
1899	88	1108	15F (h)	Pavillon de Marsan and Jardin du Carrousel	long winter shadows; few visitors	winter	sunny	afternoon
1899	86	1109	15F (h)	Pavillon de Marsan and Jardin du Carrousel	traffic; no visitors	winter	grey	morning
1899	87	1110	30F (h)	Pavillon de Marsan and Jardin du Carrousel	traffic; no visitors	winter	sunny	morning
1900	89	1136	15F (h)	Pavillon de Marsan and Jardin du Carrousel	traffic; visitors	spring	sunny	early afternoon

TABLE 7 PARIS: THE PONT-NEUF

YEAR	CAT. OR ILL. NO.	P&V NO.	FORMAT	MOTIF	SPECIFICS	SEASON	WEATHER	TIME OF DAY
1901	116	1176	25F (v)	Pont-Neuf and right bank	Seine in flood; 'Bonne Mère' barge under bridge	winter	rain	afternoon
1901	114	1177	8F (v)	Pont-Neuf and right bank		winter	rain	afternoon
1901	—	1178	25F (h)	Pont-Neuf and right bank		winter	snow	
1901	113	1179	8F (v)	Pont-Neuf and right bank		winter	fair	early afternoon
1901	—	1180	25F (h)	Pont-Neuf and right bank	Seine in flood; 'Bonne Mère' barge under bridge	winter		
1901	115	1181	30F (h)	Pont-Neuf and right bank		winter	sun	afternoon
1902	118	1210	20F (h)	Pont-Neuf and right bank	military band; barge approaching bridge	winter	after rain	afternoon
1902	117	1211	10 (v)	Pont-Neuf and right bank	omnibus; heavy traffic	winter	dry, fair	morning
1902	121	1212	15F (h)	Pont-Neuf and right bank	light traffic	winter	snow	
1902	119	1213	25F (h)	Pont-Neuf and right bank	military group	winter	after rain	early afternoon
1902	—	1214	8F (h)	Pont-Neuf seen diagonally	Bains de la Samaritaine	winter	sun	afternoon
1902	120	non-P&V	10F (h)	Pont-Neuf; same view as P&V 1176		winter	fog	
1903	—	1282	15F (h)	Pont-Neuf; same view as P&V 1176	military band; barge approaching bridge	winter	after rain	early afternoon

TABLE 8 DIEPPE: THE HARBOURS

YEAR	CAT. OR ILL. NO.	P&V NO.	FORMAT	MOTIF	SPECIFICS	SEASON	WEATHER	TIME OF DAY
1902	143	1249	25F (h)	Quai de la Poissonnerie (left)	ship's steam rolls over crowd	July–mid-Aug.	sun and clouds	
1902	142	1250	25F (h)	Quai de la Poissonnerie (left)	ships; clouds of steam; crowd	July–mid-Aug.	grey	morning
1902	144	non-P&V	15F (h)	Quai de la Poissonnerie (left)	steamboats and train; smoke, crowd	July–mid-Aug.	overcast	
1902	—	1241	15F (h)	inner harbour (centre)		July–mid-Aug.	sunny	afternoon
1902	138	1242	10F (h)	inner harbour (centre)	high tide (ebbing)	July–mid-Aug.	grey	
1902	—	1243	15 (h)	inner harbour (centre)	part of the customs cabin (right)	July–mid-Aug.	clear sky	
1902	—	1244	15 (h)	inner harbour (centre)	black sail in foreground; a few clouds of smoke	July–mid-Aug.	a few clouds	
1902	141	1245	25 (h)	inner habour (centre)	Quai de la Poissonerie (left); sailboat with British flag	July–mid-Aug.	sunny	afternoon
1902	—	1246	15 (h)	inner harbour (centre)	horizontal and diagonal clouds of steam and smoke	July–mid-Aug.	rainy	
1902	140	1247	15 (h)	inner harbour (centre)	low tide; customs house	July–mid-Aug.	sunny	afternoon
1902	139	1248	20 (h)	inner harbour (centre)	low tide; customs house	July–mid-Aug.	cloudy	
1902	—	1251	15 (h)	Bassin Duquesne (foreground)	high tide	July–mid-Aug.	grey	
1902	137	1252	25 (h)	Bassin Duquesne (foreground)	high tide	July–mid-Aug.	sunny	afternoon
1902	135	1253	15 (h)	Bassin Duquesne (foreground)	low tide; smoke on horizon	July–mid-Aug.	sunny, with clouds; 'effet fugitif'★	morning
1902	—	1254	15 (h)	Bassin Duquesne (foreground)	low tide	July–mid-Aug.	sunny, with clouds, 'effet fugitif'★	morning
1902	136	1255	25 (h)	Bassin Duquesne (foreground)	low tide	July–mid-Aug.	grey	
1902	—	1256	25 (h)	Bassin Duquesne (foreground)	low tide	July–mid-Aug.	grey	

★Bailly-Herzberg 1991, p. 262.

TABLE 9 LE HAVRE

YEAR	CAT. OR ILL. NO.	P&V NO.	FORMAT	MOTIF	SPECIFICS	SEASON	WEATHER	TIME OF DAY
1903	147	1301	25F (h)	inner harbour	trams; the Van der Veldes' landau at standstill; kiosk	beg. July– end Sept.	overcast	
1903	146	1305	25P (h)	inner harbour	kiosk and beginning of pilots' jettty; tram; crane; same trawler as in P&V 1301	beg. July– end Sept.	sun and clouds	
1903	—	1304	15 (h)	inner harbour	landau in transit; crane; same trawler as in P&V 1301	beg. July– end Sept.	grey	
1903	—	1306	15 (h)	inner harbour	crane; landau at standstill; kiosk and beginning of pilots' jetty	beg. July– end Sept.	bright sunlight	
1903	148	1308	15 (h)	inner harbour	same trawler as in P&V 1301; crane turned towards dock; landau at standstill; kiosk; sailboats	beg. July– end Sept.	fair	
1903	149	1315	15 (h)	inner harbour	crane and kiosk; very strong light contrast; trawler edited out; rising tide	beg. July– end Sept.	sunny	morning
1903	—	1307	10 (h)	inner harbour	kiosk cropped out; landau; trawler with heavy smoke	beg. July– end Sept.	sunny	afternoon
1903	—	1303	3F (h)	inner harbour	oil sketch; very close to P&V 1304	beg. July– end Sept.	overcast	
1903	153	1309	25 (h)	pilots' jetty	kiosk at lower left; milling crowd; gliding sailboats	beg. July– end Sept.	grey; misty	morning
1903	152	1310	15 (h)	pilots' jetty	contrast between steamer and white sailboat; high tide	beg. July– end Sept.	sunny	afternoon
1903	—	1311	15 (h)	pilots' jetty	umbrellas; sailboats; strong harmony of mauves and greys (sky, wet ground, roofs) v. green sea	beg. July– end Sept.	rain	
1903	—	1312	10 (h)	pilots' jetty	monticule with flags has been edited out; contrast between 3 masted ship and sailboats	beg. July– end Sept.	sun breaking through clouds	
1903	151	1313	10F (h)	pilots' jetty	monticule edited out; sails dominate everything; choreography of sails	beg. July– end Sept.	sunset	late afternoon

(continued on next page)

1903	—	1302	25P (h)	jetty and semaphore	departure of the transatlantic 'La Lorraine'	beg. July–end Sept.	grey, heavy weather	afternoon
1903	145	1298	15 (h)	jetty and semaphore	colourful contrasts; high tide	beg. July–end Sept.	sunny	morning
1903	—	1300	10 (h)	jetty and semaphore	little activity	beg. July–end Sept.		
1903	—	1314	10 (h)	jetty and semaphore	steamer enters port; high tide	beg. July–end Sept.	grey; bright light	
1903	—	1299	5 (h)	jetty and semaphore	oil sketch, focusing on one segment of jetty	beg. July–end Sept.		

SELECT BIBLIOGRAPHY

This bibliography is based on that compiled by Martha Ward and given in *Camille Pissarro 1830–1903*, the catalogue that accompanied the exhibition of the same name in London, Paris and Boston in 1980–81. That bibliography has been supplemented with selected publications that have appeared since 1980 and with publications related specifically to the series works.

I PISSARRO'S LETTERS

ARCHIVES 1975 *Archives de Camille Pissarro*, Paris, Hôtel Drouot, 21 November 1975 (sales catalogue). Preface by M. Melot.

AUTOGRAPHES 1977 *Autographes et documents divers*, Paris, Hôtel Drouot, 15 June 1977 (sales catalogue). Letters to Monet.

BAILLY-HERZBERG 1980 J. Bailly-Herzberg, *Correspondance de Camille Pissarro*, vol. I: *1865–1885*, Paris, 1980.

BAILLY-HERZBERG 1986 J. Bailly-Herzberg, *Correspondence de Camille Pissarro*, vol. II: *1886–1890*, Paris 1986.

BAILLY-HERZBERG 1988 J. Bailly-Herzberg, *Correspondance de Camille Pissarro*, vol. III: *1891–1894*, Paris, 1988.

BAILLY-HERZBERG 1989 J. Bailly-Herzberg, *Correspondance de Camille Pissarro*, vol. IV: *1895–1898*, Paris, 1989.

BAILLY-HERZBERG 1991 J. Bailly-Herzberg, *Correspondance de Camille Pissarro*, vol. V: *1899–1903*, St-Ouen-l'Aumone, 1991.

BESSON 1932 [G. Besson], 'L'Impressionnisme et quelques précurseurs', *Bulletin des Expositions*, vol. III, Paris, Galerie d'Art Braun et Cie, 22 January–13 February 1932. Letters to Duret.

CACHIN-SIGNAC 1951 G. Cachin-Signac, 'Autour de la correspondance de Signac', *Arts*, 7 September 1951, p. 8. Letter to Signac.

CACHIN-SIGNAC 1953 [G. Cachin-Signac], 'Lettres de Pissarro à Paul Signac et Félix Fénéon', *Les Lettres Françaises*, 8–15 October 1953, p. 9.

DEWHURST 1904 See Section v below. Letters to Dewhurst.

FERMIGIER 1972 See Section v below. Letters to Esther Isaacson.

GACHET 1957 P. Gachet, ed., *Lettres impressionnistes au Dr. Gachet et à Murer*, Paris, 1957.

GEFFROY 1922 G. Geffroy, 'Lettres de Pissarro à Claude Monet', in *Claude Monet, sa vie, son oeuvre*, vol. II, Paris, 1922, pp. 9–17. Repr.: Paris, 1980, pp. 269–77.

GIRIEUD 1900 J. Girieud, ed., *Les amis des monuments Rouennais; pour la maison du XVe siècle de la rue Saint-Romain; protestations*, Rouen, 1900, p. 4.

HERBERT 1960 R. and E. Herbert, 'Artists and anarchism: unpublished letters of Pissarro, Signac and others', *Burlington Magazine*, vol. CII, November 1960, pp. 472–82, and December 1960, pp. 517–9. Letters to Grave. Tr.: 'Les Artistes et

l'anarchisme', *Le Mouvement Social*, July–September 1961.

JOETS 1946 J. Joets, 'Lettres inédites de Pissarro à Claude Monet', *L'Amour de l'Art*, vol. XXVI, 1946, pp. 58–65.

KUNSTLER 1930 C. Kunstler, 'Des Lettres inédites de Camille Pissarro à Octave Mirbeau (1891–1892) et à Lucien Pissarro (1898–1899)', *La Revue de l'Art Ancien et Moderne*, vol. LVII, March 1930, pp. 173–90, and April 1930, pp. 223–26.

LAPRADE 1936 J. de Laprade, 'Camille Pissarro d'après des documents inédits', *Beaux-Arts, Chronique des Arts . . .*, 17 April 1936, p. 1, and 24 April 1936, pp. 1, 7. Letters to Duret and Murer.

LECOMTE 1922 See Section v below. Letters to Mirbeau.

LETTERS 1943 *Camille Pissarro: lettres à son fils Lucien*, ed. J. Rewald, Paris, 1950. Tr.: *Camille Pissarro: letters to his son Lucien*, London and New York, 1943. 3rd ed. rev. and enl., Mamaroneck, 1972. 4th ed. rev. London, 1980.

NICULESCU 1964 R. Niculescu, 'Georges de Bellio, l'ami des impressionnistes', *Revue Romaine d'Histoire de l'Art*, vol. I, 1964, pp. 209–78. Repr.: *Paragone*, vol. XXI, September 1970, pp. 25–66 and November 1970, pp. 41–55.

REWALD 1947 J. Rewald, *Paul Cézanne*, New York, 1947. Letters to Zola and Huysmans.

REWALD 1948 J. Rewald, *Georges Seurat*, Paris, 1948. Letters to Signac, Van de Valde and Fénéon. Repr. in Rewald 1978.

TABARANT 1924 See Section v below. Letters to Duret and Murer.

VENTURI 1939 L. Venturi, 'Lettres de Camille Pissarro' (to Durand-Ruel) and 'Lettres à Octave Maus', in *Les Archives de l'Impressionnisme*, vol. II, Paris, 1939, pp. 9–52, 232–40.

II CONTEMPORARY REFERENCES (1896–1903) TO PISSARRO'S SERIES PAINTINGS

The following references are listed chronologically and then alphabetically within each year.

ALEXANDRE 1896 A. Alexandre, 'La Vie artistique: les oeuvres de Camille Pissarro', *Le Figaro*, 17 April 1896.

FENEON 1896 F. Fénéon, 'L'Exposition Camille Pissarro', *La Revue Blanche*, n.s., vol. X, 15 May 1896.

GEFFROY 1896 G. Geffroy, 'L'Art d'aujourd'hui: Camille Pissarro', *Le Journal*, 18 April 1896. Repr.: Geffroy, *La Vie Artistique*, 6th series, Paris, 1900, pp. 174–80.

HOFFMANN 1896 E. Hoffmann, 'Camille Pissarro', *Le Journal des Artistes*, 6 April 1896.

THIEBAULT-SISSON 1896 T.S. [Thiébault-Sisson] 'Notes d'art', *Le Temps*, 18 April 1896.

ZOLA 1896 E. Zola, 'Peinture', *Le Figaro*, 2 May 1896.

DUHEM 1897 H. Duhem, *Renaissance*, Paris, 1897, pp. 24–5.

MIRBEAU 1897 O. Mirbeau, 'Famille d'artistes', *Le Journal*, 6 December 1897. Repr.: Mirbeau, *Des artistes, deuxième série*, Paris, 1924, pp. 39–45.

ROGER-MILES 1897 L. Roger-Miles, 'Camille Pissarro', in *Art et Nature*, Paris, 1897, p. 67.

ALEXANDRE 1898 A. Alexandre, 'La Vie artistique . . . II. Vues de Paris de M. Pissarro', *Le Figaro*, 3 June 1898.

AUBRY 1898 P. Aubry, 'La Vie artistique: Claude Monet-Camille Pissarro, Galerie Durand-Ruel', *Le Siècle*, 5 June 1898.

FONTAINAS 1898 A. Fontainas, 'Art moderne . . . Galerie Durand-Ruel: exposition d'oeuvres de MM. Claude Monet, Renoir, Degas, Pissarro, Puvis de Chavannes', *Le Mercure de France*, vol. XXVII, July 1898, p. 280.

GEFFROY 1898 G. Geffroy, 'Camille Pissarro', *Le Journal*, 25 June 1898. Rev. version: Geffroy, *La Vie Artistique*, 6th series, Paris, 1900, pp. 180–85.

HOFFMANN 1898 E. Hoffmann, 'Les Petits salons, Camille Pissarro' *Le Journal des Artistes*, 5 June 1898, p. 2311.

JOURDAIN 1898 F. Jourdain, 'Les Hommes du jour, Camille Pissarro *L'Eclair*, 18 June 1898.

LECOMTE 1898 G. Lecomte, 'Quelques syndiqués, Camille Pissarro', *Les Droits de l'Homme*, 4 June 1898. Repr.: *Revue Populaire des Beaux-Arts*, vol. II, 18 June 1898, pp. 42–44.

FAGUS 1899 F. Fagus, 'Petite gazette d'art: Camille Pissarro', *La Revue Blanche*, n.s., vol. XVIII, 1 April 1899, pp. 546–47.

FONTAINAS 1899 A. Fontainas, 'Art moderne: exposition de tableaux de Monet, Pissarro, Renoir et Sisley . . .', *Le Mercure de France*, vol. XXX, May 1899, p. 530.

LECLERCQ 1899 J. Leclercq, 'Petites expositions: Galerie Durand-Ruel', *La Chronique des Arts et de la Curiosité*, 15 April 1899, pp. 130–31.

GEFFROY 1900 G. Geffroy, 'Camille Pissarro', in *La*

Vie Artistique, 6th series, Paris, 1900, pp. 174–85. Repr. of Geffroy 1896 and 1898.

KAHN 1900 G. Kahn, 'L'Art à l'exposition: la centennale', *La Plume*, vol. XI, 15 August 1900, pp. 507–8.

MELLERIO 1900 A. Mellerio, 'Camille Pissarro', in *L'Exposition de 1900 et l'art impressionniste*, Paris, 1900, pp. 7, 36–38.

MORET 1901 R. Moret, 'Camille Pissarro', *Art et Littérature*, 5 February 1901.

THIÉBAULT-SISSON 1901 Thiébault-Sisson. 'Au jour le jour: choses d'art, Camille Pissarro', *Le Temps*, 20 January 1901.

DUHEM 1902 H. Duhem, 'Camille Pissarro, souvenirs', *Le Beffroi* (Lille), December 1903. Repr.: Duhem, *Impressions d'Art Contemporain*, Paris, 1913.

FONTAINAS 1902 A. Fontainas, 'Art moderne: expositions . . . Monet et Pissarro . . .', *Le Mercure de France*, vol. XLVIII, April 1902, pp. 246–47.

RIAT 1902 G. Riat, 'Expositions de Sisley et de MM. Monet et Camille Pissarro', *La Chronique des Arts et de la Curiosité*, 22 February 1902, p. 59.

SAUNIER 1902 C. Saunier, 'Gazette d'art: Monet, Pissarro, Sisley', *La Revue Blanche*, n.s., vol. XXVII, 1 March 1902, pp. 385–86.

LECOMTE 1903 G. Lecomte, 'Camille Pissarro', *L'Oeuvre Nouvelle*, December 1903, pp. 408–11.

MAUCLAIR 1903 C. Mauclair, *The Great French Painters*, London, 1903.

III EXHIBITIONS OF PISSARRO'S SERIES PAINTINGS (PRE-1903)

The following references are listed chronologically.

PARIS 1893 Paris, Galerie Durand-Ruel, *Exposition d'oeuvres récentes de Camille Pissarro*, 15–30 March 1893.

PARIS 1894 Paris, Galerie Durand-Ruel, *Exposition Camille Pissarro: tableaux, acquarelles, pastels et gouaches*, March 1894.

PARIS 1896 Paris, Galerie Durand-Ruel, *L'Exposition d'oeuvres récentes de Camille Pissarro*, 15 April–9 May 1896. Preface, 'L'Oeuvre de Camille Pissarro,' by A. Alexandre, pp. 5–14.

NEW YORK 1897 New York, Durand-Ruel Galleries, *Paintings by Camille Pissarro: views of Rouen*, March–April 1897.

PITTSBURGH 1897 Pittsburgh, Carnegie Institute, *The Second Annual Exhibition held at the Carnegie Institute*, 4 November 1897–1 January 1898.

PARIS 1898 Paris, Galerie Durand-Ruel, *Exposition des oeuvres récentes de Camille Pissarro*, 1–18 June 1898.

PITTSBURGH 1898 Pittsburgh, Carnegie Institute, *The Third Annual Exhibition held at the Carnegie Institute*, 3 November 1898–1 January 1899.

PARIS 1899(i) Paris, Galerie Bernheim-Jeune et fils, *Exposition de tableaux par C. Pissarro*, 22 March–15 April 1899.

PARIS 1899(ii) Paris, Galerie Durand-Ruel, *Exposition de tableaux de Monet, Pissarro, Renoir et Sisley*, April 1899.

PITTSBURGH 1899 Pittsburgh, Carnegie Institute, *The Fourth Annual Exhibition held at the Carnegie Institute*, 2 November 1899–1 January 1900.

PITTSBURGH 1900 Pittsburgh, Carnegie Institute, *The Fifth Annual Exhibition held at the Carnegie Institute*, 1 November 1900–1 January 1901.

PARIS 1901 Paris, Galerie Durand-Ruel, *C. Pissarro*, 14 January–2 February 1901.

THE HAGUE 1901 The Hague, *Exposition Internationale de la Haye*, 1901.

PARIS 1902(i) Paris, Galerie Bernheim-Jeune et fils, *Tableaux impressionnistes*, beginning 2 April 1902.

PARIS 1902(ii) Paris, Galerie Bernheim-Jeune, *Oeuvres récentes de Camille Pissarro et nouvelle série de Cl. Monet*, 1902.

NEW YORK 1903 New York, Durand-Ruel Galleries, *Exhibition of Paintings by Camille Pissarro*, 28 November–12 December 1903.

IV EXHIBITIONS OF PISSARRO'S SERIES PAINTINGS (POST-1903) CITED IN THE CATALOGUE

The following references are listed alphabetically.

AARAU 1960 Aarau, Aargauer Kunsthaus, *Aus aargauischem Privatbesitz*, 1960.

ABERYSTWYTH 1945 Aberystwyth, National Library of Wales, *An Exhibition of Pictures from the Gregynog Collection*, 1945.

ABERYSTWYTH 1946 Aberystwyth, National Library of Wales, *An Exhibition of Seventy-two Pictures from the Gregynog, Dulwich College and Other Collections*, 1946.

ABERYSTWYTH 1948 Aberystwyth, National Library of Wales, *An Exhibition of Seventy-seven Pictures from the Gregynog Collection, including Forty-six Etchings by Augustus John O.M., R.A.*, 1948.

ABERYSTWYTH 1951 Aberystwyth, National Library of Wales, *An Exhibition of Sixty-one Pictures from the Gregynog Collection*, 1951.

ALBI 1980 Albi, Musée Toulouse-Lautrec, *Trésors impressionnistes du Musée de Chicago*, 1980.

ALBUQUERQUE 1964 Albuquerque, University Art Gallery, University of New Mexico, *Art Since 1889*, 1964.

AMSTERDAM 1929 Amsterdam, the Van Wisselingh Galleries, *Exposition de Peinture Française, Ecole du Dix-Neuvième Siècle*, 1929.

AMSTERDAM 1930 Amsterdam, Stedelijke Museum, *Vincent van Gogh et son temps*, 1930.

AMSTERDAM 1932 Amsterdam, the Van Wisselingh Galleries, *Hollandsche en Fransche Schilderkunst der XIXe en XXe Eeuw*, 1932.

AMSTERDAM 1987 Amsterdam, Rijksmuseum Vincent van Gogh, *Franse meesters uit het Metropolitan Museum of Art: Realisten en Impressionisten*, 1987.

ANNECY 1958 Annecy, Palais de l'Isle, *Impressionnistes peintres de l'eau*, 1958.

ATLANTA 1968 Atlanta, High Museum of Art, *The Taste of Paris*, 1968.

AUGUSTA 1972 Augusta, Maine State Museum, *The Maurice Wertheim Collection*, 1972.

BALTIMORE 1963 Baltimore, Baltimore Museum of Art, *The Maurice Wertheim Collection*, 1963.

BELGRADE 1950 Belgrade, National Museum, *New French Art from the Collection of the Art Museum, Belgrade*, 1950.

BELGRADE 1972 Belgrade, National Museum, *Impresionizsm iz zbiski Narodnog musjea u Beogradu*, 1972.

BELGRADE 1987 Belgrade, National Museum – Ljubljana, National Gallery – Sarajevo, Art Gallery of Bosnia and Herzegovina – Skopje, Museum of Contemporary Art – Zagreb, Galleries of the City of Zagreb, *World Masters of Modern Art from Yugoslav Collections*, 1987.

BELLINGHAM 1976 Bellingham (Washington, D.C.), Whatcom Museum of History and Art, *5000 Years of Art*, 1976.

BERLIN 1927 Berlin, Galerie Thannhauser, *Erste Sonderausstellung in Berlin*, 1927.

BERLIN 1958 Berlin, *Von Manet bis Matisse*, 1958.

BERLIN 1963 Berlin, Orangerie Schlosses Charlottenburg, *Die Ile de France und ihre Maler*, 1963.

BERN 1953 Bern, Kunsthalle Bern, *Europäische Kunst aus Berner Privatbesitz*, 1953.

BIRMINGHAM 1990 Birmingham, City Museum and Art Gallery – Glasgow, Burrell Collection, *Camille Pissarro: Impressionism, Landscape and Rural Labour*, 1990.

BIRMINGHAM 1991 Birmingham, City Museum and Art Gallery, *French Impressionism: Treasures from the Midlands*, 1991.

BOSTON 1939 Boston, Museum of Fine Arts, *Paintings from Private Collections in New England*, 1939.

BOSTON 1970 Boston, Museum of Fine Arts, *Masterpieces of Painting in the Metropolitan Museum of Art*, 1970.

BREMEN 1910 Bremen, Kunsthalle Bremen, *Internationale Kunstausstelung*, 1910.

BREMEN 1974 Bremen, Kunsthalle Bremen, *Die Stadt: Bild-Gestalt – Vision*, 1974.

BRIGHTON 1992 Brighton, Museum and Art Gallery, *The Dieppe Connection: The Town and its Artists from Turner to Braque*, 1992.

BRUSSELS 1935 Brussels, Palais des Beaux-Arts, *L'Impressionisme*, 1935.

BUCHAREST 1971 Bucharest-Cracow-Iassi, *Pictura celebre din muzeele parisului remekmuvei*, 1971.

BUENOS AIRES 1924 Buenos Aires, *1er Salon de la Société des Arts de Buenos Aires*, 1924.

BUENOS AIRES 1932 Buenos Aires, *Amis des Arts*, 1932.

BUENOS AIRES 1939–40 Buenos Aires, Museum of Art – Rio de Janeiro – Montevideo – New York, Metropolitan Museum of Art – San Francisco, M.H. de Young Memorial Museum – Chicago, The Art Institute of Chicago, *Special Loan Exhibition of French Painting from David to Toulouse-Lautrec, 1939–40*.

BUENOS AIRES 1962 Buenos Aires, Museo Nacional de Bellas Artes, *El Impresionismo francés en las colecciones argentinas*, 1962.

BUFFALO 1930 Buffalo, Fine Arts Academy, *Exhibitions Commemorating the 25th Anniversary of the Opening of the Albright Art Gallery*, 1930.

CALGARY 1957 Calgary, Jubilee Auditorium, *French Impressionists and Post-Impressionists Loaned by the National Gallery of Canada*, 1957.

CAMBRIDGE 1946 Cambridge, Mass., Fogg Art Museum, *French Painting since 1870 Lent by Maurice Wertheim, Class of 1906*, 1946.

CHICAGO 1933 Chicago, University of Chicago, The Renaissance Society, *Paintings of Sea and Land and City Streets*, 1933.

CHICAGO 1946 Chicago, Arts Club of Chicago, *Paintings by Camille Pissarro*, 1946.

CHICAGO 1953 Chicago, College of Jewish Studies, *Loan Exhibition*, 1953.

CHICAGO 1973 Chicago, The Art Institute of Chicago, *Major Works from the Collection of Nathan Cummings*, 1973.

CLEVELAND 1936 Cleveland, Museum of Art, *Twentieth Anniversary of the Museum of Cleveland*, 1936.

COLORADO SPRINGS 1946 Colorado Springs, Colorado Springs Fine Arts Center, *19th Century French Painters*, 1946.

COLUMBIA 1960 Columbia, South Carolina, Columbia Museum of Art, *French Impressionism*, 1960.

COLUMBUS 1952 Columbus, Columbus Gallery of Fine Arts, *A Tour of Famous Cities*, 1952.

COPENHAGEN 1914 Copenhagen, Statens Museum fur Kunst, *Fransk Kunst*, 1914.

COPENHAGEN 1957 Copenhagen, Statens Museum fur Kunst, *Fransk Kunst*, 1957.

COVENTRY 1960 Coventry, Herbert Art Gallery and Museum, *Paintings from Public Collections of Friends of Coventry Overseas*, 1960.

DALLAS 1978 Dallas, Dallas Museum of Art, *Dallas Collects: Impressionists and Early Modern Masters*, 1978.

DALLAS 1989 Dallas, Dallas Museum of Art, *Impressionist and Modern Masters in Dallas: Monet to Mondrian*, 1989.

DAYTON 1951 Dayton, Ohio, Dayton Art Institute, *The City by River and the Sea: Five Centuries of Skylines*, 1951.

DEN BOSCH 1990 Den Bosch, Noordbrabants Museum, *A Feast of Colour. Post-Impressionists from Private Collections*, 1990.

DETROIT 1954 Detroit, Detroit Institute of Arts, *The Two Sides of the Medal: French Painting from Gérôme to Gauguin*, 1954.

DIEPPE 1955 Dieppe, Musée des Beaux-Arts, *Pissarro*, 1955.

DRESDEN 1914 Dresden, Galerie Ernst Arnold, *Austellung französischer Malerei des XIX Jahrhunderts*, 1914.

EDINBURGH 1944 Edinburgh, National Gallery of Scotland, *A Century of French Art*, 1944.

EDINBURGH 1949 Edinburgh, Royal Scottish Academy, *123rd Annual Exhibition*, 1949.

EDINBURGH 1968 Edinburgh, Royal Scottish Academy, *Boudin to Picasso*, 1968.

EUGENE 1962 Eugene, University of Oregon Museum of Art, *Treasure Finds in Pacific Coast Museums*, 1962.

GLASGOW 1930 Glasgow, Alex Reid & Lefevre, *French Painting from the XIX and XX Centuries*, 1930.

GLASGOW 1943 Glasgow, Glasgow Art Gallery and Museum, *The Spirit of France*, 1943.

GLASGOW 1967 Glasgow, Arts Council Gallery, *A Man of Influence: Alexander Reid*, 1967.

HAMBURG 1970 Hamburg, Hamburg Kunstverein, *Französische Impressionisten, Homage à Durand-Ruel*, 1970–1.

HAMILTON 1964 Hamilton, Ontario, Art Gallery of Hamilton, *50th Anniversary Exhibition*, 1964.

HOUSTON 1962 Houston, Houston Museum of Fine Arts, *The Maurice Wertheim Collection: Manet to Picasso*, 1962.

KURASHIKI 1988 Kurashiki, Museum of Fine Arts of Kurashiki – Osaka, Museum Nabio – Toyohashi, Gallery Seibu – Saga, Saga Prefectural Museum – Kumamoto, Kumamoto Prefectural Museum of Art – Tokyo, Tokyo Art Hall, *Le Musée des Beaux-Arts du Havre*, 1988–89.

LA COURNEUVE 1974 La Courneuve, *Aux Sources de la peinture moderne: l'impressionisme*, 1974.

LAUSANNE 1964 Lausanne, Palais de Beaulieu, *Chefs-d'oeuvre des collections suisses de Manet à Picasso*, 1964.

LE HAVRE 1958 Le Havre, Chambre du Commerce du Havre, Palais de la Bourse, *Le Havre et les Havrais au XIXe siècle*, 1958.

LE HAVRE 1986 Le Havre, Galerie Hamon, *Les peintres du Havre et de l'Estuaire*, 1986.

LENINGRAD 1968 Leningrad, The Hermitage, *Francuskaya zivopis XIX/XX vekov iz sobranya Narodnogo muzeya v Belgrade*, 1968.

LENINGRAD 1970 Leningrad–Moscow–Madrid, *Impressionnisme en URSS et en Espagne*, 1970–71.

LENINGRAD 1973 Leningrad, The Hermitage, *Les peintres du Havre fin XIXe, début XXe*, 1973.

LENINGRAD 1975 Leningrad, The Hermitage–Moscow, The Pushkin Museum, *100 Paintings from The Metropolitan Museum*, 1975.

LENINGRAD 1976 Leningrad, The Hermitage – Moscow, The Pushkin Museum – Kiev, State Museum of Ukranian Art – Minsk, Belorussian State Museum of Fine Arts – Paris, Musée Marmottan, *Paintings from American Museums*, 1976.

LENINGRAD 1986 Leningrad, The Hermitage – Moscow, The Pushkin Museum, *Masterpieces of French Painting of the Second Half of the Nineteenth to the Beginning of the Twentieth Century from the National Gallery of Art in Washington*, 1986.

LIMOGES 1956 Limoges, Musée Municipal de Limoges, *De l'Impressionnisme à nos jours*, 1956.

LJUBLJANA 1978 Ljubljana, National Gallery, *Od Corota do Bonnarda. Francoski slikarji iz zbirk Narodneya muzeja v Beogradu*, 1978.

LONDON 1905 London, Grafton Gallery, *A Selection from the Pictures by Boudin, Cézanne, Degas, Manet, Monet, Morisot, Pissarro, Renoir, Sisley*, 1905.

LONDON 1911 London, Stafford Gallery, *Exhibition of Pictures by Camille Pissarro*, 1911.

LONDON 1923 London, Leicester Galleries, *Modern French Paintings*, 1923.

LONDON 1925 London, The French Gallery, *123rd Exhibition*, 1925.

LONDON 1926 London, Tate Gallery, *The Opening Exhibition of the Modern Foreign Gallery*, 1926.

LONDON 1936(i) London, New Burlington Galleries, *Painting of French Masters of the XIX Century*, 1936.

LONDON 1936(ii) London, Leicester Galleries, *Paintings by Sisley, Renoir, Pissarro, Monet, Boudin, Cassatt*, 1936.

LONDON 1937 London, Leicester Galleries, *Paintings by Bonnard, Boudin, et al.*, 1937.

LONDON 1948 London, Tate Gallery, *Samuel Courtauld Memorial Exhibition*, 1948.

LONDON 1950 London, Royal Academy, *Landscape in French Art*, 1949–50.

LONDON 1955 London, Marlborough Fine Art, *Camille Pissarro – Alfred Sisley*, 1955.

LONDON 1957 London, Agnews, *Exhibition of Pictures from the Birmingham Art Gallery*, 1957.

LONDON 1960 London, Marlborough Fine Art, *A Selection of Important 19th-century French Masters*, 1960.

LONDON 1961 London, Marlborough Fine Art, *French Landscapes*, 1961.

LONDON 1962 London, Royal Academy of Arts, *Primitives to Picasso*, 1962.

LONDON 1963 London, Marlborough Fine Art, *A Great Period of French Painting*, 1963.

LONDON 1973(i) London, P. & D. Colnaghi, *Glasgow University's Pictures*, 1973.

LONDON 1973(ii) London, Alex Reid & Lefevre, *Important 19th- and 20th-century Paintings*, 1973.

LONDON 1979 London, Wildenstein & Co., *Paintings from the Davies Collection*, 1979.

LONDON 1980–81 London, Hayward Gallery – Boston, Museum of Fine Arts – Paris, Grand Palais, *Pissarro*, 1980–81.

LONDON 1984 London, Thos. Agnew & Son, *Thirty-five paintings from the Collection of the British Rail Pension Fund*, 1984.

LOS ANGELES 1940 Los Angeles, Los Angeles County Museum of Art, *The Development of Impressionism*, 1940.

LOS ANGELES 1946 Los Angeles, Los Angeles County Museum of Art, *The Mr. and Mrs. George Gard de Sylva Collection of French Impressionists and Modern Paintings and Sculpture*, 1946.

LOS ANGELES 1956–57 Los Angeles, Los Angeles County Museum of Art – San Francisco, The California Palace of the Legion of Honor, *The Gladys Lloyd Robinson and Edward G. Robinson Collection*, 1956–57.

LOS ANGELES 1984–85 Los Angeles, Los Angeles County Museum of Art – Chicago, The Art Institute of Chicago – Paris, Grand Palais, *A Day in the Country: Impressionism and the French Landscape*, 1984–85.

MAASTRICHT 1983 Maastricht, Noortman & Brod – London, Noortman & Brod, *Impressionists – An Exhibition of French Impressionist Paintings*, 1983.

MADISON N.J. 1986 Madison, N.J., Schering/Plough Headquarters, *The Impressionist Vision: Selections from The Dixon Gallery and Gardens*, 1986.

MADRID 1971 Madrid, *Les Impressionistes françaises*, 1971.

MANCHESTER 1907 Manchester, Manchester City Art Gallery, *French Modern Paintings*, 1907.

MANCHESTER 1965 Manchester N.H., Currier Gallery of Art, *The Maurice Wertheim Collection*, 1965.

MEMPHIS 1980 Memphis, Tennessee, Dixon Gallery and Gardens, *Homage to Camille Pissarro: The*

Last Years, 1890–1903, 1980.

MINNEAPOLIS 1958 Minneapolis, The Minneapolis Institute of Arts, *The Maurice Wertheim Collection*, 1958.

MINNEAPOLIS 1969 Minneapolis, The Minneapolis Institute of Arts, *The Past Rediscovered: French Painting 1800–1900*, 1969.

MINNEAPOLIS 1979 Minneapolis, The Minneapolis Institute of Arts, *Great Expectations* (Urban Arts Program), 1979.

MONTGOMERY 1971 Montgomery, Ark. Montgomery Museum of Art, *The Maurice Wertheim Collection*, 1971.

MONTGOMERY 1981 Montgomery, Ark. Montgomery Museum of Fine Arts, *Masterpieces of French Impressionism and Post-Impressionism*, 1981.

MONTREAL 1939 Montreal, Art Association of Montreal, *Loan Exhibition of Nineteenth-Century Landscape Paintings, no. 89*, 1939.

MONTREAL 1942 Montreal, Art Association of Montreal, *Masterpieces of Painting*, 1942.

MONTREAL 1952 Montreal, The Montreal Museum of Fine Arts, *Six Centuries of Landscape*, 1952.

MONTREAL 1966 Montreal, The Montreal Museum of Fine Arts, *Masterpieces from Montreal*, 1966.

MONTREAL 1967 Montreal, Expo '67, *Man and his World*, 1967.

MONTREAL 1970 Montreal, The Montreal Museum of Fine Arts, *De Daumier à Rouault*, 1970.

MUNICH 1964–65 Munich, Bayerische Staatsgemäldesammlungen Neue Pinakothek *Französische Malerie des 19. Jahrhunderts von David bis Cézanne*, 1964–65.

MUNICH 1990 Munich Bayerische Staatsgemäldesammlungen Neue Pinakothek, *Französische Impressionisten und ihre Wegbereiter aus der National Gallery of Art, Washington und dem Cincinnati Art Museum*, 1990.

NAGOYA 1991 Nagoya–Nara–Hiroshima, *The World of Impressionism and Pleinairism*, 1991.

NAPLES 1986 Naples, Museo di Capodimonte – Milan, Pinacoteca di Brera, *Capolavori Impressionisti dei Musei Americani*, 1986–87.

NEW DELHI 1977 New Delhi, National Gallery of Art, *Modern French Paintings*, 1977–78.

NEW HAVEN 1960 New Haven, Conn., Yale University Art Gallery, *Paintings, Drawings and Sculpture Collected by Yale Alumni*, 1960.

NEW YORK 1929 New York, Durand-Ruel Galleries, *Master Impressionists*, 1929.

NEW YORK 1940 New York, Durand-Ruel Galleries, *Paintings of Paris*, 1940.

NEW YORK 1943 New York, Knoedler Gallery – Boston, Institute of Modern Art, *Views of Paris*, 1943.

NEW YORK 1944 New York, The Carstairs Gallery, *Paris by Pissarro*, 1944.

NEW YORK 1949 New York, The Century Association, *Trends in European Painting*, 1949.

NEW YORK 1950(i) New York, Paul Rosenberg & Co., *The 19th Century Heritage*, 1950.

NEW YORK 1950(ii) New York, M. Knoedler & Co., *A Collector's Exhibition*, 1950.

NEW YORK 1952 New York, The Metropolitan Museum of Art, *The Maurice Wertheim Collection*, 1952.

NEW YORK 1953 New York, The Museum of Modern Art – Washington D.C., The National Gallery of Art, *Forty Paintings from the Edward G. Robinson Collection*, 1953.

NEW YORK 1956 New York, Delius Gallery, [no title], 1956.

NEW YORK 1957 New York, The Knoedler Galleries – Palm Beach, Florida, The Society of the Four Arts, *Paintings and Sculpture from The Minneapolis Institute of Arts – a Loan Exhibition*, 1957.

NEW YORK 1958 New York, The Metropolitan Museum of Art, *Summer Loan Show*, 1958.

NEW YORK 1959 New York, The Metropolitan Museum of Art, *Summer Loan Show*, 1959.

NEW YORK 1962 New York, Wildenstein & Co., *Modern French Paintings*, 1962.

NEW YORK 1965 New York, Wildenstein & Co., *Olympia's Progeny*, 1965.

NEW YORK 1966(i) New York, M. Knoedler & Co., *Impressionist Treasures*, 1966.

NEW YORK 1966(ii) New York, Public Education Association, *Seven Decades 1895–1965*, 1966.

NEW YORK 1966(iii) New York, The Metropolitan Museum of Art, *Summer Loan Exhibition: Paintings, Drawings and Sculpture from Private Collections*, 1966.

NEW YORK 1967 New York, Wildenstein & Co., *Treasures from the Clark Art Institute*, 1967.

NEW YORK 1968(i) New York, Acquavella Galleries, *Four Masters of Impressionism*, 1968.

NEW YORK 1968(ii) New York, The Metropolitan Museum of Art, *Summer Loan Show*, 1968.

NEW YORK 1968(iii) New York, The Metropolitan Museum of Art, *New York Collects*, 1968.

NEW YORK 1970 New York, Wildenstein & Co., *100 years of Impressionism (A Tribute To Durand-Ruel)*, 1970.

NEW YORK 1985 New York, IBM Gallery of Science and Art, *Manet to Matisse: The Maurice Wertheim Collection*, 1985.

OSHKOSH 1982 Oshkosh, Wisc., Paine Art Center and Arboretum, *18th and 19th Century French and American Paintings from the Dixon Gallery and Gardens*, 1982.

OTTAWA 1934 Ottawa, National Gallery of Canada – Toronto, Art Gallery of Toronto – Montreal, Art Association of Montreal, *Exhibition of French Paintings of the Nineteenth Century*, 1934.

OTTAWA 1962 Ottawa, National Gallery of Canada, *European Paintings in Canadian Collections: Modern Schools*, 1962.

OTTAWA 1973 Ottawa, National Gallery of Canada, *Montreal Museum Lends*: II, 1973–75.

PAISLEY 1952 Paisley, Paisley Art Institute, *Annual Exhibition*, 1952.

PALM BEACH 1960 Palm Beach, Florida, The Society of the Four Arts, *Paintings by Camille Pissarro, French Impressionist*, 1960.

PARIS 1908(i) Paris, Galerie Durand-Ruel, *Exposition Pissarro*, 1908.

PARIS 1908(ii) Paris, Galerie Bernheim-Jeune, Pissarro exhibition, 1908.

PARIS 1910(i) Paris, Galerie Durand-Ruel, *Tableaux et gouaches par Camille Pissarro*, 1910.

PARIS 1910(ii) Paris, Galerie Durand-Ruel, *Tableaux par Monet, C. Pissarro, Renoir et Sisley*, 1910.

PARIS 1912 Paris, 24 Boulevard des Capucines, *Exposition de l'art moderne*, 1912.

PARIS 1923 Paris, Laboratoires Scientifiques, *L'Art français au service de la science*, 1923.

PARIS 1925 Paris, Galerie Durand-Ruel, *Oeuvres importantes de Monet, Pissarro, Renoir, Sisley*, 1925.

PARIS 1932 Paris, Galerie Durand-Ruel, *Les Amis des enfants*, 1932.

PARIS 1936 Paris, Galerie de l'Elysée, *C. Pissarro: tableaux, pastels, dessins*, 1936.

PARIS 1937 Paris, Musée Municipal d'Art Moderne, *Exposition universelle*, 1937.

PARIS 1945 Paris, Galerie Charpentier, *Paysages d'eau douce*, 1945.

PARIS 1946 Paris, Musée de l'Orangerie, *Les Chefs-d'oeuvre des collections privées françaises retrouvées en Allemagne*, 1946.

PARIS 1951 Paris, Grand Palais, *Bi-millénaire de la ville de Paris*, 1951.

PARIS 1953(i) Paris, Musée du Petit Palais, *Un Siècle d'art français 1850–1950*, 1953.

PARIS 1953(ii) Paris, Musée National d'Art Moderne, *Corot à nos jours au Musée du Havre*, 1953–54.

PARIS 1959 Paris, Musée du Petit Palais, *De Géricault à Matisse, chefs-d'oeuvres français des collections suisses*, 1959.

PARIS 1961 Paris, Musée Carnavalet, *Paris vue par les maîtres de Corot à Utrillo*, 1961.

PARIS 1965 Paris, Musée de la Marine, *Trois millénaires d'art et de marine*, 1965.

PARIS 1967 Paris, Orangerie des Tuileries, *Chefs-d'oeuvre des collections suisses de Manet à Picasso*, 1967.

PARIS 1979 Paris, Musée Marmottan, *Chefs-d'oeuvre Impressionnistes du Musée National du Pays de Galles*, 1979.

PARIS 1981 Paris, Galerie Schmit, *Regards sur une Collection XIX–XX Siècles*, 1981.

PARIS 1984–85 Paris, Musée d'Orsay – Bobigny, *Les Arts et la civilisation industrielle (1850–1914)*, 1984–85.

PARIS 1987 Paris, Galerie Schmit, *25e Exposition maîtres français XIX–XX*, 1987.

PARIS 1988(i) Paris, Grand Palais – Tokyo, *Japonisme*, 1988.

PARIS 1988(ii) Paris, Galerie Schmit, *Maîtres français XIX–XX siècles*, 1988.

PARIS 1990 Paris, Galerie Schmit, *25 ans d'expositions maîtres français XIX–XX siècles*, 1990.

PHILADELPHIA 1947 Philadelphia, Philadelphia Museum of Art, *Masterpieces from Philadelphia Private Collections*, 1947.

PHILADELPHIA 1957 Philadelphia, Philadelphia Museum of Art, *The Maurice Wertheim Collection*, 1957.

PITTSBURGH 1951 Pittsburgh, Museum of Art, Carnegie Institute, *French Painting: 1100–1900*, 1951.

PITTSBURGH 1974 Pittsburgh, Carnegie Institute, The Sarah Scaife Gallery of Art, *Inaugural Celebration Exhibition*, 1974.

PITTSBURGH 1989 Pittsburgh, The Carnegie Museum of Art – Minneapolis, The Minneapolis

Institute of Arts – Kansas City, The Nelson-Atkins Museum of Art – St Louis, The Saint Louis Art Museum – Toledo, The Toledo Museum of Art, *Impressionism: Selections from Five American Museums*, 1989–90.

PITTSFIELD 1946 Pittsfield, Berkshire Museum, *Impressionist Painting*, 1946.

POMONA 1950 Pomona, The Los Angeles County Fair, *Masters of Art from 1790 to 1950*, 1950.

PONTOISE 1985 Pontoise, Musée Pissarro, *Peintures Neo-Impressionnistes*, 1985.

PORTLAND 1967 Portland, Portland Art Museum, *Seventy-Five Masterworks*, 1967.

PRAGUE 1971 Prague, National Gallery, *Od Corota k Bonnardovi, Francouske malirstvi 19. a 20. stol. ze sbirek Narodniho Musea v Belegrade*, 1971.

PROVIDENCE 1968 Providence, R.I., Museum of Art, Rhode Island School of Design, *The Maurice Wertheim Collection*, 1968.

QUEBEC 1949 Quebec, Musée de la Province de Quebec, *La Peinture française depuis 1870*, 1949.

RALEIGH 1959 Raleigh, North Carolina Museum of Art, *Masterpieces of Art*, 1959.

RALEIGH 1960 Raleigh, North Carolina Museum of Art, *The Maurice Wertheim Collection: Modern French Art – Monet to Picasso*, 1960.

RALEIGH 1970 Raleigh, North Carolina Museum of Art, *Exhibition Number One from the Permanent Collection*, 1970.

REIMS 1948 Reims, Musée de Reims, *La Peinture française au XIXe siècle de Delacroix à Gauguin*, 1948.

REIMS 1951 Reims, Musée des Beaux-Arts, *Les Étapes de l'art contemporain*, 1951.

REIMS 1973 Reims, Maison de la Culture de Reims, *Trésors des musées de Champagne-Ardennes*, 1973.

RICHMOND 1975 Richmond, V.A., Virginia Museum of Fine Arts, *Masterpieces from the North Carolina Museum of Art*, 1975.

ROTTERDAM 1952 Rotterdam, Boymans-van Beuningen Museum, *Frans Meesters uit het Petit-Palais*, 1952–53.

SACRAMENTO 1956 Sacramento, California State Fair, [no title], 1956.

SALZBURG 1973 Salzburg, *Trésors des musées de Reims*, 1973.

SAN FRANCISCO 1935 San Francisco, San Francisco Museum of Art, *Modern French Painting*, 1935.

SAN FRANCISCO 1939 San Francisco, San Francisco Golden Gàte International Exhibition, *Masterworks of Five Centuries*, 1939.

SAN FRANCISCO 1961 San Francisco, California Palace of the Legion of Honor, *French Paintings of the Nineteenth Century from the Collection of Mrs. Mellon Bruce*, 1961.

SAN FRANCISCO 1965 San Francisco, California Palace of the Legion of Honor, *The Collection of Mr. and Mrs. William Coxe Wright*, 1965.

SCHAFFHAUSEN 1963 Schaffhausen, Museum zu Allerheiligen, *Die Welt des Impressionismus*, 1963.

SEPTENTRION 1980–81 Septentrion (Marcq-en-Baroeul), Fondation Anne et Albert Prouvost, *Exposition Impressionnisme*, 1980–81.

SOGO 1986 Sogo, Sogo Museum of Art – Osaka, The Daimaru Museum – Himeji, City Museum of Art – Hiroshima, Hiroshima Museum of Art – Gifu, Museum of Fine Arts – Fukushima, Prefectural Museum of Art – Tokyo, Odakyu Grand Gallery – Miyazaki, Prefectural Museum – Fukuoka, Prefectural Museum of Art, *Masterpieces from the National Museum of Wales*, 1986–87.

SOGO 1991 Sogo, Sogo Museum of Art – Nara Sogo, Nara Sogo Museum of Art – Saga, Saga Prefectural Art Museum – Takamatsu, Takamatsu City Museum of Art – Yamaguchi, Yamaguchi Prefectural Museum of Art, *Masterpieces of the 19th and 20th Century: French Painting from the National Museum, Belgrade*, 1991.

STANFORD 1945 Stanford, Cal., Stanford University, *Modern French Paintings*, 1945.

SWANSEA 1980 Swansea, Swansea Festival Exhibition, *Ship-Shape 1880–1980*, 1980.

TAMPA 1981 Tampa, Florida, Tampa Museum of Art, *The Subjective Vision of French Impressionism*, 1981.

TOKYO 1972 Tokyo, Tokyo National Museum – Kyoto, Kyoto Municipal Museum, *Treasured Masterpieces of The Metropolitan Museum of Art*, 1972.

TOKYO 1979 Tokyo–Tochigi–Sapporo–Kyoto, *Chefs d'oeuvre des Musées de la villa de Paris*, 1979.

TOKYO 1981 Tokyo, Isetan Museum of Art, *Wally Findlay Collection*, 1981.

TOKYO 1983 Tokyo, Idemitsu Museum of Arts, *Chefs-d'oeuvre du Petit–Palais*, 1983.

TOKYO 1984 Tokyo, Isetan Museum of Art – Fukuoka, Fukuoka Art Museum – Kyoto, Kyoto Municipal Museum of Art, *Retrospective Camille Pissarro*, 1984.

TOKYO 1985 Tokyo, Grand Magasin Odakyu à Shinjuku – Hiroshima, Hiroshima Museum – Kobé, Hyogo Prefectural Museum of Modern Art, *Rétrospective de Paris moderne*, 1985–86.

TOKYO 1985–86 Tokyo, Tokyo, The Seibu Museum of Art – Fukuoka, Fukuoka Art Museum – Kyoto, Kyoto Municipal Museum of Art, *The Impressionist Tradition: Masterpieces from The Art Institute of Chicago*, 1985–86.

TOKYO 1989 Tokyo, Gallery Art Point, *Impressionists*, 1989.

TOKYO 1989–90 Tokyo, Nihonbashi Takashimaya – Yokohama, Yokohama Takashimaya – Toyohashi, Toyohashi City Art Museum – Kyoto, Kyoto Takashimaya, *French Masterpieces from the Ordrupgaard Collection in Copenhagen*, 1989–90.

TOKYO 1990 Tokyo, Isetan Department Store – Yamaguchi, Yamaguchi Prefectural Museum of Art, *The Maurice Wertheim Collection and Selected Impressionist and Post-Impressionist Paintings and Drawings, in the Fogg Art Museum*, 1990.

TOLEDO 1905 Toledo, The Toledo Museum of Art, *One Hundred Paintings by the Impressionists from the Collection of Durand-Ruel & Sons, Paris*, 1905.

TOLEDO 1946–47 Toledo, The Toledo Museum of Art, – Toronto, The Art Gallery of Ontario, *The Spirit of Modern France: An Essay on Painting Society*, 1946–47.

TORONTO 1926 Toronto, Art Gallery of Ontario, *Inaugural Exhibition*, 1926.

TORONTO 1937 Toronto, Art Gallery of Ontario, *Trends in European Painting*, 1937.

TORONTO 1940 Toronto, Art Gallery of Ontario, *Great Paintings*, 1940.

TORONTO 1954 Toronto, Art Gallery of Ontario – Ottawa, National Gallery of Canada – Montreal, The Montreal Museum of Fine Arts, *Paintings by European Masters from Public and Private Collections in Toronto, Montreal and Ottawa*, 1954.

TORONTO 1957 Toronto, Art Gallery of Ontario, *Comparisons*, 1957.

TROYES 1969 Troyes, Musée de Troyes, *Renoir et ses amis*, 1969.

URBANA 1961 Urbana, Krannert Art Museum, University of Illinois at Urbana-Champaign, Dedication exhibition, 1961.

VANCOUVER 1953 Vancouver, Vancouver Art Gallery, *French Impressionists*, 1953.

VANCOUVER 1963 Vancouver, Vancouver Art Gallery, *Of Ships and the Sea*, 1963.

VANCOUVER 1983 Vancouver, Vancouver Art Gallery, *Masterworks from the Collection of the National Gallery of Canada*, 1983.

VENICE 1989 Venice, Ala Napoleonica e Museo Correr – Milan, Palazzo Reale, *Impressionisti della National Gallery of Art di Washington*, 1989.

WASHINGTON 1953 Washington, D.C., National Gallery of Art, *The Maurice Wertheim Collection*, 1953.

WASHINGTON 1966 Washington, D.C., National Gallery of Art, *French Paintings from the Collections of Mr. and Mrs. Paul Mellon and Mrs. Mellon Bruce: Twenty-fifth Anniversary Exhibition 1941–1966*, 1966.

WASHINGTON 1970 Washington, D.C., National Gallery of Art – New York, Metropolitan Museum of Art, *Selections from the Nathan Cummings Collection*, 1970–71.

WASHINGTON 1982–83 Washington, D.C., National Gallery of Art, *Manet and Modern Paris*, 1982–83.

WHITE PLAINS 1956 White Plains, N.Y., *Westchester Creative Arts Festival*, 1956.

WILLIAMSTOWN 1956 Williamstown, Sterling and Francine Clark Art Institute, *French Paintings of the 19th Century*, 1956.

WINSTON-SALEM 1963 Winston-Salem, N.C., Gallery of the Public Library, *Collector's Opportunity*, 1963.

WINTERTHUR 1955 Winterthur, Kunstmuseum Winterthur, *Europäische Meister 1790–1910*, 1955.

YOKOHAMA 1989 Yokohama, Yokohama Museum of Art, *Treasures from The Metropolitan Museum of Art: French Art from the Middle Ages to the Twentieth Century*, 1989.

ZURICH 1913 Zurich, Moderne Galerie, *Französische Kunst*, 1913.

V GENERAL LITERATURE ON PISSARRO

ADAM 1886(i) P. Adam, 'Peintres impressionnistes', *La Revue Contemporaine*, vol. IV, April–May 1886, pp. 548–49.

ADAM 1886(ii) P. Adam, *et al.* 'Camille Pissarro', in *Petit Bottin des Lettres et des Arts*, Paris, 1886, p. 98.

ADHÉMAR 1970 M. Adhémar, *L'Epoque impressionniste*, 1970.

ADLER 1978 K. Adler, *Camille Pissarro: A Biography*, London, 1978.

ADLER 1986 K. Adler, 'Camille Pissarro: City and Country in the 1890s', in Lloyd 1986.

AJALBERT 1886 J. Ajalbert, 'Le Salon des impressionnistes', *La Revue Moderne*, 20 June 1886, pp. 390–91.

ALEXANDRE 1890 A. Alexandre, 'Camille Pissaro [*sic*]', *Paris*, 28 February 1890.

ALEXANDRE 1892 A. Alexandre, 'Chroniques d'aujourd'hui: Camille Pissarro', *Paris*, February 1892.

ALEXANDRE 1894 A. Alexandre, 'L'Art à Paris: Camille Pissarro', *Paris*, 8 March 1894.

ALEXANDRE 1910 A. Alexandre, 'Un mot sur Pissarro', *Comoedia*, 22 January 1910.

ALEXANDRE 1912 A. Alexandre, in *Les Arts*, 1912.

ALEXIS 1887 'Trublot' [P. Alexis], 'A minuit: la collection Murer', *Le Cri du Peuple*, 21 October 1887. Repr.: P. Gachet, *Deux amis impressionnistes*, Paris, 1957, p. 159.

ALLEY 1959 Ronald Alley, *Tate Gallery Catalogues. The Foreign Paintings, Drawings and Sculpture*, London, 1959.

ALLEY 1981 Ronald Alley, *Catalogue of The Tate Gallery's Collection of Modern Art other than Works by British Artists*, London, 1981.

ANDREI 1892 A. Andrei, 'Les Petits Salons: Camille Pissaro [*sic*]', *La France Nouvelle*, 23 February 1892.

ANONYMOUS 1877 'Exposition des impressionnistes', *La Petite République Française*, 10 April 1877.

ANONYMOUS 1880 'La journée parisienne: impression d'un impressionniste', *Le Gaulois*, 24 January 1880. Repr.: *L'Artiste*, 1880, p. 142.

ANONYMOUS 1886 [H. Le Roux?] 'L'exposition des impressionnistes', *La République Française*, 17 May 1886.

ANONYMOUS 1892 'Camille Pissarro', *L'Art Moderne*, 7 February 1892, p. 47.

ANONYMOUS 1893(i) 'M. Camille Pissarro', *L'Art Français*, 25 March 1893.

ANONYMOUS 1893(ii) 'Au jour le jour: encore des peintres . . . Camille Pissarro', *Le Temps*, 17 March 1893.

ANONYMOUS 1920 'Camille Pissarro, memorial exhibition, Leicester Galleries', *The London Mercury*, vol. II, July 1920, pp. 351–53.

ANONYMOUS 1952 'Pissarro, o il dramma del divisionismo', *Sele Arte* (Florence), vol. I, July–August 1952, pp. 15–18.

ANTOINE 1890 J. Antoine, 'Exposition Camille Pissarro', *Art et Critique*, vol. II, 1 March 1890, pp. 141–42.

ANTOINE 1892 J. Antoine, 'Critique d'art: exposition de M. Camille Pissarro', *La Plume*, 15 February 1892, pp. 101–2.

ASTRUC 1859 Z. Astruc, *Les 14 stations du Salon*, Paris, 1859, pp. 286–87.

ASTRUC 1870 Z. Astruc, 'Le Salon, sixième journée', *L'Echo des Beaux-Arts*, vol. I, 12 June 1870.

AURIER 1890(i) G.-A. Aurier, 'Camille Pissarro', *La Revue Indépendante*, March 1890, pp. 503–15. Repr.: Aurier, *Oeuvres posthumes*, Paris, 1893, pp. 235–44.

AURIER 1890(ii) G.-A. Aurier, 'Beaux-Arts: expositions de février-mars', *Le Mercure de France*, vol. I, April 1890, pp. 143–44.

AURIER 1892 G.-A. Aurier, 'Choses d'art: chez Durand-Ruel', *Le Mercure de France*, vol. III, March 1892, p. 283.

BAILLY-HERZBERG 1975 J. Bailly-Herzberg, 'Essai de reconstitution grâce à une correspondance inédite du peintre Pissarro au magasin que le fameux marchand Samuel Bing ouvrit en 1895 à Paris pour lancer l'Art Nouveau', *Connaissance des Arts*, September 1975, pp. 72–81.

BAZIN 1947(i) G. Bazin, *L'Amour de l'Art* (special issue on Impressionism), n.s., vol. XXVII, nos 3 and 4, 1947.

BAZIN 1947(ii) G. Bazin, *L'Epoque impressionniste*, Paris, 1947.

BELL 1952 C. Bell, *The French Impressionists*, London and New York, 1952.

BELLONY-REWALD 1976 A. Bellony-Rewald and R. Gordon, *The Lost World of the Impressionists*, London and Boston, 1976.

BENISOVICH 1966 M. Benisovich and J. Dallett. 'Camille Pissarro and Fritz Melbye in Venezuela' *Apollo*, vol. LXXXIV, July 1966, pp. 44–47.

BERALDI 1891 H. Beraldi, 'Camille Pissarro', in *Les Graveurs du XIXe siècle*, vol. XI, Paris, 1891, pp. 12–14.

BERNIER 1965 R. Bernier, 'Les Nouvelles Installations et les collections du Los Angeles County Museum', *L'Oeil*, March 1965.

BERTALL 1877 Bertall, 'Exposition des impressionnistes', *Paris-Journal*, 9 April 1877.

BESSONOVA 1985 M. Bessonova, (introductory article), *Impressionist and Post-Impressionist Paintings in Soviet Museums*, Oxford and Leningrad, 1985.

BIGOT 1876 C. Bigot, 'L'Exposition des "intransigeants"', *La Revue Politique et Littéraire*, 2nd series, vol. X, 8 April 1876, p. 351.

BIGOT 1877 C. Bigot, 'L'Exposition des "impressionnistes"', *La Revue Politique et Littéraire*, 2nd series, vol. XII, 28 April 1877, p. 1047.

BLEMONT 1876 E. Blemont, 'Les Impressionnistes' *Le Rappel*, 9 April 1876.

BLUNDEN 1970 M. and G. Blunden, *Journal de l'Impressionnisme*, Geneva, 1970. Tr.: *Impressionists and Impressionism*, Geneva, 1970.

BODELSEN 1968 M. Bodelsen, 'Early impressionist sales, 1874–94, in the light of some unpublished procès-verbaux', *Burlington Magazine*, vol. CX, June 1968, pp. 330–49.

BODELSEN 1970 M. Bodelsen, 'Gauguin, the collector', *Burlington Magazine*, vol. CXII, September 1970, pp. 590–615.

BOGGS 1971 J.S. Boggs, *The National Gallery of Canada*, Oxford, 1971.

BORGMEYER 1913 C.L. Borgmeyer, *The Master Impressionists*, Chicago, 1913.

BOULTON 1966 A. Boulton, *Camille Pissarro en Venezuela*, Caracas, 1966.

BOULTON 1975(i) A. Boulton, 'Camille Pissaro in Venezuela', *Connoisseur*, vol. CLXXXIX, May 1975, pp. 36–42.

BOULTON 1975(ii) A. Boulton, 'Un error sobre Camille Pissarro', *Boletin Historico* (Caracas), May 1975, pp. 239–43.

BOURGEOIS 1928 S. Bourgeois, *The Adolph Lewisohn Collection of Modern French Paintings and Sculptures*, New York, 1928.

BOURGET 1974 Jean-Loup Bourget, 'Le Centenaire de l'Impressionisme', *Vie des Arts,* vol. XIX, no. 76, autumn 1974.

BOWRON 1983 E.P. Bowron, *Introduction to the Collections in the Fogg Art Museum*, Chapel Hill, 1983.

BOWRON 1990 E.P. Bowron, *European Paintings before 1900 in the Fogg Art Museum: A Summary Catalogue including paintings in the Busch-Reisinger Museum*, Cambridge, Mass., 1990.

BRAYER 1979 Y. Brayer, 'Chefs-d'oeuvre Impressionnistes de la Collection Davies', *L'Oeil – Revue d'Art*, June 1979, no. 287.

BRETTELL 1977 R. Brettell, *Pissarro and Pontoise: the painter in a landscape*, unpublished Ph.D. thesis, New Haven, Yale University, 1977.

BRETTELL 1980 R. Brettell, and C. Lloyd, *Catalogue of the drawings by Camille Pissarro in the Ashmolean Museum*, Oxford, 1980.

BRETTELL 1987 R. Brettell, *French Impressionism*, Chicago, 1987.

BRETTELL 1989 R. Brettell, *Pissarro and Pontoise: The Painter in a Landscape*, New Haven and London 1989.

BROOKNER 1962 A. Brookner, 'Pissarro at Durand-Ruel's', *Burlington Magazine*, vol. CIV, August 1962, p. 363.

BROUDE 1970 N. Broude, 'Macchialioli as "proto-impressionists"; realism, popular science and the re-shaping of Macchia romanticism 1862–1886', *Art Bulletin*, vol. XII, December 1970, p. 409.

BROWN 1950 R. Brown, 'Impressionist technique; Pissarro's optical mixture', *Magazine of Art*, vol. XLIII, January 1950, pp. 12–15. Repr.: B. White, *Impressionism in Perspective*, Englewood Cliffs, 1978, pp. 114–21.

BROWN 1952 R. Brown 'The Color Technique of Camille Pissarro', unpublished Ph.D. thesis, Harvard University, 1952.

BUHOT 1888 'Pointe-Seche' [F. Buhot], 'Le Whistlerisme et le Pissarisme à l'exposition des XXXIII', *Le Journal des Arts*, 13 January 1888.

BURTY 1874 [P. Burty], 'Exposition de la société anonyme des artistes', *La République Française*, 25 April 1874. Repr.: *Centenaire de l'Impressionnisme*, Paris, Grand Palais, 1974, pp. 261–62.

BURTY 1879 P. Burty, 'L'Exposition des artistes indépendants', *La République Française*, 16 April 1879.

BURTY 1880 P. Burty, 'Exposition des oeuvres des artistes indépendants', *La République Française*, 10 April 1880.

BURTY 1882 P. Burty, 'Les Aquarellistes, les Indépendants et le Cercle des Arts Libéraux', *La République Française*, 8 March 1882.

CAILAC 1932 J. Cailac, 'The prints of Camille Pissarro; a supplement to the catalogue by Loÿs Delteil' *The Print Collector's Quarterly*, vol. XIX, January 1932, pp. 74–86.

CANADAY 1969 J. Canaday, *The Lives of the Painters*, London, 1969.

CANADAY 1981 J. Canaday, *Mainstreams of Modern Art*, 2nd ed., London, 1981.

CARDON 1881 E. Cardon, 'Choses d'art: l'exposition des artistes indépendants', *Le Soleil*, 7 April 1881.

CARDON 1894 L. Cardon, 'Camille Pissarro', *L'Evénement*, 6 March 1894.

CASTAGNARY 1863 J.-A. Castagnary, 'Salon des refusés, XIV', *L'Artiste*, 1 December 1863. Repr.: Castagnary, *Salons*, Paris, 1892, vol. I, pp. 175–76.

CASTAGNARY 1866 J.-A. Castagnary, 'Salon de 1866', *La Liberté*, 5–13 May 1866. Repr.: Castagnary, 1892, vol. I, p. 235.

CASTAGNARY 1868 J.-A. Castagnary, 'Salon de 1868, V', *Le Siècle*, 7 May–12 June 1868. Repr.: Castagnary, 1892, vol. I, p. 278.

CASTAGNARY 1870 J.-A. Castagnary, 'Salon de 1870', *Le Siècle*, May 1870. Repr.: Castagnary, 1892, vol. I, p. 426.

CASTAGNARY 1874 J.-A. Castagnary, 'L'Exposition du boulevard des Capucines; Les Impressionnistes', *Le Siècle*, 29 April 1874. Repr.: *Centenaire de l'Impressionnisme*, 1974, p. 265.

CHAMPA 1973 K. Champa, 'Pissarro – the progress of Realism', in *Studies in Early Impressionism*, New Haven, 1973, pp. 67–79.

CHAMPIER 1882 V. Champier, 'La Société des artistes indépendants', *L'Année Artistique*, vol. IV: *1881–82*, Paris, 1882, p. 168.

CHAMPSAUR 1887 F. Champsaur, 'A travers les ateliers', in *Le Défilé*, Paris, 1887, pp. 131–40.

CHARRY 1880 P. de Charry, 'Le Salon de 1880; préface, les impressionnistes', *Le Pays*, 10 April 1880.

CHARRY 1882 P. de. Charry, 'Beaux-Arts', *Le Pays*, 14 March 1882.

CHESNEAU 1873 E. Chesneau, 'Notes au jour le jour sur le Salon de 1873', *Paris-Journal*, 11 May 1873.

CHESNEAU 1874 E. Chesneau, 'Avertissement préalable', *Paris-Journal*, 9 May 1874.

CHESNEAU 1882 E. Chesneau, 'Groupes sympathiques: les peintres impressionnistes', *Paris-Journal*, 7 March 1882.

CHRISTOPHE 1888 J. Christophe, 'Chronique: chez Durand-Ruel', *Le Journal des Artistes*, 10 June 1888, p. 185.

COE 1954 R.T. Coe, 'Camille Pissarro in Paris; a study of his later development', *Gazette des Beaux-Arts*, 6th series, vol. XLIII, February 1954, pp. 93–118.

COE 1963 R.T. Coe, 'Camille Pissarro's *Jardin des Mathurins*; an inquiry into impressionist composition', *Nelson Gallery Atkins Museum Bulletin* (Kansas City), vol. IV, 1963, pp. 1–22.

COGNIAT 1974 R. Cogniat, *Pissarro*, Paris, 1974 and 1978. Tr.: *Pissarro*, New York, 1975.

DU COLOMBIER 1930 P. du Colombier, 'Le Centenaire de Pissarro', *La Gazette des Beaux-Arts*, Paris, 20 March 1930.

COMAN 1991 F.E. Coman and E.P. Steicher, *Joie de Vivre: French Paintings from the National Gallery of Art*, Washington, D.C., 1991.

COMPIN 1986 I. Compin and A. Roquebert, *Catalogue sommaire illustré des peintures du Musée du Louvre et du Musée d'Orsay*, vols III, IV, V: *Ecole françaises*, Paris, 1986.

COOLUS 1892 R. Coolus, 'A Pissarro' (poem), *La Revue Blanche*, n.s., vol. II, February 1892, p. 125.

COOPER 1946 D. Cooper, 'The literature of art' (review of *Camille Pissarro: Letters to his son Lucien*), *Burlington Magazine*, vol. LXXXIII, January 1946, p. 24.

COOPER 1954(i) D. Cooper, *The Courtauld Collection*, London, 1954.

COOPER 1954(ii) D. Cooper, in *Burlington Magazine*, vol. XCVI, 1954.

COOPER 1955 D. Cooper, 'The painters of Auvers-sur-Oise', *Burlington Magazine*, vol. CVII, April 1955, pp. 100–5.

COURTHION 1957 P. Courthion, tr. S. Gilbert, 'A Ramble Through Paris', *Paris in Our Time*, Skira, 1957.

COURTHION 1972 P. Courthion, *Impressionism*, New York, 1972.

COWART 1982 J. Cowart, 'Impressionist and Post-Impressionist Paintings', *The Saint Louis Art Museum Bulletin*, vol. XVI, no. 2, 1982.

DALLIGNY 1881 A. Dalligny, 'Les Indépendants, sixième exposition', *Le Journal des Arts*, 8 April 1881.

DALLIGNY 1892 A. Dalligny, 'Expositions particulières . . . Pissaro [*sic*]', *Le Journal des Arts*, 12 February 1892.

DANIELS 1939 P.P. Daniels, 'Technique of Painting – II, A Study of Impressionism', *Coronet*, vol. 6, no. 2, June 1939.

DARGENTY 1883 G. Dargenty, 'Exposition des oeuvres de M. Pissarro', *Le Courrier de l'Art*, 31 May 1883, p. 255.

DARGENTY 1890 G. Dargenty, 'Chronique des expositions: . . . II. M. Pissaro [*sic*]', *Le Courrier de l'Art*, 7 March 1890, p. 75.

DARZENS 1886 R. Darzens, 'Exposition des indépendants', *La Pléiade*, May 1886, p. 90.

DAULTE 1957 F. Daulte, 'L'Exposition Pissarro au Musée de Berne', *Schweizer Monatshefte*, Zurich, March 1957.

DAVIES 1970 M. Davies, *National Gallery of London: French School, early 19th century, Impressionists, Post-Impressionists etc.*, London, 1970.

DE LA VILLEHERVE 1904 R. De La Villehervé, 'Choses du Havre; les dernières semaines du peintre Camille Pissarro', *Le Havre Eclair*, vol. I, 25 September 1904.

DENVIR 1974 B. Denvir, *Impressionism*, London, 1974.

DENVIR 1991 B. Denvir, *Impressionism: The Painters and the Paintings*, London, 1991.

DESCLOZEAUX 1887 J. Desclozeaux, 'L'Exposition internationale de peinture', *L'Estafette*, 15 May 1887.

DEWHURST 1904 W. Dewhurst, 'Camille Pissarro, Renoir, Sisley', in *Impressionist painting*, London and New York, 1904, pp. 49–56.

DICK 1928 S. Dick, 'The National Gallery of Canada. Second Article: British and Continental Schools', *Saturday Night*, 26 May 1928.

DUNSTAN 1976 B. Dunstan, 'Camille Pissarro', in *Painting Methods of the Impressionists*, London and New York, 1976, pp. 68–75.

DURANTY 1946 E. Duranty, *La nouvelle peinture*, Paris, 1876. Repr.: Paris, 1946.

DURANTY 1879 E. Duranty, 'La Quatrième exposition faite par un groupe d'artistes indépendants', *La Chronique des Arts et de la Curiosité*, 19 April 1879, pp. 126–27.

DURET 1870 T. Duret, 'Le Salon: les naturalistes, Pissaro [*sic*]', *L'Electeur Libre*, 12 May 1870. Repr.: Duret, *Critique d'avant-garde*, Paris, 1885, pp. 7–8.

DURET 1878 T. Duret, *Les peintres impressionnistes*, Paris, 1878. Repr.: Duret, *Critique d'avant-garde*, Paris, 1885, pp. 75–80; Duret, *Les peintres impressionnistes*, Paris, 1923.

DURET 1885 T. Duret, *Critique d'avant-garde*, Paris, 1885, pp. 7–8, 75–80. Repr. of Duret 1870 and 1878.

DURET 1904 T. Duret, 'Camille Pissarro', *Gazette des Beaux-Arts*, 3rd series, vol. XXXI, 1 May 1904, pp. 395–405. Expanded version in: Duret, *Histoire des peintres impressionnistes*, Paris, 1906.

EITNER 1988 L. Eitner, *An Outline of 19th Century European Painting*, New York, 1988.

ELIAS 1914 J. Elias, *Camille Pissarro*, Berlin, 1914.

ELSEN 1972 A.E. Elsen, *Purposes of Art*, New York, 1972.

ENAULT 1876 L. Enault, 'L'Exposition des intransigeants', *Le Constitutionnel*, 10 April 1876.

EPHRUSSI 1880 C. Ephrussi, 'Exposition des artistes indépendants', *La Gazette des Beaux-Arts*, 2nd series, vol. XXI, 1880, p. 487.

EPHRUSSI 1881 C.E. [C. Ephrussi], 'Exposition des artistes indépendants', *La Chronique des Arts et de la Curiosité*, 16 April 1881, p. 127.

EVANS 1939 M. Evans, 'Technique of Painting, Pt. II, A Study of Impressionism', *Coronet*, vol. VI, no. 2, 1 June 1939.

FAURE 1921 E. Faure, *History of Art: Modern Art*, New York, 1921.

FENEON 1886(i) F. Fénéon, 'VIIIe exposition impressionniste', *La Vogue*, 13–20 June 1886. Repr.: with revisions: Fénéon, *Les Impressionnistes en 1886*, Paris, 1886. Repr.: Halperin 1970, pp. 29–38.

FENEON 1886(ii) F. Fénéon, 'L'Impressionnisme aux Tuileries', *L'Art Moderne*, 19 September 1886. Repr.: Halperin 1970, pp. 29–38.

FENEON 1887 F. Fénéon, 'Le Néo-Impressionnisme', *L'Art Moderne*, 1 May 1887. Repr.: Halperin 1970, pp. 71–76.

FENEON 1888 F. Fénéon, 'Calendrier de décembre, 1887 . . . v. Vitrines des marchands de tableaux . . . VII. Exposition de la Revue Indépendante', *La Revue Indépendante*, January 1888. Repr.: Halperin 1970, pp. 90, 92.

FENEON 1888 F. Fénéon, Calendrier de mars . . . II. Aux vitrines des marchands de tableaux, chez Van Gogh . . .', *La Revue Indépendante*, April 1888. Repr.: Halperin 1970, pp. 102–3.

FENEON 1888 F. Fénéon, 'Quelques impressionnistes', *La Cravache*, 2 June 1888. Repr.: Halperin 1970, p. 127.

FENEON 1888 F. Fénéon, 'Calendrier de septembre . . . III. Chez M. Van Gogh', *La Revue Indépendante*, October 1888. Repr.: Halperin 1970, p. 118.

FENEON 1889(i) [F. Fénéon], 'Exposition Pissarro', *L'Art Moderne*, 20 January 1889. Repr.: Halperin 1970, pp. 137–38.

FENEON 1889(ii) F. Fénéon, 'Les peintres-graveurs', *La Cravache*, 2 February 1889. Repr.:

Halperin 1970, p. 140.

FÉNÉON 1891 F. Fénéon, 'Cassatt, Pissarro', *Le Chat Noir*, 11 April 1891. Repr.: Halperin 1970, pp. 185–86.

FÉNÉON 1892 F. Fénéon, 'Exposition Camille Pissarro', *L'Art Moderne*, 14 February 1892. Repr.: Halperin 1970, p. 209.

FÉNÉON 1892 F. Fénéon, Untitled note in *L'En Dehors*, 21 February 1892. Repr.: Halperin 1970,p. 895.

FERMIGIER 1972 A. Fermigier, 'Pissarro et l'anarchisme', in *Turpitudes sociales*, Geneva, 1972, pp. 3–8.

FÈVRE 1886 H. Fèvre, 'L'Exposition des indépendants', *Revue de Demain*, May 1886, pp. 150–51. Repr.: Fèvre, *Etude sur le Salon de 1886 et sur l'Exposition des Impressionnistes*, Paris, 1886.

FIERENS 1930 P. Fierens, 'Beaux-Arts: Pissaro [*sic*]', *Le Journal des Débats*, vol. XXXVII, 7 March 1930, pp. 401–3.

FINSEN AND WIVEL 1989 H. Finsen and M. Wivel, *French Masterpieces from the Ordrupgaard Collection in Copenhagen*, exh. cat., Tokyo, 1989.

FOCILLON 1928 H. Focillon, 'L'Impressionnisme', in *La Peinture aux XIXe et XXe siècles: du réalisme à nos jours*, Paris, 1928, p. 217.

FONTAINAS 1922 A. Fontainas, and L. Vauxcelles, 'Camille Pissarro, Sisley, Guillaumin . . .', in *Histoire générale de l'art Français de la Révolution à nos jours*, Paris, 1922, pp. 159–68.

FOUQUIER 1886 M. Fouquier, 'Les Impressionnistes', *Le XIXe Siècle*, 16 May 1886.

FRANCASTEL 1939 P. Francastel, *Monet, Sisley, Pissarro*, Paris, 1939.

FRANKFURTER 1946 A.M. Frankfurter, 'Today's Collectors: Modern Milestones', *Art News*, June 1946.

GABANIZZA 1976 V. Gabanizza, *Il futurisme*, c.1976.

GAILLARD 1991 M. Gaillard, *Paris au XIX siècle*, Marseille, 1991.

GALERIE DURAND-RUEL 1873–75 Galerie Durand-Ruel, *Recueil d'Estampes*, Paris [1873–75]. 'Préface' by P.A. Silvestre, 1873, pp. 22–23.

GARDNER 1975 H. Gardner, *Art Through the Ages*, New York, 1975.

GATO 1975 J.A. Gato, *Emphasis: A Design Principle*, Worcester, Mass., 1975.

GEFFROY 1881 G.G. [G. Geffroy] 'L'Exposition des artistes indépendants', *La Justice*, 17 April 1881.

GEFFROY 1886 G. Geffroy, 'Salon de 1886: VII. Hors du Salon, les impressionnistes', *La Justice*, 21 May 1886.

GEFFROY 1887 G. Geffroy, 'Chronique: Salon de 1887: X. Hors du Salon, rue de Sèze et rue Laffitte', *La Justice*, 13 June 1887.

GEFFROY 1894(i) G. Geffroy, 'Histoire de l'impressionnisme' and 'Camille Pissarro', in *La Vie artistique, histoire de l'Impressionnisme*, 3rd series, Paris, 1894, pp. 1–53, 96–110.

GEFFROY 1894(ii) G.G. [G. Geffroy] 'Camille Pissarro, chez Durand-Ruel, exposition d'oeuvres de l'artiste', *Le Matin*, 6 March 1894.

GEORGE 1926 W. George, 'Pissarro', *L'Art Vivant*, vol. II, 15 March 1926, pp. 201–4.

GEORGE 1932 W. George, 'The French Paintings of the XIXth and XXth Centuries in the Adolph and Samuel Lewisohn Collection', *Formes*, nos 27–29 (English ed.), Paris, 1932.

GEORGEL 1986 C. Georgel, *La Rue*, Paris, 1986.

GEORGET 1887 A. Georget, 'Exposition internationale de peinture', *L'Echo de Paris*, 17 May 1887.

GERHARDT 1980 E. Gerhardt, 'Camille Pissarro, peintre et anarchiste', unpublished Diplôme de l'Ecole des Hautes Etudes en Sciences Sociales, Université de Paris, 1980.

GOETSCHY 1881 G. Goetschy, 'Exposition des artistes indépendants', *Le Voltaire*, 5 April 1881.

GOFF 1987 Goff, Cassar, Esler, Holka and Waltz, *A Survey of Western Civilizations*, St. Paul, Minn., 1987.

GONZAGUE-PRIVAT 1881 Gonzague-Privat, 'L'Exposition des artistes indépendants', *L'Evénement*, 5 April 1881.

GOTTHARD 1924 J. Gotthard, *Pissarro*, Paris, 1924.

GRABER 1943 H. Graber, 'Camille Pissarro', in *Camille Pissarro, Alfred Sisley, Claude Monet nach eigenen und fremden Zeugnissen*, Basel, 1943, pp. 19–107.

GREENBERG 1944 C. Greenberg, 'Grand Old Man of Impressionism' (review of *Camille Pissarro: letters to his son Lucien*), *The Nation*, vol. CLVIII, 24 June 1944, pp. 740–42.

GRONKOWSKI 1927 C. Gronkowski, *Catalogue sommaire des collections municipales*, Paris, 1927.

GSELL 1892 P. Gsell, 'La Tradition artistique française; I. L'Impressionnisme', *La Revue Politique et Littéraire*, vol. XLIX, 26 March 1892, p. 404.

GUERMAN 1973 M. Guerman, *Pissarro*, Leningrad, 1973.

GÜNTHER 1954 H. Günther, *Camille Pissarro*, Munich, Vienna and Basel, 1954.

HABERMAN 1987 A. Haberman, *The Modern Age*, 1987.

HALPERIN 1970 J.U. Halperin, *Félix Fénéon: oeuvres plus que complètes*, vol. I, Geneva and Paris, 1970.

HAMEL 1914 M. Hamel, 'Camille Pissarro: exposition rétrospective de ses oeuvres', *Les Arts*, March 1914, pp. 25–32.

HAMERTON 1891 P.G. Hamerton, 'The present state of the fine arts in France: IV. Impressionism', *Portfolio*, vol. XXII, February 1891, pp. 72–73.

HAMILTON 1970 G.H. Hamilton, *19th and 20th Century Art*, New York, 1970.

HANDLIN 1971 O. Handlin, *Wonders of Man*, Newsweek Book Division, 1971.

HAUSTENSTEIN 1949 W. Haustenstein, *Hauptwerke des Kunstmuseums Winterthur*, Winterthur, 1949.

HAVARD 1879 H. Havard, 'L'Exposition des artistes indépendants', *Le Siècle*, 27 April 1879.

HAVARD 1882 H. Havard, 'Exposition des artistes indépendants', *Le Siècle*, 2 March 1882.

HENNEQUIN 1882 E. Hennequin, 'Les expositions des arts libéraux et des artistes indépendants', *La Revue Littéraire et Artistique*, vol. V, 11 March 1882, p. 155.

HENRIET 1883 F. Henriet, 'L'exposition des oeuvres de C. Pissaro [*sic*]', *Le Journal des Arts*, 25 May 1883.

HEPP 1882 A. Hepp, 'Impressionisme [*sic*]', *Le Voltaire*, 3 March 1882.

HERBERT 1970 R. Herbert, 'City vs. country: the rural image in French painting from Millet to Gauguin', *Artforum*, vol. VIII, February 1970, pp. 51–52.

HERVILLY 1879 E. d' Hervilly, 'Exposition des impressionnistes', *Le Rappel*, 11 April 1879.

VAN HEUGTEN 1987 S. van Heugten *et al.*, in *Franse meesters uit het Metropolitan Museum of Art: Realisten en Impressionisten*, exh. cat., Rijksmuseum Vincent van Gogh, Amsterdam, 1987.

HIND 1908 A.M. Hind, 'Camille Pissarros Graphische Arbeiten. Seine Radierungen, Lithographien und Monotypien und Lucien Pissarros Holzschnitte nach seines Vaters Zeichnungen', *Die Graphischen Künste*, vol. XXXI, 1908, pp. 34–48.

HOLL 1904 J.C. Holl, 'Camille Pissarro et son oeuvre', *L'Oeuvre d'Art International*, vol. VII, October–November 1904, pp. 129–56. Repr.: Holl, *Camille Pissarro et son oeuvre*, Paris, 1904; expanded version: *Portraits d'Hier*, vol. III, July 1911, pp. 35–64.

HOLL 1928 J.C. Holl, 'Pissarro', *L'Art et les Artistes*, vol. XXII, February 1928, pp. 144–70.

HONEYMAN 1953 T.J. Honeyman, *Catalogue of French Paintings, Glasgow Art Gallery and Museum*, Glasgow, 1953.

HOPE 1974 H.R. Hope, 'Midwestern University Paintings Exhibition', *Art Journal*, vol. XXXIII, no. 3, spring, 1974.

HOUSE 1978 J. House, 'New material on Monet and Pissarro in London in 1870–71', *Burlington Magazine*, vol. CXX, October 1978, pp. 636–42.

HOUSE 1985 J. House, *Impressionist Masterpieces: National Gallery of Art, Washington*, New York, 1985.

HOUSE 1986 J. House, 'Camille Pissarro's *Seated Peasant Woman*: the rhetoric of inexpressiveness', in *In Honor of Paul Mellon*, ed. J. Wilmerding, Washington, D.C., 1986, pp. 154–71.

HUBBARD 1962 R.H. Hubbard, *European Paintings in Canadian Collections*, vol. II: *Modern Schools*, Toronto, 1962.

HUBBARD 1972 G. Hubbard and M.J. Rouse, *Art 4: Meaning, Method and Medica*, Westchester, 1972.

HUGHES 1982 P. Hughes, *French Art from the Davies Bequest, National Museum of Wales*, Cardiff, 1982.

HUSTIN 1883 A. Hustin, 'Exposition de Pissarro', *Le Moniteur des Arts*, 11 May 1883, p. 166.

HUYSMANS 1883 J.-K. Huysmans, 'L'Exposition des indépendants en 1880', 'L'Exposition des indépendants en 1881' and 'Appendice I' [1882], in *L'Art Moderne*, Paris, 1883. Repr.: Huysmans, *L'Art Moderne/Certains*, Paris, 1975, pp. 105, 235–38, 251–52, 265.

HUYSMANS 1887 J.-K. Huysmans, 'L'exposition internationale de la rue de Sèze', *La Revue Indépendante*, June 1887, p. 353.

INGAMELLS 1967 J.A.S. Ingamells, *The Davies Collection of French Art, National Museum of Wales*, Cardiff, 1967.

INGAMELLS 1968 J.A.S. Ingamells, *French Impressionists from the Davies Bequest, National Museum of Wales*, Cardiff, 1968.

IOUDENITCH 1963 I.V. Ioudenitch, *Paysages de Pissarro à l'Hermitage*, Leningrad, 1963.

IWASAKI 1978 Y. Iwasaki, *Pissarro*, Tokyo, 1978.

225

JACQUES 1877 E. Jacques, 'Menus propos: salon impressionniste', *L'Homme Libre*, 12 April 1877.

JACQUES 1883 E. Jacques, 'Exposition de M. Pissarro', *L'Intransigeant*, 14 May 1883.

JARVIS 1947 J.A. Jarvis, *Camille Pissarro*, Virgin Islands, 1947.

JEDLICKA 1950 G. Jedlicka, *Pissarro*, Berne, 1950.

JEU DE PAUME 1984 Musée du Jeu de Paume, *Chefs d'Oeuvre impressionnistes du Jeu de Paume*, London, 1984.

JOETS 1947 J. Joets, 'Camille Pissaro et la période inconnue de St-Thomas et de Caracas', *L'Amour de l'Art*, vol. XXVII, 1947, pp. 91–97.

JOURDAIN 1895 F. Jourdain, 'Camille Pissarro', in *Les Décorés, ceux qui ne le sont pas*, Paris, 1895, pp. 193–97.

KAHN 1887 G. Kahn, 'La vie artistique', *La Vie Moderne*, 21 May 1887, p. 328.

KAHN 1889 G. Kahn, 'Chronique: l'art français à l'exposition', *La Vogue*, n.s., vol. I, 1889, pp. 132–33.

KAHN 1913 G. Kahn, 'Art: une rétrospective Camille Pissarro', *Mercure de France*, vol. CL, 1 February 1913, pp. 636–37.

KAHN 1924 G. Kahn, 'Art: Loys Delteil, Le Peintre-Graveur Illustré, tome XVII', *Mercure de France*, vol. CLXIX, 1 February 1924, pp. 779–82.

KAHN 1930(i) G. Kahn, 'Camille Pissarro', *Mercure de France*, vol. CCXVIII, 1 March 1930, pp. 257–66.

KAHN 1930(ii) G. Kahn, 'Le Rétrospective de Pissarro', *Mercure de France*, vol. CCXVIII, 15 March 1930, pp. 697–700.

KARLSRUHE 1963 Karlsruhe, Staatliche Kunsthalle, *Französische Meister Karlsruhe*, Karlsruhe, 1963.

KELDEN 1970 D. Kelden, *French Impressionists and their Century*, London, 1970.

KIMBALL 1948 F. Kimball and L. Venturi, *Great Paintings in America*, New York, 1948.

KIRCHBACH 1904 W. Kirchbach, 'Pissarro und Raffaëlli, zwei Impressionisten', *Die Kunst unserer Zeit*, vol. XV, 1904, pp. 117–36.

KOENIG 1927 L. Koenig, *Camille Pissarro*, Paris, 1927.

KOSTENEVICH 1987 A. Kostenevich, *Western European Painting in the Hermitage, 19th–20th Centuries*, Leningrad, 1987.

KOSTOF 1985 S. Kostof, *A History of Architecture*, New York, 1985.

KUNSTLER 1928(i) C. Kunstler, 'Camille Pissarro' *La Renaissance*, vol. XI, December 1928, pp. 497–508.

KUNSTLER 1928(ii) C. Kunstler, *Paulémile Pissarro*, Paris, 1928.

KUNSTLER 1929 C. Kunstler, 'La Maison d'Eragny', *ABC, Magazine Artistique et Littéraire*, vol. V, March 1929, pp. 79–83.

KUNSTLER 1930(i) C. Kunstler, 'A propos de l'exposition du Musée de l'Orangerie aux Tuileries; le centenaire de Camille Pissarro', *L'Art Vivant*, vol. VI, 1 March 1930, pp. 185–90.

KUNSTLER 1930(ii) C. Kunstler, *Camille Pissarro*, Paris, 1930.

KUNSTLER 1967 C. Kunstler, *Pissarro: villes et campagnes*, Lausanne and Paris, 1967. Tr.: *Pissarro: landscapes and cities*, New York [n.d.].

KUNSTLER 1972 C. Kunstler, *Camille Pissarro*, Milan, 1972. Tr.: *Camille Pissarro*, Paris, 1974.

LABARRIERE 1883 P. Labarrière, 'Exposition Pissaro [*sic*], boulevard de la Madeleine, 9', *Le Journal des Artistes*, 1 June 1883.

LAMARCHE 1991 Hélène Lamarche, *Petit Guide – Pocket Guide: The Montreal Museum of Fine Arts*, Montreal, 1991.

LANES 1965 J. Lanes, 'Loan exhibition at Wildenstein', *Burlington Magazine*, vol. CVII, May 1965, pp. 274–76.

LAPAUZE 1906 H. Lapauze, *Catalogue sommaire des collections municipales*, Paris, 1906.

LAURENT 1879 P.L. [P. Laurent] 'Eau-forte de M. Pissarro', *Les Beaux-Arts Illustrés*, vol. III, 1879, p. 96.

LAUTS 1964 J. Lauts, in *Jahrbuch I*, 1964.

LAUTS 1971 J. Lauts and W. Zimmerman, *Katalog Neuere Meister 19 und 20 Jahrhunderts*, Karlsruhe, 1971/2.

LECOMTE 1890(i) G. Lecomte, 'Camille Pissarro', *Les Hommes d'Aujourd'hui*, vol. VIII [1890].

LECOMTE 1890(ii) G. Lecomte, 'Toiles récentes de M. Camille Pissarro', *Art et Critique*, vol. II, 6 September 1890, pp. 573–74.

LECOMTE 1891(i) G.L. [G. Lecomte] 'Expositions à Paris: . . . Camille Pissarro, Mary Cassatt', *L'Art Moderne*, March 1891, pp. 136–37.

LECOMTE 1891(ii) G. Lecomte, 'M. Camille Pissarro', *La Plume*, 1 September 1891, pp. 301–2.

LECOMTE 1892(i) G. Lecomte, 'Exposition Camille Pissarro', *Art et Critique*, vol. IV, 6 February 1892, pp. 49–52.

LECOMTE 1892(ii) G. Lecomte, *L'Art Impressionniste d'après la Collection Privée de M. Durand-Ruel*, Paris, 1892.

LECOMTE 1922 G. Lecomte, *Camille Pissarro*, Paris, 1922.

LECOMTE 1930 G. Lecomte, 'Un Centenaire: un fondateur de l'Impressionnisme, Camille Pissarro', *Revue de l'Art Ancien et Moderne*, vol. LVII, March 1930, 157–72.

LECUYÈRE 1935 R. Lecuyère, 'Regards sur les musées de Province XXVIII – Le Havre', *L'Illustration*, 13 April 1935.

LEE 1969 K.C. Lee, 'French Impressionism and Post-Impressionism', *Toledo Museum News*, vol. XII, no. 3, autumn, 1969.

LEFEBVRE 1970 G. Lefebvre, 'De Daumier à Rouault', *The Montreal Museum of Fine Arts Quarterly Magazine*, March 1970.

LEGENDRE 1888 M. Legendre, 'L'Exposition de la Galerie Durand-Ruel', *Le Journal des Arts*, 12 June 1888.

LENINGRAD 1976 The State Hermitage, *Catalogue of Western European Painting*, Leningrad, 1976.

LE PASSANT 1890 'Le Passant', 'Les on-dits', *Le Rappel*, 10 March 1890.

LEPINOIS 1859 E. de B. de. Lepinois, *L'art dans la rue et l'art au Salon*, Paris, 1859, p. 225.

LE ROUX 1890 H. Le Roux, 'Exposition C. Pissarro' *Le Temps*, 7 March 1890.

LEROY 1874 L. Leroy, 'L'Exposition des impressionnistes', *Le Charivari*, 25 April 1874. Repr.: *Centenaire de l'Impressionnisme*, 1974, pp. 259–670.

LETHÈVE 1979 J. Lethève, 'J.-K. Huysmans et les peintres impressionnistes: une lettre inédite à Camille Pissarro', *Bulletin de la Bibliothèque Nationale*, vol. IV, June 1979, pp. 92–94.

LEYMARIE 1955 J. Leymarie, *L'Impressionnisme*, 2 vols, Lausanne [1955]. Tr.: *Impressionism*, 2 vols, Lausanne [1955].

LEYMARIE 1971 J. Laymarie, and M. Melot, *Les Gravures des Impressionnistes: Manet, Pissarro, Renoir, Cézanne, Sisley, oeuvre complet*, Paris, 1971. Tr.: *The Graphic Works of the Impressionists*, London and New York, 1972.

LLOYD 1975 C. Lloyd, 'Camille Pissarro and Hans Holbein the Younger', *Burlington Magazine*, vol. CXVII, November 1975, pp. 722–26.

LLOYD 1978 C. Lloyd, 'The literature of art . . . Camille Pissarro, a biography' (review of Adler 1978) *Burlington Magazine*, vol. CXX, October 1978, pp. 683–84.

LLOYD 1979 C. Lloyd, *Pissarro*, Oxford, 1979.

LLOYD 1980 C. Lloyd, A. Distel *et al.*, *Pissarro*, exh. cat., Hayward Gallery, London, 1980.

LLOYD 1981 C. Lloyd, *Camille Pissarro*, New York, 1981.

LLOYD 1983 C. Lloyd, 'Camille Pissarro: towards a Reassessment,' *Art International*, no. 25, 1983.

LLOYD 1984 C. Lloyd, *Retrospective Camille Pissarro*, exh. cat., Japan 1984.

LLOYD 1986 C. Lloyd, ed., *Studies on Camille Pissarro*, London and New York, 1986.

LORA 1874 L. Lora, de. 'Petites nouvelles artistiques: exposition libre des peintres impressionnistes', *Le Gaulois*, 18 April 1874. Repr.: *Centenaire de l'Impressionnisme*, 1974, p. 257.

LORA 1877 L. Lora, de. 'L'Exposition des impressionnistes', *Le Gaulois*, 10 April 1877.

LOSSKY 1938 B. Lossky, 'L'Art français en Yougoslavie', *Annales de l'Institut Français de Zagreb*, no. 7, December 1938.

LOSTALOT 1892 A. de L. [A. de Lostalot] 'L'Exposition des peintures de M. Camille Pissarro', *La Chronique des Arts et de la Curiosité*, 6 February 1892, pp. 41–42.

LOUCHEIM 1946 A.B. Loucheim, 'Buddy de Sylva: Gift to Hollywood', *Art News*, September 1946.

MACAULAY 1953 W.J. Macaulay, 'Some additions to the Glasgow Art Collection', *Scottish Art Review*, vol. IV, no. 3, 1953.

MALVANO 1965 L. Malvano, *Pissarro*, Milan [1965]. Tr.: *Pissarro*, Paris, 1967.

MANSON 1920 J.B. Manson, 'Camille Pissarro', *The Studio*, vol. LXXIX, May 1920, pp. 82–88.

MANSON 1930 J.B. Manson, 'Camille Pissarro', *The Studio*, vol. XCIX, June 1930, pp. 409–15.

MANSON 1944 J.B. Manson, *Camille Pissarro*, a lecture delivered by the late J.B. Manson to the Ben Uri Art Society on January 23rd 1944, London, 1944.

MANTZ 1877 P. Mantz, 'L'Exposition des peintres impressionnistes', *Le Temps*, 22 April 1877.

MANTZ 1881 P. Mantz, 'Exposition des oeuvres des artistes indépendants', *Le Temps*, 23 April 1881.

MARTELLI 1879 D. Martelli, 'Gli Impressionisti, mostra del 1879', *Roma Artistica*, 27 June and 5 July 1879. Tr.: F. Errico, *Diego Martelli: Les Impressionnistes et l'art moderne*, Paris, 1979, p. 30.

MATISSE 1951 H. Matisse, Conversation with Pissarro, in A. Barr, *Matisse: his art and his public*,

New York, 1951, 1974, p. 38. Repr.: B. White, *Impressionism in Perspective*, Englewood Cliffs, 1978, p. 26.

MAUCLAIR 1904 C. Mauclair, 'Les Artistes secondaires de l'Impressionnisme', in *L'Impressionnisme, son histoire, son esthétique, ses maîtres*, Paris, 1904.

MAUCLAIR 1923 C. Mauclair, *Les Maîtres de l'Impressionnisme, leur histoire, leur esthétique, leurs oeuvres*, Olendorf, 1923. Rev. ed. of Mauclair 1904.

MAUCLAIR 1931 C. Mauclair, *Une Belle collection argentine des maîtres français du XIX siècle; Conférence sur la Collection du Dr. Francisco Llobet de Buenos-Aires*, Paris, 1931.

MAUS 1889 O. Maus, 'Le Salon des XX à Bruxelles', *La Cravache*, 16 February 1889.

MAXON 1970 J. Maxon, *The Art Institute of Chicago*, New York, 1970.

MEADMORE 1962 W.S. Meadmore, *Lucien Pissarro: un coeur simple*, London, 1962.

MEIER 1965 G. Meier, *Camille Pissarro*, Leipzig, 1965.

MEIER-GRAEFE 1904 J. Meier-Graefe, 'Camille Pissarro', *Kunst und Künster*, vol. II, September 1904, pp. 475–88. Repr.: Meier-Graefe, *Impressionisten: Guys, Manet, van Gogh, Pissarro, Cézanne*, Munich, 1907, pp. 153–72.

MELLERIO 1891 A.M. [A. Mellerio] 'Les artistes à l'atelier: C. Pissarro', *L'Art dans les Deux Mondes*, 6 June 1891, p. 31.

MELOT 1974 M. Melot, *L'Estampe Impressionniste*, exh. cat., Bibliothèque Nationale, Paris, 1974.

MELOT 1977 M. Melot, 'La Pratique d'un artiste: Pissarro graveur en 1880', *Histoire et Critique des Arts*, vol. II, June 1977, pp. 14–38. Tr.: 'Camille Pissarro in 1880: an anarchistic artist in bourgeois society', *Marxist Perspectives*, vol. II, winter 1979–80, pp. 22–54.

MERCURE 1894 'Mercure', 'Choses d'art: exposition Camille Pissarro', *Mercure de France*, vol. x, April 1894, p. 377.

MICHEL 1893 A. Michel, 'Exposition d'art', *Le Journal des Débats*, 16 March 1893.

MILLIER 1946 A. Millier, 'De Sylva Collection Enriches Los Angeles', *Art Digest*, 15 October 1946.

MIRBEAU 1886 O. Mirbeau, 'Exposition de peinture: I rue Laffitte', *La France*, 21 May 1886.

MIRBEAU 1887 O. Mirbeau, 'L'Exposition internationale de la rue de Sèze', *Gil Blas*, 14 May 1887.

MIRBEAU 1891 O. Mirbeau, 'Camille Pissarro', *L'Art dans les Deux Mondes*, 10 January 1891, pp. 83–84.

MIRBEAU 1892 O. Mirbeau, 'Camille Pissarro', *Le Figaro*, 1 February 1892. Repr.: Mirbeau, *Des Artistes, première série*, Paris, 1922, pp. 145–53.

MOORE 1892 G. Moore, 'Monet, Sisley, Pissarro and the decadence', in *Modern Painting*, London and New York, 1893, pp. 84–90. Repr.: London, 1897 and numerous subsequent editions.

MOORE 1906 G. Moore, *Reminiscences of the impressionist painters*, Dublin, 1906, pp. 39–41.

MONTIFAUD 1874 M. de. Montifaud, 'L'Exposition du boulevard des Capucines', *L'Artiste*, 1 May 1874. Repr.: *Centenaire de l'Impressionnisme*, 1974, p. 267.

MOREL 1883 H. Morel, 'Camille Pissarro', *Le Réveil*, 24 June 1883.

MORICE 1904 C. Morice, 'Deux morts: Whistler, Pissarro', *Mercure de France*, vol. L, April 1904, pp. 72–97. Expanded version: Morice, *Quelques maîtres modernes*, Paris, 1914, pp. 28–45.

MUTHER 1893 R. Muther, 'Camille Pissarro', in *Geschichte der Malerei im XIX. Jahrhundert*, vol. II, Munich, 1893, pp. 638–43.

MYERS 1966 F.A. Myers, 'The Great Bridge at Rouen', *Carnegie Magazine*, May 1966.

NAKAMURA 1978 S. Nakamura, *Le Comte de Monte-Cristo, La Dame aux Camélias*, 1978.

NATANSON 1948 T. Natanson, 'L'apôtre Pissarro', in *Peints à leur tour*, Paris, 1948, pp. 59–63.

NATANSON 1950 T. Natanson, *Pissarro*, Lausanne, 1950.

NATHAN 1946 F. Nathan, *Zehn Jahre Tätigkeit in St. Gallen*, St Gallen, 1946.

NATHAN 1961 F. Nathan, *25 Jahre Dr. Fritz Nathan und Dr. Peter Nathan, 1936–1961*, Winterthur, 1961.

NAUTET 1889 F.N. [F. Nautet?] 'Arts, sciences et lettres: l'exposition Pissarro', *Le Journal de Bruxelles*, 19 January 1889.

NEUGASS 1930(i) F. Neugass, 'Camille Pissarro 1830–1903 zur Zentenarausstellung in der Orangerie der Tuilerien', *Die Kunst für Alle*, vol. VL, May 1930, pp. 232–39. Tr.: 'Camille Pissarro 1830–1903, 100th anniversary, July 10, 1930', *Apollo*, vol. XII, pp. 65–67.

NEUGASS 1930(ii) F. Neugass, 'Camille Pissarro', *Deutsche Kunst und Dekoration*, vol. XXXIV, December 1930, p. 159.

NICOLSON 1946 B. Nicolson, 'The anarchism of Camille Pissarro', *The Arts*, no. 11, 1946, pp. 43–51.

NIVELLE 1882 J. de. Nivelle, 'Les Peintres indépendants', *Le Soleil*, 4 March 1882.

NOCHLIN 1965 L. Nochlin, 'Camille Pissarro: the unassuming eye', *Art News*, vol. LXIV, April 1965, pp. 24–27, 59–62.

O'BRIAN 1988 J. O'Brian, *Degas to Matisse, The Maurice Wertheim Collection*, New York and Cambridge, Mass., 1988.

O'CONNOR 1951 J. O'Connor, Jr, 'From our Permanent Collection', *Carnegie Magazine*, September 1951.

PATAKY 1972 D. Pataky, *Pissarro*, Budapest, 1972.

PAULET 1886 A. Paulet, 'Les Impressionnistes', *Paris*, 5 June 1886.

PERRUCHI-PETRI 1975 U. Perrucchi-Petri, 'War Cézanne Impressionist? Die Begegnung zwischen Cézanne und Pissarro', *Du*, vol. XXXV, September 1975, pp. 50–65.

PERRUCHOT 1965 H. Perruchot, 'Pissarro et le Néo-Impressionnisme', *Jardin des Arts*, November 1965, pp. 48–57.

PHILLIPS 1926 D. Phillips, *A Collection in the Making*, Washington, D.C., and New York, 1926.

PICA 1908 V. Pica, 'Camille Pissarro, Alfred Sisley . . .', in *Gl'Impressionisti Francesi*, Bergamo, 1908, pp. 125–38.

PISSARRO 1922 L.-R. Pissarro, 'The etched and lithographed work of Camille Pissarro', *The Print Collector's Quarterly*, vol. IX, October 1922, pp. 274–301.

PISSARRO 1936 L.-R. Pissarro, 'Au sujet de Pissarro', *Beaux-Arts*, vol. LXXIV, 26 June 1936, p. 2.

PISSARRO AND VENTURI 1939 L.-R. Pissarro and L. Venturi, *Camille Pissarro: son art–son oeuvre*, 2 vols, Paris, 1939. Rev. ed.: San Francisco, 1989 (referred to throughout catalogue as P&V).

PLANT 1976 M. Plant, *French Impressionists and Post-Impressionists*, National Gallery of Victoria, Melbourne, 1976.

POMARÈDE 1970 F. Pomarède, 'A voir au Musée St. Denis', *L'Union*, 31 March 1970.

POOL 1967 P. Pool, *Impressionism*, London and New York, 1967,.

PORCHERON 1876 E. Porcheron, 'Promenades d'un flaneur: les impressionnistes', *Le Soleil*, 4 April 1876.

POTHEY 1876 A. Pothey, 'Chronique: exposition des "impressionalistes" chez Nadar, boulevard des Capucines', *La Presse*, 31 March 1876.

PREUTU 1974 M. Preutu, *Pissarro: monografie*, Bucharest, 1974.

RAVENEL 1865 J. Ravenel, [A. Sensier] 'Salon de 1865', *L'Epoque*, vol. I, 15 June 1865.

RAVENEL 1870 J. Ravenel, [A. Sensier] 'Préface au Salon de 1870', *La Revue Internationale de l'Art et de la Curiosité*, vol. III, 15 April 1870, p. 323.

RAVIN 1981 J.G. Ravin, 'Art and Medicine: Pissarro', *Bulletin, Academy of Medicine of Toledo and Lucas County*, vol. LXXII, no. 2, March–April, 1981.

RAVIN 1984 J.G. Ravin, 'Opthalmology and the arts: Pissarro's lacrimal problems', *Opthalmic Forum*, vol. II, no. I, 1984.

REDON 1868 O. Redon, 'Le Salon de 1868', *La Gironde*, 1 July 1868.

REFF 1964 T. Reff, 'Copyists in the Louvre', *Art Bulletin*, XLVI, December 1964, p. 556.

REFF 1967 T. Reff, 'Pissarro's Portrait of Cézanne', *Burlington Magazine*, vol. CIX, November 1967, pp. 626–33.

REFF 1982 T. Reff, *Manet and Modern Paris*, exh. cat., National Gallery of Art, Washington, D.C., 1982.

REID 1977 M. Reid, 'Camille Pissarro: three paintings of London. What do they represent?', *Burlington Magazine*, vol. CXIX, April 1977, pp. 251–61.

REIDEMEISTER 1963 L. Reidemeister, *Auf den Spuren der Maler der Ile de France*, exh. cat., Staatliche Museen, Berlin, 1963.

REWALD n.d. J. Rewald, *Pissarro*, Paris, n.d.

REWALD 1936 J. Rewald, 'L'Oeuvre de jeunesse de Camille Pissarro', *L'Amour de l'Art*, vol. XVII, April 1936, pp. 141–45.

REWALD 1937 J. Rewald, 'Paysages de Paris, de Corot à Utrillo', *La Renaissance*, January–February 1937.

REWALD 1938 J. Rewald, 'Camille Pissarro: his work and influence', *Burlington Magazine*, vol. LXXII, June 1938, pp. 280–91.

REWALD 1939(i) J. Rewald, *Camille Pissarro au Musée du Louvre*, Paris and Brussels, 1939.

REWALD 1939(ii) J. Rewald, *Pissarro*, Paris [1939].

REWALD 1942 J. Rewald, 'Camille Pissarro in the

West Indies', *Gazette des Beaux-Arts*, 6th series, vol. XXII, October 1942, pp. 57–60.

REWALD 1943 J. Rewald, 'Pissarro's Paris and his France; the camera compares', *Art News*, vol. XLII, 1 March 1943, pp. 14–17, and 15 March 1943, p. 7.

REWALD 1953 J. Rewald, *Pissarro*, Paris, 1953.

REWALD 1954 J. Rewald, *Camille Pissarro*, Paris, 1954. Tr.: *Camille Pissarro*, New York, 1954.

REWALD 1962 J. Rewald, *Pissarro*, Paris, 1962. Reduced text, Tr.: *Pissarro*, London and New York, 1963.

REWALD 1973(i) J. Rewald, *The History of Impressionism*, New York, 4th ed. rev., 1973. Earlier eds: 1946, 1955, 1961. Tr.: *L'Histoire de l'Impressionnisme*, Paris, 1955, 1965, 1971, 1976.

REWALD 1973(ii) J. Rewald, 'Theo van Gogh, Goupil and the Impressionists', *Gazette des Beaux-Arts*, 6th series, vol. LXXXI, January 1973, pp. 1–64, February 1973, pp. 65–108.

REWALD 1978 J. Rewald, *Post-Impressionism, from van Gogh to Gauguin*, New York, 3rd ed. rev., 1978. Earlier eds: 1956, 1962. Tr.: *Le Post-Impressionnisme*, Paris, 1961.

REWALD 1984 J. Rewald and F. Weitzenhoffer, *Aspects of Monet: A Symposium of the Artist's Life and Times*, New York, 1984.

REY 1936 R. Rey, 'Pissarro aux Iles Vierges', *Beaux-Arts*, vol. LXXIV, 1 May 1936, p. 6.

RIVIÈRE 1877 G. Rivière, 'L'Exposition des impressionnistes', *L'Impressionniste: Journal d'Art*, 6 April 1877, p. 2 and 14 April 1877, pp. 3–4. Repr.: Venturi, *Les archives de l'Impressionnisme*, vol. II, Paris, 1939, pp. 308, 317–18.

ROBINSON 1984 S.B. Robinson, ed., *The French Impressionists in Southern California: Paintings, Sculpture and Prints in Public Collections*, Los Angeles, 1984.

ROCHEBLAVE n.d. S. Rocheblave, *French Painting of the XIX Century*, New York, n.d.

ROGER-MARX 1927 C. Roger-Marx, 'Les Eaux-fortes de Pissarro, Galerie Bine', *La Renaissance*, vol. X, April 1927, pp. 203–5.

ROGER-MARX 1928 C. Roger-Marx, 'Camille Pissarro', *Les Annales Politiques et Littéraires*, 15 December 1928, pp. 578–79.

ROGER-MARX 1929 C. Roger-Marx, *Camille Pissarro*, Paris, 1929.

ROSENBLUM 1989 R. Rosenblum, *Les Peintures du Musée d'Orsay*, preface by Françoise Cachin, Paris, 1989.

ROSENSAFT 1974 J.B. Rosensaft, 'Le Néo-Impressionnisme de Camille Pissarro', *L'Oeil*, February 1974, pp. 52–57, 75.

ROSTRUP 1966 Haarvard Rostrup, *Catalogue of the Works of Art in the Ordrupgaard Collection*, Copenhagen, 1966.

ROTHENSTEIN 1947 J. Rothenstein, *One Hundred Modern Foreign Pictures in the Tate Gallery*, London, 1947.

ROUSSEAU 1866 J. Rousseau, 'Le Salon de 1866, IV', *L'Univers Illustré*, vol. IX, 14 July 1866, p. 447.

RUBIN 1967 W. Rubin, 'Jackson Pollock and the Modern Tradition, Part II', *Artforum*, vol. V, 1967.

SALLANCHES 1882 A. Sallanches, 'L'Exposition des artistes indépendants', *Le Journal des Arts*, 3 March 1882.

SAUNIER 1892 C. Saunier, 'L'Art Nouveau: I. Camille Pissarro', *La Revue Indépendante*, April 1892, pp. 30–40.

SAUNIER n.d. C. Saunier, *Anthologie d'Art Français, XIXe siècle*, Paris, n.d.

SCHIRRMEISTER 1982 A. Schirrmeister, *Camille Pissarro*, New York, 1982.

SCHNEIDER 1968 P. Schneider and the Editors of Time-Life Books, *The World of Manet*, New York, 1968.

SCHOP 1876 'Baron Schop' [T. de Banville], 'La semaine parisienne, l'exposition des intransigeants, l'école des Batignolles, impressionnistes et plein air', *Le National*, 7 April 1876.

SCHUMANN 1914 P. Schumann, 'Französische Ausstellung in Dresden', *Die Kunst*, July 1914.

SCHWARTZ 1971 P.W. Schwartz, *Camille Pissarro, Great Art of the Ages Series*, New York, 1971.

SEIBERLING 1988 G. Seiberling, *Monet in London*, Seattle and London, 1988.

SERTAT 1890 R. Sertat, 'Exposition C. Pissarro', *Le Journal des Artistes*, 2 March 1890, p. 58.

SERULLAZ 1955 M. Serullaz, *Camille Pissarro*, Arcueil, 1955.

SHAPIRO 1971 B. Shapiro, 'Four intaglio prints by Camille Pissarro', *Boston Museum Bulletin*, vol. LXIX, 1971, pp. 131–41.

SHAPIRO 1975 B. Shapiro and M. Melot, 'Catalogue sommaire des monotypes de Camille Pissarro', *Nouvelles de l'Estampe*, January–February, vol. XIX (1975), pp. 16–23.

SHIKES 1980 R. Shikes and P. Harper, *Pissarro: His Life and Work*, New York and London, 1980.

SICKERT 1923 W. Sickert, 'French pictures at Knoedler's Gallery', *Burlington Magazine*, vol. XLIII, July 1923, pp. 39–40. Repr.: O. Sitwell, *A Free House*, London, 1947, pp. 155–58.

SILVESTRE 1874 P.A. Silvestre, 'Chronique des beaux-arts: l'exposition des révoltés', *L'Opinion Nationale*, 22 April 1874.

SILVESTRE 1876 A. Silvestre, 'Exposition de la rue Le Peletier', *L'Opinion Nationale*, 2 April 1876.

SILVESTRE 1880 A. Silvestre, 'Le Monde des arts: exposition de la rue des Pyramides', *La Vie Moderne*, 24 April 1880, p. 262.

SILVESTRE 1881 A. Silvestre, 'Le Monde des arts', *La Vie Moderne*, 16 April 1881, p. 251.

SILVESTRE 1882 A. Silvestre, 'Le Monde des arts', *La Vie Moderne*, 11 March 1882, p. 151.

SILVESTRE 1894 [A. Silvestre], 'Oeuvres de M. Camille Pissarro', *L'Art Français*, 10 March 1894.

SKIRA n.d. A. Skira, *Paris des temps nouveaux: De l'Impressionisme à nos jours*, n.d.

SLOCOMBE 1938 G. Slocombe, 'Papa Pissarro', *Coronet*, vol. IV, no. 1, 1 May 1938.

STABELL 1982 A. Stabell, *Catalogue of the Ordrupgaard Collection*, Copenhagen, 1982.

STEEGMAN 1960 J.H. Steegman, *Montreal Museum of Fine Arts: Catalogue of Paintings*, Montreal, 1960.

STEIN 1955 M. Stein, *Camille Pissarro*, Copenhagen, 1955.

STEPHENS 1904 H. Stephens, 'Camille Pissarro, impressionist', *Brush and Pencil*, vol. XIII, March 1904, pp. 411–27.

STERLING 1951 C. Sterling, *French Painting, 1100–1900*, Carnegie Institute, 1951.

STERLING 1967 C. Sterling and M. Salinger, *Metropolitan Museum of Art, French Paintings*, vol. III: *XIX–XX Centuries*, New York, 1967.

STORROCK 1953 A. Storrock, 'Impressionist paintings in Glasgow', *Apollo*, vol. LVII, 1953.

SWANE 1954 L. Swane, *Katalog over Kunstvaerkerne på Ordrupgård*, Copenhagen, 1954.

TABARANT 1925 A. Tabarant, *Pissarro*, Paris, 1924. Tr.: *Pissarro*, New York and London, 1925.

THIÉBAULT-SISSON 1921 Thiébault-Sisson, 'Camille Pissarro et son oeuvre', *Le Temps*, 30 January 1921.

THOMSON 1990 R. Thomson, *Camille Pissarro: Impressionism, Landscape and Rural Landscape*, Birmingham, 1990.

THORNLEY n.d. Thornley, *Vingt-cinq illustrations d'après Pissarro*, Paris, n.d.

THOROLD 1978 A. Thorold, 'The Pissarro collection in the Ashmolean Museum, Oxford', *Burlington Magazine*, vol. CXX, October 1978, pp. 642–45.

TOKYO 1972 *Seurat et le néo-impressionnisme*, Tokyo, 1972 (text in Japanese).

UHDE 1937 W. Uhde, *Impressionisten*, Vienna, 1937.

VAIZEY 1981 M. Vaizey, 'Camille Pissarro, Poet of the Ordinary', *Portfolio*, May/June 1981.

VALABRÈGUE 1881 A. Valabrègue, 'Beaux-Arts: l'exposition des impressionnistes', *La Revue Littéraire et Artistique*, vol. IV, 15 April 1881, p. 181.

VALLOTON 1892 F. Valloton, Article on Pissarro in *La Gazette de Lausanne*, 24 February 1892.

VAN DE VELDE 1891 H. Van De Velde, *Du paysan en peinture*, Brussels [n.d., lecture delivered in 1891], pp. 17–9. Remarks on Pissarro repr.: *L'Art Moderne*, 22 February 1891, pp. 60–62, and *L'Art Moderne*, 28 August 1892, pp. 276–77.

VARNEDOE 1976–77 J.K.T. Varnedoe and T.P. Lee, *Gustave Caillebotte*, exh. cat., Houston and Brooklyn, 1976–77.

VARNEDOE 1989 *A Fine Disregard: What Makes Modern Art Modern*, New York, 1989

VASSY 1876 G. Vassy, 'L'Exposition des impressionnistes', *L'Evénement*, 2 April 1876.

VENTURI 1935 L. Venturi, 'L'Impressionismo', *L'Arte*, vol. XXXVIII, March 1935, pp. 118–49. Tr.: 'Impressionism', *Art in America*, vol. XXIV, July 1936, pp. 94–110. Repr.: B. White, *Impressionism in perspective*, Englewood Cliffs, 1978, pp. 105–13.

VENTURI 1939 L. Venturi, *Les Archives de l'Impressionnisme*, vol. II, Paris, 1939.

VENTURI 1950 L. Venturi, 'Camille Pissarro', in *Impressionists and Symbolists*, New York and London, 1950, pp. 67–79.

VERGNET-RUIZ 1962 J. Vergnet-Ruiz and M. Laclotte, *Petits et grands musées de France*, Paris, 1962.

VERHAEREN 1885 E. Verhaeren, 'L'Impressionnisme', *Le Journal de Bruxelles*, 15 June 1885. Repr.: Verhaeren, *Sensations*, Paris, 1928, p. 180.

VERHAEREN 1887 E. Verhaeren, 'Le Salon des Vingt à Bruxelles', *La Vie Moderne*, 26 February 1887, p. 138.

WALDMANN 1927 E. Waldmann, *Die Kunst des Realismus und des Impressionismus*, Berlin, 1927.

WALKER 1976 J. Walker, *National Gallery of Art, Washington*, New York, 1976.

WALTER 1968 Rodolphe Walter, 'Pieter Van Der Velde, un amateur éclairé', *Gazette des Beaux-Arts*, vol. LXXII, 1968, pp. 203–6.

WECHSLER 1952 H.J. Wechsler, *French Impressionists*, New York, 1952.

WEDMORE 1883 F. Wedmore, 'The Impressionists', *Fortnightly Review*, n.s. vol. XXXIII, January 1883, p. 81.

WEISBACH 1911 W. Weisbach, *Impressionismus: ein Problem der Malerei in der Antike und Neuzeit*, vol. II, Berlin, 1911, pp. 142–44.

WERNER 1965 A. Werner, 'The Quiet Grandeur: The Oeuvre of Pissarro', *Arts Magazine*, March 1965.

WHITE 1965 H. and C. White, *Canvases and Careers: Institutional Change in the French Painting World*, New York, 1965.

WILENSKI 1931 R.H. Wilenski, *French Painting*, Boston, 1931.

WILHEIM 1961 J. Wilhelm, *Paris vu par les peintres*, Paris, 1961.

WOLFF 1876 A. Wolff, 'Le calendrier parisien', *Le Figaro*, 3 April 1876.

WOLFF 1879 A. Wolff, 'Les Indépendants', *Le Figaro*, 11 April 1879.

YOUNG 1967 A. McLaren Young, 'Le Pont Boieldieu à Rouen: Soleil Couchant', *The Listener*, 8 June 1967.

ZOLA 1866 E. Zola, 'Adieux d'un critique d'art', *L'Evénement*, 20 May 1866. Repr.: Zola, *Mon salon*, Paris, 1866; Zola, *Mes haines*, Paris, 1867. Repr.: F.W.J. Hemmings and R.J. Niess, *Emile Zola: Salons*, Geneva and Paris, 1959, p. 78.

ZOLA 1868 E. Zola, 'Mon Salon, III. Les naturalistes' and 'Les paysagistes', *L'Evénement Illustré*, 19 May and 1 June 1868. Repr.: F.W.J. Hemmings and R.J. Niess, *Emile Zola: Salons*, Geneva and Paris, 1959, pp. 126–29, 135.

ZOLA 1880 E. Zola, 'Le naturalisme au Salon', *Le Voltaire*, 18–22 June 1880. Repr.: F.W.J. Hemmings and R.J. Niess, *Emile Zola: Salons*, Geneva and Paris, 1959, pp. 233–54.

PHOTOGRAPH ACKNOWLEDGEMENTS

In most cases the illustrations have been made from transparencies and photographs provided by the owners or custodians of the works. Those plates for which further credit is due are listed below. Numbers in **bold** refer to catalogue or illustration numbers; all others refer to comparative figure numbers.

Tibor Franyo **16**
Photographie Giraudon **149**
© Foto Anne Gold **81**
Elizabeth Gombosi **56**
Richard Goodbody **46**
David Harris **78**
© Colorphoto Hans Hinz, Allschwil-Basel **109**, **139**
Foto-Studio H. Humm **94**
Jacques Lathian 6
The Lefevre Gallery, London/A.C. Cooper **108**
Pennisi **22**
Hans Petersen **105**

Piraud et Grivel **111**
© Photo R.M.N. **3**, **19**, **132**, **135**, **152**
Jean-Olivier Rousseau **17**, **42**
Peter Schälchli Fotoatelier, Zürich **144**
Galerie Schmit, Paris **27**, **37**, **122**, **141**
Scott Bowron Photography, New York **88**
John Seyfried 27
Sotheby's **139**
Richard Stoner **6**
© Steven Tucker **86**
Graydon Wood **68**

FRIENDS OF THE ROYAL ACADEMY

SPONSORS
Mr Brian Bailey
Air Marshal Sir Erik Bennett
Mr P.F.J. Bennett
Mrs J. Brice
Mr Jeremy Brown
Mrs Susan Burns
Mrs Elizabeth Corob
Mr and Mrs S. Fein
Mr J.G. Fogel
Miss C. Fox
Mr and Mrs R. Gapper
Mr and Mrs Michael Godbee
Lady Gosling
Mr Peter G. Goulandris
Lady Grant
Mr J.P. Jacobs
Mrs Sonya Jenkins
Mr Harold Joels
Mr J. Kirkman
Mr and Mrs N.S. Lersten
Dr Abraham Marcus
The Oakmoor Trust
Ocean Group p.l.c. (P.H. Holt Trust)
Mr William Plapinger
The Rufford Foundation
The Worshipful Company of Saddlers
Mr Robin Symes
Sir Brian Wolfson

ASSOCIATE SPONSORS
Mr Richard B. Allan
Mr Richard Alston
Mr Ian F.C. Anstruther
Mrs Ann Appelbe
Mr John R. Asprey
Mr Edgar Astaire
Lady Attenborough
Mr J.M. Bartos
Mrs Olive Bell
Mr David Berman
Mrs Susan Besser
Mrs John Bibby
Mrs Linda Blackstone
Mrs C.W.T. Blackwell
Mr Peter Boizot
Mr C.T. Bowring (Charities Fund Ltd)
Mrs J.M. Bracegirdle
Mr G. Bradman
Mr John H. Brandler
Mr Cornelius Broere
Lady Brown
Mr P.J. Brown Jr
Mrs A. Cadbury
Mr and Mrs R. Cadbury
Mrs C.A. Cain
Mrs L. Cantor
Carroll Foundation
Mr E.V. Cass
Miss E.M. Cassin
Mr R.A. Cernis
Mr W.J. Chapman
Mr Michael Chowen
Mrs J.V. Clarke
Mrs D. Cohen
Ms E.D. Cohen
Mrs R. Cohen
Mrs N.S. Conrad
Mr C. Cotton
Mrs J. Curbishley

Mrs Saeda H. Dalloul
Mr John Denham
Mr Richard Dobson
The Marquess of Douro
Mr Kenneth Edwards
Mrs K.W. Feesey MSc
Mrs B.D. Fenton
Dr Gert-Rudolph Flick
Mrs J. Francis
Mr Gregory H. French
Mr Graham Gauld
Mr Robert Gavron
Mr Stephen A. Geiger
Lady Gibberd
Mrs E.J. Gillespie
Mrs R.H.I. Goddard
Mr M.L. Goldhill
Mrs P. Goldsmith
Mr Gavin Graham
Mrs J. Green
Mr R.W. Gregson-Brown
Mrs M. Griessman
Mrs O. Grogan
Mrs W. Grubman
Mr J.A. Hadjipateras
Mr Jonathan D. Harris
Mr Robert Harris
Mrs Mogens Hauschildt
Miss Julia Hazandras
Mr M.Z. Hepker
Mr Malcolm Herring
Mrs K.S. Hill
Mr J. Hoare
Mr Reginald Hoe
Mr Charles Howard
Mrs A. Howitt
Mr John Hughes
Mr Christopher Hull
Mr Norman J. Hyams
Mr David Hyman
Mrs Manya Igel
Mr C.J. Ingram
Mr S. Isern-Feliu
Ms K.B. Isman
Mrs I. Jackson
Lady Jacobs
Mr and Mrs Jaqua
Mrs A. Johnson
Mr I.E. Joye
Mrs G. Jungles-Winkler
Mr and Mrs S.D. Kahan
Mr Simon Karmel
Mr D. H. Killick
Mr P.W. Kininmonth
Mrs L. Kosta
Mrs E. Landau
Mrs J.H. Lavender
Mr and Mrs Thomas Leaver
Mr Ronald A. Lee
Mr Morris Leigh
Mr and Mrs J.R.A. Leighton
Mr and Mrs R. Leiman
Mr David Levinson
Mr Owen Luder
The Hon. Simon Marks
Mr and Mrs V.J. Marmion
Mr B.P. Marsh
Mr and Mrs J.B.H. Martin
Mr R.C. Martin
Mrs G.M.S. McIntosh
Mr Malcolm McIntyre
Mr Peter I. McMean
Mr J. Menasakanian

Mr J. Moores
Mrs A. Morgan
Mrs A. Morrison
Mr A.H.J. Muir
Mr David H. Nelson
Mrs E.M. Oppenheim-Sandelson
Mr Brian R. Oury
Mrs J. Palmer
Mr J.H. Pattisson
Mrs M.C.S. Philip
Mr Ralph Picken
Mr G.B. Pincus
Mrs J. Rich
Mr Clive and Mrs Sylvia Richards
Robinson Charitable Trust
Mr F.P. Robinson
Mr D. Rocklin
Mrs A. Rodman
Baron Elie de Rothschild
Mr and Mrs O. Roux
The Hon. Sir Stephen Runciman CH
Sir Robert Sainsbury
Mr G. Salmanowitz
Lady Samuel
Mrs Bernice Sandelson
Ms J. Sandeman-Allen
Mrs Bernard L. Schwartz
Mrs L. Schwartz
Mr and Mrs D.M. Shalit
Shell U.K. Ltd
Mr Mark Shelmerdine
Mrs Heather Shemlit
Mrs P. Sheridan
Mr Mohamed Shourbaji
Mr R.J. Simmons
Mr John H.M. Sims
Dr and Mrs Leonard Slotover
Mr and Mrs R. Slotover
Mrs Smiley's Charitable Trust
The Spencer Wills Trust
Dr M. Stoppard
Mrs B. Stubbs
Mr J.A. Tackaberry
Mr G.C.A. Thom
Mr H.R. Towning
Mrs Andrew Trollope
Mr A.J. Vines
Mr R. Wallington-Green
Mr D.R. Walton Masters
Mr Neil Warren
Miss J. Waterous
Mrs C. Weldon
Mr Frank S. Wenstrom
Miss L. West Russell
Mr R.A.M. Whitaker
Mr J. Wickham
Wilde Sapte
Mr Colin C. Williams
Mrs I. Wolstenholme
Mr W.M. Wood
Mr R.M. Woodhouse
Mr David Young
Mr F. Zangrilli

ROYAL ACADEMY TRUST

BENEFACTORS
H.M. The Queen
AIG Inc.
Mr and Mrs Russell B. Aitken
The Annie Laurie Aitkin Charitable Trust
American Associates of the Royal Academy Trust
American Express Company
Mrs John W. Anderson II
The Hon. Walter H. and Mrs Annenberg
Mr Walter Archibald
The Hon. Anne and Mr Tobin Armstrong
Asprey
AT&T
Mrs Henry Bagley
Miss Nancy Balfour
The Bank of England
Barclays Bank plc
The Baring Foundation
B.A.T. Industries plc
Mr Tom Bendhem
Mr and Mrs James Benson
In Memoriam: Ida Rose Biggs
Dame Elizabeth Blackadder RA
Bowne of New York City
Sir Peter Bowring
The Lady Brinton
British Airways
British Gas plc
The British Petroleum Company plc
BP America
British Steel plc
Mr Keith Bromley
The Brown Foundation Inc.
BT
Bunzl plc
Mr and Mrs Walter Burke
The Rt Hon. the Lord Carrington
The Trustees of the Clore Foundation
The Worshipful Company of Clothworkers
Mr and Mrs Christopher Clutz
The John S. Cohen Foundation
The Colby Trust
Commercial Union Assurance Company PLC
The Ernest Cook Trust
Mrs Jan Cowles
Credit Suisse First Boston
The Cresent Trust
Lord Willoughby de Broke
Sir Roger de Grey PRA
The Worshipful Company of Distillers
Sir Harry and Lady Djanogly
In Memoriam: Miss W.A. Donner
Alfred Dunhill Limited
Miss Jayne Edwardes
The John Ellerman Foundation
English Heritage
Mrs Roberta Entwistle
Esso UK PLC
Mr Anthony Eyton RA
The Esmée Fairbairn Charitable Trust
Mr Michael E. Flintoff
The Hon. Leonard K. and Mrs Firestone
The Worshipful Company of Fishmongers
Mr Walter Fitch III
Mrs Henry Ford II
The Henry Ford II Fund
The Late John Frye Bourne
The Garfield Weston Foundation
The Gatsby Foundation
The Getty Grant Program

The J. Paul Getty Jr Trust
The Lady Gibson
Glaxo
Mrs Mary Graves
The Jack Goldhill Charitable Trust
The Horace W. Goldsmith Foundation
The Worshipful Company of Goldsmiths
Mr and Mrs John Gore
The Greentree Foundation
Mr Lewis Grinnan Jr
The Worshipful Company of Grocers
The Worshipful Company of Haberdashers
Mr and Mrs Melville Wakeman Hall
The Paul Hamlyn Foundation
The Late Dr and Mrs Armand Hammer
Mrs Sue Hammerson
Philip and Pauline Harris Charitable Trust
The Hayward Foundation
Mr and Mrs Randolph A. Hearst
Klaus and Belinda Hebben
The Hedley Foundation
Mrs Henry J. Heinz II
The Henry J. and Drue Heinz Foundation
The Heritage of London Trust
Mr D.J. Hoare
IBM United Kingdom Limited
The Idlewild Trust
The Inchcape Charitable Trust
The Worshipful Company of Ironmongers
Mr and Mrs Ralph Isham
The J.P. Jacobs Charitable Trust
Elin and Lewis Johnston
Kankaku (Europe) Limited
Mrs D. King
Irene and Hyman Kreitman
The Kresge Foundation
The Kress Foundation
Ladbroke Group PLC
Mr D.E. Laing
The Maurice Laing Foundation
The Landmark Trust
The Lankelly Foundation
Mr John S. Latsis
Mr Roland P. Lay
The Leche Trust
Sir Hugh Leggatt
Mr and Mrs Panagiotis Lemos
Mr J.H. Lewis
Lex Services plc
The Ruth and Stuart Lipton Charitable Trust
Sir Sydney and Lady Lipworth
Lloyds Bank PLC
Mr Jack Lyons
Mrs T.S. Mallinson
The Manifold Trust
Mr and Mrs John L. Marion
Mrs W. Marks
Marks & Spencer
Mrs Jack C. Massey
Mr Paul Mellon KBE
The Anthony and Elizabeth Mellows Charitable Trust
The Mercers' Company
Lieut. Col. L.S. Michael OBE
The Lord and Lady Moyne
Mrs Sylvia Mulcahy
Museums and Galleries Improvement Fund
National Westminster Bank PLC
Mr Stavros S. Niarchos
NTT Europe Ltd
Otemae College
Mrs Vincent Paravicini
Mr Richard Park
Mr and Mrs Frank Pearl

The Pennycress Trust
In Memoriam: Mrs Olive Petit
Mr and Mrs Milton Petrie
The P.F. Charitable Trust
The Pilgrim Trust
Mr A.N. Polhill
The Hon. Charles H. and Mrs Price II
Prudential Assurance Company Ltd
The Radcliffe Trust
Mr and Mrs John Raisman
Ranks Hovis MacDougall plc
The Rayne Foundation
Mr and Mrs Laurance S. Rockefeller
The Ronson Charitable Foundation
Rothschilds Inc
The RTZ Corporation PLC
The Late Dr Arthur M. Sackler
Mrs Arthur M. Sackler
The Sainsbury Family Charitable Trusts
Mrs Jean Sainsbury
Mrs Basil Samuel
The Peter Samuel Charitable Trust
Mrs Louisa Sarofim
Save & Prosper Educational Trust
Sea Containers Limited
The Rt. Hon. the Lord Sharp
Shell UK Ltd
The Very Reverend E.F. Shotter
Dr Francis Singer
The Worshipful Company of Skinners
Mr and Mrs James C. Slaughter
The Late Mr Robert Slaughter
The Spencer Charitable Trust
Miss K. Stalnaker
Mr and Mrs Stephen Stamas
The Starr Foundation
Lady Daphne Straight
Bernard Sunley Charitable Foundation
Mrs Pamela Synge
Mr and Mrs A. Alfred Taubman
Mr Harry Teacher
Texaco Inc
G. Ware and Edythe Travelstead
The TSB Foundation for England and Wales
The 29th May 1961 Charitable Trust
Unilever PLC
Mr Alexander Von Auersperg
The Henry Vyner Charitable Trust
The Wates Foundation
S.G. Warburg Limited
Dorothy, Viscountess Weir
The Weldon UK Charitable Trust
Mr and Mrs Keith S. Wellin
The Welton Foundation
Westminster City Council
Mr and Mrs Garry H. Weston
Mr Anthony Whishaw RA
Mr Frederick B. Whittemore
The Hon. John and Mrs Whitehead
Mrs John Hay Whitney
Mr and Mrs Wallace S. Wilson
Mr A. Witkin
The Wolfson Foundation
The Late Mr Charles Wollaston
The Late Mr Ian Woodner
Mr and Mrs William Wood Prince

CORPORATE MEMBERS

Amdahl UK Limited
Arthur Andersen and Andersen Consulting
A.T. Kearney Limited

Barclays de Zoete Wedd
BAT Industries PLC
BP Chemicals Limited
BP International
British Alcan Aluminium PLC
British Gas PLC
Bunzl PLC
Chesterton International
Chubb Insurance Company
Cookson Group PLC
The Diamond Trading Company (Pty) Limited
Ford Motor Company
Goldman Sachs International Limited
Glaxo Holdings PLC
Grand Metropolitan PLC
Hill Samuel Bank Limited
Hillier Parker May & Rowden
IMS International
Intercontinental Hotel Group
Intercraft Designs Limited
Jaguar Cars Ltd
John Laing PLC
Lehman Brothers International
Lloyds Private Banking Limited
London & Edinburgh Trust PLC
E.D. & F. Man Limited Charitable Trust
Marks & Spencer
Midland Group
MoMart Ltd
J.P. Morgan
Morgan Stanley International
Northern Telecom
The Peninsular and Oriental Steam Navigation Co
The Reader's Digest Association
Reed Elsevier (UK) Limited
The Reuter Foundation
Rothmans International PLC
Rothmans International Tobacco (UK) Limited
The RTZ Corporation PLC
Salomon Brothers Europe Limited
Santa Fe Exploration (U.K.) Limited
Silhouette Eyewear
Smith & Williamson
Southern Water PLC
St James's Place Capital PLC
The Daily Telegraph
Thorn EMI PLC
TI Group PLC
Unilever PLC

CORPORATE ASSOCIATES

3i PLC
Allen & Overy
American Express Europe Ltd
The Arts Club
A T & T (UK) Ltd
Bankers Trust Company
Banque Paribas
Barclays Bank plc
Barlow Lyde & Gilbert
Belron International BV
BMP DDB Needham
The BOC Group
Booker PLC
Bovis Construction Ltd
Brixton Estate plc
Burmah Castrol plc
Cable and Wireless plc
Charterhouse plc
CJA (Management Recruitment Consultants) Limited
Clifford Chance

CME.KHBB Ltd
Coopers & Lybrand
Courage Charitable Trust
Coutts & Co
The Dai-Ichi Kangyo Bank Limited
Dalgleish & Co
The De La Rue Company plc
Denton Hall Burgin & Warrens
Durrington Corporation Limited
Enterprise Oil plc
J.W. Falkner and Sons Ltd
Fina plc
Foreign & Colonial Management Ltd
Forte plc
Gartmore Investment Management Limited
General Accident PLC
The General Electric Company plc
Global Asset Management
Granada Group
Guardian Royal Exchange plc
Halecrest – Design and Build
Hay Management Consultants Ltd
H.J. Heinz Company Limited
IBM UK Ltd
Inchcape plc
S.C. Johnson
Kleinwort Benson Limited
Kodak Limited
Laing & Cruickshank
Lex Service plc
Linklaters and Paines
Y. J. Lovell (Holdings) plc
John Lewis Partnership plc
London Weekend Television
Macfarlanes
Mars Electronics International
Martini & Rossi Ltd
The Mercers' Company
Motion Picture Enterprises Ltd
Nabarro Nathanson
National Power plc
NCR Ltd
NEC (UK) Ltd
The Nestlé Charitable Trust
Nihon Keizai Shimbun Europe Ltd
Occidental International Oil Inc
Ove Arup Partnership
Pearson plc
Pentagram Design Ltd
Pentland Group plc
The Post Office
The Rank Organisation plc
Reliance National Insurance Company (UK) Ltd
Robert Fleming & Co Limited
The Royal Bank of Scotland
Royal Insurance Holdings plc
Sainsbury's plc
Saurer Group Investments Limited
Save & Prosper Educational Trust
Schroder Investment Management Ltd
J. Henry Schroder Wagg & Co Limited
Sears plc
Sedgwick Group plc
Slough Estates PLC
SmithKline Beecham
Sony (UK) Limited
Sotheby's
Stanhope Properties plc
Sun Life Assurance Society plc
Tate + Lyle plc
Taylor Joynson Garrett
Tomkins plc
Trafalgar House Construction Holdings Ltd

United Biscuits (UK) Ltd
S. G. Warburg Group plc
The Wellcome Foundation Ltd
Wood & Wood International Signs Ltd
Yamaichi International (Europe) Ltd

SPONSORS OF PAST EXHIBITIONS

The Council of the Royal Academy thanks sponsors of past exhibitions for their support. Sponsors of major exhibitions during the last ten years have included the following:

ALITALIA
Italian Art in the 20th Century 1989

AMERICAN EXPRESS FOUNDATION
Masters of 17th-Century Dutch Genre Painting 1984
'Je suis le cahier': The Sketchbooks of Picasso 1986

ARTS COUNCIL OF GREAT BRITAIN
Allan Gwynne Jones 1983
The Hague School 1983
Peter Greenham 1985

BANQUE INDOSUEZ & W.I. CARR
Gauguin and The School of Pont-Aven: Prints and Paintings 1989

BAT INDUSTRIES PLC
Murillo 1983
Paintings from the Royal Academy US Tour 1982/84, RA 1984

BBC RADIO ONE
The Pop Art Show 1991

BECK'S BIER
German Art in the 20th Century 1985

BMW 8 SERIES
Georges Rouault: The Early Years, 1903–1920 1993

ROBERT BOSCH LIMITED
German Art in the 20th Century 1985

BOVIS CONSTRUCTION LTD
New Architecture 1986

BRITISH ALCAN ALUMINIUM
Sir Alfred Gilbert 1986

BRITISH GYPSUM LTD
New Architecture 1986

BRITISH PETROLEUM PLC
British Art in the 20th Century 1987

BT
Hokusai 1991

CANARY WHARF DEVELOPMENT CO
New Architecture 1986

THE CHASE MANHATTAN BANK
Cézanne: The Early Years 1988

THE DAI-ICHI KANGYO BANK, LIMITED
222nd Summer Exhibition 1990

DEUTSCHE BANK AG
German Art in the 20th Century 1985

DIGITAL EQUIPMENT CORPORATION
Monet in the '90s: The Series Paintings 1990

THE ECONOMIST
Inigo Jones Architect 1989

EDWARDIAN HOTELS
The Edwardians and After:
Paintings and Sculpture from the Royal Academy's Collection, 1900–1950 1990

ELECTRICITY COUNCIL
New Architecture 1986

ELF
Alfred Sisley 1992

ESSO PETROLEUM COMPANY LTD
220th Summer Exhibition 1988

FIAT
Italian Art in the 20th Century 1989

FINANCIAL TIMES
Inigo Jones Architect 1989

FIRST NATIONAL BANK OF CHICAGO
Chagall 1985

FONDATION ELF
Alfred Sisley 1992

FORD MOTOR COMPANY LIMITED
The Fauve Landscape: Matisse, Derain, Braque and their Circle 1991

FRIENDS OF THE ROYAL ACADEMY
Allan Gwynne Jones 1983
Peter Greenham 1985
Sir Alfred Gilbert 1986

GAMLESTADEN
Royal Treasures of Sweden, 1550–1700 1989

JOSEPH GARTNER
New Architecture 1986

J. PAUL GETTY JR CHARITABLE TRUST
The Age of Chivalry 1987

GLAXO HOLDINGS PLC
From Byzantium to El Greco 1987
Great Impressionist and other Master Paintings from the Emil G. Bührle Collection, Zurich 1991

GUINNESS PLC
Twentieth-Century Modern Masters: The Jacques and Natasha Gelman Collection 1990
223rd Summer Exhibition 1991
224th Summer Exhibition 1992
225th Summer Exhibition 1993

GUINNESS PEAT AVIATION
Alexander Calder 1992

HARPERS & QUEEN
Georges Rouault: The Early Years 1903–1920 1993

THE HENRY MOORE FOUNDATION
Henry Moore 1988
Alexander Calder 1992

HOECHST (UK) LTD
German Art in the 20th Century 1985

IBM UNITED KINGDOM LIMITED
215th Summer Exhibition 1983

THE INDEPENDENT
The Art of Photography 1839–1989 1989
The Pop Art Show 1991

THE INDUSTRIAL BANK OF JAPAN
Hokusai 1991

INTERCRAFT DESIGNS LIMITED
Inigo Jones Architect 1989

JOANNOU & PARASKEVAIDES (OVERSEAS) LTD
From Byzantium to El Greco 1987

THE KLEINWORT BENSON GROUP
Inigo Jones Architect 1989

LLOYDS BANK
The Age of Chivalry 1987

LOGICA
The Art of Photography, 1839–1989 1989

LUFTHANSA
German Art in the 20th Century 1985

THE MAIL ON SUNDAY
Royal Academy Summer Season 1992
Royal Academy Summer Season 1993

MARTINI & ROSSI LTD
The Great Age of British Watercolours, 1750–1880
1993

MELITTA
German Art in the 20th Century 1985

PAUL MELLON KBE
The Great Age of British Watercolours, 1750–1880
1993

MERCEDES–BENZ
German Art in the 20th Century 1985

MERCURY COMMUNICATIONS
The Pop Art Show 1991

MIDLAND BANK PLC
The Art of Photography, 1839–1989 1989

MITSUBISHI ESTATE COMPANY UK LIMITED
Sir Christopher Wren and the Making of
St Paul's 1991

MOBIL
Modern Masters from the Thyssen-Bornemisza
Collection 1984
From Byzantium to El Greco 1987

NATIONAL WESTMINSTER BANK
Reynolds 1986

OLIVETTI
The Cimabue Crucifix 1983
Andrea Mantegna 1992

OTIS ELEVATORS
New Architecture 1986

PARK TOWER REALTY CORPORATION
Sir Christopher Wren and the Making of
St Paul's 1991

PEARSON PLC
Eduardo Paolozzi Underground 1986

PILKINGTON GLASS
New Architecture 1986

REDAB (UK) LTD
Wisdom and Compassion: The Sacred Art of Tibet
1992

REED INTERNATIONAL PLC
Toulouse-Lautrec: The Graphic Works 1988
Sir Christopher Wren and the Making of
St Paul's 1991

REPUBLIC NATIONAL BANK OF NEW YORK
Sickert: Paintings 1992

ARTHUR M. SACKLER FOUNDATION
Jewels of the Ancients 1987

SALOMON BROTHERS
Henry Moore 1988

SEA CONTAINERS & VENICE SIMPLON–ORIENT EXPRESS
The Genius of Venice 1983

SIEMENS
German Art in the 20th Century 1985

SILHOUETTE EYEWEAR
Egon Schiele and his Contemporaries from the
Leopold Collection, Vienna 1990
Wisdom and Compassion: The Sacred Art of Tibet
1992

SPERO COMMUNICATIONS
The Schools Final Year Show 1992

SWAN HELLENIC
Edward Lear 1985

TEXACO
Selections from the Royal Academy's Private
Collection 1991

THE TIMES
Old Master Paintings from the Thyssen-Bornemisza
Collection 1988
Wisdom and Compassion: The Sacred Art of Tibet
1992

TRAFALGAR HOUSE
Elisabeth Frink 1985

TRUSTHOUSE FORTE
Edward Lear 1985

UNILEVER
The Hague School 1983
Frans Hals 1990

VISTECH INTERNATIONAL LTD
Wisdom and Compassion: The Sacred Art of Tibet
1992

WALKER BOOKS LIMITED
Edward Lear 1985

OTHER SPONSORS
*Sponsors of events, publications and other items in the past
two years:*

Academy Group Limited
Air Seychelles
Air UK
American Airlines
Austrian Airlines
British Airways
Bulgari Jewellery
Cable & Wireless
Cathay Pacific
Christies International plc
Columbus Communications
Condé Nast Publications
Eileen Coyne
Brenda Evans
Fina PLC
Forte
Hard Rock Café
Tim Harvey Design
Holiday Inn Worldwide
IBM United Kingdom Limited
Inter-Continental Hotels
Intercraft Designs Limited
Jaguar Cars Limited
A.T. Kearney Limited
KLM
The Leading Hotels of the World
Martini & Rossi Ltd
Merrill Lynch
Midland Bank PLC
Anton Mosimann

Patagonia
Penshurst Press Ltd
Polaroid (UK) Ltd
Princess Rama Malla
Ring & Brymer
The Robina Group
Romilly Catering Co
Royal Mail International
Royal Nepal Airlines
Sherpa Expeditions
Paul and Mary Slawson
Mr and Mrs Daniel Unger
Kurt Unger
United Airlines
Venice Simplon-Orient Express
Vista Bay Club Seychelles
Vorwerk Carpets Limited
White Dove Press
Whyte & Mackay
Winsor & Newton
Mrs George Zakhem